Herman Göring and the Nazi Art Collection

*The Looting of Europe's
Art Treasures and Their
Dispersal After World War II*

KENNETH D. ALFORD

McFarland & Company, Inc., Publishers

Jefferson, North Carolina, and London

To the memory of
Thomas L. Sharp
(1923–2012)

LIBRARY OF CONGRESS CATALOGUING-IN-PUBLICATION DATA

Alford, Kenneth D.
Hermann Göring and the Nazi art collection : the looting of Europe's
art treasures and their dispersal after World War II / Kenneth D. Alford.
p. cm.
Includes bibliographical references and index.

ISBN 978-0-7864-6815-7
softcover : acid free paper ∞

1. Art treasures in war — Europe — History — 20th century. 2. Art thefts —
Europe — History — 20th century. 3. World War, 1939–1945 —
Destruction and pillage — Europe. 4. Göring, Hermann, 1893–1946 —
Art collections. 5. Germany — Cultural policy. I. Title.
N9160.A44 2012 709.4'09043 — dc23 2012010669

BRITISH LIBRARY CATALOGUING DATA ARE AVAILABLE

Front cover: Hermann Göring (1893–1946) in
SA-Gruppenführer uniform; Italian 16th–18th century, green silk,
velvet, Bellini Gallery; frames and drapery © 2012 Shutterstock

Manufactured in the United States of America

McFarland & Company, Inc., Publishers
Box 611, Jefferson, North Carolina 28640
www.mcfarlandpub.com

Acknowledgments

I am thankful to the many people and institutions who have helped with the research and writing of this book. A special thanks to M'Lisa Whitney, National Archives and Records Administration; Suzanne Freeman and Lee Bagby Viverette, Virginia Museum of Fine Arts. Last but not least, I pay tribute to my wife Edda. Without her support the tasks that I undertake would be unattainable.

Table of Contents

Preface

A few years ago my friend Dr. Klaus Goldmann, curator of the Berlin Pre and Early History Museum phoned to say that S. Lane Faison had donated his papers to the National Art Gallery in Washington, D.C. He stated that a copy of Faison's Office of Strategic Services (OSS) interrogations were included in the papers and asked if I could obtain a copy for him. An informative phone call, as I had been looking for these papers for many years. These documents, along with all the World War II OSS papers, had been turned over to the CIA in 1948 and subsequently placed in their archives at the National Security Agency in Fort Meade, Maryland, apparently, never to see the light of day again.

My response was immediate. I would be there the following day. When the door opened at the National Gallery, I entered and requested the Faison papers. To my complete surprise his file contained all three OSS "Art Looting Investigations" reports along with one by Captain Jean Vlug of the Royal Netherlands Army. I immediately inquired as to the location of the copy machine, as I intended to copy the documents, more than a thousand pages. The young lady helping me asked why the files were so important and further stated I was the third person to copy the papers in the past two days. I asked her who else had copied them. From her response, I knew that I had hit the jackpot. She said, "Employees from the Israeli and German embassies!" This confirmed to me that the files had not previously been disclosed and were indeed important. I also conjectured that someone from the German embassy had tipped off Dr. Goldmann. Of course, I mailed Goldmann a copy and kept one for myself. I have used this information for various references in my previous books.

These four Investigations, consisting of about 2,000 pages, are the basis for this book, along with the Munich Collection Point, Property Art Cards from the National Archives. Each of these 2,301 cards contain the description of each piece of Göring's art collection captured by U.S. Forces in Berchtesgaden. A hundred or so of the cards are missing and others contain mistakes, but overall they are a trove of information. The captured Göring Collection consisted of 3,325 objets d'art that included 1,160 paintings.

Of all the accounts surrounding the Göring Collection, these OSS reports remain the most compelling because the Germans connected with the Göring Art Collection

were engaged in the creation of these reports. In the summer of 1945, during the 90 days of developing these documents, some of the German scholars involved in their preparation received a dollar a day and two meals. The information from these Consolidated Interrogation Reports is carefully footnoted.

The appendices are inventories from original documents. A and B are verbatim copies of originals. In Appendix C, names of artists and titles of paintings — where there were multiple versions — have been standardized.

Appendix C is an excellent tool in accessing the Hermann Göring property cards in the National Archives. Organized alphabetically by artist and title of the object, the property card number is included with each entry. This is also the number of the corresponding art object referenced. As noted before, there are mistakes in the property cards.

This book scrutinizes the Hermann Göring Art Collection as it was upon its capture at the end of World War II; it is not an analysis of all the art acquired and traded by Göring during the war years. It is a study of the history and formation of the collection and the methods used by the Reichsmarschall of the Third Reich to strip the occupied countries of Europe of a large part of their artistic heritage. This widespread enterprise, which worked in the shadow of occupying forces, took the form of looting and so-called legal purchases. Looting always accompanies war; but Nazi art looting was different, as it was officially planned and expertly carried out. Looted art gave tone to an otherwise bare New Third Reich Order. In the program to enhance the cultural prestige of the "Master Race," the Adolf Hitler and Hermann Göring Art collections were the master organizations. Their collections had a symbolic value far beyond the mere gathering of an art collection.

The Nazis took millions of items of incalculable artistic and sentimental value estimated in the hundreds of millions of dollars. The collection, under Hitler's directions, was to exceed the collection amassed by the Metropolitan Museum in New York, the British Museum in London, the Louvre in Paris and the Tretiakov Gallery in Moscow. By the end of the war it was estimated that the Nazis had stolen roughly one-fifth of the entire art treasures of the world.

Operating within the intellectual limits of Nazi philosophy, it barred the work of nearly every non–German who flourished after 1800. It attempted to exalt 19th century German masters by removing all relevant competition. Together with officially approved contemporary German art, these collections were an argument for the modern primacy of Germany. With its immense resources and its official prestige the Nazi party tried to bring art under the shadow of the Swastika. For a time it did.[1]

The following 1945 value of currencies in U.S. dollars is included as a reference:

$1.00 = 2.5 reichsmarks
$1.00 = 40 French francs
$1.00 = 1.88 Dutch guilder/florin
$1.00 = 4.31 Swiss francs
$1.00 = 5.3 Italian lire
$35 = 1 ounce of gold

1

Göring's Life Summary

One of Göring's greatest weaknesses was he had absolutely no conception of right from wrong in accumulating wealth or treasure.— Dr. Walter Funk, Reich Minister of Economics

On April 8, 1945, Hermann Göring held the following titles: Prussian Prime Minister, President of the Prussian State Council, Deputy of Hitler as Reich Governor of Prussia (President of the Reichstag), Reich Minister of Aviation and Commander in Chief of the Air Force, Reich Forestry Master, Reich Hunting Master, Delegate for the Four Year Plan, Member of the Secret Cabinet Council, Chairman of the Ministerial Council for the Defense of the Reich, Reich Marshal, SA Senior Group Leader. A month later he had been degraded to the status of "Prisoner of War."

Hermann Göring was born January 12, 1893, in Rosenheim, Upper Bavaria. His parents had been married in London in 1885. His father, Heinrich, was 27 years older than his 19-year-old German bride, Fanny Tiefenbrunn. They were on their way to Africa where Heinrich was to be established as the first governor-general of Germany's South West Africa. In a year's time the older brother Karl was born in

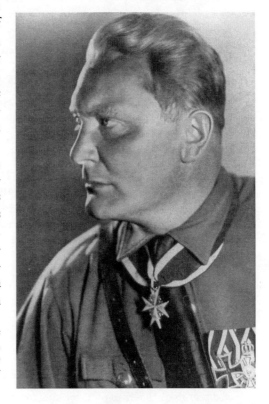

Hermann Göring in uniform with decorations. The most prized German decoration of World War I, the Pour le Mérite, or Blue Max, was awarded to First Lieutenant Hermann Göring by His Majesty the Kaiser and King on June 4, 1918.

Africa and was delivered by a plump and neatly mustached doctor by the name of Ritter Hermann von Epenstein. The young Fanny was enamored with the middle-aged doctor, who quickly became a family friend. After several years in Africa, Heinrich served as consul-general in Haiti. Here Fanny became pregnant with her fourth child in three years. In correspondences with Epenstein, he advised Fanny to return to the sanitarium at Rosenheim, Germany, for the birth of her child. She took his advice and returned to Germany and Epenstein met her at Rosenheim. On the morning of January 12, 1893, she gave birth to her son and named him Hermann, after von Epenstein. Shortly afterwards, Epenstein announced that he would appoint himself godfather to Hermann Wilhelm Göring. Fanny was determined to repay Epenstein — and indeed she would.

After three months she returned to Haiti, where she had left her husband and the other children. Hermann remained in the care of Mrs. Graf in Furth, Bavaria. The Göring family returned to Germany after a three-year absence and took Hermann back into their household. For two years they lived in Berlin, where the father was employed by the government and their frequent visitor was none other then von Epenstein.

In 1898 Göring's father was pensioned and by this time Epenstein had retired. He had always been rich and had acquired considerable land, including two castles. Upon Epenstein's invitation the Göring family spent considerable time at Epenstein's Mauterndorf Castle in Austria. Shortly thereafter they moved to Neuhaus, Bavaria, and occupied the Veldenstein Castle, also owned by Hermann von Epenstein. Hermann Göring's mother shared Epenstein's bedroom when he was "visiting" the castle, as the eligible bachelor traveled considerably. He had the reputation of being the lover of several cordial mothers. The young Hermann Göring grew up here and attended several prestigious schools.

At the outbreak of World War I, Göring was attached to a battalion stationed in Muhlhausen and saw some action on the western front in the first few months of the war. During the early months of the war, he returned to Veldenstein for a short leave and was taken aback by the condition of his parents. His father shuffled around the castle, usually quite drunk, and his mother had suddenly become middle-aged and quite chubby. Von Epenstein had arrived earlier and told his 46-year-old mistress that he was in love with the 20-year-old Lilli von Epenstein, who was to become his wife. When informed of this, Heinrich Göring, in a drunken stupor, declared that von Epenstein had betrayed him and his family (by cheating on the cockade's wife with another woman?). The Göring's 15-year stay at Veldenstein Castle was ended by a curt note arriving from Mauterndorf giving the Göring family short notice to leave the castle. This they did in the spring of 1913, by moving to Munich.[1]

In 1914 Hermann Göring joined the 112th Infantry Regiment. During January 1914 he had fought in the Argonne and was awarded the Iron Cross Second Class. Nine months later he was awarded the Iron Cross First Class during the battle at Kanonenberg Heights. On June 30, 1915, he attended flying school at Freiburg, Germany, and, after a long-distance reconnaissance flight to the Epernay Chalon line in France, was awarded an Observation Badge on November 14, 1914, followed by his Pilot Badge on October 12, 1915. For pursuits of flight and valor during trench warfare near Verdun, In March 1916 he joined a squadron of chaser planes, ranking as one of Germany's top air aces. He was shot down, wounded and hospitalized for four months. He was awarded the Knight's Cross. By May

1917, however, Göring had returned to active duty and was placed in charge of the 17th Fighter Squadron. In July 1918, he was appointed commander of the well-known Richthofen (Red Baron) Fighter Squadron. On June 4, 1918, he was awarded the Royal Prussian Medal Pour le Mérite. He was a much decorated flying ace who had shot down 22 planes. When the armistice of November 1918 brought an end to the war, Göring disobeyed orders to surrender his planes to the American forces and flew his entire force back to Darmstadt, Germany. It was during these war years that he established a lasting relationship with his immediate superior, Karl Bodenschatz, and flying ace Ernst Udet.[2]

The end of the war found Göring without employment, and he left for Scandinavia. He spent a year in Denmark, working as a pilot, and then departed to Sweden, where he worked first as a transport pilot and subsequently became an official of the Swedish air line in Stockholm. It was there on February 20, 1920, that he met the 32-year-old brunette Carin von Kantzow. The baroness was one of five daughters from the wealthy, aristocratic Swedish family of Carl von Fock. She was married to a professional Swedish soldier, Nils von Kantzow, and they had an eight-year-old son. She was bored with the predictable daily routine of being married to a soldier and was searching for a leading man to bring exuberance to her way of life. The handsome World War I hero Hermann Göring was her ticket to leave the successions of army garrison camps. A few days later he was invited to have dinner with Captain von Kantzow and his wife. Carin let her husband know that she found Göring irresistible. A few months later she and Göring left Sweden and shared Göring's villa in Bayrischzell, a few miles south of Munich.

In December Carin returned to Stockholm and her husband. On December 20, 1920, she wrote to Hermann that her husband was happy that she was living with him and that "no one else is angry with me" except her mother-in-law, who wrote her saying "no one knows better than I how much Nils suffered during your absence." Carin ended that note with this: "Isn't she a conceited, Idiotic Monkey???" In a short time Göring returned to Stockholm, where they shared an apartment.[3]

In 1921, Carin and Göring returned to Germany and he joined the Nazi movement, which was then in its very beginning. He enrolled as a student of history and economics at the University of Munich, but most of his time was spent in Nazi Party activities. After a month in Germany Carin returned home and told her husband that she intended to marry Hermann and asked for a divorce. Her husband, Captain von Kantzow, even agreed to give her alimony and access to their son anytime she was in Sweden. The divorce was settled quickly and she and Hermann were married on February 3, 1923. Carin was quickly caught up in the Nazi movement with enthusiasm and fell under the magic charm of Adolf Hitler.

In the meantime, Hitler had ask Göring to take charge of the recruiting for the SA (Storm Troops), which had made their first public appearance at a speech of Hitler's in the Hofbrauhaus in Munich. Göring was officially named chief of the SA and established his headquarters at the village of Obermenzing in Upper Bavaria. On November 8, 1923, when Hitler made his bid for power, Göring participated in that unsuccessful Nazi putsch at the Feldherrnhalle in Munich. As the leader of the Stormtroops, Göring marched at the head of the parade with Hitler and General Eric Ludendorff and was seriously wounded

by machine gun bullets. Sixteen young Nazis from all walks of life were killed; their deaths were used for propaganda for martyrdom by the Nazi Party.

In the meantime, comrades carried Göring away and he and Carin traveled in a car from Munich to Garmisch, where they stayed for two days. They then went to the Austrian border but were arrested and taken back to Garmisch, where Göring was placed in a nursing home. His passport was taken and he was surrounded the police. Carin wrote: "Hermann was carried out again, he can not take a step, dressed only in a nightshirt, coat, and blanket and was over the border with a false passport within two hours." The following day, Carin joined Göring and his doctor in Innsbruck, Austria, where Göring was hospitalized for treatment. Here in the hospital, as a visitor, appears Hitler's sister, Paula, one of the few times she is referenced in history. Paula inquired about Göring, and she was described by Carin as "a charming, ethereal, creature with great soulful eyes in a white face, trembling with love for her brother."[4] Carin would later write that Paula Hitler spent all day with them; they ate lunch together, talked about her brother and "she followed us like a child the whole time."

After recovering from his injury in a hospital in Innsbruck and facing arrest, Hermann and Carin left Austria for Italy on May 11, 1924. There, Göring was to be the personal representative of Hitler in dealing with Mussolini, who had been in power since 1921. They went first to Rome and later to Venice. They lived on Carin's money, but because of Göring's World War I hero status they were accorded food and room at the best prices. Still, they were always short of cash.

Carin missed her son and became quite homesick for Sweden. She wrote her mother: "I cannot deny myself a return to my own country, to my parents, to my own little child, just because he [Nils, her former husband] would become disturbed. Consideration for him *must* have its limits!" The letter continued with the downgrading of her former husband and her concern for Thomas, her son, and her love for Hermann. During that summer in Rome, Carin wrote that the crowds treated Mussolini as if his words had come from God himself in heaven: "Hitler above all is more genuine. Above all he is a genius, full of the love of truth and burning faith…. We have not had such a great man in the world in a hundred years, I believe. I worship him completely."[5]

After a few months of hotel life in Rome, the Görings began to have real financial difficulties. In the fall of 1924, they moved to Venice, where Göring continued his work as a go-between for the Fascists in Germany. But they received no money from the impoverished Nazi party and Carin was forced to write her family for support. Her mother came to their aid, but her father was still unreconciled to her divorce and remarriage.

From Venice she began a letter to her mother: "Deepest, Deepest thanks! Just now my darling mother's little letter came with all the money enclosed." Again she extolled her love for Hermann: "It lasts even in such difficult times, this love which I never had *dreamt* of feeling for a man." Carin informed her mother that Hitler had written a book, *Four and a Half Years' Battles Against Lies, Cowardice, and Stupidity*, and expected the sales to yield millions, thus rescuing the Görings from their poverty, as Carin assumed that Hitler was obligated to Hermann, who had sacrificed himself completely for the betterment of the Nazi party. Before the press release the title of the book was changed to *Mein Kampf* by a more progressive salesman. In discussing a move to Sweden and

employment for Göring, she writes a most descriptive sentence regarding his thought on the question of the Jewish race. "The trouble is that *Hermann can not possibly* nor *will* he go into a company, where there is one iota of Jewish blood.... That would bring disgrace on his whole position, and on Hitler and his entire philosophy. We would rather starve to death, *both* of us."[6]

By the end of 1924, they *were* close to starving. In December Göring sent Carin to Munich to beg for money so she and Hermann could return to Sweden. Göring could not go to Germany, as he still had an outstanding warrant for his arrest due to his role in the Munich putsch. First she would attempt to sell Göring's villa at Obermenzing and then plead with Hitler and other influential Nazi Party members to provide them with the necessary funds for travel. She first contacted Ernst Roehm and wrote Göring: "Please don't trust too much in him." She continued to denigrate Roehm and begged Hermann to "keep his eyes open" regarding him. This is most interesting in view of Roehm's later liquidation in the purge of 1934 on orders signed by Hermann Göring.

Her two commanding letters (consisting of nine pages) of January 17, 1925, to Göring in Venice show Carin's shrewd political sense and her familiarity with party matters. She explains to her husband that it is most difficult to obtain money from their friends and that they only discuss their own money problems. She goes into detail about his activities in Italy and writes how Göring should approach Hitler: "Point out that you still have connections, etc. Now if you suddenly speak with Hitler *only* of the impossibilities in Italy, and about your personal plan in Sweden (as my native country) he can easily get the impression that you are prompted by personal motives and want to go to Sweden at any price."[7] And indeed they intended to travel to Sweden for personal reasons, as it would be difficult to convince the Swedish to become Fascists. Göring indeed wrote a long letter delivered to Carin for Hitler's attention. She met with Hitler and read Göring's letter to him. During this meeting she told Hitler of their misadventures and he went to a cupboard in his office and removed a large amount of lira, marks, and Austrian schillings and gave them to her.[8]

In the spring of 1925, with these funds and the proceeds from the sale of the villa, they left Rome and proceeded to Sweden via Czechoslovakia, Poland and Danzig. They stayed there for two years. During this time they both spent many months in sanitariums, Carin for her chronic illnesses — heart trouble and tuberculosis — and Göring for a nervous breakdown, partly caused by his increased addiction to morphine.

In Stockholm, Göring had been unable to obtain employment and he and Carin lived by selling off her furniture and by handouts from her mother. Göring by now was hopelessly addicted to morphine. Their family life was one of misery and grief. Göring was declared insane and entered the Langebro-Sinnes-Sjukhus asylum as a morphine addict. After three months without drugs he was sent home, where he had a relapse. He returned for two more months of treatment and was cured. He never took morphine again.[9] In January 1927, after amnesty had been granted to the participants of the Munich putsch and Hitler had long been released from imprisonment in the Landsberg prison, Göring bid a sickly Carin a tearful farewell and returned to Germany. Three weeks later she wrote him a heartbreaking letter that let him know the doctor had told her that her fragile health was hopeless.

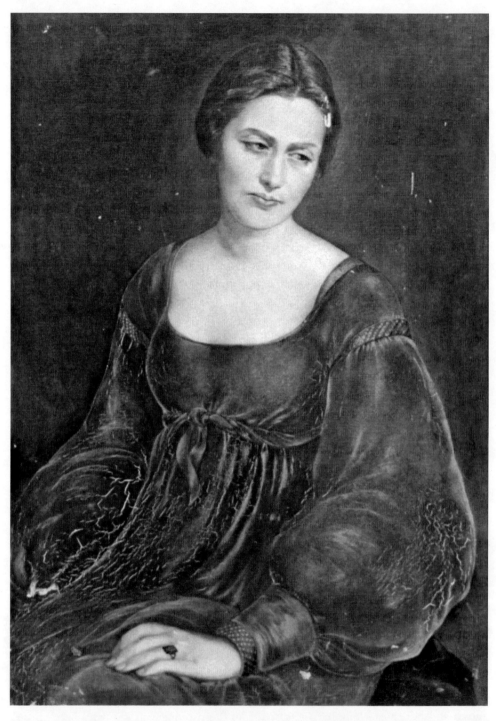

Göring's young first wife, Carin, was painted by Paraskewe von Bereskine, in this red velvet dress, just before her death on October 17, 1931. She was always in poor health due to weak lungs, a bad heart and low blood pressure. This was a gift from Paul Koerner. In 1952 this portrait was given to her son, Thomas von Kantzow, of Stockholm.

Göring had been away for four years. Hitler and the Nazi Party had changed and Göring was not in their current plans. He met Hitler in Munich and was given a disappointing interview in which Hitler wished him the best of luck. Göring traveled to Berlin and obtained a job with the Bavarian Motor Works. Ever the salesman, and working long hours and using every contact he had from the Great War, Göring was quite successful.

One day Adolf Hitler showed up unexpectedly and asked Göring to be a candidate on the Nazi Party ticket. As the Munich putsch had failed, the Nazis had altered their tactics, trying to gain power through constitutional methods rather than through open revolt. In this national election of May 1928, they made their first gains. Göring was one of the first twelve Nazis elected to the Reichstag. He represented the Potsdam District. Now Carin joined him in his small apartment in Berlin. She was not well, but wanted to be with him when he was at last realizing his first big political success.

In 1930 Göring was reelected and Nazi representation in the Reichstag rose from twelve to 107 seven seats. To promote the interests of the party so suddenly enhanced in power, Hitler appointed Göring his deputy in all political matters for the Berlin area, while Hitler himself concentrated his activities in southern Germany. In this capacity Göring played a prominent part in bringing Hitler to power. Carin returned to Sweden for another extended stay in a Swedish sanitarium and returned to Berlin to find Göring completely immersed in political affairs.

On January 16, 1931, he took part in discussions with Chancellor Heinrich Bruning, who had invited representatives of the Nazi Party to the Reich Chancery in a vain effort to come to terms with the Nazis. By now Carin and Hermann were part of the inner social circle of Berlin. Prince and Princess zu Wieds were showing a great interest in the Hitler movements and as a result the Wieds brought the Görings in touch with the prominent families in Berlin society. Göring was successful enough to hire a permanent maid, Cilly Wachowiak, a young peasant girl who remained with the Göring family until the end.

Carin was spending considerable time in the sanitarium in Bad Altheide, Germany. Their personal fortunes were greatly improving with the expansion of the Nazi Party; but Carin was dying, and her husband was involved in politics to the exclusion of everything else. In a July 14, 1931, she wrote from Bad Altheide to her mother: "Here things are pleasant and serene. The mineral baths are tiresome, but my doctor is cautious. I lie down three hours a day and go for short walks, which increases a little each day. But great news, Hitler gave us a wonderful car.... Gray outside, red leather inside, long elegant and stylish! They made only one like it."

Due to some bickering in the Nazi Party, Göring's power within the party was further enlarged. During these political maneuvers Carin was becoming increasingly sick, with her heart growing weaker. In Stockholm, her mother, who had been seriously ill for some time, closed her eyes and died. Carin begged to go to her mother's funeral in spite of her doctor's warning that the trip might well kill her. She and Göring traveled to Stockholm even though her mother was buried days before they arrived. Upon arrival, Carin collapsed and was carried to bed. The doctor expressed doubts that she would survive the night. Göring stayed by her bedside for four days. On October 4, 1931, he received a telegram from Hitler requesting his return to Berlin. Upon Carin's insistence, Göring returned to

Berlin, where he accompanied Hitler to an interview with President Paul von Hindenburg. While Göring was thus involved in this round of pointless political negotiations, Carin died in Sweden, on October 17, 1931. In the summer of 1934 Göring brought her body from Sweden to Germany and buried it with great pomp at his Schorfheide estate, which was named after her as Carinhall.

It was also during 1931 that Göring went on one of his first missions abroad on behalf of the Nazi cause. He went to Rome, where he had discussions with high officials of the Vatican. In an effort to win the approval of the Church for the Nazi movement he assured members of the College of Cardinals that the Nazis had no intention of introducing Germanic pagan cults but would welcome the support of the Church.

After the fall of the Bruning cabinet, Göring conducted negotiations with members of the von Papen cabinet on behalf of Hitler and the Nazi Party. As a result of the election, the Nazis, although lacking a majority, were the largest party in the Reichstag. When, nevertheless, Hitler was offered only the position of vice chancellor under Papen instead of chancellor, he refused. Göring, however, was elected president of the Reichstag and used this position to bring about a vote of no confidence in the Papen cabinet, just before Papen was able to carry into effect the dissolution of the Reichstag.

In the election of November 6, 1932, the Nazi Party lost seats in the Reichstag, but their number was still sufficiently large to reelect Göring president of the Reichstag when it met in December. During these critical days, Göring represented the Nazi Party in the negotiations for the formation of a new cabinet, making every effort to persuade Hindenburg to appoint Hitler as chancellor. Only by deceiving Hindenburg with false reports of an attempted coup d'etat did Göring finally succeed in having Hitler appointed chancellor, and it was Göring who first publicly announced the appointment to his Nazi followers.

For his efforts Göring was immediately rewarded with a number of influential positions in the Hitler government, as he was appointed Reich Minister without portfolio and at the same time Prussian minister of the Interior. He used the latter position to terrorize and suppress the political opponents of the Nazis in anticipation of the forthcoming election. He removed anti–Nazis from the civil service, issued a decree forbidding the Communists to hold public meetings, and ordered the police to support the SA and SS. He also organized an "auxiliary police" comprising members of the SA and the SS.

Another woman entered Göring's life and she was as different from Carin as she could be. Emmy Sonnemann was a professional actress and had previously married Karl Koestin, an actor, in 1916 and divorced him in 1923.[10] Emmy was blond, sexually attractive and 38 years old, the same age as Göring. She was a mainstay at the Weimar Theater, playing the leading roles in *Faust*, *Egmont* and Richard Wagner's productions. It was here that Göring first became aware of Emmy. It came about when he saw her and a girlfriend sitting at a table and asked permission to join her and her friends. The two then left the table for a walk and Göring "spoke of his wife who had recently died, with so much love and genuine sadness that my esteem for him grew with every word."[11]

It did not take long for Emmy to begin starring in roles in Berlin and living with Göring in his apartment. During these chaotic days in Berlin, Göring gave her a revolver "just in case anything happens." Being afraid of guns, she gave the pistol to Cilly.[12] At

this time Göring placed an ad in the Berlin newspaper seeking a butler. The advertisement was answered by ex-navy veteran Robert Kropp and he joined Göring's growing household staff.

After the new Reichstag voted Hitler extraordinary powers, thus virtually abrogating the Weimar constitution, the campaign to eradicate political opponents of the Nazis was carried out on an even larger scale. Under the law of April 7, 1933, a sweeping purge of the civil service was carried out. Göring was appointed deputy of Hitler as governor of Prussia. On April 10, while on a diplomatic mission in Rome, he was appointed prime minister of Prussia. He assumed this new office upon his return from Rome and immediately set about reorganizing the Prussian police further. Göring abolished the Prussian police and in its place organized the Gestapo, which became the most dreaded instrument of Nazi terror. Their personnel were recruited mainly from the SA and SS, with a view to political reliability. At this time also, under the authority and direction of Göring, the first concentration camps were established.

In April 1934 the Prussian Ministry of the Interior was merged with the Reich Ministry of the Interior. Göring thus relinquished the post of minister of the Interior, but he retained control over the Prussian Criminal and Administrative Police. The Secret State Police (Gestapo) came under Himmler's control and by that time controlled the Gestapo in all the German states, though Göring as prime minister still exercised overall supervision in Prussia. Not until 1936 did Göring relinquish control over the Prussian police entirely and the entire German police was unified and placed under the control of Himmler.

Early in the Nazi regime Göring gained control of all matters pertaining to forestry and hunting in the entire Reich. The Prussian Forest Administration was removed from the jurisdiction of the Ministry of Agriculture and placed under Göring's control; he reorganized it on a central as well as on a regional level. By law of July 3, 1934 (law for the transfer of the forest and hunting administration to the Reich), the Reich Ministry of Forests was established, and Göring was appointed Reich Forestry Master with far-reaching control over the forest administration, lumber trade, etc., of the entire Reich. Finally, in 1935, the Reich and the Prussian Ministry of Forests were merged, and the streamlining of the German Forest Administration was thus completed. Similarly, hunting regulations throughout the Reich were centralized. Then the Reich Hunt Association asked Göring to become protector of the German Hunt. Subsequently he reorganized the hunting laws of Prussia and the law was given Reich-wide jurisdiction. By today's standards he would have been judged as a environmentalist of great imagination and accomplishment.

Completely controlled by Göring from the beginning of the Nazi regime was the field of aviation, both civilian and military. On January 30, 1933, he was appointed Reich commissioner for Aviation. Only a little over a month later, the Reich Air Ministry was established and Göring appointed Reich Air Minister. By year's end the administration of German air traffic, control over German aviation, was centralized in Göring's hands. Göring also controlled air research and air protection. He founded and became president of the German Academy for Air Research and established the Reich Air Protection League, with himself as president; he revoked all former laws concerning air raid protection and issued new regulations. He chose his former World War I commander, Karl Bodenschatz, to organize these various functions of the German Air Force. It was at his apartment in

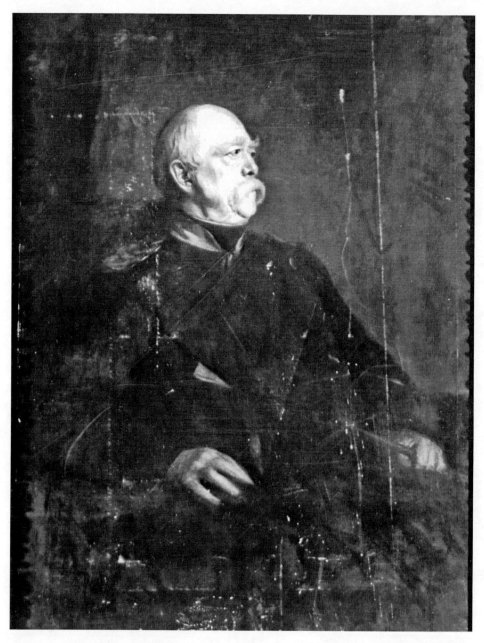

The Führer, ruler of the Third Reich, gave Emmy this *Portrait of Bismarck*, by German painter Franz von Lenbach, her favorite artist.

Berlin that he had interviewed Bodenschatz after displaying his small art collection of three Lucas Cranach paintings — gifts from the city of Dresden — a Madonna statue from Mussolini, and his ever-present, large painting of Carin.

Hermann Göring married Emmy Sonnemann on April 10, 1935, and Hitler was his best man. With a very serious look on his face, Hitler told Emmy, "You are now the first lady of the Third Reich."[13] The couple were both 42 years old, but during this time they behaved as if they were half that age. The bride and groom were showered with

many precious gifts, including jewels, oriental rugs and two paintings by Cranach. Göring had an absolute obsession with the works of Lucas Cranach (1472–1553). A painter, engraver and designer of woodcuts, Cranach was a German and a lifelong friend of Martin Luther. He portrayed the Reformer many times and painted the first protestant artworks under Luther's direction. Cranach exhibited an intense interest in landscapes and in the expressionistic possibilities of the human figure, including florid nudes that were prized by Göring.

A transition from civilian to military aviation came with the founding of the German Air Sports Union by Göring. In January 1937 the name of this organization was changed to National Socialist Flyers Corps. Although new airmen for the corps were recruited entirely from the Hitler Youth, the National Socialist Flyers Corps retained its financial and administrative control inde-

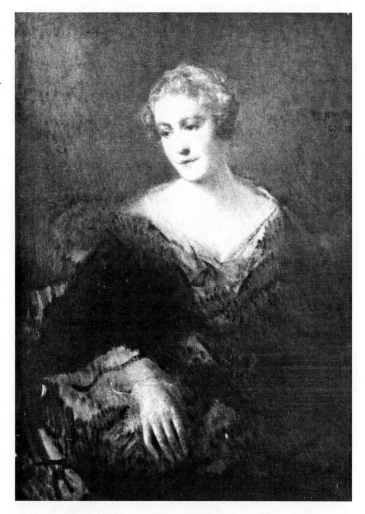

Hermann Göring's second wife, Emmy, was painted by Raffael Schuster-Woldan in 1937. He was professor of the Prussian Academy of Fine Arts in Berlin. Hitler purchased Schuster-Woldan's painting *Life* for his Linz Museum. This enhanced Schuster-Woldan's reputation in Nazi Party circles.

pendent of the Nazi Party, remaining under the jurisdiction of the Air Ministry and thus directly under Göring's control.

On March 1, 1935, the formation of the new German Air Force was officially announced by Hitler, and Göring was appointed commander in chief of the air force. Göring soon developed it into one of Germany's most powerful tools of military aggression, particularly after Hitler had officially repudiated the limitations on German armaments imposed by the Treaty of Versailles.

The year 1937 also saw the establishment of the Göring industrial complex, which became the third largest industrial trust in Europe as the Hermann Göring Works was formed. In a speech on July 23, before representatives of the iron producing and iron

consuming industry, Göring announced that construction of the first plant at Bleckenstadt near Salzgitter had begun. The Hermann Göring Works rapidly expanded. Reorganized in 1941, it controlled vast industrial properties not only in Germany but also throughout German-annexed and occupied territory.

Throughout these years before the war, Göring frequently represented the Nazi government on missions abroad; during the same period, he received numerous foreign visitors both at his official residence in Berlin and at his Carinhall estate. The latter was the gathering place for the zu Wieds, the Thyssens, the Krupps, the Göring sisters, and Carin's relatives as well as Emmy's sister and nieces.[14]

Meanwhile, Lilli von Epenstein had traveled to Berlin and in a bolt from the blue deeded the Veldenstein Castle to Göring and his daughter, Edda. The castle at Mauterndorf would follow without delay after her death. As part of this gesture, fearing war in Europe, she pleaded with Göring for a visa allowing her to travel to the United States. He accomplished this task and Lilli went to live in Chicago. Unfortunately she did not enjoy America and returned to Germany in the summer of 1939. On September 1, 1939, while listening to the radio announcement that German troops had invaded Poland, she died of a heart attack.

With the outbreak of war, Göring's power was further increased. Hitler established the Ministerial Council for the Defense of the Reich and appointed Göring its chairman. In the council, legislative as well as executive authority was centralized to the largest possible degree, members of the council being authorized to issue laws and decrees even if contradictory to existing legislation. A further decree of January 1941 empowered Göring to enact any legislation necessary for air raid protection of the Reich. A month later the Industrial Council of the Reich Marshal for Aircraft Production was established under Göring's direction, with Erhard Milch deputy commander in chief of the Luftwaffe. On September 2, 1943, Göring became chairman of the Central Planning Office for War Production, subordinated to him in his capacity as commissioner for the Four-Year Plan. This office engaged primarily in long-range overall planning for war production, leaving the arrangement of detailed plans to other agencies.

Beginning in 1943, and particularly the latter part of 1944, reports were numerous concerning the decline of Göring's power as a result of his rivalry with Himmler as well as with Speer. It was during this time that relations between Göring and Milch became strained; the relationship disintegrated in June 1944. Not until April 27, 1945, did Göring officially relinquish any of his important offices, when he resigned as Reich Air Minister and commander in chief of the German Air Force. Less than two weeks later he surrendered to the American Seventh Army in Austria, where he had taken refuge when he fled from Berlin.

2

Prewar Art

The history of the Göring Art Collection is a perfect reflection of the character of its creator and the political regime for which he administered it. Göring began to collect art objects in a modest way after World War I. After the Nazis came to power, he and Hitler formed a plan according to which Göring was to gather a large collection, to be presented eventually to the German nation. This was to be known as the Hermann Göring Collection and was to be located in a large museum, the site of which was to be determined. Both the city of Berlin and Carinhall were considered. In case the latter were chosen, it was to be transformed into a tourist mecca, with its own special railway straight from Berlin. The funds used in purchasing the collection were to be derived from the state.

In accordance with this idea, Göring began to collect on a large scale, everything from Roman architectural fragments to modern German paintings and including tapestries, carpets, objets d'art and jewelry. He always availed himself of the services of professional advisers. The first of these was Dr. Binder, the Berlin art historian-dealer, who was subsequently succeeded by Walter Hofer. However, regardless of the quality of the advice he received, it was always Göring's taste which predominated in the choice of objects for the collection. This is evident in the large number of female nudes, portraits, and triptychs, all of which were favorites with him. Göring had no real artistic judgment, and he knew it; however, if an argument arose in public, he overrode his adviser. Later, when they were alone, Hofer says it was always easy to bring him around and change his mind. This mixture of conceit and stubbornness in public with a certain weakness and humility in private seemed to have been characteristic of the man.

There are three aspects of Göring's character which played an important part in the formation of the collection. The first was his all-embracing acquisitiveness. There were no limits to his desires as far as the collection was concerned. The second was his greediness — an unexpected trait in a man who must had unlimited resources at his disposal. The witnesses are unanimous in declaring that he always bargained, no matter how small the amount involved. This even distressed so devoted a follower as Bruno Lohse, who stated that he considered it unworthy of a reichsmarschall. The correspondence

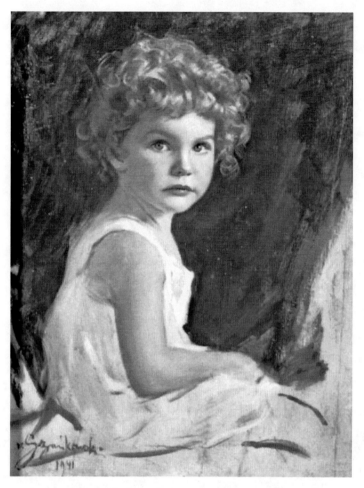

This portrait of Hermann and Emmy's daughter, Edda, was painted in 1941 by Boleslaw von Szankowsky, an international artist known for his work with children's portraits.

reveals that Göring was invariably slow in paying his bills. All in all, he hated to part with money. Finally, Göring always wanted to maintain the appearance of being "correct." He would not consider having anything on his walls which had been confiscated. He always "intended" to pay for the objects he took from a task force, or "special purpose staff," called Einsatztab Rosenberg after its head, Alfred Rosenberg. He never accepted presents from Jews who received favors from him. The idea of putting pressure to sell on the unwilling owner of an object which he wanted was unthinkable. However, as will be seen in what follows, this was merely the face he presented, or tried to present, to the world.

The most striking fact which comes out of the story of the Göring collection is the extraordinary amount of time Göring spent in looking for works of art, even in the most crucial years of the war. He made trips, displacing his entire staff and special train, solely for the purpose of visiting a dealer who had an object Göring wanted to acquire. No matter what the business on hand, he always found time to stop and consider the purchase of something new. He had a fanatical interest in the art market, and one of the duties of his private secretary was to attend auctions in Berlin as an observer. Toward the end of the war, when prices became astronomical, he formulated a plan by which to control the market. He always expressed his astonishment at the variation in values of different types of paintings. In short, he was a passionate collector, and in this all who knew him concurred.[1]

For his home, Göring had chosen an area around Schorfheide, a great rolling expansion of forest and lakes, two hours drive northeast of Berlin. This large estate, Carinhall, was named after Göring's first wife, Baroness Carin von Kantzow of Sweden. It was Hitler's desire that Carinhall become a public museum for the German people upon Göring's

death. In addition to the gardens, ponds, buildings and main house, the estate contained a mausoleum for Carin's remains.

In early 1936 Göring began acquiring more art for Carinhall. An important part of his early collection was made up of gifts presented to him by his friends and other important Nazis. As time passed, purchases became increasingly important to his collection. Some of the funds Göring used to buy artworks came from Dr. Kurt Hermann, a wealthy industrialist from Leipzig with a diversity of business interests including insurance, publishing and clothing manufacturing. He even took over the successful Friedlander jewelry shop from its Jewish owners. At one point Dr. Hermann was charged with tax evasion, but Göring had the charge dropped and from that day forward millions of marks were deposited in the "Charity Fund Account" in the August Thyssen Bank. The money could be withdrawn by Göring or his wife, Emmy, at will.

No one was more responsible for the success of Hitler and the Nazi Party than the son of a banker, August Thyssen, who was himself a banker, as well as an industrialist and party member and heir to the family fortune. August was as much to blame as Hitler for World War II. For 20 years Thyssen played a very dangerous political game. He used his wealth and power to finance the Nazi Party. Any funds needed by the party or its prominent members were supplied by Thyssen. Göring's first Berlin apartment was enlarged and furnished by Thyssen; because of this subsidy Thyssen was appointed Prussian state councilor for life by Göring.

After the invasion of Poland in 1939, Thyssen began to doubt his long-held belief that he could control the Nazi Party through money and power. In a letter of open disobedience from France, he challenged Hitler's decision to wage war. After the French surrender in 1940, he was arrested by the French Vichy police and turned over to the Germans, making him one of the first influential citizens to find out that you were either with Hitler or against him. As the 67-year-old Thyssen was being taken to a concentration camp, he acknowledged "what a fool I have been."[2] As many of Hitler's followers would learn, neither high finance nor flattery could control the actions of the demonic Führer.*

Another wealthy industrialist, Franz Neuhausen, began supplying Göring with money in the late 1930s. Neuhausen was a representative of the German railroads and under the Four-Year Plan; his function was to insure that Germany acquired the raw materials needed for war production. With the help of Göring, he purchased many shares in mining companies and iron and steel mills. The purchase of stock in these companies was described as a very dirty business. Neuhausen was arrested several times by the Gestapo and accused of bribery, corruption, and the transfer of foreign currency abroad. Göring would always intercede and have the principal charges changed to some minor offenses. Because of these favors, Neuhausen supplied the Reichsmarschall with foreign currency. Always present at Göring's birthday parties, each year he gave Göring a 30-pound bar of gold or silver, apparently the by-product of one of his copper mines.

With these "donated" funds and in accordance with the agreement with Hitler that

Thyssen and his wife were imprisoned for the remainder of the war. Göring stated he had taken the side of Thyssen and due to his influence Thyssen and his wife were committed to a sanatorium. Because of Thyssen's notable service to the Nazi Party, he and his wife were given favorable treatment, survived the war, and relocated to Argentina after liberation.

the Göring estate become the property of the Third Reich upon Göring's death, Carinhall grew even more opulent. Göring began to collect on a grand scale — everything from Roman architectural fragments to modern German paintings, tapestries, carpets, objets d'art and jewelry.

To ensure that he was getting quality stuff, he always availed himself of the service of a professional art advisor. The chief of these advisors was Walter Andreas Hofer, who first came into contact with Göring as a dealer offering paintings. Gradually, as the relationship grew more intimate, Hofer became the director of the official Hermann Göring Art Collection. Göring often called Hofer in to get an opinion on a prospective purchase. Regardless of the quality of the advice he received however, it was always Göring's taste which predominated in the choice of works for the collection. Devoting all his time and energy to the Göring collection, Hofer was Göring's alter ego in catering to his taste for florid nudes and elaborate altarpieces. All those who knew Hofer agreed that he was a tireless worker who devoted every minute of the day to the Göring Collection but he appeared to trust no one — a sentiment that was heartily reciprocated by those who came into contact with him.

Hofer always did the bargaining and made the arrangements as to the type of payment. In this, he followed the rule set down by Göring, which was to use every available advantage over the seller to bring him down to a rock-bottom price. Then, after negotiating, Göring was invariably slow in paying his bills, although he always wanted to maintain the appearance of being professional in his business dealings.[3]

3

Göring's Personal Staff

The people who worked for Göring were divided into two groups. One, the civilian staff, was made up of civil servants and the officers of his military household; the second group was the purchasing agents who were concerned only with art. However, as the collection was a permanent concern of the Reichsmarschall, it played some part in the job of each one of his employees, whether directly connected with art or not.

It was characteristic of Göring that he took a personal interest in the work of everyone who worked for him and insisted on being informed in detail of everything that went on. In contrast to this, there was an unwritten law that the civil servants themselves should under no conditions have conversations about their respective jobs outside of what was necessary for the successful execution of business. In fact, Göring appears to have basically distrusted everyone. He never took any one person completely into his confidence. This tendency to distrust increased as the years went by, and at the end of the war he had brought all branches of his activities under his direct control. This is a curious trait in a man whose external manner appeared so expansive and friendly. However, the truth seems to be that Göring had no friends, with the exception of the hard-drinking, womanizing, Ernst Udet — the youngest ace of World War I with 62 conquests — whom he had served with during that war. Those who worked for him say that Udet committed suicide because of his disappointment with Göring and the Nazi Party and that no one ever took his place in Göring's life.[1]

Walter Andreas Hofer was born on February 10, 1893. During World War I he fought as a private in the infantry for the entire war. He began his career in art immediately after the war as an assistant in the firm of his brother-in-law, in Munich and The Hague. In 1928 they broke off relations after a quarrel and Hofer moved to Berlin, where he studied art for two years. From 1930 to 1934 he was employed as an assistant to the art dealer, J.F. Reber of Lausanne, Switzerland. He acted as secretary and companion, accompanying Reber on trips to England, France, Holland and Italy. In 1935 Hofer became an independent art dealer in Berlin. He began as a small Berlin dealer offering pictures. In 1936, Dr. Binder, Göring's art advisor, purchased a 16th century master from Hofer and this purchase attracted Göring's attention to Hofer. Several more paintings were purchased

the following year and gradually, as their relationship grew closer, Hofer succeeded in replacing Göring's advisor, Dr. Binder. Finally, in 1937, he became director of the Reichsmarschall's collection and his chief confidential operator.[2]

They agreed that Hofer was to remain an independent dealer, but he was to act as Göring's buyer, with the right to keep for himself anything that Göring did not want. Hofer himself insisted on this arrangement even after being appointed director of the collection and in spite of the fact that Göring wanted to pay him a salary. For Hofer the advantage of their arrangement was unique. First of all, he had the protection and support of the second most important man in the Reich. This opened up to him doors, not only of collections in Germany, but of almost any source of works of art in the occupied countries. It also gave him the possibility of promising protection to those persecuted by the Nazis, in exchange for the sale of something which he might desire. He took advantage of every such opportunity. This arrangement also gave him the opportunity for travel, which was difficult during the war years, and most important of all, it made available to him a constant source of foreign currency. This arrangement for Göring had the advantage of an insurance against his being cheated by his agents. Whenever he felt that an object was too expensive or that he was being tricked, he could simply hand it back to Hofer.[3]

One of Hofer's main duties was the conservation of objects in the collection. His own specialty was paintings, but he was responsible for the storage, transport and cataloguing of everything that was acquired. His purchasing activities took up most of his time, as he traveled almost every week. Göring also required that Hofer give his approval to all paintings which came into the Collection, even if they were procured by Göring or another agent. Hofer's actions in this respect were very personal and most unpopular with his colleagues. One of them was quoted as saying that whenever Hofer was called in to give his opinion, there were sure to be endless difficulties to overcome. Hofer always did the bargaining and made the arrangements as to the nature of the payments. In this he followed the line set down by Göring, to use every available advantage over the sellers and bring them down to rock-bottom prices.

Hofer's role was by no means limited to obeying orders. Whatever the situation, he was always present at Göring's beckoning with a plan fair or foul to obtain the objective they desired. In most cases their views coincided, and as Göring had many other problems to keep him occupied Hofer was able to carry out his own suggestions. He played upon Göring's taste for florid nudes and elaborate altarpieces, appealing to his avarice and flattering his vanity. He always worked alone. He never even employed a secretary, but typed his correspondence himself. He was most fortunate in that the other aspects of dealing with art, such as transportation and storage, were taken care of by the Luftwaffe.

In Germany, Hofer was in contact with all the important dealers, although he seemed to have a tendency to prevent rather than encourage their selling to Göring. He also acted as Göring's liaison with private individuals who had paintings to offer. He attended auctions, occasionally to buy, but mostly to keep an eye on the current trends in price. Hofer kept a sharp eye out for Einsatzstab Rosenberg confiscation of French 19th century pictures, which neither man appreciated, for the express purpose of using them for exchanges, as such pictures brought enormous prices on the Berlin art market.

As the war progressed, every able-bodied male was required to perform military

duty. It is interesting to note that in January 1944, Hofer was drafted as a private in the guard regiment of the Hermann Göring Division. Called to active duty in October, he was promoted to sergeant and assigned to Carinhall, where he spent his entire military service. Göring even violated his own rules for favoritism if it were beneficial to himself.

The aspect of Hofer's activity which is of most interest was his travels through the occupied and neutral countries. The trips were always planned in connection with Göring. Hofer went ahead and prepared the scene, looking over the local market and arranging for objects to be brought to Göring or for Göring to visit the owner. When Göring appeared, Hofer always accompanied him when pictures were examined with the idea of a possible purchase. Then, in many cases Hofer would make a later trip to complete arrangements for delivery and to make arrangements for payment. He played a decisive role in the choice of pictures, in the method of bargaining and in the decision as to the nature of the payment.

Hofer encouraged Göring to take over or purchase confiscated Jewish collections in France. He drew Göring's attention to the Rothschild collection of modern jewelry. With some pride, Hofer told Göring of the Braque collection and of his role in the speedy release of the collection, which had been illegally seized in the first place. Göring had supplied the initial impulse for the method of how the collection was acquired, although Hofer was responsible for the purchase of the Braque collection.

Outside of Germany, Hofer, who had not traveled extensively before the war, had certain contacts who kept him acquainted with local conditions. The most important of these contacts was Hans Wendland, who operated in France and Switzerland and who seems to have had a hand in every deal. In Holland and Belgium Hofer was advised by his friend and business partner Walter Paech, a German dealer residing in Holland. In Italy his guide to dealers and introduction to collectors was his former employer G.F. Reber.[4]

Hofer was paid a commission from Wendland in gratitude for sales to Göring. However, here again this was done indirectly and the money came out of Göring's pocket. This was accomplished by Hofer and Wendland agreeing on a given increase in prices which were submitted to Göring; after payment was completed, the difference was paid back by Wendland.

In the glorious days of Nazism, when most of Europe was cowering in terror of the Luftwaffe, Hofer proudly flaunted his business card and stationery on which appeared the title "Director of the Art Collection for the Reichsmarschall" and insisted being known by this title wherever he went. There is little doubt that he not only was, and wanted more than anything else to be, Göring's alter ego as far as the Collection was concerned. After the defeat of Germany, Hofer insisted that his relationship to his former chief was always as an independent dealer who gave the first right of refusal to Göring, his most important client.[5]

A month before Göring's death the art officer interrogating Göring stated that now that Göring was imprisoned Hofer was claiming all the credit for himself in the acquisition of Göring's collection and reflecting a rather bad light on Göring's art judgments. Göring responded: "Yes, meanwhile I have realized that quite clearly. I believe, judging by my experience, one must be careful in negotiating with art traders that is a game all of its

This Jan van Goyen, *View of Nymwegen*— the village of Nijmegen on the River Waal — from the Katz Collection was given to Göring by Dr. Erich Gritzbach.

own, as I finally observed."[6] This was Göring's final statement regarding the relationship of Walter Hofer and the Reichsmarschall.

Dr. Erich Gritzbach, an associate of Göring for many years, was the author of what was then the best-known book about Göring's life. Gritzbach had formerly been the head of Göring's military household. During the war he acted as Göring's chief liaison officer with the Hermann Göring Works and with German industry in general. He was one of the most important means of approach to the Reichsmarschall. Gritzbach played an active part in the formation of the Collection. He was in charge of the business end of all the purchases made in Holland in 1940 and was Göring's chief representative in the Goud-stikker transaction (discussed in detail in a later chapter). During this early period, most of the bills from Dutch dealers were presented to Göring's attention under the Gritzbach name. Gritzbach was in charge of the choice of works of art intended as birthday presents for the Reichsmarschall. He also bought some objets d'art and pictures for Göring. Gritzbach himself had a small painting collection. He seems to have been one of many used by Göring to apply pressure upon people who were unwilling to part with objects desired by the Reichsmarschall.

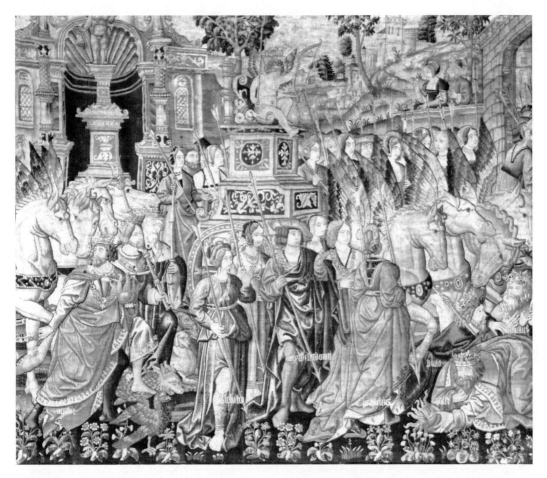

Brussels about 1510, *Triumph of Cupid*, wool and silk, Belgian unknown owner, 395 × 330 cm. The god Cupid is seated on a carriage before a Renaissance building. Around the carriage are gentlemen and ladies in Renaissance costumes. Along the bottom flowers appear that are part of a greater tapestry. The top and both sides are cut, with no border. This tapestry was signed for and inventoried by Gisela Limberger. She was unable to identify the tapestry for American art officers at the end of the war.

Göring's personal secretary was Miss Gisela Limberger, who was born August 30, 1893. She was employed as a secretary by the German State Bureau for Anglo-German Relations in Berlin from 1921 to 1925 and then transferred to London from 1925 to 1930. In 1932 she was a librarian in the Prussian State Library in Berlin and worked on matters related to the art collection of the library. When Göring became the minister of Prussia, Limberger was assigned to his staff.[7]

She was in charge of all Göring's private correspondence and finances and of the complete art collection, including its display and storage, until February 1944, when it was turned over to Hofer. Before taking over this job completely, Miss Limberger had worked under the brilliant and efficient Mrs. Greta von Kornatski, who had been Göring's secretary for years. The latter is reported to have known everything about Göring's private

affairs, down to the most intimate details. She was absolutely devoted to her master. She married a Luftwaffe officer during the war. When she died in August 1942 of fish poisoning, it was a tremendous blow to Göring, who gave her a funeral almost as elaborate as that of a minister of state. Although Miss Limberger was Kornatski's successor, she never reached the same degree of intimacy. However, Göring insisted that she do all his personal typing herself. It was characteristic of him to reduce the number of persons concerned with a particular matter as much as possible.

Regarding Limberger, Christa Gormanns had this to say: "I had the suspicion for some time that Miss Limberger was taking some drug like morphine or cocaine. Besides, it was the general opinion that Miss Limberger was a heavy drinker and heavy smoker and she at times made a complete absent-minded impression."[8]

Fritz Goernnert was originally one of the leaders of the S.A. and acted always as Göring's liaison with Bormann and the Nazi Party. He was the Reichsmarschall's social secretary and kept the lists of guests for all official and private functions. He was also in charge of Göring's four "Special Trains," which Goernnert had helped to design and build. His only connections with the Collection came through transportation. The personnel of this section always accompanied Göring when he traveled on the special trains.

Heinrich Gerch's status was mixed civilian and military, as he was also in charge of the "Military Fund." Originally he had worked under Mrs. Kornatski. However, after her death, he was put on an equal footing with Fraulein Limberger because, according to Nazi ideology, it was unworthy for a man to work under the direction of a woman. He was in charge of matters which had a military connection, and he replaced Fraulein Limberger when she was absent. Hofer says that during the latter years he dealt with Gerch more frequently than with Fraulein Limberger.

Christa Gormanns joined the Berlin household of Hermann Göring in November 1933. Göring had undergone an operation to his jaw and the physician that performed the surgery recommended Gormanns for his care. She moved into the household of Göring and became an essential member of his staff. While recovering he developed a habit of taking paracodeine, a mild morphine derivative. The following year he underwent a cure to get away from this habit and according to Miss Gormanns the cure was a success. (This was not true, for by war's end he was taking more than 60 pills a day.) Göring was widowed at this time and the household included Göring's two sisters; his deceased wife's sisters; his adjutants; Miss Emmy Sonnemann, his future wife; Emmy's sister, Elsa; Prince Philip of Hessian, who had a private room; and other people who would stay for weeks. Therefore Gormanns was asked to take care of "things a woman normally takes care of in the household." Additionally there was frequently someone sick in the house; Göring needed prolonged dental care and, as his dentist made house calls, Gormanns helped in this area.

Gormanns accompanied Göring on most of his trips that were made on his special train. The train was most comfortable and included bedrooms that were used during their travels to Holland, France, Norway, Italy, Yugoslavia, Greece, and the Balkans throughout the late 1930s. On these trips Gormanns bought clothing for the children of the household staff and other articles. Also she was responsible for paying the bills such as household expenses, Christmas gifts and other gifts. During these trips the foreign currency was taken care of by Göring's secretary, Mrs. Greta Kornatski.[9]

General Karl-Heinrich Bodenschatz (Luftwaffe, formerly Infantry) had formerly been head of the military household. He acted as Göring's liaison with Adolf Hitler and the armed forces. During the latter years he spent more and more of his time with Hitler. He was in charge of the Göring Art Fund, and all orders for payments or credits in this connection had to pass through him. He was seriously burned during the attempt on the Führer's life on July 20, 1945. After he left the hospital in Berlin, he went to Carinhall to live.[10]

Within Göring's personal associates, there was a feeling of distrust which originated with Göring and seemed to have spread to the members of the staff; they all disliked and gossiped about one another. Miss Limberger accused Hofer of concealing from her the details of the art transactions. They finally quarreled and did not speak to each other again. Hofer accused Lohse of intriguing to displace him as director of the collection. Miedl suspected that Gritzbach and Hofer denounced him to the Gestapo. There was general gossip that some sort of unsavory alliance existed between Gritzbach and Hofer. Even afterwards, under interrogation by foreigners and enemies, these dislikes still had an influence on their statements. Göring appears to have been sitting upon a viper's nest — but pleased to do so, since thus he was at least assured that his subordinates would not join forces against him.

Göring needed a large staff to help keep track of his large collections of art distributed through his residences. The residences were as follows:

Berlin: Göring town residence, 3 Leipzigerstrasse, Berlin, a house in the same block as the offices of his personal staff. This was his most important residence until 1937. The house was completely renovated under the supervision of Hitler's chief architect, Albert Speer. Speer completely rearranged it by ripping out walls and turning the first floor into four large stained glass rooms. The biggest was Göring's study, mostly bronze and framed glass. On the wall opposite his disk, under a light, hung Rubens' *Diana at the Stag Hunt*, borrowed from the Kaiser Frederick Museum. Here he lived and held official receptions. After 1937 he still occupied the house but only less important works of art were kept here.

Carinhall: From its inception the estate was a memorial to Göring's dead wife, Carin. The feudal home was built on the shore of a small lake surrounded by a large forest. Large courtyards, equestrian trails and thatched buildings surrounded the remote estate. Until the first air raids of Berlin all his most important works of art were exhibited here. Robert Kropp, the Reichsmarschall's personal valet, had a private apartment here. When Allied bombing became a threat, the most important works of art were stored in air raid shelters located within the house.

Ringewalde: Situated about 12 miles from Carinhall. This was an 18th century country house which Göring never occupied, but his wife's brother lived in the house with a number of acquaintances who had been bombed out from Berlin. It contained mostly modern furniture and one part was used for storage.

Gollin: A farm located near Carinhall used for the storage of furniture. Gritzbach and Hofer were allowed to keep their household goods there after their homes were bombed out in Berlin.

Veldenstein Castle: Located 45 miles from Nuremberg on the road to Bayreuth. It was a 16th century castle which Göring received from Lilly Epenstein in 1938. Göring was in the process of restoring the castle. Renovation was under the supervision of architect Hetzelt, who was assisted by local builders. The castle originally contained paintings of secondary importance and modern German paintings such as the Breughel School *A Peasant Fair* and a small number of sculptures and Gothic tapestries. The size of the rooms did not allow for large art objects.

Berchtesgaden: Göring's house in the Obersalzberg region. This was an elaborate dwelling occupied mostly by Emmy Göring, who usually went here after the Reichsmarschall's birthday in January and stayed until early summer. It contained a small number of paintings, sculptures, and tapestries.

Mauterndorf Castle, Austria: Göring inherited this castle also from Lilly Eppenstein in 1939, but he never lived there. He allowed his sisters, Mrs. Paula Hueber and, his favorite, Olga Rigele, to live there and it was furnished and decorated with their own belongings. Olga had been a volunteer Luftwaffe nurse on the Russian front during the bitter winter of 1941. The castle contained an altarpiece attributed to Pacher, some 16th century paintings and a collection of ecclesiastical vestments that Göring valued very highly.[11]

Rominten Heath: Göring's hunting lodge, on 60,000 acres of woodland, located on the frontier between East Prussia and Russia. It was elaborately furnished but contained no works of art of any value.

Kurfuerst: A large air raid shelter near Potsdam. From 1942 on, after the first serious raids on Berlin, all of the best of Göring's collection was stored here. These massive six-story towers, of 15-foot concrete reinforced with steel, were designed as antiaircraft defense and as a civilian shelter, with room for 10,000 civilians and even a hospital ward inside. The normal procedure for acquired art objects was that they be taken to Carinhall first, where they were examined and admired by Göring, after which they went straight to Kurfuerst. Here they were well guarded by a staff of Luftwaffe guards under the command of Colonel Shomburg.

Göring's four favorite paintings remained in a safe area at Carinhall for the duration of the war. They were Memling's *Madonna and Child* (Renders Collection), Memling's *Madonna and Child* (Rothschild Collection), Lochner's *Madonna and Child* (bought from Freiherr von Palm, a private collector in Berlin) and Vermeer's *Christ and the Woman Taken in Adultery* (from Miedl). More will be discussed about these paintings in later chapters.

4

Art Dealers in Germany

The works of art purchased by Göring in his own country were not necessarily seized by the Reichsmarschall. However, many German dealers who sold to Göring were active in occupied countries and the exact provenances of these purchases were unknown.

Joseph Angerer was the most important of Göring's agents. Born in 1899, he grew up in Berchtesgaden and entered the army in 1916. While Göring lay wounded in a Munich hospital in 1923, Angerer, who bore a resemblance to the Reichsmarschall, traveled through Austria masquerading as Göring. Wearing duplicates of Göring's World War I decorations, he used Göring's name to obtain money and indulge in sundry other shabby deals. Only a conviction of rape in 1923 stopped Angerer's charade. He was released from jail and returned to Germany in 1925.[1]

Unable to obtain a job in Berchtesgaden, he traveled to Berlin and obtained a job as a clerk at Quantmeyer & Eike, a leading carpet and tapestry firm. The owners of the firm were relatives of his wife. Angerer first met Göring in 1934 when the firm for whom he worked delivered carpets to the new Reich chancellery. Angerer purchased two tapestries for the chancellery with the help of Karl Haberstock from the Munich firm of Franz Drey for 100,000 reichsmarks. Thereafter Göring purchased tapestries for his various homes and Angerer saw him quite frequently. Through this association the Quantmeyer & Eike firm rose to prominence under the Nazi regime and the company was a member of the group of model Nazi-sanctioned firms specially decorated and lauded by the Nazi Party.

Angerer traveled extensively and had contacts in France, Switzerland, Italy, Spain, Iran, and South America. In Iran his firm had a factory, and reportedly he traveled there during the war years. His relation to Göring was that of an independent dealer specializing in tapestries, textiles, rugs, sculpture and stained glass and he worked with Göring, the same as Hofer did, on a first refusal basis. When Angerer traveled he carried a letter that stated he was on business for the Reichsmarschall. He obtained foreign currency through the staff of Göring or from the Luftwaffe. On January 30, 1943, he received two million lira from the German attaché in Rome. When Göring wanted to make an anonymous sale of some of his art objects at auction it was camouflaged under the name of Angerer's firm.

During 1940 and 1941, Angerer preceded Hofer to France and established contact with the German military government and the Devisenschutzkommando (Foreign Currency Control) in Paris. Angerer was responsible for selecting and shipping the first confiscated works of art from France to Carinhall. Later, when Hofer arrived in France, they carried out business together, with Hofer choosing the paintings and Angerer the tapestry and sculpture. Angerer also introduced Hofer to many dealers in France and Italy.

Angerer had his agents on the spot in various occupied countries. One of these in France appeared to be Tudor Wilkinson, an aging American millionaire and art collector who remained in Paris throughout the war and helped Angerer with prospective purchases. During the hostilities, Wilkinson's wife, an English citizen and former famous Ziegfeld Girl, was arrested and placed in a concentration camp. Angerer arranged for her release through Göring's intervention.[2]

This slightly damaged School of Gaddi *Saint John and Baptist Saint* from an unknown collection was purchased as a gift for Göring by Joseph Angerer from France. His specialties were tapestries and textiles.

Walter Bornheim was born in Cologne on August 23, 1888. He served as a corporal during World War I. He specialized in sculpture and had studied in England and France. In 1936 Bornheim took over the well known Munich firm of Franz Drey, who was a Jew. Drey wanted to leave Germany because of the recent death of his father and the increasing difficulties which were being made for German Jews. The art firm was Aryanized as Bornheim took what remained of Brey's art inventory, valued at 500,000 reichsmarks, Bornheim's first contact with Göring occurred when the Reichsmarschall visited his shop. Later he was called to Berlin to discuss a specific object and from that time on he became the chosen buyer of sculpture for the Göring Collection.

In spite of the fact

Kajetan Muehlmann improved his status with Göring by purchasing this Flemish master, 1520, *Adoration of the Magi*, from the Charpentier Gallery. This is the center of a triptych, purchased in Paris in the spring of 1941.

that Bornheim never wanted to return to France, because of the treatment he had received as a prisoner of war during World War I, Göring persuaded him to go to Paris to buy sculpture in early 1941. From that time on he went to Paris, staying from six weeks to two months, for the purpose of buying in the French market. As always Göring had first refusal on everything he bought, but Bornheim also acquired a great deal for his firm in Munich. He was the most popular and biggest German buyer in France because he paid in cash and required no specific information on his receipts. He kept a briefcase full of French

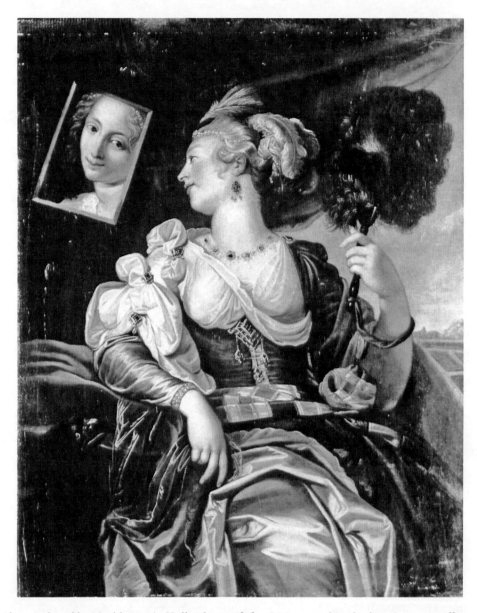

Also purchased by Muehlmann in Holland as a gift for Göring was this Abraham Janssens, *Allegory of Vanity.*

francs next to his desk in the Parisian Grand Hotel. Taken as a whole, his purchases seemed to be more important than those of any other German buyer in France.

In addition to what he sold Göring direct, a great many of the objects that Bornheim purchased went into Göring's Collection as birthday presents. His gallery was the main source for these presents and he was always visited by the representatives of ranking Nazis in search of presents for Göring.[3]

Kajetan Muehlmann had offices in Warsaw, Cracow, Berlin, Vienna and Paris. He

was one of the earliest Austrian Nazis. Prior to his membership in the Nazi Party he had been an art critic and advertising man for various Salzburg festivals. Under the Nazi regime he became an important figure and rose to the rank of colonel in the SS, with a special art group under his command. He came into contact with Hermann Göring when he sold him works of art from the confiscated Jewish collection in Vienna.

In 1940 Arthur Seyss-Inquart, the Nazi governor of the Netherlands, called Muehlmann to the Hague and requested him to form a special Art Bureau which was to buy art in Holland for the Führer Collection. Seyss-Inquart did this primarily to improve his relations with Hitler. The purpose of the Art Bureau, as previously stated, was to purchase art for the Führer. However, Göring always claimed second choice for any items acquired by Muehlmann and of course he made every effort to please the Reichsmarschall. When Jewish collections were confiscated Muehlmann was advised and he selected art objects for Göring at the same time Hitler's representatives were appraising the collections.

The money used by Muehlmann to "purchase" art for the Führer was obtained through a special fund assigned to him by Seyss-Inquart. It was occasionally increased by profits derived from the sale of the confiscated art. When something was purchased by Göring, the account was settled by Göring's personal staff. The Reichsmarschall did not like Muehlmann and always complained that he offered him a poor second choice of the objects acquired by the Art Bureau.

Dr. Bruno Lohse was the deputy director to Einsatzstab Rosenberg in art matters in France and special art representative of Hermann Göring. Wilhelm Peter Bruno Lohse was born September 17, 1911. He completed elementary and intermediate schooling in Berlin and graduated from the University of Berlin in 1932. He obtained his PhD in fine arts from Frankfurt University in 1939 at the age of 28. He had joined the Nazi Party in 1937. Drafted in 1939, he was an enlisted man in the Luftwaffe. After a long period of convalescence due to ill health, he was attached for four weeks of temporary duty with Einsatzstab Rosenberg in Paris. Then, due to his educational background, he was assigned in Paris to work for Colonel Baron Kurt von Behr. Lohse's duties were to arrange exhibits at the Jeu de Paume for inspection by the Reichsmarschall, to watch the Paris market for buying opportunities, and to take care of details of packing and dispatching of works of art which were to be sent to Carinhall.[4]

After escorting Göring and impressing him with his knowledge concerning several disputed paintings, Lohse received a special document signed by Göring authorizing his activity in the Reichsmarschall's behalf and requesting all military, state and party organizations to facilitate his mission. In July 1941, Lohse was transferred formally to a Luftwaffe detachment in Paris. Because of his special mission for Göring he was allowed to wear civilian cloths and drive a private car. Therefore his role in the Einsatzstab grew in importance, his stature and independence in the organization greatly increased due to his activity for the Reichsmarschall.

Because of this, a bitter rift developed between Lohse and Dr. Walter Borchers, the deputy director of Einsatzstab Rosenberg, and Lohse made a request to return to active military duty. Lohse was granted his request and given leave prior to returning to active duty with the Luftwaffe. During this holiday he broke his leg while skiing. During all this Göring found out about the transfer and ordered Lohse to remain in Paris and con-

tinue to work on Göring's special assignments, divorced from Einsatzstab Rosenberg except for administrative purposes.

In August 1944, during the German rout in France, all male employees of Einsatzstab Rosenberg were ordered to active military duty for the defense of the Reich, on a 48-hour notice. On August 8, 1944, Lohse telephoned Göring of the order given by the German military commander in France. Lohse was apprehensive that this swift withdrawal by the Einsatzstab staff would result in the abandonment of essential records and a number of valuable art treasures. He was told to proceed to Berlin immediately. He returned to Paris 10 days later and found the Einsatzstab headquarters abandoned. He then returned to Berlin, reporting to Göring's headquarters, and he was transferred to Göring's airborne unit in Berlin on that date.

Shortly thereafter, he was given permission to go to Merano, Italy, for a week's leave. He had been under treatment for kidney stones and as his condition did not improve he was advised to undergo an operation in November 1944, but the Berlin hospital to which he had been ordered was destroyed in an air raid shortly before his arrival. He was then granted permission to travel to Füssen, Germany, to have the operation there. In Füssen he lived with the Einsatzstab staff assigned to Hitler's museum treasures stored at Neuschwanstein Castle. While here, Lohse consolidated art treasures from other locations to the castle. On May 4, 1945, Lohse surrendered to the Americans.[5]

Dr. Hans Posse became director of the world renowned Dresden Gallery in 1910 at the young age of 31. His father was a well known archivist in Dresden and was a friend of the finance minister of that city. After the Nazis gained power in Germany, Posse was removed from office in 1938 by Gauleiter Martin Mutschmann for anti–Nazi sentiments and for having acquired art they considered "degenerate" and which had been created by such artists as Cézanne, Gauguin, Picasso, Matisse, Klee and even van Gogh. After a word from Karl Haberstock to Adolf Hitler, Posse was reinstated by Hitler personally in June 1939 and later summoned to Obersalzberg and commissioned for the foundation of a new art museum.

"You are responsible to me alone," Hitler said. "Keep me well informed and I will make the decisions."[6] Posse purchased more than 1,200 paintings, for the Linz Museum, of which every one was a masterpiece, including 11 Rembrandts. The Führer always said, "Buy! Buy! What we can not use in Linz the smaller museums will get." "Marie Dietrich bought a lot of inferior stuff and wanted to sell it to Hitler for good money. My husband was supposed to validate the transactions in his name. Such people were part of an unpleasant incident in the art market."[7] Everything was sent to Munich, where it was exhibited every six months for the Führer.

Mrs. Posse wanted to make a point to the U.S. Army investigator with the statement that Göring had summoned her husband to Berlin and reprimanded him severely, asking him why he took it upon himself to buy all the older art objects without taking into consideration Göring's own attempts to do the same. "Göring was our greatest rival," she said. "When my husband discussed this with the Führer, he said, 'I collect for the people, he for himself.'"[8]

During the three years of duty, until his death from tongue cancer, Posse performed his duties loyally. He died in December 1942 and the Führer honored him with a state

funeral. After Posse's death, his position was wide open to the competition. Various museum directors in Vienna thought of themselves as the probable successor. The least likely candidate, Dr. Hermann Voss, was appointed to direct the activities for the Linz Museum. He had been director of the Dresden Museum and was well known for his anti–Nazi opinions.

Dr. Hermann Voss' interrogation by his American captors revealed an enigmatic personality. He was born on July 30, 1884, in Luneberg and obtained his early education in that town. He studied art history at the University of Berlin and obtained a doctor of philosophy from the prestigious University of Heidelberg in 1906. After graduation he traveled to Paris and Holland and studied the details of Italian paintings in Italy. During World War I he served in the political Intelligence unit.

He married Marianna Bose in 1919; they never had any children. Mrs. Kornmann reported that Marianna deserted her first husband and several-month-old son for Voss' sake. She further said, "Marianna Voss never during all her life, cared for her only child, who grew up in the family of his father and stepmother who was sincerely fond of him." She stated, "Voss was a strong morphinest and enthusiastic homosexual."[9]

In the early 1920s Voss worked for the Kaiser Friedrich Museum in Berlin. He organized several successful exhibitions in Berlin and traveled widely, visiting museums and private collections in New York, Philadelphia, Washington, Boston, Chicago and Milwaukee.

Voss had difficulties with the Nazi Party because of his cosmopolitan and democratic tendencies and his friendship with many Jewish colleagues. He was demoted and requested a leave of absence for several months. During this time he tried unsuccessfully to find a position with an art museum in England. In 1935 he found a job as the director of a small

This painting signed Jan van Neck, *Lying Venus with Children and Amor*, from an unknown collection was acquired by Bruno Lohse, "Special Art Representative" for Göring in Paris during December 1941. Upon seeing the picture, Göring took it away the same day he was visiting the Jeu de Paume.

local museum in Wiesbaden. This job was widely regarded in art circles as a politically inspired position and, in a sense, a reflection upon his competence as a scholar and museum director. During his eight years of tenure at Wiesbaden, he built up a collection of German 19th century paintings which became known for its completeness and quality.[10]

In February 1943, two months after the death of Posse, Voss received in Wiesbaden an entirely unexpected telephone call from Dr. Josef Goebbels, the minister of propaganda, requesting that Voss see him the following day at noon in Berlin. Indeed, next day Voss was ushered into a room with Goebbels, who asked Voss if he was inclined to take over as director of the large, prestigious Dresden Gallery. Voss told Goebbels that he was not a member of the Nazi Party, to which Goebbels replied the task did not require any party affiliation. Voss then immediately declared himself ready to accept the position. Goebbels asked Voss about his previous career and personal situation such as marriage and children. Goebbels said he would notify Hitler of Voss' decision.[11]

Ten days later, Voss booked passage on the night express from Berlin to Rastenburg, Hitler's headquarters in East Prussia. The officer assigned to Voss as his adjutant for the day told him that he knew Mrs. Posse and that she had told him it was Posse's last wish that Voss be appointed as his successor in recognition of his accomplishments as a scholar and museum director and his special knowledge of German and Italian painters.

Late the following evening Voss met Hitler and Martin Bormann, who remained silent. For more than an hour Hitler talked without stopping. He gave a sort of lecture on the origin and importance of such old princely galleries as that of Dresden and subsequently explained his intentions regarding the Linz Museum. The main emphasis, he directed, should be placed on German 19th century paintings, particularly the schools of Munich and Vienna. In addition, older German paintings should be collected as well as those of the Netherlands, Italy and France. He then complained that up to that time cultural activities had been centralized in Vienna. Smaller centers like Linz, Graz and Salzburg were now to receive cultural assistance. Linz, because of its beautiful site on the Danube, was to be especially favored.[12] With that the Führer appointed Voss as director of the Dresden Museum and the Linz Museum.

In this capacity Voss acquired a few works of art for the Dresden Museum and many acquisitions for Linz, including confiscated items from Einsatzstab Rosenberg. After the devastating Allied bombardment of Dresden in February 1945, Voss made his residence at the castle of Wessenstein, 12 miles from Dresden. This castle was the main repository for art objects from the museums in Dresden and the Saxon State Collection. Immediately after the Soviet forces occupied Dresden, the Trophy Brigades removed the better art objects from Wessenstein Castle and sent them to Russia.

Voss left the Russian zone of Germany and arrived in Wiesbaden on July 29, 1945, and presented himself to the American authorities in charge of the Wiesbaden Museum. He, the highest functionary in Nazi art circles, arrived as the savior of the art acquired by Germany during the war. He thought the Americans would know who he was and expected no one to question his motives. He also thought the Americans would transport his wife, he himself and his belongings out of the Russian zone. His reception abruptly ended and he was incarcerated in Wiesbaden by the Americans.

Karl Haberstock was born in Munich in 1878 to a middle class family. His entire

career was based on two principals: anti–Semitism and German chauvinism. He is said to have been a vociferous anti–Semite from the beginning and to have attracted a certain clientele in this way, particularly in the 1920s when the art market and other elements of finance and the commercial world were dominated by Jews. This clientele, drawn mostly from reactionary German circles, also had a natural taste for 19th century German art as opposed to the "degenerate" French products of the same periods or for art by their own progressive German contemporaries

When Hitler came to power, Haberstock joined the Nazi Party. He never liked risks and he always saw to it that he had something to fall back on should a plan miscarry. Even after he became a Nazi, he maintained his membership in the International Rotary, and throughout the period of Jewish persecution he helped certain Jewish colleagues to escape. When National Socialist reforms were put into practice Haberstock became an enthusiastic crusader against the exhibition of "degenerative art" paintings in the German museums. However, his fervor was considerably tempered by self interest. He played a leading part in the disposal of these paintings on the international market, thus obtaining foreign currency for the German government and large profits for himself.

Thanks to his early clientele and his political activity, Haberstock became the most important international art dealer of Nazi Germany. He traveled throughout Europe and had affiliations with many of the leading dealers, such as Theodor Fischer of Lucerne, in whose company he visited London in 1939; Georges Wildenstein, with whom he owned paintings in a joint account; and the Seligman brothers, with whom he planned a system for representatives in the United States. Just prior to the war, Haberstock sold Georg Wildenstein of New York a painting by Gauguin for 2,000 British pounds. The funds were deposited into Haberstock's bank account in London with the Swiss Bank Corporation.

In business dealings Haberstock was known by his colleagues as a sharp trader and one not entirely to be trusted. He almost always worked alone, although when he was not successful in obtaining the results he wanted he brought his wife, who was known generally as one of the chief reasons for his success.

Haberstock's career was crowned with his appointment by Hitler as chief adviser to Posse. In this capacity he was able to exert a direct and powerful influence on the formation of Hitler's collection for the Linz Museum. He became so influential that he dared to oppose Göring. Prior to this he was close to Göring, but the working relation was broken because of Haberstock's close connection with Posse and his association with the Führer's collection for the Linz Museum.

His most important center of art activity was in France, where he had two groups of agents working for him. The more important of the two was centered in Paris, where he was closely associated with Roger Dequoy and Baron von Poelintiz, who operated in the free zone of southern France, where he believed new art discoveries could be made. In this area he worked with a former Berlin dealer, Alexander Ball, who had been a refugee in Paris shortly before the war and after the invasion of German troops made his way south to Aix, where he sought out private collectors who were willing to sell to Germans. On January 3, 1941, Ball wrote Haberstock about a van Dyck and Breughel discovery near Lyon. In this letter he also wrote that Guy de Rothschild was living in La Bourboule, as

the Germans were looking for Rothschild and his art collection. Alexander Ball and his brother, Richard, who was living in Marseilles, left France and made it to the United States.[13]

Maria Dietrich was born in Munich on June 28, 1892. She had an illegitimate daughter, Mini, born in 1910. Dietrich's father was Jewish. In 1921 she married Ali Almas-Diamant, a Turkish Jew and tobacconist, whom she divorced in 1937. She adopted the Jewish faith and Turkish citizenship at the time of her marriage. From 1933 on she had considerable difficulties with the Nazi authorities on both of these accounts, until she had her German citizenship restored in 1940. She resumed her maiden name but kept the name Almas for her gallery, located on 9 Ottostrasse, Munich. According to her sworn testimony, she was never a member of the Nazi Party, but as an art dealer in good standing, she was automatically a member of the Reich Culture Center that gave her access to top party members. She met Hitler through Heinrich Hoffmann. It was rumored that she had a long intimate relationship with Hoffmann. Her sales increased from 47 thousand reichsmarks in 1937 to 483 thousand the following year and remained in six figures throughout the war.

Mrs. Dietrich was an energetic buyer at auction houses in Germany, particularly Lange in Berlin, where she became notorious for the high prices she paid. Quantity not quality was her forte and competition was her mainspring. Her trips outside Germany during the war were restricted chiefly to Paris. Here she had a number of agents. Chief among them was a Russian princess, Therese Vatchnadze, to whom she paid a small commission. Another source for her in Paris was Göring's agent, Bruno Lohse, who passed on information to her as a friendly service. Through him Dietrich bought for the Linz Museum at the end of 1943 Bocksberger's *Creation* and Boucher's *Epiphany* for 140,000 reichsmarks and sold them to Hitler for 160,000 reichsmarks.

Dietrich visited friends in Holland in 1941, although she had already acquired part of the Goudstikker through Hoffmann, and Miedl from the Witzig Bank in Munich that was owned by Miedl. The Goudstikker paintings were sold to the Führer directly from Mrs. Dietrich, without going through Posse or Voss. This did not sit well with the two agents, as the paintings were destined to become part of the Linz Museum Collection.

Dietrich was always correct in her dealings and she seemed to have dealt with only one Einsatzstab Rosenberg item, Pissarro's *View of Honfleur*, in exchange for two small Portuguese 15th century panels. This was negotiated in Munich and signed subsequently by von Behr in Paris. She deemed it unwise to have this painting in her inventory and gave it to her daughter, Mini, who lived in Velden, Bavaria. There was no question regarding the honesty of Mrs. Dietrich, but her reliability as a connoisseur of paintings was questionable. Her inventory was full of entries that read "marked down because false." Both Hitler and Bormann took issue with her judgment of a Rudolf Alt water color and admonished her to be more careful. Dr. Ernst Buchner, director of the Bavarian State Museum, insisted that he once put her out of his office in exasperation at being shown so many second-rate and fake items from the Almas Gallery. Regardless of these difficulties, she was one of the most prolific dealers in Germany.[14]

Hans Adolf Wendland traveled constantly between Switzerland, France and Germany. His residence and headquarters were in the lavish Hotel Ritz in Paris, where he was

unquestionably the most important contact for the Göring Collection and was unofficially king of the art world. He dealt only with Hofer, who had met him in 1922 in Berlin and who had unlimited admiration for his connoisseurship and extensive contacts. Wendland traveled frequently through unoccupied France, in particular the Midi-Pyrenees region, where most of the Jewish dealers had taken refuge. His business was still done mostly on a commission basis. He worked with all the French dealers, many of whom came to him for advice. Many of the middlemen, couriers, and restorers who abounded in Paris worked for Wendland. He formed a sort of informal syndicate comprising Archilo Boitel, Allen Loebl and Yves Perdoux, and they were used by more careful dealers to camouflage sales to Germans. Wendland was also connected with Roger Dequoy and was instrumental in the purchase of Boucher's *Ceiling* and negotiated the sale of Courbet's *The Dead Fox* for 2,000,000 francs.

Wendland was the artistic advisor to Buehrle, the Oerlikon arms manufacturer. They were always together in Zürich and appeared to have some business connection. Wendland arranged for transportation of a group of paintings Buehrle had brought from Dequoy in Paris. They traveled by way of Berlin, where Göring's personal staff became involved, with the understanding that Buerhle would supply Göring with much needed Swiss francs.

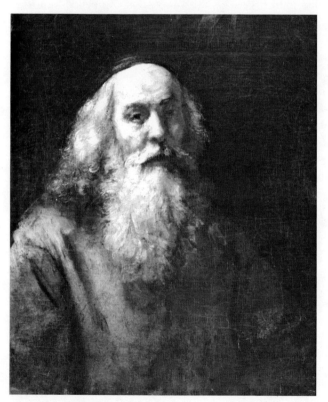

One thing was certain about Wendland, he was an adventurer and always ready to make any deal, however shady, if he thought he could make money. There was ample evidence of this in his prewar reputation, his associates in Paris and his attitude to the Einsatzstab Rosenberg exchanges. It was said to be common gossip in Paris that through his position as an expatriate German resident in Switzerland and doing business in Paris, he managed to never pay taxes. An investigation of his financial status would probably reveal that he knew much about concealed German assets in Switzerland and France.

Wendland's travel arrangements during the war were most

This cracked Rembrandt, *Portrait of an Old Man with a Beard*, from Marseilles, France, was one of Hans Wendland's most important purchases while he worked for the Reichsmarschall. According to Wendland it was offered to him by a French Jew who requested payment in U.S. dollars. Today it hangs in the Louvre.

unusual, for few Germans could go back and forth between occupied and unoccupied France, Germany and Switzerland without great difficulties. Hofer insisted categorically that Wendland never traveled with a letter of authorization from Göring. Wendland never discussed his ease of travel with Hofer and so it is possible that he was backed by the Gestapo, Military Intelligence, or other high ranking Nazi organization. He had no political convictions but was capable of undertaking anything out of self interest. For instance, it had been reported that he and his partner Boitel concealed Jewish collections from Einsatzstab Rosenberg through von Behr. The Swiss authorities refused him a reentry visa and the Swiss police questioned him for nine hours. This may have been in connection with his business activities but it also may have had something to do with his work for the German services.[15]

On April 1, 1946, Wendland left Switzerland on an exit permit from the Canton of Geneva and went to Rome, where he remained past the expiration date (June 1, 1946) of his permit, until his arrest on July 25. He offered various confused and conflicting reasons for his flight to Italy, among them the desire to become a Catholic and effect a proposed exchange of certain works of art of religious significance between Switzerland and the Vatican. He professed never to have stated that he was going to Italy on behalf of the Allies, as was suggested by one Swiss source. Perhaps the motive that compelled him to leave Switzerland was, as Wendland implied in the course of his interrogation, the sense of having become a moral outcast in Switzerland. Perhaps also he feared the consequences of another investigation by the Swiss into the art dealings of Fischer and himself.[16]

Wendland was arrested in Rome by the American forces on July 25, 1946, at the request of the American legation in Berne. After a preliminary interrogation there, he was transferred to Oberursel near Frankfurt about August 22. Wendland had been on the Allied "Proclaimed List" during the war, as well as on the Allied "Repatriation List," and he was returned to Germany in accordance with a request from the United States Department of State. On August 31, Wendland was transferred to Wannsee Internment Camp, near Berlin. He was to be returned within the next week to the internment camp at Oberursel for further disposition.[17]

5

The Annexation of Austria

Göring's adversary in the collection of art was none other than Adolf Hitler. Like many a small-town boy who had made good, Hitler wanted his hometown of Linz, Austria, to bask in his success. It was here that he had attended various schools and had passed his troubled childhood years.

Hitler was artistically inclined and in his younger days had wanted to become a painter. The University of Vienna, however, refused him as a student. He could never forgive Vienna for this act and though he was an Austrian, Hitler from that time forth always resented the cosmopolitan atmosphere of Vienna. It was natural, therefore, that Linz should figure prominently in his anticipated post-victory plans. He was determined that Linz should supplant Vienna as the Austrian capital and that its new prominence should cement the Austro-German bond so vital to the constructive growth of National Socialism.

For Linz, Hitler planned a total transformation by which the old city would become the nucleus of a modern industrial metropolis. An array of public buildings were designed under Hitler's personal supervision and exhaustive studies were made of every aspect of city life in Linz. Full architectural renderings of buildings were prepared. So sweeping were the proposed changes that the central railroad and station were to be moved three miles to the south of their existing location.

A cultural superstructure, envisaged as an imposing city square, was the proposed Hitler Museum and Library. The museum, with a colonnaded facade about 500 feet long, would parallel the great Museum for German Art already erected in Munich, and was to be only one of several related buildings. An armory and theater were to be housed separately and the library was designed to accommodate 250,000 volumes initially, with many times that number in planned expansions. The study for this complex was prepared under Hitler's direction by the Economic and Research Section, Department of Interior.

For the city of Linz, Hitler desired an art museum rivaling those of Cologne, Berlin and Frankfurt. As early as 1935, Hitler began to collect 19th century German art for the future museum. Martin Bormann, secretary of the Nazi Party, was hardly less energetic

in Linz affairs than was Hitler himself. All correspondence went through Bormann's office and much of it was handled by Bormann personally. He had no interest in art and did not know anything about it, but because art was a passion of Hitler's, he participated with particular zest.[1] Bormann became indispensable to Hitler and his art-collecting mania because he did not shrink from any responsibility to attain the objectives of the Nazi Party or the desires of his führer. Until he was caught up in the maelstrom of a world war, Hitler devoted a disproportionate amount of time and energy, for a chief of state, to the plans for Linz, personally creating the architectural scheme for an imposing array of public buildings and setting the formula for an art collection emphasizing German nineteenth century painters.[2]

Having masterminded the phenomenal growth of Germany's military power in the 1930s, Hitler could now use the threat of force to secure territorial gains and the respective booty earmarked for the Reich. Austria was the first victim. Germanic in blood and language, it had been part of the German Confederation; but a true union was forbidden, unwisely so, by the Versailles Treaty. Hitler began undermining the Vienna government by cajoling it with false promises and by inciting internal Nazi-led revolts. On March 13, 1938, at 8:00 A.M., General Heinz Guderian, Germany's architect of tank warfare, crossed the Austrian border with the Second Panzer Division and the Leibstrandarte SS Adolf Hitler Division to annex that country, without resistance, to the Greater Third Reich. By incorporating Austria, Hitler secured two great strategic advantages: he forced Mussolini to support him and his cause and he encircled Czechoslovakia in Nazi territorial pincers.

Special German laws called "Divisions Laws," which prohibited Jews from owning property, were enforced in Austria. The first Jewish art collection to be confiscated was that of Alphons and Louis Rothschild in Vienna. Other Jewish confiscations soon followed, including a coin collection belonging to Louis Rothschild and Leo Fuerst. Dr. Hans Posse, director of the Linz Museum and a man of indefatigable energy, was quick to seize the opportunity. Posse determined to surpass even Hitler's ambition by making Linz not just an Austrian-Bavarian cultural center, but also an important seat of European culture. Posse selected the best of the paintings for the Linz Museum, the lesser-known art being sent to museums or auctioned at the Dorotheum, a Viennese auction house in Vienna.[3]

Dr. Hans Posse, the Linz Museum director, purchased outright the most outstanding painting, the Jan Vermeer *The Artist in His Studio*, for the Linz collection. It was purchased from the Czernin brothers of Vienna. The original asking price was 2 million reichsmarks. The Führer considered this to be considerably overpriced. Then there was some question that the Count Jaromir Czernin-Morzin and his brother were in arrears in payment of their taxes and as a result Hitler could not purchase the painting, as it was attached as a tax lien. In September 1940 Martin Bormann cleared up the tax matter. Then the Czernins were asking 1,400,000 reichsmarks, plus now an inheritance tax, for a total of 1,650,000 reichsmarks. This was a sum equal to $660,000, a fortune in 1940. Bormann passed this information on to Posse, who left immediately for Vienna and negotiated the purchase of the painting. On October 11, 1940, Posse received a telegram: "Arrive with painting Saturday early afternoon, dimension 120 cm high by 100 cm wide [52" × 43"]." Thus

The Artist in His Studio arrived in Munich. After the sale, the receipt for the purchase was signed by Count Jaromir Czernin-Morzin, who added in his own handwriting his sincere thanks for the purchase of the painting.[4]

Ferdinand Bloch-Bauer, a wealthy Czech sugar magnate, had fled Austria shortly after its annexation, leaving behind his sugar factory, a castle, and several Gustav Klimt paintings, including one painting in particular: the impressive gold-flecked 1907 portrait of his wife, Adele Bloch-Bauer. His art was confiscated, including the "degenerate" Klimt paintings, and quickly acquired from the Nazis by several museums and private collectors. Five of the Klimt paintings, the portrait of Bloch-Bauer's wife among them, ended up in the Austrian National Gallery in Vienna. The better works of Bloch-Bauer's art, including his porcelain collection, were confiscated and reserved for Hitler's Linz Museum.

In January 1941, Posse visited the restoration studio of the Vienna Gallery and saw an extremely beautiful painting, *Ganymede Carried Off by an Eagle*, by Rubens, which was stored in Schwarzenberg Palace. At that time, the palace was being refurbished for a museum. Posse wrote Martin Bormann that the painting had been confiscated and that he desired it be obtained for the Linz Museum. Bormann added that the Führer desperately wanted this painting for his collection and "was squeamish about taking the painting from the Austrian National Gallery. For unspecified psychological reasons he directed it be acquired through an exchange."[5] Therefore he gave the Bloch-Bauer porcelain collection to the city of Vienna and the Ruben entered his collection as a gift from the Vienna Gallery. (The Ganymede painting had been photographed in *Klassiker der Kunst*, Band Rubens, 4th edition, 1921, illustration 39.)

In November 2006, Maria Altmann of California, the heir to the Klimt paintings, after years of legal proceedings received them from the Austrian National Galley and then sold them. The portrait *Adele Bloch-Bauer* was purchased by cosmetics magnate Ronald Lauder for $135 million. The four remaining paintings were auctioned by Sotheby's to anonymous buyers for $192.7 million and the proceeds were divided up among Altmann's heirs.[6]

Hermann Göring acquired the following art objects from Austria; also the Vienna Art History Museum would "loan" the Reichsmarschall a series of nine Brussels tapestries representing hunting scenes, after designs by Rubens:

Suebia, about 1480	*Annunciation*
Suebia, about 1480	*Nativity of Christ*
Alt, Rudolf	*Forum Nero in Rome* (51 × 66)
Austria, about 1520	*Saint Knight*, Wood
Waldmueller	*Bathing Woman* (138 × 97)
Pacher, Michael	*St. Barbara* (48 × 48)
List	*Two Hunters with Dead Hares* (150 × 250)
School of Botticelli	*Virgin, Child, St. John*

The following Göring art was returned to Austria after the war:

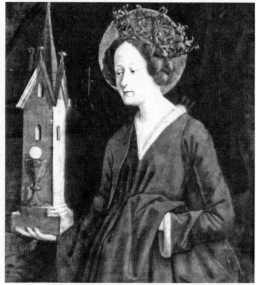

Above, left: This Suebia, about 1480, wood sculpture *Annunciation* was taken in 1939 from the Academy in Vienna by Baldur V. Schirach as a gift to Göring. Schirach was the head of the Hitler Youth. *Right:* Charles Neumann from Vienna gave Pacher's *St. Barbara* to Göring as a bribe. The documentation is unclear as to the bribe, but it appears to have been an export permit for the Neumann collection.

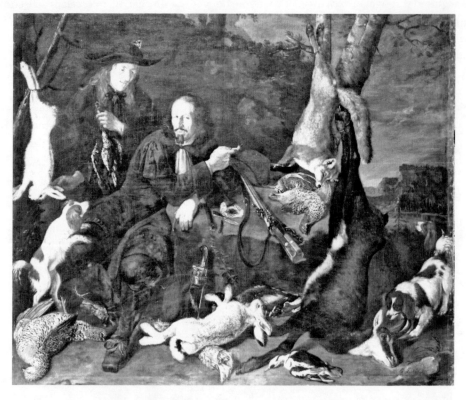

Georg List's *Two Hunters with Dead Hares* was removed from Saint Peter's Abbey, Salzburg, in April 1938 and presented to Göring.

This Rudolf Alt, *Forum Nero in Rome*, was confiscated from Julia Grüss in Vienna and acquired by Göring.

The year 1938 was a favorable one for the Reich. After the annexation of Austria, the French and British, awed by Germany's Luftwaffe and the West Wall, preferred an uneasy peace to the dangers of war. Hitler demanded that Czechoslovakia allow Germany to annex the German-speaking Sudetenland, which was achieved by the infamous Munich Accord of September 30, 1938. By acquiring her mountain passes and munitions works, Germany deprived Czechoslovakia of power and tactical positions for future resistance.

Neville Chamberlain, the prime minister of England, was pleased with the Munich Accord and told the British people this agreement provided "peace for our time." In less than six months, Czechoslovakia was dismembered and became a puppet state of Nazi Germany. After first Bohemia and then Moravia became protectorates of Germany, the Reichsbank replaced Czechoslovakian currency with German reichsmarks.

6

The Invasion of Poland

The prelude to World War II ended on September 1, 1939, when Germany invaded Poland. Honoring an existing defense pact with Poland, England and France declared war on Germany.

The invasion was over in a few weeks and in their occupation of Poland, the Germans followed the policy that church property, state museums and private collections were available for confiscation and that the Poles would keep nothing. Repositories were established in the Warsaw National Museum and by the end of 1939 the booty was available for inspection by Linz authorities. For the time being, the plan was to keep Polish objects in Poland, under the so-called safeguarding activities of the Germans. But due to the influence of Willy Liebel, the bürgermeister of Nuremberg, the Veit Stoss Altar was disassembled and removed from the church of Saint Mary at Cracow. This large sacred piece had been commissioned by the king of Poland in 1477 and took ten years to carve. It required several trucks to haul the 12-foot apostolic figures to Nuremberg, the home of Veit Stoss, who had died there in the 15th century at the age of 83. As the war continued, Polish valuables began to pour into Germany. Warsaw's Synagogue Library, one of the richest repositories of Jewish culture, was carted off to the "Fatherland."

The following letter by Hans Posse describes the art scene in Poland:

The major parts of the art collection are still in boxes, making it impossible to carry out the order as to the final disposition of the confiscated art objects. Most of these were located in palaces in Warsaw and ready for transportation to Cracow. Since October 6, 1939, the art property has been safeguarded under the direction of Muehlmann, a special delegate of the Reichsmarschall, and head of the science and education department, along with experts from Berlin and Vienna. The greater part of their work was salvaging the furniture and inside decorations from the gravely damaged Royal Castle. Almost daily cargo trains arrive in Cracow carrying art objects from public, clerical and private collections. By next February we should be able to properly arrange the works of art from the new building of the Jaghellon Library. Soon we should be able to inventory the complete Polish art property and make photographs of all the important art objects and submit the albums to the Führer.

In Warsaw and Cracow, I succeed in visiting public and private collections as well as church property. The inspection confirmed my supposition that except for the higher class of art already known to us, such as the Veit Stoss Altar, the panels of Hans von Klumbach

and several works of the National Museum in Warsaw, there is not very much which could embellish the German stock of great paintings and sculpture. The Polish store of applied art is much richer and more varied; goldsmith's and silversmith's works, mostly of German origin especially in the Cracow Marien Church and Wawel Cathedral. Their work in tapestries, armor, chinaware, furniture, bronzes, coins, rare manuscripts, and books are finished in the finest of craftsmanship. It is typical that besides original paintings, many copies are to be found in Polish castles and private collections.

I am not in a position to make any detailed suggestions for distribution, before a survey is possible for the entire confiscation material. But I should like to propose now that the three paintings at the Czartoryski Collection by Raphael, Leonardo and Rembrandt, which are presently located in the Kaiser Frederick in Berlin, be reserved for the Art Museum in Linz. It is further desirable that the wainscoating, doors, inlaid floors, sculpture, mirrors, chandeliers, furniture, chinaware and interior decorations of the Warsaw Royal Castle, completed and furnished by Saxon architects and artists be given to the pavilions of the Zwinger palace in Dresden.[1]

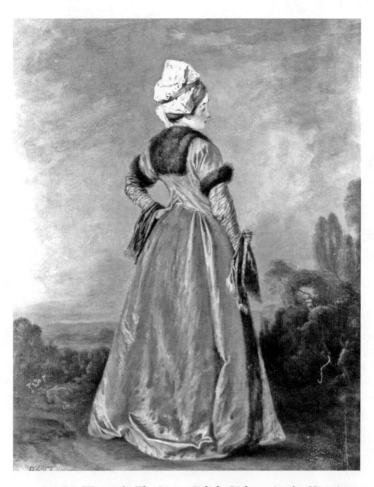

Antoine Watteau's *The Pretty Polish Girl* was in the Hermitage Museum until 1926 and was purchased and taken to Lazienski Castle. In 1939 Muehlmann confiscated the painting and presented it to Göring.

The Museums of Princess Czartoryski at Goluchow and Cracow contained over 10,000 works of art and were considered among the greatest of private collections, having been begun by Princess Isabel Czartoryski in the 18th century. The most valuable items from the collection were sent to the Sieniawa Castle in Goluchow during the early days of fighting. There the items were secretly walled up in the castle, but after the invasion a brick mason disclosed the hiding place to the Germans.

When the Germans had occupied Poland in 1939, Göring appointed Muehlmann special commissioner for the "Protection of Works of Art in the Occupied Territories" by a special letter to Hans Frank, the general governor of Poland. Muehl-

mann later sent Göring three pictures from the Czartoryski Collection: *Portrait of a Young Man* by Raphael, *Girl with an Ermine* by Leonardo da Vinci, and *Landscape* by Rembrandt. Muehlmann insisted they were taken by the Germans in full agreement with Count Stefan Zamoyski because he wanted to save the collection from the Russians.

The pictures were not considered confiscated, but only removed for safekeeping, but Göring refused to keep the paintings in his collection. He told Muehlmann that they should be placed in the Kaiser Frederick Museum. This he considered important in the case of the Leonardo because the museum was void of his works. The pictures remained in Berlin for a few months and then were returned to Poland. In 1942 Göring again demanded the return of the paintings to Berlin, but as the danger of Allied air raids increased they were returned to Poland, where they were kept in Wawel Castle at Cracow, the residence of Governor General Hans Frank. They remained there until the final retreat of the German military from Poland, when the three paintings were shipped to Frank's home at Neuhaus, Bavaria, Germany. From there *Portrait of a Young Man*, by Raphael, disappeared and was never recovered. The Leonardo da Vinci and the Rembrandt were recovered by U.S. forces and shipped to the Munich Collection Point.

Early in 1941 Muehlmann presented Göring with another painting from Poland, *The Pretty Polish Girl*, by Watteau. This painting had been taken into "safekeeping" from the Lazienki collection by Muehlmann's brother Dr. Joseph Muehlmann. It was sent to Berlin, where it was restored and given to Göring at Carinhall. It was listed as an object from the special commissioner for the Protection of Works of Art in Poland. Of these four paintings from Poland only the last was taken into the Reichsmarschall's collection.

7

Einsatzstab Rosenberg in France

The German war with France and England was stalemated for six months and became known as the "sitzkrieg." On May 10, 1940, the stalemate ended and a furious attack on Western Europe began. Ninety-four German divisions assaulted the Allies through Holland, Belgium, Luxembourg, and France. The Dutch fought heroically for four days and surrendered, followed by Luxembourg. Six weeks later, on June 22, 1940, an armistice was signed between Germany and France.

Behind the conquering German army in Western Europe in 1940 came Einsatzstab Rosenberg. (The paintings shown throughout this chapter were confiscated in France by Einsatzstab Rosenberg.) It was formed by a decree signed by Hitler on September 17, 1940, and permitted the seizure of "ownerless" works of art formerly possessed by Jews in occupied Western Europe. It was the most elaborate and extensive art looting operation undertaken by the Germans during World War II. The task force was headed by Alfred Rosenberg, who was born in 1893 in czarist Russia and educated as an architect in Moscow. He left Russia at the outbreak of the revolution; and, full of anti–Semitic sentiments, he made his way to Germany. He joined the Nazi Party and became editor of its newspaper in 1923. Rosenberg was the trustee for the whole spiritual and ideological education of the Nazi Party. Beginning in 1937 he had full authority to bring the art world into line. Jewish paintings and so-called degenerate paintings disappeared from German museums, private collections and dealers' galleries. Rosenberg did not seek personal financial gains from the task force and it was a constant source of irritation to him. On more than one occasion he was heard to say, "Do not ever mention the word *Einsatzstab* to me again."[1] For the most part, he tried to direct the task force from Berlin or assumed other duties in Poland and Russia. Regardless of his lack of enthusiasm, a large western headquarters was established in the Hotel Commodore in Paris. There were two commissions, the Rosenberg staff and the Jewish Commission. They worked in combination with the French and confiscated all property. The French were supposed to take half and the Germans the other half. Hitler would sometimes see a picture or something he wanted and would get it. Göring stated, "I worked to get things for a museum in Linz; also for my own collection in Carinhall."[2]

48

This painting by Jean Honore Fragonard, *Girl with a Chinese Doll*, from the Rothschild Collection, was taken along with 27 more paintings the Führer had selected from photographs for his collection. It was removed on February 8, 1941, from this group by the Reichsmarschall himself. Tracking the "missing" painting to the Göring Collection caused considerable commotion in Berlin.

In a letter to Adolf Hitler about the Linz Museum, Alfred Rosenberg closes the last paragraph with the following tribute to the aesthetic tastes of the Führer: "I shall take the liberty of giving you my Führer another 20 folders of pictures, with the hope these beautiful things of art which are nearest to your heart will send a ray of beauty and joy into your revered life."

Rosenberg's deputy director in Paris was Colonel Baron Kurt von Behr, an aristocratic German with an attractive English wife.* The baron was a major in the SS and as a

*At war's end, von Behr and his devoted wife committed a most elegant suicide, in their Berlin castle, by drinking vintage champagne mixed with poison. Shortly afterwards the American Monument, Art and Archival officer, Captain Norman T. Byrne, looted von Behr's Castle.

Vincent van Gogh's *The Bridge*, from the Rothschild Collection, is today in a private collection in Paris.

member of the German Red Cross held the title of colonel. He was so intensely vain that he always wore the uniform of the German Red Cross to reflect the higher rank and utilized his position as a stepping-stone to personal prominence in Paris and in German military circles. He initiated, directed and personally conducted the majority of the Einsatzstab Rosenberg confiscations without fear of consequences, legal pretext, or respect for ownership. Behr, although by no means directly attached to Göring, was occasionally charged with special missions for the Reichsmarschall. He was a middle-aged member of the aristocratic Mecklenburg family and utilized his position in the Einsatzstab as a stepping-stone to personal prominence in German war circles in Paris. He purchased some pictures for Göring and also was responsible for many exchanges of pictures.

The conquest of France offered unparalleled opportunities for art acquisitions. Rosenberg was charged primarily with the location, confiscation, and removal to Germany of

art collections owned by Jews or individuals opposed to Nazi ideology. His staff began in October 1940 in Paris with the seizure of the works of art of the internationally known Jewish Rothschild family. They and other Jewish families had fled prior to the German occupation. The task force not only seized the art treasure abandoned in the Rothschild palace in Paris but also systematically searched the occupied area of France for other valuables the family had left behind while escaping for their lives. The art collections of the Rothschilds were traced not only to cleverly hidden items secreted in individual castles but also to depots and warehouses. In a warehouse in Bordeaux, for example, a large collection of Rothschild art had been assembled and packed for shipment to the United States. This collection, along with many more from other French Jews, was seized in its entirety by Einsatzstab Rosenberg.

After the seizure of the most famous Jewish art collection in Paris, all abandoned dwellings, warehouses and shipping firms belonging to wealthy Jews were systematically searched by Einsatzstab Rosenberg. Very often these valuables were concealed by French gentiles. The seizures were carried out on the basis of preliminary exhaustive investigations of the address lists of the French police: Jewish handbooks, warehouse inventories, and order books of French shipping firms. The clearly established Jewish origin of individual ownership was proven in each case, in cooperation with the French police and the Gestapo. Many valuable paintings and other art treasures were found in this manner.

Whereas the confiscations were conducted by Rosenberg under authority from Hitler, the important operations of the task force were dominated by Göring in contradiction to Hitler's formal orders. Rosenberg felt he should literally carry out Hitler's orders, but he was not strong enough to oppose Göring on even terms. Additionally, Göring's command of the Luftwaffe enabled him to supply the task force with much-needed motor transport, military escort personnel, and other such needed operational support that the organization was unable to obtain from other sources.

Selected works of the confiscated art were brought to the Jeu de Paume Museum located in the corner of the Tuileries Gardens overlooking the Palace de la Concorde. Here in the central clearing exhibition building they were identified and sorted by qualified experts who were chosen for their knowledge without regard for their political sympathies. In charge of art conservation at the Jeu de Paume was Mlle. Rose Valland. She and other employees became trusted members of the German staff and remained at their posts after the Germans took over. During her work, Mlle.

Rembrandt's *Portrait of Boy with Red Cap*, from the Rothschild Collection was confiscated on May 11, 1940, from the Jeu de Paume, Paris.

Valland made intentional mistakes and encouraged other French laborers to do likewise. Mlle. Valland also made a complete file of the German personnel working there and, in defiance of her conquerors, made observations of the collection of art and determined the destination of major shipments. Several times she was threatened with arrest, but the courageous Frenchwoman remained on the job.

In late 1940, following a conference in Berlin, Dr. Robert Scholz, Rosenberg's chief advisor in art matters, went to Paris to determine the extent of Göring's interest in the material obtained by Einsatzstab Rosenberg. On arrival, Scholz was told by Kurt von Behr that Göring had received Hitler's permission to examine the collections already confiscated. Scholz received the impression that von Behr was working entirely in Göring's interest. On his return to Berlin, Scholz reported to Rosenberg that the confiscations were not consistent ideologically with the political functions of Einsatzstab Rosenberg.[3]

Göring's control of Einsatzstab Rosenberg was clearly indicated on numerous occasions. Any time von Behr received word that Göring would be in Paris, he would put his entire staff to work to arrange a special exhibition in the Jeu de Paume. Sometimes Göring would arrive in full dress, surrounded by his entourage, which included valet Robert Kropp and nurse Christa Gormanns, who kept him supplied with paracodeine pills. At other times he appeared straight from the battlefront in boots and a stained raincoat. But even on short notice, Baron von Behr could work up a superb exhibition complete with tea, champagne and potted

Of the School of Fontainebleau, *Three Graces*, from an unknown collection, was acquired for Göring by Lohse through an Einsatzstab Rosenberg exchange with art dealer Rochlitz in Paris on July 24, 1942.

This Hubert Robert, *Landscape with Figures at River*, from an unknown collection, was acquired by Hofer in Paris for Göring and contained a French customs stamp.

flowers. Von Behr prominently displayed and emphasized those objects which he believed Göring would wish to take for himself.

In November 1940, Göring visited the Jeu de Paume, where he selected 52 of the most valuable works including paintings, tapestries, handicrafts and furniture. Hitler had reviewed photographs of the collection and requested Göring to select 41 of the valuable objects for him. These selected pieces represented the most valuable works in the entire Rothschild Collection.

Göring's selections were placed in two freight cars and attached to his special train, supposedly by a mistake of the shrewd Reichsmarschall. The Rothschild jewel collection also was loaded onto this Berlin-bound train, addressed to the attention of Göring's "Personal Staff." The jewels had been seized by the German Foreign Currency Control from the Bank of France and the Credit Lyonnais in Paris on Göring's orders and taken to the Jeu de Paume.[4] Following Göring's train was a shipment of 26 carloads of extremely valuable art. The train was under tight security and included a fighter plane escort. Three months later Göring was back at Jeu de Paume and busily filled two more railroad cars with acquisitions.

Göring made over 20 trips to the Jeu de Paume from 1940 through 1942 and was seldom opposed in his choice of material for his own collection. His trips were usually hurried but, as always, he devoted much time to purchases for his collection. Dr. Hans Posse, the Linz Museum director, was reluctant to implement Hitler's order giving Göring

full authority over the disposal of the confiscated collection. At that time Posse was a sick
man with oral cancer and came infrequently to Paris.

In this trove of treasures, Walter Andres Hofer reported to the Reichsmarschall in a
September 26, 1941, letter:

> The Lange auction was in part really sensational. [A large Berlin auction house, Lange had
> established a branch in Paris.] You will meanwhile have received the catalogue with prices
> through Miss Limberger. I could only purchase for you the Grimmer appraised at 4,000
> reichsmark; the Nic. Maes went unusually high for 20,000 reichsmark. I stopped bidding
> at 25,000 since the co-bidder was a commissioner whom I knew to have a higher order.
> The very beautiful, unfortunately very Jewish looking portrait of a boy by Albert de Gelder,
> climbed to 25,000 and also the Goyen was adjudicated only at 38,000. The picture was not a
> pleasing one though too blackish in tone. The Grimmer however is a very beautiful, colorful
> picture, which is likely to gain by cleaning. But the sensation was the French picture of the
> 19th century, which brought prices hitherto unattained. And this in spite of the fact to be
> able to tell you, that the French 19th century pictures, which I recently selected for you in
> Paris, are of much higher quality.
>
> [In reference to art looted by Einsatzstab Rosenberg, Hofer continues.] From the collec-
> tion of Paul Rosenberg in Paris, I have chosen for you and reserved with Mr. von Behr: 2
> Ingres drawings, 7 pictures and 1 drawing by Corot, 1 watercolor by Daumier, 3 pictures by
> Manet, 5 by Sisley, 3 water colors by Cezanne, 4 pictures by Monet, 3 drawings and 5 by
> Renoir, 1 picture by Van Gogh, 1 picture and 2 drawings by Seurat and 1 picture by Toulouse
> Lautrec. All are of outstanding quality, and measured by the results of the Lange auction,
> exceedingly cheap and particularly suitable for exchange. Since Professor Beltrand who acts
> in Paris as our expert on appraisals, I naturally accepted the value set for export at 3,795.00
> French francs. I told Mr. von Behr that this sum will be put at his disposal through General
> Hanesse for payment from the account known to him. The remaining property from Paul
> Rosenberg, I left to the Einsatzstab Rosenberg. They are mainly degenerate art and 19th cen-
> tury pictures, not appropriate, in my opinion for exchange. From the Seligmann collection
> I had these pictures also transferred to Mr. von Behr, a number of them reserved for your
> appraisal and put aside until your next visit to Paris. These pictures of the 16th–19th cen-
> turies are partly rather interesting and suitable for your collection.
>
> The Braque collection is owned by an Aryan and he lives in Paris as a painter. His collec-
> tion in Bordeaux was placed in security by the German Foreign Currency Control and there-
> fore must by unblocked. I negotiated with Braque personally about his Cranach, *Portrait of a
> Girl*, and held out to him the prospect of an early release of his collection, if he were ready to
> sell his Cranach! He is reserving the picture for me, which he intended to never sell, and will
> notify me of his decision on my next visit to Paris.
>
> The Joseph Reitter collection is in Paris and the proprietor of this collection is reported
> to be in Holland. The German Foreign Currency Control has safeguarded this collection in
> a Parisian bank. These very important pictures of his, I have inspected. Among them is a
> Rubens, *Portrait of the Scholar Jean Woverius*, from the collection of the Duke of Arenberg,
> a beautiful *Parc Scene* by Pater and 2 further pictures by Rubens and van Dyck. I am now
> ascertaining whether the proprietor is a Jew; until then the pictures will remain in safekeep-
> ing with the bank.
>
> I have inspected the pictures of Baroness Alexandrine Rothschild, which you have not seen
> yet and which the Foreign Currency Control has safeguarded. This certainly was a sensation!
> They are 25 of the utmost quality and highest importance, among them an enchanting *Por-
> trait of the Infanta Margherita* by Velasquez [*sic*], which by all means you must acquire for
> your collection. You will never again get such an exquisite quality combined with absolute
> faultless condition. The picture constitutes a wonderful addition to your collection, in which

Velasquez [*sic*], probably the greatest painter, is not yet present. In addition, there are among others wonderful pictures by P. de Hoog, *A Head of a Child*, by van Dyke, very beautiful pictures of the French 18th century, and first rate pictures by van Gogh and Cezanne, highly welcomed as exchange pictures. The Foreign Currency Control will safeguard these pictures until you come to Paris. This collection which also comprises the voluminous collection of modern family jewels, naturally remain blocked pending your decision.[5]

The General Hanesse mentioned in Hofer's letter was General Karl Friedrich Hanesse of the Luftwaffe, who had taken over the Rothschild townhouse in the Avenue de Marigny as his official residence. There he gave magnificent receptions, for Göring among others, which attracted a number of stars from the French stage. After the war, on his return from a concentration camp, Baron Élie de Rothschild remarked to the old family butler, Félix, that the house must have been very quiet under General Hanesse's occupation. "On the contrary, Monsieur Élie. There were receptions every evening," was the reply. "But who came?" the baron asked. "The same people, Monsieur Elie," the butler told him. "The same as before the war."[6]

On June 18, 1942, Rosenberg boldly wrote Göring that it would no longer be possible for Einsatzstab Rosenberg to make available works of art for Göring's personal selection. Rosenberg thanked Göring for his personal support in supplying transportation and personnel. He stated that the professional art historians employed by Einsatzstab Rosenberg would remain at Göring's disposal for all questions of consultation and advice.[7]

On October 20, 1942, a list of 596 items from the Jeu de Paume taken by Göring was prepared by the staff of Einsatzstab Rosenberg. Photographs corresponding to 490 items on that list were, later in the summer of 1945, taken from the Göring Collection in Berchtesgaden and deposited in the Munich Collection Point.[8]

Many objects of art for the Linz Museum were purchased with money from a special art fund. The Reich postal authorities issued a special Hitler stamp with the Führer's portrait. The stamp was specially taxed and the funds obtained were used exclusively for the purchase of art. The purchases were also financed

This Cuyp, *Cocks on a Basket*, from an unknown collection, was a settlement in Paris between Hitler's staff (Joachim Ribbentrop) and Göring, as Ribbentrop made the arrangements to receive for himself a Courbet, *Forest Scene*, while Göring acquired this Cuyp. Parenthetically, Ribbentrop was obligated to secure his picture in this manner as he was not in a position to go to Göring or Hitler for such favors.

from revenues received from the publication of *Mein Kampf*, which was of course printed in the millions. Hitler had final say on the disposition of the funds but no purchases were made without Martin Bormann's express approval. After 1941, Hitler gave up all ideas for a private art collection. Everything that he bought was intended primarily for the Linz Museum and if the quality was not considered to be up to his required standard, he had reserved the leftovers to the provincial museums of greater Germany. Items acquired for the Linz Museum were displayed and stored at the Führerbau, one of the buildings in the complex headquartering the Nazi Party in Munich.

Periodically, as significant new art was acquired, leather-bound volumes of photographs were prepared by the Rosenberg staff and sent to Hitler. Over 100 volumes were prepared to acquaint Hitler with the specific objects available for potential purchase for the Linz Museum. Hitler then thumbed through the volumes and chose items as if he were ordering from a mail-order catalogue. All drafts for the Führer's reading were typed on thick paper using a special typewriter with a large type font.[9] He took extraordinary precautions to clothe all Linz transactions in the appearance of legality. Purchase requisitions were filled out and the Linz Commission paid the bills for works of art obtained from Einsatzstab Rosenberg's repositories. Hitler shied away from helping himself freely to the contents of public art collections, and the great majority of the acquisitions for the Linz Museum collection came by purchase. Most of the purchases were freely entered into and dealers often sought out Linz agents with the greatest enthusiasm.

Einsatzstab Rosenberg also removed from France valuable paintings and archival objects that had been looted by Napoleon. The largest items returned were old bronze cannons and military equipment taken in the early 1800s. The cannons seized had been taken to Paris (the late-model ones were melted down to make the Venolome columns) and along with other military items housed in French museums. The German military felt it had a sacred duty to take back any weapons and armor of Germanic origin. Also, valuables seized from Spain were returned to Generalissimo Francisco Franco, the Spanish chief of state. Valuable books, paintings and archives previously seized from Germany and Austria by Napoleon were also returned to the Reich collection.

Einsatzstab Rosenberg seized thousands of paintings, innumerable pieces of sculpture, crystal, tapestries, glass and porcelain, antique weapons, rare coins and furniture—all valued at 2.5 billion dollars, which was more than the estimated value of all the works of art in the United States in 1945. The seizures were believed to have totaled 21,903 items from 203 collections, including these: from the several Rothschild collections alone, 5,009 objets d'art; David Weill Collection, 2,687; Alphonse Kann, 1,202; Levy de Benzion, 989; and George Wildenstein, 302.[10] The complete looting of the cultural treasures of nearly all of Europe did not enhance Germany's war effort. After Germany's defeat at Stalingrad in the winter of 1942, even the most uninformed knew the tide of the war had turned in favor of the Allies. The stolen works of art were taken not only to enrich the cultural holdings of Germany, but also to satisfy the greed of a number of individual collectors.

During the early war years, only works of unassailable artistic quality were to be sent to Germany. These valuables were shipped in the special baggage cars that were normally attached to deluxe passenger trains. Thirty such cars, capable of being heated, were

obtained and escorted by Luftwaffe personnel. This valuable art was stored in Neuschwanstein Castle in Bavaria (home of the notorious "Mad King" Ludwig), Chiemsee Castle, Buxheim Monastery, Kogl Castle, Seisenegg Castle, and Nickolsburg Castle. Early in 1944, because of allied bombing, the valuables taken by Einsatzstab Rosenberg were shipped to the Steinberg salt mine at Alt Aussee and became the most important Linz depository as shipments began arriving there with increasing frequency. After arriving at their locations, the shipments were unpacked and stored in areas relatively secure from air raids fires. The packing materials were returned to Paris and other points of origin for repeated use. Each piece was recorded by Einsatzstab Rosenberg as to history, scope, and scientific and political significance.[11]

A separate branch of Einsatzstab Rosenberg was formed to loot Jewish house furnishings. This branch was formalized as the so-called M-Action and seized the contents of over 71,000 homes. The M-Action organization shipped out over 27,000 railroad cars of loot. The whole Einsatzstab organization was self-contained and administratively independent of the German armed forces. By 1943 wholesale confiscation of valuables took place under the direction of M-Action. The clearance of apartments proceeded in such a manner that everything — furniture, rugs, lamps, dishes, pictures and photographs — were hauled in one shipment to the central collection depots. Not the slightest consideration was given to the fragility of the items. Most of the pictures and glassware arrived at the

Master H.B., *Samson and Delilah*, although classified as "Unknown," came from Rochlitz, who stated he had purchased it outright from Seligmann in 1937. This *Samson and Delilah* was exchanged for a Renoir, *Reclining Nude*.

Giiovanni Battista Tiepolo's *Alexander the Great and Campaspe in Studio of Apelles*, is from an unknown collection. The young court painter, Apelles, gazes longingly at Alexander the Great's concubine, Campaspe, whose portrait he is painting. This young artist was considered the greatest of his time. The painting was returned to France and deposited in the Louvre. In 1999 it was returned to heirs of Frederico Gentile di Giuseppe and auctioned in January 2000 by Christie's. It was purchased by the J. Paul Getty Museum.

depots completely damaged, with the glass smashed. The items were heaped into piles with total disregard as to value. The household goods were packed in wooden crates and shipped to Germany to be doled out to German victims of Allied bombing.

In early 1942, additional negotiations were carried out between the German embassy and the Vichy government for items in the unoccupied area of France. Darquier de Pellepoix, the French commissioner for Jewish Affairs, met with Kurt von Behr and stated he had been authorized by the French government to sell the Schloss collection. The Henri Schloss Collection, 332 paintings by 17th century Dutch painters, was in the Vichy Zone of France.

Pellepoix stated the following conditions: the collection was not to be confiscated by the Germans following its transfer to Paris and, should the collection not be purchased by the Germans, he wanted complete assurance that it would be returned to the unoccupied zone; the collection was to be placed in the Dreyfus Bank in Paris under full French control and the Louvre had first option to purchase any part of the collection; and the collection was to be transported to Paris by the Germans.

These conditions were communicated to Göring, who was highly interested in the collection, and he authorized Lohse in his name to make to de Pellepoix the stated guar-

antees. As the collection was still in the Vichy-controlled section, the Luftwaffe could not provide transportation. Von Behr obtained a truck and a civilian escort through the auspices of a French firm. The security of the shipment through the German occupied territory was to be provided by the German SS; its participation in the transfer was simply to be that of protection. Through an apparent lack of judgment, none of the officials in the negotiations were present when the escort arrived in the town of Tulle to pick up the valuable Schloss Collection. After several hours of waiting, the party lost patience and prevailed upon the custodian of the 17 cases of paintings to relinquish them and they started out for Paris. The local French police became suspicious and overtook the truck, forcing it to halt by the roadside.

An altercation followed and one of the escorts telephoned the Gestapo headquarters in Limoges requesting help. Armed Gestapo agents arrived on the scene shortly thereafter and took the cases of art back to Limoges, where the collection was deposited in the Gestapo barracks until an order by Göring caused the return of the cases to the French authorities. The 17 cases were then placed in a bank and ultimately brought to Paris by de Pellepoix and placed in the Dreyfus Bank. However, word got out and the impression persisted in French quarters that the collection had been confiscated by the Germans.

Because the collection was spoken of as being worth fifty million francs, and because of the unfortunate events which had taken place, Göring personally insured the collection. In the meantime, Hitler, through Bormann, had ordered the collection to be acquired for his Linz Collection. The counselor of the German embassy in Paris was ordered to handle the details of the purchase. Lohse was asked by the German counselor to aid him in the acquisition of the collection for Hitler's museum. With the paintings under the jurisdiction of the German embassy, Göring's guarantee had been fulfilled. However, the 17 large cases were opened by the French Commission without any German officials present.

Several days later, after the Louvre had made its final choice from the Schloss collection, Lohse and several German art representatives visited the collection and found the paintings had already been appraised as to value by the official appraisers of the French government. The Vichy government had negotiated the purchase of the collection with the Schloss family. The agreed purchase price was 69,000,000 French francs, with the Germans furnishing 50,000,000. The Louvre purchased some of the 332 paintings; 262 were taken to the Jeu de Paume and subsequently sent to the repository for the Linz Museum. Hitler learned of this transaction after it had taken place and his resentment at not having had the opportunity to obtain the best paintings became well known. He would have been more furious had he known that the Vichy government took the German payment but never paid the Schloss family a cent for the paintings.[12]

A few of the "degenerate" Schloss paintings were sold to German dealers. Einsatzstab Rosenberg acquiring two small portraits through the unflappable Mrs. Dietrich. At the time of the sale the two small paintings, which were in poor condition, were believed by the experts to be copies. Under better lighting Lohse became convinced the Rembrandt was actually genuine and the "copy" of Franz Hals was probably a work of Judith Loyster. When Göring visited Paris, Lohse showed Hofer the two small portraits and tried to convince Hofer they were genuine. After Hofer declined, Lohse asked Mrs. Dietrich to pur-

chase the two paintings and, after cleaning them, to sell them to Göring and if this did not happen to sell them to Hitler for his Linz Museum. When word got out, to save face Rosenberg acquired the two Schloss paintings from Dietrich. As late as May 8, 1944, less than a month from the Allied invasion of France, she purchased in Paris a Watteau landscape from the Einsatzstab for three million francs.[13]

Michelangelo's famous statue *Madonna and Child*, from Bruges, was another masterpiece destined to be sent into Germany's interior. The marble statue was carved by Michelangelo in 1501, when he was only 26 years old, and was purchased from him by the brothers of Bruges, who presented it to the church of Notre Dame. In the early days of World War II, the statue had been removed from its traditional place in the chapel to a specially built shelter in another part of the church. The Germans, with a heavily armed crew, loaded the statue and 11 paintings belonging to Notre Dame into two Red Cross trucks and disappeared into fortress Germany, which now housed the most outstanding artwork in the world.

The Edouard, Maurice, and Robert de Rothschild collection of art had been seized by Einsatzstab Rosenberg from the five vaults along with 20 cases of jewelry. These were regarded as the most valuable private art collection in France. A memorandum regarding this confiscation stated that in view of the large number and heavy packing of the objects a detailed inventory and the drawing up of a list were waived. Following a superficial inspection, the packed objects were removed by Einsatzstab Rosenberg.[14] Along with the art was modern and antique jewelry and a silver collection. On Göring's orders, this collection was taken over by the Foreign Currency Control, which sent the complete jewelry collection to Göring's personal staff. It was signed for by Miss Limberger. The jewelry was contained in leather cases especially designed for the individual pieces divided among the members of the family — Robert, Maurice, Edouard, etc. The total number of cases was approximately twenty.

The jewelry was appraised by a representative of the official German Gold and Art Section and the appraisal list was sent to Göring. He discussed the Rothschild jewelry collection with the Führer and the two decided to divide the collection in two equal parts (or five equal portions) and sell one-half to the Führer's jeweler and the other to the jeweler of Göring's choice. (The documentation is a bit confusing.) The total collection was divided into five equal portions and two of these shares were bought respectively by Dr. Kurt Hermann, 67 Unter den Linden, Berlin, and Professor Herbert Zeitner, 33 Hardenbergstrasse, Berlin. (This was the same Kurt Hermann who Göring had protected from tax evasion in 1935 and who since that time had made substantial contributions to Göring as well as to Hitler. Zeitner made silver frames and repaired silver and gold cups, candelabras, etc., for Göring.) Then, according to Miss Limberger, the other three shares were sold to Kurt Hermann. This seems to be affirmed by a letter from Hermann: "I beg to communicate with you, that I have taken these three jewels [diamond brooches] according to your suggestion at a total price of 151,075 reichsmarks. As was done for the jewelry we had previously taken over, I have assigned the sum to the Main Reich Bank in the form of a check."[15] This collection of 20 cases of jewels included such famous pieces as a collar containing three Giaconda diamonds, a tiara for a Hindu headpiece, and an emerald collar presented by Napoleon to the Austrian archduchess.[16]

8

Art Dealers in France

The Paris art market was by far the most active in Europe. It set in place the enormous inflation in prices that took place during the war years. German buyers came to Paris by the hundreds. There was nothing to hold them back. Armed with paper invasion money which cost their country nothing, they had a twenty-to-one advantage over the franc and the reassuring knowledge that no matter what they were paying in France, they could usually make 100 percent profit at home. Much of the art was sold in German auctions, where even art condemned by the regime as degenerate was sold at extravagant prices.

Almost all the French dealers sold to the Germans. It was hard to resist the temptation to fleece the arrogant Teutonic invaders. Added to the established dealers came a flock of intermediaries and middlemen to guide the Germans. They all worked together and the same pieces of art turned up at different places at different times with a higher price. The most important of these groups was headed by Hans Wendland and Paris art dealer Yves Perdoux. They all had connections to Hermann Göring, through Wendland and Hofer, as Wendland represented Göring in the Greater Reich and Perdoux with his contacts throughout France. They were all equally unscrupulous and they must have dealt in the millions.[1]

The wise dealer and collector avoided giving any bill of sale or receipt for the legitimate purchase of objets d'art by German customers. Many of the owners frankly stated that they expected to get their artistic possessions back after the war. They would declare the property stolen and based on historic principal the Allies would return the property to the original owner regardless of the circumstances in which it was obtained.[2]

Göring's trips to the Jeu de Paume have already been discussed. In addition, he made occasional visits to an art dealer's shop, but usually he received the dealer, with their items, in his Paris office. He was represented in Paris by Hofer, Bornheim, Lohse, Angerer and Dr. Joseph Muehlmann, who made regular trips to Paris and stayed as long as two or three months at a time. Göring's purchasing activity was enormous, as validated by the Carinhall shipping tickets in the files of Schenker Transportation Company. Wendland was most active in Paris, capitalizing upon his German citizenship in a land occupied by Germans and upon his wide prewar acquaintance with those in the Paris art market,

Wendland became a kind of advisor and guide to many of the French dealers anxious to do business with Germans. He gradually formed an informal syndicate of the French dealers Boitel, Perdoux, and Loebl. He was connected with the Dequoy-Fabinai combination, and he is known to have had interests in the Mandl-Birtschanksy art association. Just how formalized were these dealing syndicates formed by or participated in by Wendland is difficult to ascertain. The following is a discussion of some of the more interesting transactions of the many French dealers that sold art to Göring's purchasing agents.

Purchased in 1943 by Hofer from *Achillo Boitel, 6 rue de Teheran, Paris*, Lucas Cranach's *Portrait of a Young Woman* was first offered to Hofer by Perdoux, Allen Loebl and Wendland for 600,000 French francs. The painting was supposedly in the hands of a restorer in Versailles. Therefore Hofer reserved it. A year later Lohse offered this Cranach to Göring, as coming from Loebl, for a price of 3,500,000 francs. Göring protested the price but carried the painting back to Berlin. The provenance of the painting was given by Loebl as a French collection in Versailles which Hofer had formerly visited. After a lapse of time the dealer Boitel was revealed as the original owner and an agreement was reached at 50,000 Swiss francs, which was paid secretly through Göring's personal staff because Boitel did not want trouble with the Current Control Authority. The payment was sent in cash by Hofer with these instructions; "Please destroy this letter immediately and give me a receipt on my next visit to Paris."[3]

Boitel was the chief financial figure in the French collaborationist art market. He was a kind of black-market banker and money changer and was used extensively by Wendland for currency manipulations, picture storage, and cover for veiled transactions. He was a wealthy Frenchman and owner of an airplane engine factory that also made trunks and wooden cases, which he supplied to the German military. He was an out-and-out collaborationist, had been born in Germany and spoke the language fluently. The Resistance often threatened him and finally killed him with a bomb connected to the starter of his automobile.

The dealer *Brimo, Laroussilhe de la, 58 rue Jeuffroy, Paris*, specialized in tapestries and objets d'art of the Middle Ages but would sell any type of object. Bornheim was one of his principal clients and visited him on every trip to Paris. Brimo brought his objects to the Grand Hotel and acted as Bornheim's guide through unoccupied France in 1941. He sold for cash and preferred not to give a receipt. Bornheim purchased many items from Brimo, but one of interest was the French 16th century *Figure of a Man with a Hawk*, presented to Göring as a gift from the Luftwaffe.

At the *Gallery Charpentier, Paris*, in March 1941, Dr. Joseph Muehlmann organized an exposition for the special benefit of Göring. The idea was a complete success, as the Reichsmarschall bought everything that was shown. What catches the eye with this sale was the purchase of a most valuable tapestry (Flemish, 16th c.), *Scenes from the Life of Emperor Charles V*, for 2,500,000 francs as well as the following paintings, all by Flemish masters: *Adoration of the Magi* (90 × 68), *Circumcision of Christ* (91.5 × 30), *Nativity of Christ* (91.5 × 30).

Maison Deçour, 28 rue François Ier, Paris, worked through Bornheim and dealt with him only. This dealer had a big architect and interior decorating office, to which his art dealing was an adjunct. During the last years of the war, he was frequently visited by

many German architects who came to Paris buying for Albert Speer and Joseph Goebbels. Bornheim purchased Fragonard's *The Bagatelle Ceiling* for 1,200,000 francs. The painting was reported in January 1945 to be in the free port of Stockholm. Hofer stated he last saw the *Ceiling* in the Ringenwalde country house in December 1944. The 18th century house was situated about 12 miles from Carinhall. Upon further questioning, Hofer and Miss Limberger said they believed the art was still in the Ringewalde and it would have been almost impossible for it to have been sent away without their knowledge.

Roger Dequoy was with the *Wildenstein Gallery, 57 rue de la Boétie, Paris*. Karl Haberstock first visited Paris in October 1940 in the company of Hans Posse. At this time Haberstock called on all his old friends among the Parisian dealers to discuss with them the purchase of important pictures for the Linz Museum. On this trip Haberstock visited the Wildenstein Gallery, with which he had done extensive business during the prewar years. Here he found in charge of the gallery Roger Dequoy, whom he knew quite well. Dequoy, who had just arrived from the United States, explained that George Wildenstein had taken refuge in Aix-en-Provence, France, about 300 miles south of Paris while awaiting passage to the United States. Dequoy further told Haberstock that the pictures of the firm were stored there and were in danger of being confiscated under the German decree to seize all Jewish property and he was most anxious to pay a visit to the unoccupied zone of France to have a talk with Wildenstein before he left.

Haberstock, who was keen to do business, took it upon himself to arrange this trip and in November 1940, he and Dequoy paid a visit to Aix, where they spent four or five days in the Hotel du Roy Rene and met with Wildenstein. Dequoy stated that Wildenstein was very eager to do business and proposed to Haberstock that in exchange for Impressionist pictures from Germany he would give a Tiepolo and various other paintings from his inventory. The Tiepolo was said to be unsalable in the U.S., whereas the Impressionists would bring high prices. Wildenstein discussed the possibility of moving his pictures out of the Château de Sourches so that Dequoy could keep the gallery open. They agreed that Haberstock would have the first option on obtaining pictures from the collection.

They discussed the future of the paper *Gazette des Beaux Arts*, Wildenstein being anxious that it would continue to be published. He stated that it cost him annually 50,000 French francs for publications. Haberstock told him a German friend, Mr. Breuer, editor of *Die Weltkunst*, would take over the publication. Wildenstein authorized Dequoy and Haberstock to make the necessary arrangements, which they did. At this meeting Wildenstein gave Dequoy full "authority to deal with his collection and to sell anything to the Germans and in particularly to Haberstock and make it his business to discover important collections or single works of art in France which the Germans would be interested in acquiring."[4]

Both parties were apparently greatly satisfied by the results of this meeting, and directly after the return to Paris Haberstock began to think of ways and means of arranging the removal of the Wildenstein collection from the threat of Einsatzstab Rosenberg. Details of what happened in the next few months are not quite clear but it appears that through the joint efforts of Haberstock and Dequoy in April 1941 the collection was Aryanized in Dequoy's name. The paintings were trucked on May 14, 1941— accompanied by two representatives of Haberstock, Baron von Poelinitz and Hugo Enge — from Wildenstein's

Château de Sourches to Dequoy in the *Wildenstein Gallery at 57 rue de la Boétie, Paris*—
just in time, as the Einsatzstab Rosenberg had scheduled to seize the paintings the follow-
ing day.

Einsatzstab Rosenberg officials telephoned Göring immediately in Berlin and
informed him of the movement of the paintings, hoping that the Reichsmarschall would
intervene and prevent the transfer that was in violation of Germany's rights over Jewish
property. Göring's reaction was to say that if the collection was Jewish then it belonged
to Einsatzstab Rosenberg, but that if it was Aryanized then it belonged of course to the
new owner. Haberstock had indeed done Wildenstein a great favor. During this activity,
the Wildenstein family had successfully moved to New York.

Haberstock informed Göring that by arrangement with Dr. Hans Posse the collection
was reserved for themselves and it was not to be offered or sold to anyone else, but that
of course anything not wanted by the Führer would be offered to Göring. According to
Haberstock when he actually saw the pictures which came from Château de Sourches, he
was so appalled by the poor condition that he only purchased seven of them.

Once Dequoy was reestablished he dropped the name Wildenstein from the gallery
and substituted his own. Then in 1942 further difficulties arose, as the German authorities
were anxious to requisition the gallery for a German who wished to open an art shop at
the same location. Again Posse and Haberstock were called to the rescue. On March 10,
1942, Dequoy wrote Haberstock:

> You already know that I am taking a lot of trouble to give you satisfaction to procure good
> pictures for you and for the museums of the Reich. So it is essential that I should keep the
> house just as it is, for thereby I have benefit of a long past, a solid reputation, a proper
> organization and more possibility of having offers made than anyone else in Paris. To this
> must be added my own ability, and I would make the maximum effort if I am allowed to stay
> where I am. You realize what a pity to say the least it would be if all your efforts on behalf of
> myself and the firm were to be wasted owing to a misunderstanding which would be of no
> profit to anyone.[5]

Through their intervention the danger was avoided and Dequoy remained at 57 rue de
la Boétie.

In business with a small stock, he set to work looking for additional art inventory.
His wish to procure good paintings was soon gratified, as he was an intermediary with
several wealthy wine merchants. Through this relationship he sold two Rembrandts to
Haberstock for the Linz Museum for 60,000,000 francs. Dequoy's commission was
1,800,000 francs. Dequoy was perhaps the worst of the collaborationists among the Paris
dealers. He sold large quantities to the big German dealers and museums. Göring pur-
chased several paintings from Dequoy, including the following: Lemoyne, *Bathing Women*
(161 × 119); Moor Antonis, *Portrait of a Man* (50 × 39); Cotter de Coolin, *Dolorous Maria*
(54 × 35).

Raoul, Vicomte, 44 rue du Bac, Paris, was an amateur dealer who sold from his
apartment. He had an elaborate setting on which he presented his wares, stressing the
fact that they were family heirlooms. His clients were always served champagne, even in
the mornings, his primary client being Bornheim. Vicomte was associated with deal-
ers of the Clignancourt flea market. In this clandestine sale of objects, many items

arrived in the Clignancourt from Einsatzstab Rosenberg, placed there by Baron von Behr.

Geladakis, 1 rue Milton, Paris, specialized in Greek, Roman, Egyptian and Medieval sculpture. Göring's collection contained the following sculpture acquired from Geladakis, including the two (later-established) forgeries:

Burgund	*St. George with Dragon in Hand*
German 15th c.	*Madonna* (× 110)
Dutch 15th c.	*St. John* (× 122)
Dutch 15th c.	*Madonna* (× 116)
French 16th c. forgery	*St. George* (× 118)
French 15th c.	*St. Barbara with Book* (× 102)
French 14th c.	*Sitting Madonna with Child* (× 91)
French 15th c. forgery	*St. Michael* (× 140)

Leonnardi, Edouard, 8 Avenue de Friedland, Paris, was an architect by profession and his wife ran the art establishment. They specialized in the Middle Ages and worked on commission for several French dealers. Of the six sculptures purchased by Hofer, three were later established to be forgeries:

French 15th c. forgery	*St. Martin with Begger* (× 75)
Swiss c. 1500 forgery	*Female St.* (× 91)
French 16th c. forgery	*Architect* (× 113)
French 16th c.	*Angel* (× 110)
French 14th c.	*Part of Madonna*
French 14th c.	*Madonna*

Allen Loebl, a French Jew, had been employed for a number of years by the art shop of *Kleinberger at 9 rue de l'Echelle, Paris*. After occupation the firm was Aryanized with the name of Gallery Garin, but Allen Loebl became in fact the firm's manager. He was protected from the anti–Semitic laws on the recommendation of Lohse in obtaining special privileges for him. In gratitude for this Loebl wanted to give Göring his extensive library, but the gift was partially refused, as it was exchanged to Einsatzstab Rosenberg for a confiscated painting.

Hofer and Lohse both agreed that the Gallery Garin was the most popular meeting place in the collaborationist Paris art market. It was also the meeting place of the informal agent syndicate of Wendland, Perdoux, Boitel, Loebl and most of the German buyers. The correspondence sent by the gallery to its clients was written in German. Loebl's business was done mostly on a commission basis. He was considered to be the one to approach when a German was purchasing an expensive work of art and wanted to conceal their identity: Loebl was one of the outstanding collaborationists in Paris during the war.

Hofer purchased many items from the Gallery Garin. Salmom van Ruysdael's *River Landscape*, signed and dated 1647, was purchased in 1944 on Hofer's last trip to Paris. He stated that although the price was 900,000 French francs he could receive double that price in Berlin without any difficulty. J.F. de Troy, *Portrait of a Lady*, was purchased as a present to Göring from Gauleiter Franz Schwede-Coburg, who was so closely identified

François de Troy, *Portrait of Mme. Titon de Coigny*, was from the Loebl Gallery and in 1941 was presented to Göring as a birthday gift from Gauleiter Schwede-Coburg.

with the Nazi movement as mayor of Coburg that in 1935 he added the name of the city to his own name.

Judith Leyster, *Mandolin Player*, was a gift from General Director Rudolf Stahl, who had won a gold medal on the men's handball team in the 1936 Olympus. Other items included the West German School *The Holy Family*; Franco-Flemish, *Lucretia*, a bone carving; and David Temiers, *Country Fair*, a gift from Friederick Flick, who was the director of United Steel Works, the largest steel producing firm in Germany. Flick maintained a close relation with Göring and Heinrich Himmler.

There was also Bernard van Orley's tapestry *The Hunt*; the School of Bernard van Orley *Portrait of a Young Woman*; the School of Rubens *Nymphs in a Landscape*; Bellevoir's *Seascape*; the French, ca. 1520, *Portrait of a Boy*; the German 18th c. *Bivouac Scene*; two van Osten *Landscapes*; and a French 14th c. stone, *Figure of an Apostle*. The *Holy Family* and *Lucretia* were purchased in the last days of 1943. In the course of the war Lohse was obliged to leave Paris, as the American army was advancing into France. As a result, he was unable to pay the 280,000 francs for the two paintings.

Regarding Loebl there is the following distressing letter: "Dr. Bruno Lohse: I hereby request an order stating that I am permitted to arrange for two Jews, the brothers Loebl, to be placed by the Gestapo at my disposal for further work. [Signed] Lohse." Below on this letter is a note written in ink by Miss Limberger: "Submitted to the Reichsmarschall: Lohse is to make sure that he handles this question so that the Reichsmarschall's name shall not be connected with Jews. If he is successful in doing this, the matter is to be carried out undercover."[6]

Gouvert, Paul, 18 rue Foureroy, Paris, specialized in stone statuary of all periods. A connoisseur whose prices were high and who would not bargain, he was consulted as an expert by the Louvre and sold a large numbers of objects to the Germans. Angerer was one of his best clients. Göring himself visited the shop and Hofer and Angerer purchased a number of decorative garden sculptures. A group of these objects arrived in Carinhall on October 1, 1941. Included were also architectural elements such as windows, doors, benches, fountains, and the like. At the time of delivery, Angerer presented Göring's personal staff a bill for 130,000 reichsmarks for the balance of the account.

Mandl, Victor, 9 rue du Boccador, Paris, was a German dealer, formerly active in Germany, who was related to the Hamburg firm with the same name. In Paris he did business from his apartment. He bought mostly from small dealers and from customers in the hotel Drouot. He did not have much money at his disposal and in some ways was helped in financial matters by Wendland. At one time Mandl wanted to co-buy a small Rembrandt with Hofer, who refused because he did not find the painting attractive. Mandl was used as a middleman for many French people and never revealed the provenance of his paintings. Hofer purchased the following paintings from him: Adrian van der Werff, *Venus*; Vernet, *View of a Harbor with Bathing Women*.

F. Nestrallet, 22 Avenue Matignon, Paris, worked with Lohse, who introduced him to Hofer in 1944. Nestrallet was a small dealer who specialized in Dutch 17th century paintings. He did not want it known that he had dealings with the Germans and usually worked through a middle man such as Loebl. He generally gave no receipts. Lohse purchased the following paintings from him: Salomon van Ruysdael, *River Landscape*; Roeland Savery, *Biblican Scene Noah's Ark*; and Jodocus de Memper, *Mountain landscape*.

Perdoux, Yves, 6 rue du Teheran, Paris, worked with the firm of Goynot, which, according to Hofer, Perdoux took over. Known for his extensive contacts in the French provinces, he was said to have been involved in a number of shady deals and his reputation was one of the worst among the Paris dealers. Nevertheless, Hofer purchased several works of art, including Jan Broughel and Jan van Balon, *Landscape with Bathing Nymphs*, for 850,000 francs.

In February 1941, Lohse was told by Birtschansky that *Rochlitz Gustav of Paris* had

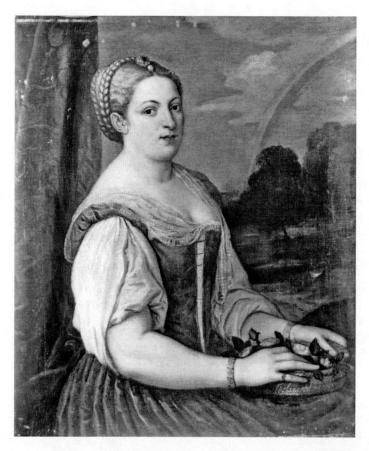

From the workshop of Titian, *Lavinia Lady's Portrait Before Rainbow* (Rochlitz Gallery) is a modern portrait of Titian's daughter taken by Göring from the Jeu de Paume, Paris, on August 14, 1941. Rochlitz stated the paintings came originally from a German collection and were auctioned by Christie's in London before the war.

a Titian, *Man with a Beard*, at his gallery. Lohse proposed an exchange of the Titian for paintings which, according to German conception, were out of the question for transfer to Germany. On February 17, Rochlitz visited the Jeu de Paume and chose eleven modern and impressionist paintings which he wished to receive as payment. But difficulties had arisen. Birtschansky, who held the major interest in the Titian, demanded cash payment, preferably in American dollars, rather than payment in pictures. Perhaps, too, he balked at the risk involved in receiving confiscated art. The entrance of Wendland into this affair at this moment of impasse was, therefore, providential for the Nazis. Without seeing the Titian (which at that time was probably at the Jeu de Paume for Göring's inspection) Wendland agreed to buy Birtschansky's share (for 12,000 dollars) and to receive, upon consummation of the exchange, six of the eleven modern pictures. These pictures were delivered to Wendland in Paris. They were as follows:

> Corot, *Mother and Child* (Rosenberg-Bernstein Collection)
> Degas, *Madame Camus at the Piano* (Kann Collection)
> Braque, *Still Life* (Kann Collection)
> Matisse, *Women, At a Table* (Rosenberg-Bernstein Collection)

The exchange occurred March 3, 1941, without Wendland ever seeing the Titian. The others five paintings went to Rochlitz as a commission. Wendland never did paid Birtschansky the full amount promised in American dollars but at some later date made a settlement of the unpaid balance in terms of French francs. Two years later, while visiting at the Berlin apartment of Hofer, Wendland was asked to admire a Titian. "That Titian

is not authentic," Wendland said. "Where did you get it?" Hofer responded that it came from Rochlitz. "Good God!" Wendland exclaimed, purportedly overcome by the belated realization of the role he had been playing. "Then the Titian was intended for Göring and the modern paintings must have been confiscated works of art!"[7] The following were also acquired from Rochlitz:

Valkenbrough	*The Constantine Battle* (135 × 267)
Cantena	*Portrait of a Man* (66 × 44)
School of Fontainebleau	*Venus Reposing* (101 × 158)
School of Fontainebleau	*Venus and Adonis* (132 × 107.5)
Workshop of Titian	*Lavinia Lady's Portrait before Rainbow*
Ziegler	*Joachin and Ann under Golden Gate*
Sassetta	*Madonna and Child* (50 × 37)
Savery	*Paradise with Noah's Ark* (83 × 137)

Schmidt, Jean, 22 rue de Charonne, Paris, owned one of the largest interior decoration concerns in Paris, of which the antique dealing department was an important part. He was more of a speculator than an art expert. During the war he worked with many German buyers. With some difficulty, Bornheim purchased Rubens, *Venus and Adonis,* from him. On his first trip to Paris, Bornheim did not have enough money to buy the painting and asked Schmidt to reserve it for Göring. During his absence Haberstock saw the painting and, on being told it was not for sale, forcibly removed it, by two members of the Gestapo, in the name of the Führer. On being informed of this by Bornheim, Göring became furious and after an investigation obtained the painting for himself.[8]

The following were acquired from Schmit:

Beaubrun, Charles	*Madame de Montespan as Diana*
Reubens School	*Venus and Adonis* (203 × 240)
French c. 1600	*The Temptation* (73 × 98)
School of Fontainebleau	*Venus with Two Putti* (33 × 35)
Master of Burgundy 1480	*St. George and the Dragoon* (69 × 74)
Mieris	*Sleeping Woman* (28.5 × 23)
Burgundy	*St. Genivene* (× 96)

Dr. Hermann Bunjes, the director of the German Fine Arts Institute in Paris, began as a member of the German government in Paris. As director he was in charge of photographing French historical monuments and he compiled two volumes of a series devoted to this subject. Göring received a copy of them. As a result of this book, Bunjes caught the attention of Göring and became his liaison with the French government.

Bunjes obtained for Göring copies of well-known French monuments by the bronze casting firm Rudier. Among these reproductions were the *Diana* of Fontainebleau, the *Diana* of Anet, and several Rodins, including *The Gates of Hell.* Bunjes had something to do with the removal from the Louvre of a marble copy of *Nike of Samothrace* which was presented to Göring by the Luftwaffe. He also had a standing order from Göring to supply his library with books on art. Miss Limberger reported that a large shipment arrived in Berlin and Göring found them boring, so he shipped the books back to Paris.

Even before the war, Göring had expressed a desire to possess the *Belle Allemande* (Mary Magdalene), a work of art owned by the Louvre:

> I was very much interested in two art objects that were at the time in French museums and one was the *Belle Allemande* which means, the beautiful German woman, which was a wooden statue. The other was the Altar of Basle. One was in the museum of Clungy and the other was in the Louvre. The altar dated from the 12th century and was a masterpiece of German art. I had never seen it before, but of course I was familiar with all literature and history concerning this object and had a special interest in it. I remember that I was in the inner room and the *Belle Allemande* altar was outside. I was very annoyed that after long negotiations the exchange would not be accepted. I left in rage and returned to my room upstairs but as soon as I got up there I thought what a shame that in my excitement I had not even looked at the altar. Then I returned to the downstairs room and looked at it shortly.[9]

Göring was successful with the wooden statue also known as the *Figure of St. Magdalene*, which was particularly suited to his taste, being German and nude and carved in the 16th century by Gregor Erhart, out of lime wood. Göring told Hofer that the French had promised him the statue as a present, but in his desire to be fair he refused to accept the offer unless he could give something in payment. Regarding an exchange for the statue in a January 1944 letter to Bunjes, Hofer writes: "I am sure you will join in my opinion that these suggestions present a really generous offer on our part…. Especially the fact that two beautiful sculptures will be exchanged for the *Belle Allemande* which had already formerly been offered to the Reichsmarschall as a gift, should be considered as a most obliging act on the Reichsmarschall's part."[10]

Thus the preliminary details for an exchange of objets d'art began with photographs of the objects to be given by Göring being sent from Berlin to Paris. The exchange items between the Louvre and Göring were, from the Louvre, Gregor Erhart, *Figure of St. Magdalene*, and Master of the Holy Kinship,

Gregor Erhardt, *Belle Allemande* from the Louvre. The most outstanding piece of sculpture acquired by the Reichsmarschall was this life size, nude, lime wood statue of Magdalene. Erhardt carved the masterpiece about 1510 and it decorated a church in Augsburg for centuries. Offered for sale on the German art market, it was purchased by the Louvre in 1902. When the statue was recovered by the Allies in Berchtesgaden she had two broken fingers.

This painting by Master the Holy Kinship of the Cologne School of the 15th century contains three panels. The left represents *Christ Appearing to Mary*, the center *Presentation in the Temple*, and the right *Adoration of the Magi*. During its travels the center panel developed a noticeable crack. The painting was acquired by the Louvre. Upon its recovery, the frame was broken and a missing part had been added.

Presentation of Christ in the Temple, and, from Göring, two statues and three paintings: Charles Coypel, *Open Air Theater*, from the Rothschild Collection; School of Hans von Kulmbach, *The Betrothal of St. Catherine*, purchased from the Dutch dealer Hoogendijk, and a School of Danube, ca. 1530. When an agreement was arrived at, the objects were sent from Berlin to Paris on Göring's special train and handed over to Bunjes. The Austrian ca. 1450 statue, *Saint George and the Dragon*, and the Coypel painting arrived at the Louvre on March 15, 1944, and the Nuremberg School statue *Madonna and Child* arrived there on March 31, 1944. The exchange transaction became final when it was published in the French *Journal Officiel*.

Bunjes had organized all of the arrangements for a general exchange between the Louvre and Germany after the war, to include such masterpieces as Watteau, *Enseigne de Guersaint*. By this arrangement the French were to receive well-known works of art that had been held in Germany for many years and the Germans would receive the equivalent from France. The final disposition in this matter was prevented by events in the war beyond the responsibility of Bunjes, Hofer and the art officials at the Louvre as U.S. troops liberated Paris on August 19, 1944.

9

The Art Market in Holland

After France, Holland was the most important source of acquisitions for the Göring Collection. If confiscations were set aside and a comparison is made on the basis of "legal" purchases only, then Holland represents the most important source of all. Göring was well aware of the richness of the Dutch art market. That he did not wish to miss any of the chances afforded by the occupation is evidenced by the fact that he sent Hofer on his first trip on May 20, 1940, five days after the surrender. Göring himself followed a week or so later. As will be seen, he acquired almost all his most important works during these first visits in the spring and autumn of 1940. From this time on, he frequently went to Holland, traveling in his special train or by plane. He liked Holland and had friends there. The principal of those friends was General (of the Luftwaffe) Christiansen, commander in chief of the military government in Holland and a friend from the last war and who had belonged to the same group as Göring and Ernst Udet. Another friend was Director Seekatz, a school friend of Göring and the director of the Fokker Works. Seekatz acted as the Reichsmarschall's *homme de confidante* and business intermediary, taking over the Hotel Astoria in Amsterdam when this was necessary, arranging entertainments, and even on one occasion bringing a group of pictures for sale. These were said to have been found deposited in the warehouses of de Gruyter, the shipping company, and were later discovered by Hofer to be, in large part, fakes.

The Dutch art market, which had come to an almost complete standstill in 1938 and 1939 because of the war scare, was revived by the German occupation and gradually reached an almost unheard of development. This was due chiefly to the large number of Germans with unlimited supplies of money who visited the country in search of works of art. The opportunities to purchase were unlimited, whether from dealers or private collectors. Göring and his henchmen took full advantage of those opportunities.[1]

The situation in Holland was different from France in other respects as well. Important Jewish collections did not exist to the same extent. Most of the outstanding dealers remained in spite of the German occupation and dealt directly with the invaders. The middleman played a much less important role than in Paris. There were of course Dutchmen who wanted to sell to the Germans without this being known to their compatriots, but they did this through comparatively secondary figures in the art market.

72

Collaborationist circles, both professional and amateur, seem to have centered on Max Freidlände, the well-known German art historian and specialist in early Flemish painting who was formerly of the Kaiser Friedrich Museum, Berlin. In spite of his being a Jew and a refugee, he was treated with care and respect by the Germans. He wrote expertly for both the Dutch and the Germans, and he sometimes gave the latter tips about the location of interesting pictures. His chief confidant and helper was Vitale Bloch, a Polish or Russian Jew and formerly an art dealer in Berlin and London. Freidlände arrived in Holland shortly before the war and was protected against the anti–Semitic laws by the official representatives of the Führer Collection for Linz. In exchange he gave them right of first refusal for anything he found on the market in Holland. Both remained in close contact with art dealer Walter Paech.[2]

Confiscations were not carried out by Einsatzstab Rosenberg, as they were in Paris. The representative of Enemy Property Control in Holland was Schmidt-Staehler and he concentrated on the political program and general property seizure, with no particular emphasis on art. The Foreign Currency Administration played a secondary role. First choice of the seizure of art which came under the control of Enemy Property Control went to Kajetan Muehlmann's Art Bureau, which sold the objects to Hitler, Göring and other German museums. What was left over was auctioned off by The Hague, Amsterdam, Lange in Berlin, and Austrian citizen Adolf Weinmüller, who had established an auction house in Munich and received thousands of items, including trainloads of paintings, Chinese flasks, Ming bottles, furniture, etc.[3]

Muelhmann had arrived in his SS uniform on May 15, 1940, while Rotterdam was still burning from the German bombing. His greatest achievement for the Third Reich in Holland was the acquisition in its entirety of the Fritz Mannheimer Collection, one of the most important private collections in Europe. Mannheimer had borrowed a considerable amount of money from the Mendelssohn Bank in Amsterdam and after his death the loan was in arrears. His collection had been used as collateral and the bankers offered the collection to satisfy the loan agreement. These proceedings had begun before the invasion of Germany. Muehlmann, taking advantage of this turmoil, bought this collection for the Führermuseum (an unrealized complex planned to be built in Linz, Austria) for a staggering total of 6,000,000 guilders. With the aid of a special directive obtained by Posse from Martin Bormann, which effectively blocked all competition, the major portion of the collection was purchased in Holland in 1941. A smaller portion had been moved from Paris to Vichy, the unoccupied section of France, by Mannheimer's widow just prior to the occupation of France; a few remaining items were kept in their large country house at Vaucresson, just outside of Paris. In May 1944, the remaining art objects of the collection were seized by the Germans in Paris and shipped directly to Alt Aussee.[4]

Göring was represented in Holland by Hofer, who had many contacts of his own, made in the 1920s when he had been an employee of his brother-in-law in The Hague. During Hofer's absence from Holland, he was unofficially represented by his friend and business partner Walter Paech. Lohse only came to Holland occasionally on special missions from Paris. Hofer's official representatives were Miedl and Muehlmann. The most important member of the Art Bureau, for the development of the Göring Collection, was Eduard Plietzsch.

Plietzsch, deaf and using an earphone, was the prototype of a thin German with impeccable manners, a love for art, and no feeling of guilt in dealing with confiscated art objects. As an art expert he joined Muehlmann's staff in Holland from Berlin. He received 15 percent from the paintings that he recommended and a thousand reichsmarks a month for living expenses. In September 1940, Plietzsch presented to Muehlmann an elaborate report analyzing the Dutch market that gave an insight into the thoroughness with which the Germans approached the purchase of works of art even during this early period. As the war ended, Plietzsch was shrewd enough to burn all of his correspondence in his cellar.[5]

The most active agent in Holland was Alois Miedl, a banker and speculator from Munich who had moved to Holland with his family in 1932. He had known Göring for a number of years through Göring's sister. Although in every sense an independent businessman in Amsterdam, he was nevertheless closely bound to Göring; and for all practical purposes he was a member of Göring's personal staff for all matters in art. He was always ready to serve the Reichsmarschall in any one of a number of capacities having to do with business or the collection of art. Miedl was most active in Holland and Belgium on Göring's account. Göring's hold on Miedl comes from the fact that he protected Miedl's Jewish wife and from the tremendous advantage which Miedl derived from such an association. Göring was well aware of this and missed no opportunity which could be gained from the situation. Miedl paid, and paid heavily, for Göring's shielding of his wife. The Goudstikker deal, the purchase of six Impressionist pictures from the Göring Collection, and the Vermeer exchange all bear witness to this arrangement. Miedl also obtained some very tangible advantages, among them his release from jail and, last but not least, help in organizing his flight, with his family and his assets, to Spain, a neutral country.[6]

10

Art Dealers in Holland

This chapter is a list of art dealers in Holland during the Third Reich.

Gelder, Smit van, Avenue de Belique. This Dutch man, a wealthy paper mill owner, resided in Belgium; the rest of his family lived in Holland. In 1940 he came on his own accord to Muehlmann's Art Bureau offering to sell paintings from his own collection and asking for help in obtaining an exit visa for Belgium. He obtained the visa, and about 15 paintings were selected from his collection. From that time on, he was a regular visitor to the Art Bureau. He was eager for publicity and always insisted that Hitler and Göring know that he was selling them his paintings.

Gutmann, Fritz, 501 Heerengracht, Amsterdam. A German resident in Holland, well-known banker with the Dresdener Bank, Gutmann wanted to leave Holland and finally succeeded in doing so through his sister, who was married to an Italian diplomat in Rome. According to other reports he died in a concentration camp. His collection comprised objets d'art and paintings known to be of the highest quality. Haberstock purchased his Memling, *Madonna with an Angel Playing a Harp*, and six other paintings. Hofer, in the company of Miedl, acquired three paintings from Gutmann that went to Göring in the first Goudstikker deal.

Koenigs, Franz, 121 Keizersgracht, Amsterdam. Koenigs was a German who had lived in Holland since just after the First World War. He was from a well-known Hamburg family and owner of the Rhodius Koenigs Bank. A big financial speculator, he had never been known to sell anything. Hofer visited his collection with Miedl on his first visit to Holland. Miedl, who had just begun to go into dealing on a large scale, asked Hofer's advice about purchasing this large collection. Hofer advised strongly that he buy it and give Göring the right of first refusal. Miedl purchased most of the collection for 700,000 guilders. Göring acquired the better paintings, including nine by Rubens, which arrived in Carinhall on June 10, 1941.

The acquisition of the collection by Miedl was considered a sensation at the time. Posse, purchasing for the Führer Collection, followed shortly on Hofer's tracks and bought some of the remaining paintings. Hofer tried to buy Koenig's well-known Gruenwald, *Crucifixion*, but negotiations were interrupted by the death of Koenigs in a railway accident in Cologne in 1943. The following were from the Koenig Gallery:

Rubens' *Crucifixion*, Keonig Gallery, was bought by Göring through Miedl.

Cossa, Franc	*Angel of Annunciation* (203 × 119)
Rubens	*Crucifixion*
Rubens	*Helene Fourment*
Peseline	*The Expulsion from Paradise*
South German master	*Portrait of a Man*
School of Rubens	*The Bath of Dianna*
Rubens	*Callisto*
Rubens	*Achilles and Daughter of Lycomedes*
Savery	*Mountain Landscape*
North German master	*Portrait of a Man*
Rubens	*Landscape in a Storm*
Patinier	*Sodom and Gomorrha*
Burgundy	*Portrait of a Young Man*
Rubens Workshop	*Diana at Bath*
Rubens	*Landscape*
Titian copy	*The Bath of Diana* (68 × 57)
Rubens	*Two Roman Soldiers*
Averkamp	*Winter River Scene*

von Pannwitz, Catalina, Heemstede bie Haarlem. This dealer was a wealthy German, resident in Holland since the last war. Mrs. von Pannwitz had interests in Argentina and an Argentinean passport. Her large collection had been formed by her late husband. In 1940 Hofer visited von Pannwitz and she told him that she wanted to go to Switzerland and asked his help with Göring in obtaining an exit visa. Hofer suggested the sale of some of her art and told her Göring would visit her house and select the paintings. Göring agreed and obtained a visa for her. In addition he permitted her to export approximately 15,000 Swiss francs. He also declared her house off limits to German troops. Hofer purchased several paintings, including a Rembrandt and a Lucas Cranach. Payment was made by deposit in von Pannwitz's name, in guilders in an Amsterdam bank. Hofer denied the stories that the sale was made under duress; however, he did admit the visa was a condition of the transaction. He further pointed out that the prices were high at the time and no bargaining was done. Also, later, when he visited Mrs. von Pannwitz in Switzerland, he was well received.

The remainder of the von Pannwitz collection was left in storage with the Rijksmuseum in Amsterdam. The collection was the object of special attention to a group of Dutch collectors who were interested in preserving the paintings for Holland. A letter from Göring to Hofer indicated that the Reichsmarschall intended to seize the complete collection in case Argentina declared war on Germany. In 1944, Heinrich Himmler instructed Muehlmann to purchase a Frans Hals from the van Pannwitz collection, but the negotiation was unsuccessful.[1]

The following were in Göring's collection:

Klumbach	*The Birth of Maria* (1.10 × 98)
Master of Messkirch	*St. Wernherus* (37 × 164)
Cranach	*Madonna and Child with St. John*

Rembrandt *Portrait of a Man with Beard* (59 × 72)
Gothic Style *Chair*
Master of Frankfurt *St. Catherine* (69 × 157)
Master of Frankfurt *St. Barbara*

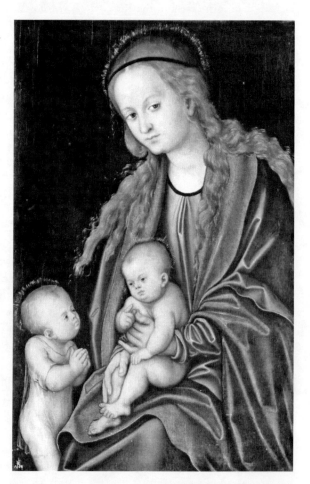

Phillips Factory, Eindhoven. Hofer was sent to the village of Eindhoven by Göring to judge whether two pictures of the School of Cranach owned by Phillips should be acquired for his collection. Hofer was received by an official, formerly of the large German Krupp munitions manufacturers and in charge of the large Phillips electronic factories during the occupation. It is not certain whether the Cranach was to be purchased or presented to Göring as a gift. In any event, the two paintings, *Portrait of Martin Luther* and *Portrait of Melanchton*, were acquired. The painting of Melanchton was later stolen by a member of the U.S. 101st Airborne Infantry while it was stored at Unterstein, Germany.

Hoogendijk, 640 Keizersgracht, Amsterdam. In 1937, D.G. Hoogendijk had been instrumental in the purchase of a newly discovered Vermeer painting, *The Supper at Emmaus.* This most inspired Expressionist piece was the finest first-rate example of Vermeer and was defined as the greatest painting of the 17th century. The painting was donated to the Boijmans Gallery, Rotterdam.

Lucas Cranach, *Madonna with Child* (above), and Rembrandt, *Portrait of a Man with a Beard* (top of page 79). These art objects were purchased from the Catalina Pannwitz Collection. The wealthy Catalina carried an Argentinean passport.

Hoogendijk discovered two additional Vermeer paintings, *Head of Christ* and *The Last Supper.* These Vermeers, as we shall see later, would turn out to be fakes.

Hoogendijk worked with Hofer, as Göring was fond of him as a person and visited his shop whenever he could. Although his appraisals were high, the quality of his wares and his methods of dealing appealed to the Reichsmarschall. Hoogendijk once admitted that he had charged Göring 130,000 guilders for a painting that he had purchased for 20,000 guilders. He had explained the enormous profit by saying it was necessary for part

of the dealer's everyday risks. Göring was apparently impressed by this statement because when Hoogendijk's brother was placed in jail he was released through Göring's intervention.

Five paintings purchased by Göring had a half-interest by Asscher and Welcker of London. Wishing to observe international law, Göring wrote to arrange for the English firm's share to be paid to Enemy Property Control. The letter is an interesting revelation of the Reichsmarschall's business methods. He paid Hoogendijk a total of 140,250 guilders and should have paid an equal amount as the English firm's share. Instead, he paid Hoogendijk 22,500 guilders and stated more than once that he considered this ample compensation of the Englishmen. Hofer was involved in this transaction, but as expected he denied having any part in such a business. These painting were transported from Amsterdam on November 11, 1940. Hoogendijk also sold to Posse and Voss, but after 1943, perhaps sensing the turning tide of victory, he curtailed his sales to the Germans.

Left (bottom): Cranach, *Portrait of Martin Luther,* Phillips Factory, dated 1532. The painting is signed with Cranach's signature, an embedded flying snake, which is represented on the object in Luther's hand. Sold by Sotheby's, Amsterdam, December 4 and 5, 2006.

Göring purchased the following:

Schwabish School, 15th c.	*The Adoration of the King*
Miereveld, van	*Female Portrait* (90 × 112)
Droochsloot	*Village Street*
Capelle, van de	*Marine Landscape* (105 × 77)
Loo, van	*Diana and Callysto* (120 × 85.5)
Fyt, J.	*Still Life with Dead Sheep*

Bol, Ferdinand	*Alexander and Roxane* (179 × 219)
Wildens, Jan	*Diana in Solo Chase* (140 × 218)
Rubens	*Female Head* (× 52)
Baalen, v. Hendrik	*Diana with Her Women after Hunt*
Flemish School	*Portrait of Catherine Tudor of Brends*
Bellevois, Jacob	*Sea Battle* (77.5 × 118)
Goltius	*Jupiter and Antiope* (128 × 175)
School of Veronese	*Male Portrait*
Flemish School, 1600	*Landscape with Attack Robbers*
Dyck, van	*Portrait of Lady* (109 × 145)
Monaco Lorenzo	*Madonna with Child*
Teunissen	*Portrait of a Man* (39.5 × 44.5)
Oostsanen	*St. Mary with Child and Angels* (57 × 66)
Wouverman	*Officer on Horseback*
Umbrian School	*St. Sebastian*
German, about 1425	*Pieta*
Flinck	*Portrait of a Young Man* (46.5 × 54.5)
Ostade, v. Isaak	*Peasants Slaughter a Pig* (65 × 48)
Ruysdael, v.	*River near Rhenen* (42.5 × 52)

Jan van Scorel, ***Triptych Mary and Child, St. Ann,*** **Katz Gallery. Sale by Sotheby's, London, July 8, 1999, E. Loncke Collection, Belgium, 1999.**

Master of Cologne	*The Flight to Egypt* (46 × 32)
Neer	*Daylight Landscape* (42.7 × 28.5)
Velde, van	*Seascape*
Willaerts	*Harbor Scene*

Katz, Nathan, 35 Lange Voorhout, The Hague. Katz was essentially a businessman-dealer who at one time had the reputation of working on a large scale. He had excellent connections with many Dutch collectors and many of his paintings were on assignment. Katz worked through Hofer, but Göring went to this firm on one occasion and purchased van Dyke, *Portrait of a Family,* for 200,000 reichsmarks. According to the original agreement of the sale, Göring was to pay Katz—$80,000 to a bank in New York or 350,000

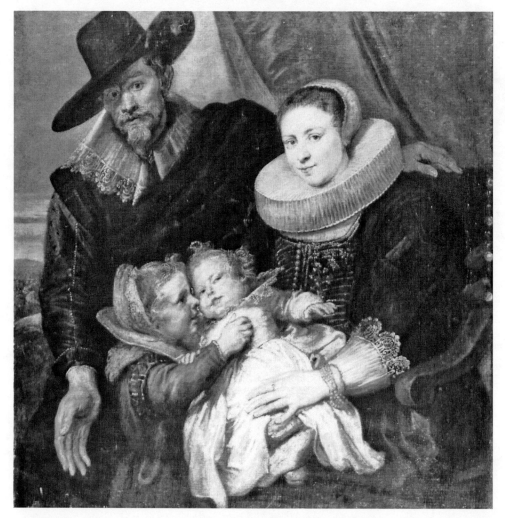

Anthony van Dyck's *Family Portrait*, Katz Gallery, oil on canvas, was purchased in March 1941, prior to U.S. entry into the war. Göring was to pay Katz $80,000 deposited to a bank in New York. Later it was purchased for 250,000 reichsmarks. It was sold in 1981 to a private collection in the Channel Islands.

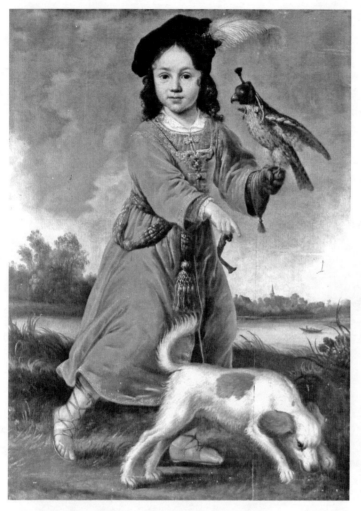

Albert Cuyp's *Michiel Pompe van Slingelandt at the Age of Six*, Katz Gallery, oil on panel, signed and dated 1649, was badly broken when recovered in Berchtesgaden.

francs in Switzerland. That was March 1941 and the United States was still neutral. Later it became impossible for the Germans to deposit the money in New York, and Swiss francs were becoming difficult to obtain.

At year-end he agreed to accept 200,000 deutschmarks or 152,000 guilders. In February and then again in March 1944, Katz notified Hofer that he had not been paid for the van Dyke painting and requested payment be made to a Swiss bank in Basle. Hofer notified Katz that indeed he had paid Katz's lawyer at his request — 200,000 reichsmarks on July 7, 1943. Hofer received a letter from a Swiss lawyer in Zürich advising him of his July 7 letter to Nathan Katz: "What you have written does not correspond with the true situation."[2] The Katz family had been allowed to go to Switzerland. Just when it appeared that the situation could not become more muddled, on May 25, 1945, a telegram from London was received informing Katz that he had taken the Van Dyke, *Portrait of a Family*, illegally during the German occupation from Hoogendijk and that he demanded its return at once. The facts of this case speak of the turbulent times during World War II.

The following items were purchased from Katz for the Göring Collection:

Scorel, van	*Mary and Child St. Ann* (89 × 58)
Dyck, van	*Family Portrait*
Pickenoy	*Portrait of a Lady* (89 × 123)
Dutch, 16th c.	*Triptych* (× 120)
Beyeren, von	*Still Life with Fruit* (99 × 122)
Cuyp	*Young Boy with Hawk* (79 × 106)

Dyke, van	*Portrait of Duchess of Hamilton* (213.5 × 127)
Dyke, van	*Duke of Richmond* (206 × 125)
Scorel, van	*Founder with Her Patron* (88 × 23)
Scorel, van	*Founder with His Patron* (88 × 23)
Goyen van	*View of Nymwegen*
Orley, van	*Triptych Center* Crucifixion *and 14 scenes*
Hals, Frans	*Portrait of a Man* (68 × 84)
Goyen, van	*Landscape with Monastery* (89 × 58)
Brouwer	*Drinking Peasants* (33 × 42.5)
Goyen, van	*Landscape with Two Cars* (41 × 58)
Vermeyer	*Portrait of a Man* (34 × 46)
Goyen, van	*Skating Near Dordrecht* (43 × 67.6)
Miereveldt	*Portrait of Miss Teding van Berkhout* (57 × 68)
Rembrandt	*Portrait of His Sister Elizabeth Ryn* (53 × 69)
Rembrandt	*Portrait of Saskia* (48 × 66)
Cock, van, Aelst Pieter	*Adam and Eve* (48.5 × 38)

Paech, Walter, 57 Rokin, Amsterdam. Paech was a German resident in Holland for many years who was married to a Dutch woman. He acted as an intermediary for Hofer both in Holland and Belgium. According to reports, he had a bad name with the Dutch, who refused him membership in the Dutch dealer syndicate before the invasion. During the war he was more than once mentioned as the worst of the German dealers who operated in Holland during the occupation. He was a friend of Miedl and worked with Jan Dik Jr. He had been an active dealer in Belgium before the war and knew that market. He had brought some paintings in that country and presented them to Göring in the Hotel Metropole in Brussels during one of his visits. He sold Hofer many paintings, including by Lucas Cranach and the following:

Miereveld, van	*Portrait of a Man* (1.12 × 90)
Morcelse	*Portrait of a Woman* (92 × 80)
Ruysdael, v.	*Landscape* (85 × 115.5)
Momper de Frans	*Village Landscape with Figures*
Heil, van	*A Town at the Port* (50.5 × 83)
Flemish, 16th c.	*Susanna and the Elders* (67 × 51)
Hylst	*River Landscape* (33.5 × 52)
Steen	*Village Landscape Dancing*
Oosten	*Landscape with 3 Peasant Cars*
Backhuysen	*Marine* (36 × 36.5)
Dutch Follow Mostaert	*Gentlemen from Liere* (95.5 × 183)
Grimmer	*Landscape with Castle* (37.5 × 72)
Cassel	*Landscape with Flight from Egypt*
Brueghel, Pieter	*Crucifixion of Christ* (118 × 161)

Tietje, Hans, 42 Konigslaan, Amsterdam. Tietje was a German who had resided in Holland for many years. He was married to a Jewess and had three daughters. He was

essentially a businessman dealing in the production of steel, and a speculator rather than a collector in the art world. Initially he did not sell, but he saw the advantages for his steel business in dealing with Göring. He sold Göring the following:

Master of Alkmaar	*St. Joachim and St. Anna Golden Gate*
Master of Alkmaar	*Rejection of St. Joachims Sacrifices*
Master of St. Gudule	*The Betrothal of Mary*
Stimmer	*Portrait of a Man* (42 × 67)
Cranach	*Madonna and Child with Grapes* (61.5 × 42)
English, c. 1530	*Portrait of a Man*
English, c. 1530	*Portrait of a Lady*
Grimmer	*Winter Landscape* (22.5 × 35)
Donau School	*Portrait of a Man* (48 × 35.5)
Donau School	*Portrait of a Woman* (48 × 35.5)

Wolf, Brothers Daniel and Marcel, Wassenaar. The brothers were well known for having financed the Republic government during the Spanish Civil War; they left Holland to escape the Germans. Miedl purchased the brothers' bank and cinema theater. Their gallery was taken over by Göring's close friend General Christiansen. The following paintings were negotiated by Miedl for the Göring Collection.

Tintoretto	*Portrait of Sculptor Strada*
Cleve van	*Portrait of a Man* (66 × 83)
Gogh van	*Flower Piece* (32 × 67)
Bol, Ferdinand	*Pyrrus* (118 × 96.5)
Neer, van der, Aert	*Winter Landscape Skating*
Metsu	*The Tease* (141 × 110)

Dik, Jan, Jr., Amsterdam. This dealer was the son of Jan Dik, the restorer and salesman for the Goudstikker Gallery who remained with Miedl after he had acquired the firm. Both father and son became very rich during the war and both acted as official appraisers for Enemy Property Control. At first the men worked for Goudstikker, but the son, in about 1943, went into business for himself, He made several trips to Paris in connection with his business with Lohse. Working closely with Jan Dik Jr. was Miss Rudolpha Begeer, the daughter of a Dutch jeweler. She was employed as a private secretary associated with the German Art Bureau. She was ambitious, egoistic, and avaricious; she was also indispensable because of her knowledge of foreign languages. Early on, she had an argument with Kajetan Muehlmann's brother, Joseph, and was barred from the bureau. She had some knowledge of the history of art and had a reputation for using her position with the Germans, whom she worked with as a guide and in other activities for making personal profits. She frequently traveled to Paris, where she carried considerable clout due to her influence with the Germans. Begeer was one of the most active of the collaborationist hangers-on in Holland.[3]

In October 1942, Begeer shipped Ilse Göring, Hermann's sister-in-law, a railroad car of household furnishings from several Dutch dealers to her Berlin residences. The shipment of armchairs, oak tables, Louis XVI table, panels, chinaware fountain, tea sets,

cups, vases and oak wooden bookcase also included two paintings, one by Tenors, and four 1750 sculptured Dutch chairs.[4] Göring's brother, Karl, died in 1932 and Ilse remarried Rudolph Diels in 1942. He had a strong Nazi background and held a high position in the Hermann Göring Industrial Works. He had been most helpful, when Göring had been appointed Prussian minister, by informing him who in the government was anti–Nazi. However, due to friction between Ilse and Diels, he fell into disfavor with Göring. This resulted in a divorce in December 1944 after two years of marriage. Ilse then worked for the Red Cross and remained in Berlin through the bitter end of the war.

Delaunoy, Etienne, 118 Rokin, Amsterdam. Delaunoy was a small-time dealer with a large shop containing every variety of art object. Agents of German museums were among Delaunoy's best clients. Göring visited the shop several times, as he enjoyed going to a place where he could buy a large number of inexpensive things. Those included the following:

Grimmer, Abel	*Winter Landscape*
Koninck	*View of Hague* (71 × 61)
Vinkebooms	*Sow Chase* (49.5 × 69)
Diest, van	*Marine* (58 × 80)
Burgundy	*Madonna with Child*
German, 1500	*The Last Supper*
German, 1650	*Two Angel Heads* (× 50)
Mirou	*River Landscape* (29 × 46)

Kroeller-Mueller Museum, Veluwe, Holland. Göring had known of the existence of German paintings in the Kroeller-Mueller Museum since well before the invasion. In 1941, when he found out the museum was moving from its original location to Veluwe, he asked Hofer to find out whether they would consider selling the paintings. As the negotiations dragged on, Göring decided to place Muehlmann in charge of the conciliation. Göring presented the exchange to Muehlmann as a matter of national prestige. He said the paintings had been bought in Germany just after the last war during the inflation period and the purchases was made under adverse and unfair conditions for the Germans. He further stressed that both he and Hitler insisted the paintings be acquired for the Third Reich. Then he left the acquisition up to Muehlmann.

In the beginning of 1942, Göring deposited 600,000 guilders in the De Bari Bank in Amsterdam and gave the museum seven confiscated 19th century French paintings for Hans Baldung Gruen, *Venus and Cupid*; Barthel Bruyn, *Portrait of a Lady*; and Lucas Cranach, *Venus and Cupid*. Once the seven paintings were presented to the museum the officials spontaneously declared they considered themselves better off with the trade.[5]

Following the settlement of this deal, Göring offered to sell Miedl six Impressionist paintings for 750,000 reichsmarks. The paintings consisted of one by Van Gogh and three by Cézanne from the confiscated Paul Rosenberg Collection; a Cézanne from the Rothschild Collection; and a Jan Steen originally in the Goudstikker Collection. Miedl agreed to the sale on the condition the paintings would be sent to Switzerland. At this time Miedl intended to send his Jewish wife and children to Switzerland for protection from the Nazi anti–Jewish laws. He concluded the paintings would provide her with

needed monetary support. In the summer of 1942 the paintings were sent to Switzerland by the German diplomatic courier. Hofer picked them up at the German legation in Berne and handed them to Miedl's lawyer, Dr. Wilhelm Frick.[6] Miedl later moved most of his art collection and his family to Spain. This was accomplished by authorization from Göring. Miedl's move was because he thought his Jewish wife was not safe in Holland and Göring agreed.[7]

Dutch art dealer P. De Boer was well known in German circles and was often visited by these art dealers. In the spring of 1941 Hermann Göring visited with De Boer and purchased several paintings from him. De Boer's wife was Jewish and De Boer unsuccessfully begged Muehlmann to obtain an Aryan certification for her. De Boer played a part in the discovery of two unknown Vermeers in Holland that created a sensation in the Dutch art world. The first painting surfaced in June 1943 and was *Christ in the House of Mary and Martha*. It was brought to De Boer under unusual circumstances The owner carried the painting nailed in the bottom of a wooden case, insisted on remaining absolutely anonymous, and asked an enormous price which was to be paid in cash on delivery. A number of experts validated the picture and it was purchased by the famous Rijksmuseum. The price was 1,340,000 guilders. The museum was reluctant to let Hofer view the painting, but he finally obtained permission to see the Vermeer after giving his word that he would

make no attempt to purchase it for Göring. However, in a letter to Göring, Hofer pronounced it unquestionably a Vermeer and wrote he made no attempt to buy the painting because of its condition and high price.

A few weeks later Hofer was told by De Boer about a second Vermeer. De Boer promised Hofer that if he could find it he would offer the painting to Göring. Then one day in September 1943, Alois Miedl telephoned Hofer from Amsterdam to say he was traveling immediately to Berlin with a very important picture. Shortly afterwards he showed Hofer another Vermeer, *Christ and the Woman*

Forgery Vermeer/Hans van Meegeren, *Christ and the Woman Taken in Adultery*, De Boer Gallery. In exchange for this painting, Miedl gave one picture from the Renders Collection and Göring gave 150 paintings, mostly from the Goudstikker Collection. The painting has large cracks in the paint, which makes it appear very old.

Taken in Adultery, nailed to the bottom of a case, in exactly the same way as the first one had been when it was showed to De Boer. Miedl told Hofer he had first heard about the painting from former employees of his bank and then he was brought the painting by a man insisting on maintaining his anonymity and requesting two million guilders, again payable in cash. Heinrich Hoffmann, Hitler's official photographer and inner-circle friend, saw the Memling and immediately wanted to buy it for the Führer. Hofer quickly took the Vermeer with him to Carinhall. Göring was suitably impressed with the painting but balked at the price. He was afraid that the picture might be stolen property or that a Jew might be planning to sell something to him and use the sale to blackmail him later on.

Negotiations over the Vermeer continued over a period of months, during which time Göring refused to return the picture in spite of the fact that Miedl had received an even larger offer from a group of Dutch collectors who wanted to save the painting for Holland. Finally, Göring agreed to exchange the equivalent of 1,650,000 guilders in paintings for the Vermeer and six additional paintings from the Renders Collection. Miedl accepted the offer and Göring sent Miedl 150 paintings which were chosen by Miedl at Carinhall. Fifty-four of the paintings were from the Goudstikker Collection, which Göring no longer wanted in his collection. Payment was completed on February 9, 1944. The Vermeer was cleaned by Mrs. Hofer, who declared it was unquestionably a 17th century painting. This Vermeer, *Christ and the Woman Taken in Adultery*, was — and in Göring's mind would remain — the most prized painting in his collection. But we shall see later that this may not be the case.[8]

Also purchased from De Boer were the following:

Beukelaer	*The Easter Lamb*
Flemish, 1600	*Caritas with Five Children*
Sebastian Vrancx	*Village Landscape with Many People*
Provoost, Jan	*Female Saint with Book and Palm*
Provoost, Jan	*St. Catherine*
Pollack, Jan	*St. Martin* (125 × 54)
Brueghel d. Pieter	*Summer* (91 × 56)
Master the Alter	*Mass of Gregory* (83 × 166)
Doomer	*Mountain Valley with Donkey Driver*
Brekelenkamp	*Interior with Two Figures* (42.5 × 53)
Mirou	*Landscape with Village and Cattle*
Noort	*Mythological Scene* (65 × 79)
Goyen, van	*View of Nymwegen* (91 × 47)
Momper	*Procession in a Grotto* (62 × 92)
Steen	*Landscape with Peasant Family*
Goyen, van	*Cottage Near River* (57.5 × 46)
Ostade	*House and Hay Carriage* (37 × 33.5)
Bles de met, Henri	*Lot with Daughters* (27 × 40)
Savery	*Landscape with Hunter* (49 × 31)

Göring exchanged 137 paintings for the fake Vermeer and six paintings from the Renders Collection.

Goudstikker, Jaques, 458 Herengrach, Amsterdam. Jaques Goudstikker had the fore-sight to anticipate the occupation of Holland and in 1939 had deposited $50,000 in a bank in New York. With that money, in 1939, his family could live comfortably for at least ten years. When Germany forces crossed the Dutch border on May 10, 1940, Goud-stikker, his young second wife, Desirée, and their recently born child, like thousands of his countrymen, escaped through the Holland port of IJmuiden. They were stuffed into the bottom of the crowded ship. Jacques told his wife he needed some fresh air and on the blacked-out deck he fell to his death through an uncovered hatch. After much difficulty Desireé and the child continued on to Canada.[9]

It is probable that the Goudstikker firm was nearly bankrupt in 1939. The firm had been in financial difficulties ever since Goudstikker had to take back a number of expensive but doubtful paintings he had sold to Fritz Thyssen. Apart from the number of clients that had lent him money, the bulk of Goudstikker's paintings were pledged as security for a loan from the large financial institution Nederlandsche Bank. Under these conditions, and with an absent owner, it was easy for the invading forces to acquire the Goudstikker Collection.

The negotiations took place during Göring's first visit to Holland in June 1940. Dr. Erick Gritzbach, Göring's chief liaison officer, originally wanted to buy the complete col-lection, including the real estate, choose what was important for the Göring Collection, and sell the rest at auction in Berlin. Hofer advised against this because of the amount of work and complications involved in transportation, cataloguing, etc. Göring was con-sulted at Carinhall, and finally Hofer and Gritzbach returned to Amsterdam to conclude the final agreement: Göring would purchase most of the removable art, which included about 1,300 old masters, and Miedl would own the real estate — Nyenrode Castle, Villa Oostermeer, the Amsterdam Gallery and the firm's name. The contract was signed on July 13, 1940, in Amsterdam. The original price requested by the Goudstikker's represen-tatives was eight million guilders. A few days later the price was down to two million guilders, with 1.5 million guilders to be paid on the day of signing and the remainder 14 days later.[10] Hofer remembered that Miedl insisted on protecting the rights of Goud-stikker's widow. (Miedl indeed protected Desireé Goudstikker's share of the company by investing in Dutch securities. When she returned to Holland after the war her homes and these securities were at her disposal.)

From this collection Göring acquired a total of 600 works of art, the great majority of which were paintings. The first Goudstikker deal was a very favorable one for the Göring Collection. Among the Goudstikker lot there were many important pictures such as Rembrandt, *Two Philosophers* (later given by Göring to Hitler), Frans Hals, *Portrait of a Young Man*; Salmon Ruysdeal, *River Landscape*; Terborch, *Duke Cosimo die Medici*. The value of the four paintings alone was 992,600 guilders. Miedl spoke of this one art trans-action often to Hofer and seemed to expect some further settlement after the war. How-ever, the immediate advantages to Miedl were many: his Göring contacts afforded him all sorts of amenities, including the purchase of an art-dealing business at a time when the boom was about to occur. It also included the protection of his wife from anti–Jewish laws.

These paintings were inventoried by Hofer and Miss Limberger in Amsterdam. Those

chosen for Göring were sent to the Shantung Handels, an agency in Berlin that, in conjunction with the Landsvolksbank, appeared to handle Mendel's Berlin business. Those left over were bought back by Miedl for approximately 1,750,000 reichsmarks well before the settlement of the 14 days. Gritzbach then purchased many of the objets d'art from the collection, and over the next few years, from the sale of these remaining paintings, Miedl would more than triple his original investment. Göring gave Hofer a 50,000 reichsmark commission for his part in this acquisition.[11]

Among the Goudstikker paintings acquired by Göring were 13 that had a half interest. A list of these was sent to Hofer by Miedl with the names of the people sharing ownership and the value of their interest. Among the people were Jews, enemy nationals and Germans. Göring intended to pay the Germans directly but the other money owed would be paid to the Enemy Property Control. The personnel of Enemy Property Control, in true German efficiency, insisted payment be made to the Goudstikker firm; then they were instructed to pay the Enemy Property Control and this was how the matter was finally settled.

The Mathiessen Gallery in Berlin owned a share of Barthel Bruyn, *Portrait of a Man* and *Portrait of a Woman*, valued at 6,600 guilders. Göring's personal staff paid the gallery directly with a check for 30,000 reichsmarks, dated September 16, 1942.

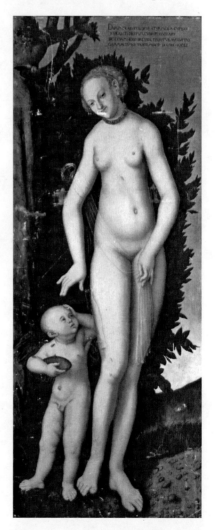

Mrs. Sotchek Blumenreich owned a share of Memling, *Four Angels*, which was two double-sided paintings. She was the widow of a Berlin Jew and the paintings were at first considered to be "enemy," as she was living in California. Then it was later found out that she was an Aryan living in Berlin. The paintings were valued at 30,000 guilders. Therefore a check was sent to her on July 17, 1943, drawn on a bank in Amsterdam. The paintings (Goudstikker inventory numbers 2446 and 2447), originally painted on both sides, were split into four paintings. Therefore Göring would have four Memling paintings instead of two. This was common practice in that era. Unfortunately, two of these paintings would be stolen from the U.S. 101st Airborne storage facility in Unterstein.[12]

The Goudstikker Collection was partially restituted to Marie von Sahre in February 2006. The following paintings previously in the Göring Collection were offered for auction by Christie's in 2007:

Cranach, **Venus and Cupid, the Honey Theft**, Goudstikker Collection, one of several paintings by Cranach depicting Cupid stealing honey from a honeycomb. The artist was a favorite of Göring's. This work was auctioned for $824,000.

Top: At a Christie's auction this Salomon van Ruysdael, ***Ferry Boat with Cattle on the River Vecht Near Nijenrode***, sold for $2,280,000. The ferryboat was the subject of many of the artist's paintings. Göring acquired this valuable painting on his first Goudstikker deal.

Left: This painting in the Göring Collection was identified on the 101st Airborne Infantry inventory by Sergeant Edward Peck, an art teacher at Ohio University, as "Ambrozio Lorenzetti, *Mary Magdalena*, 122 × 61 cm." It was recognized by the competent German staff at the Munich Collection Point as "Ambr. Lorenzetti, *St. Magdalena*, oil on panel" from Goudstikker inventory number 2599 as well as references to Goudstikker notebook page 125. In 1969 this painting was attributed to Jacopo del Casentino, *Saint Lucy*, "following Fehm's review in *The Burlington Magazine*." On April 19, 2007, Christie's in New York offered the painting for $800,000, the minimum bid $361,000. The painting was withdrawn. Could the bidders have questioned its origin?

Simon de Vlieger, *The Entrance to a Harbor*, Goudstikker Collection. Vlieger was an important Dutch painter in the early 1600s. Here the fisherman is hauling in a net while a man is gesturing in a rowboat. This painting was auctioned for $420,000.

François Boucher, *The Judgment of Paris*, Goudstikker Collection. Boucher was closely associated with French rococo art and is best remembered for his taste in nude females and erotic scenes. The minimum bid for this painting was $400,000.

Philips de Koninck, *An Extensive Landscape with Trees and a Cottage*, Goudstikker Collection. Koninck was known for his panoramic views, and this composition depicts a woman and child sitting under a tree with a view that opens out into the distance. The painting was withdrawn from a 2007 auction when it did not meet the minimum bid of $1,500,000.

Isaac van Ostade's *Winter*, from the Goudstikker Collection, was sold at Christie's in 2007 for $288,000. Ostade's favorite subject appears to be winter scenes.

Top: Andrea Schiavoue, *Stoning of the Elders*, Goudstikker Collection. Sold at Christie's of London, July 5, 2007.

Philip Wouverman, *Winter Landscape with Farm and Church*, Goudstikker Collection. Auctioned at Christie's, Amsterdam, November 14, 2006, for $33,109.

Pieter Brueghel, *November Landscape*, Goudstikker Collection. After its return to Holland the painting was reported as stolen. Max Friedländer, Göring's art adviser in Holland, said, "As far as Brueghel is concerned he was less clever than his interpreters, but their superior as to sense of humor." This is well illustrated in this painting.

11

The Art Market in Belgium and Luxembourg

Göring's most important acquisition in Belgium was the Emile Renders Collection. He himself rarely went there and when he did it was usually on his way from France to Holland. As far as is known, he did not have friends in Belgium. The art market was lively in all the occupied countries. However, the Belgians did not deal actively with the Germans except through auctions. If something of importance appeared on the market it was usually sold in Paris, where the possibilities of obtaining a higher price were more likely. Göring's agents seemed to have considered Belgium as an annex to the Dutch market. Hofer complained that the Belgium collectors were very cold and inhospitable. Walter Paech was Hofer's agent in Belgium. Also, Miedl and Muehlmann made an occasional buying trip to Belgium and Luxembourg.

Hofer was introduced to Emil Renders by Paech, who had heard the collection was for sale and had already consulted with Max Freidländer as to its value. On September 16, 1940, Hofer and Paech, who acted as his interpreter, visited Renders, who stated unquestionably he wanted to sell his collection. He gave his reason for doing so as his fear that after his death it would be broken up by litigation of his heirs. He was particularly interested in keeping the collection together and insisted on selling the complete collection or none. He had formerly been a banker, and coming to an arrangement about the exact form of payment was difficult. At first he wanted 450,000 U.S. gold dollars, then gold francs, then securities, but he always managed to prolong the negotiations by changing his mind at the last moment.

Hofer became exasperated by this indecision and decided to call in Miedl, whom they believed, as a banker, would be best qualified to talk to Renders in his own business terms. On September 21, Hofer and Miedl visited Renders and after a long conversation the two men were most dismayed; upon leaving, they told Renders to think the matter over. Four days later two German policemen from the Foreign Currency Control arrived and informed Renders he was forbidden to discuss the sale of his collection without authorization, thus freezing the possibility of his selling his collection. A month later

Hofer and Paech arrived and informed Renders that they had been able to unfreeze his collection and they could resume negotiations. Again Renders was difficult to deal with. Hofer later admitted the Foreign Currency Control had been called in to hasten negotiations.

Göring wrote Renders a letter on March 17, 1941, advising him to make up his mind once and for all or else he (Göring) would no longer be able to answer for the consequences. After this threat, and only when Miedl showed him a letter from Göring calling off the Foreign Currency Control, did they finally come to an agreement. In March 1941, six months after initial negotiations, Miedl purchased the complete collection for 800,000 guilders, to be paid in securities chosen by Renders' bank. Thus the purchase of the securities was only possible through Göring, because the stock market was officially closed due to the occupation. (Renders' painting Memling, *Madonna and Child*, would disappear while under the protection of the U.S. Army. This incident will be described in a later chapter. Regarding Göring's March 17 letter, after the war Hofer was shocked at reading it. On being shown the letter, Kajetan Muehlmann smiled and said, "He didn't usually put that sort of thing in writing."[1])

Two years later, and apparently satisfied with the sale of his paintings, Renders offered his sculpture collection to Göring under the same conditions. However, the offer was not taken up because of the complications in the previous transaction involving his collection. This offer is confirmed in a July 14, 1943, letter from Hofer to Göring in which he reports on his examination of the sculpture collection and quotes the price requested by Renders. It this letter he specifically states that Renders wants payment to be similar in form to be what he received for the paintings — that is, to be "the same Belgium securities."[2]

The story of the sale of the Renders Collection was important for two reasons. The first was because the collection was the most important art of Flemish primitives in private hands, and the second was because Renders had presented to the Allied Restitution Authorities, after the war, an elaborate report stating he was forced to sell his pictures to Göring and was demanding their return. Strangely enough, although it was established that pressure was brought to bear on Renders, further analysis of the sale of his art shows that Renders was probably not a victim of the occupying forces. His offer to sell his sculpture collection to Göring is proof that he was satisfied with the payment for his paintings. He appears to have been driving a hard bargain rather than "resisting for six months." He was likely pleased with the price received for his collection. Like many collaborationists converted by Allied victory, he was probably trying to have his cake and eat it too,[3] for in January 1943, representatives of Britain, France and the United States met in London and declared that they reserved the right to find null and void any property transfer during the Nazi occupation. This inter–Allied declaration was known as the London Declaration.

Art purchased from Renders included these:

Massys	*Madonna with Child on Lap* (47.5)
Master of Baroncelli	*The Annunciation* (40 × 50)
Memling, Hans	*Angel from Annunciation*
Memling, Hans	*Virgin from Annunciation*
Weyden	*Madonna with Child* (39 × 29)

· + · M·CCCC·LXXVII·

Francesco Fiorentino, *Madonna Enthroned with Saints and Angels*, Van Gelder Gallery. When recovered by Allied Forces, there was a note that the edges were damaged and covered with tissue paper.

van Gelder, Mme., 44 rue Saturn. Mme. van Gelder was a Dutch resident in Belgium who had a large collection containing paintings from Hals and reportedly a complete room of Jordeans. This collection was undoubtedly one of the most important collections in Belgium. After the death of Michel van Gelder the widow started selling some of the paintings, before World War II began. On May 13, 1941, Mme. van Gelder sold Göring eight paintings, which were fetched by Göring's special train. She later sold some paintings for the Hitler Linz Collection. Then she sold about 30 excellent paintings to the Dorotheum, a Viennese auction house in Vienna. Most of them were purchased for the Linz Collection.[4] Following are six of the paintings purchased for the Göring Art Collection:

Fiorentino, Francesco	*Madonna Enthroned with Saints Angele*
School of Weyden	*Madonna with Child, Joseph Angels*

Rubens	*Head of a Moorish King*
Bohemian Master	*The Virgin with Child* (44 × 34)
Stoss, Veit	*Two Young Knights* (165 × 85)
Giovanni	*Madonna with Child* (66.5 × 54)

Heulens, Franz, 5 rue D'Aumale, Anderlecht. Heulens was a successful Brussels doctor who had been released by the Germans from a prisoner of war camp. He was a small collector and especially interested in Brueghel, whose birthplace he had bought and intended to give to the city of Brussels as a Brueghel museum. He was fond of Germans and did business with them but he was apparently aware of the possible consequences of this because he never wanted to be seen in public with them. Hofer purchased the following from Heulens:

Rottenhammer, Attrib to	*Landscape with Venus, Flora, Baccus*
School of Rottenhammer	*Diana and Callisto* (56.5 × 94)
Wytewael	*Judgment of Paris* (21.5 × 28)
Moreelse	*Female dressed up as Juno* (87 × 73)

Reiffers, Luxembourg. He had a collection of Italian Renaissance art and sold Göring's agents the following:

Giovanni di Paolo	*Two Saints: St. Paul and Nicolas*
Giovanni di Paolo	*Madonna with Angels* (144.5 × 59.5)
Giovanni di Paolo	*Two Saints: Pieter and Marguarit*
Haarlem, Cornelius	*Portrait of Nude Woman* (70.5 × 60)
Florentine, 14th c.	*Two Male Saints* (96 × 52.5)
Florentine, 14th c.	*Two Male Saints* (96 × 53)

Langrand, Maurice, 15 rue de la Regence, Brussels. He frequently traveled to France and went to live in Paris during the later part of the war. He sold to Hofer the following:

Valckenborgh, L.	*House and Bridge at Small River* (54.5 × 83)
Ostade van, Isaak	*Man Reading a Paper* (29 × 22.5)
German, about 1496	*Triptych: The Adoration of the Magi*

J. van der Veken, 5 rue Andre Fauchille, Brussels. He lived in Brussels, was a well-known Belgian art restorer and worked for many years with Renders. Hofer had great respect and admiration for his work. Hofer's wife had spent some time in his shop studying his techniques. He sold some paintings on a commission from Belgians who did not want to make direct contact with the German buyers. Payments were made directly to him in reichsmarks. In a December 18, 1942, letter, Veken informed Hofer that in 1940 he was sent by the Belgium government to Pau, France, where he was in charge of the restoration of van Eyck, Ghent Altarpiece. He informed Hofer that the artwork was now in Munich, Germany, and he requested Hofer's help in relocating him to Munich so he could continue his restoration of van Eyck. He further wrote: "van Eyck has remained my hobby and I go on dreaming about him."

The following were purchased from van der Veken: Beukelaer, *Sellers of Vegetables and Fruit,* and Brueghel the Younger, *Flemish Wake* (111 × 162.5).

Indeed, from Belgium Hitler had filched the greatest single art treasure in that country and one of the most famous works ever created in the Western world. The Ghent Altarpiece of van Eyck was the most priceless artwork seized by the Germans from any country during the course of World War II. A very early oil painting, it consisted originally of twelve panels, eight of which were painted on both sides. The altarpiece was planned as a giant triptych of three panels. The matching side panels were designed to fold together like shutters over a window. The panels symbolizing the resurrection of Jesus Christ had been sold and resold and wound up in Germany. In 1918, by the terms of the Versailles Treaty, the panels of the Ghent Altarpiece were taken from German museums and sent back to the Cathedral of St. Bavon in Ghent, Belgium. In 1934, two of the panels were stolen by a minor cathedral official. The theft became an international incident, as the Belgians accused the Germans of taking the panels. In the midst of the uproar a church custodian disclosed the hiding place of one of the panels, but during the

Florentine 14th century, *Two Male Saints*, Reiffer Collection, attributed to Taddo Gaddi.

interrogations he died suddenly of a heart attack. The second missing panel, *Just Judges*, has never been found. Its substitute is only a skillful copy.

During the invasion of the Low Countries, the Belgian government removed the 20 panel pieces from St. Bavon. They were packed in ten cases and entrusted to the French government. The altarpiece and many important works of art from the Louvre were sent

Pieter Brueghel the Younger, *A Flemish Wake*, Veken Gallery, today in the Musée Royaux des Beaux-Arts, Brussels.

south and stored in the Château of Pau. In July 1942, however, Ernst Buchner, director of the Bavarian State Museums, received an order from Hitler to make the preparations necessary to transfer the Ghent treasure back to Germany. Buchner and his staff left Germany and traveled to Pau, France. At the French border they were met by a German delegation from Paris. Special arrangements had been made for the party to travel in the unoccupied area of France. After Buchner arrived in Pau, it took an additional three days for the release of the Ghent Altarpiece. The German carpenter traveling with Buchner took special precautions to build packing crates for the six-foot wooden panels of biblical scenes. The large *Adoration of the Holy Lamb* was carefully secured against pressure and shock. The convoy of two cars and a truck left Pau on August 6 and was protected by French military personnel as far as the demarcation line. It was then escorted to Neuschwanstein Castle in Bavaria.[5] The Ghent Altarpiece remained there for two years and was sent to the Alt Aussee salt mine as a safeguard measure against air raids.

12

The Art Market in Italy

Hitler and Mussolini signed the Axis Pact of Steel in 1939. They were therefore committed to the same fate and as a result there was no organized looting in Italy. All art objects in Italy would have to be purchased.

The Italian market, similar to the other European markets, reached an unusual level of activity during the early stages of the war. Hofer noted that at the beginning only Italian works were expensive and there seems to have been almost an ignorance of the value of other works of art. However, when the Italians found out what was going on in the rest of Europe, it was not long before they were second to none in the prices they demanded. Italy was full of dealers and middlemen who used every means at their disposal to take money from their German Axis partners. Göring's agents bought everything from paintings to furniture, and in such quantities that the Italian government took notice and the minister of education broadcast a new law against exporting works of art. In the speech the minister made on this occasion, he specifically mentioned the purchases made by Göring and other Germans such as Hans Posse and Prince Phillip of Hesse. Nevertheless, Göring did not have any difficulties in getting his purchases out of Italy; he sent them out through diplomatic channels using the German embassy.[1]

One of Göring's most prolific agents working through Hofer in Italy was Dr. Gottlieb Friedrich Reber. He was born in Lage, Lippe, Germany, on March 23, 1880. His father was an Evangelist pastor, and Reber lived at several places in Germany with his family until he had completed school about 1900. He then went to Bremen and Hamburg, where he entered the textile industry and made such a success that he opened his own firm near Cologne shortly thereafter.

Reber became interested in art when he was about 27 years old. Having a smoothly running business, he was able to devote considerable time to studying art at the university in Bonn. In 1911 he settled down to studying art seriously and went to Paris, He bought up collections of Cézanne and Renoir paintings for small sums of money and then displayed them to collectors. Reber claimed considerable credit for popularizing their works, which became very valuable shortly thereafter. In 1914, he returned to Germany but was not taken into the army until 1916. He then served only about three months, being released

on "industrial" leave. Between 1929 and 1933 he lived mainly In France, Switzerland, and Germany, although he made several trips to England and one trip to the United States in 1929, where he was very well received as a famous art collector. In 1932 he gave an exhibition before the Royal Academy in London.

In 1933 he left Germany permanently. Reber was a 33rd degree Mason and occupied one of the highest posts in Germany. The Nazis tried to get him to sign a statement denouncing the Scottish Rite, but he refused. He lived in both France and Switzerland until 1940 and stated that the Gestapo frequently tried to embroil him with the local authorities, denouncing him as a spy or as a possible criminal, but nothing ever came of their efforts. Reber was in Switzerland at the time France fell. It was about that time that he was approached by Walter Hofer, who asked him to go to France as his agent in purchasing paintings. Reber refused to comply. Hofer then proposed that Reber go to Italy, which offer Reber accepted, arriving in Italy on March 23, 1941, and setting up his headquarters in Florence.[2]

Reber never met Göring and on the occasions when Göring came to Florence Hofer exerted every effort to get Reber out of town so that they should not meet. The art objects which were bought by Hofer and Angerer for Göring always left Italy by special train, with the approval of the Italian government. Göring was always in Italy to accommodate the special train, except on one occasion. Reber was told by Hofer that Göring had met the train, somewhere in Germany, in his pajamas as he was so eager to examine his new acquisitions.[3]

An agent for Posse was Prince Philip von Hessen. Born in 1896, the prince was a descendant of Emperor Friedrich III of Prussia and also of Queen Victoria of England. He became a general in the early S.A. (Brownshirts) and actively recruited agents for Nazism in Italy, where he had moved in 1922 and joined the Fascist movement. In 1925 he married Princess Mafalda, second daughter of King Victor Emmanuel. His education included sojourns at Frankfurt, Oxford and Potsdam. Prince Philip, the son-in-law of the king of Italy and ambassador to Italy, was a good friend of Göring until differences arose between them two or three years into the war. Christa Gormanns said that up until 1938 or 1939 he had a private room at Göring's apartment. Gisela Limberger confirmed this. Göring bought some Italian busts and marble from him. The prince is said to have made many art purchases in Italy. Emmy Göring said that Göring had some business relations with him.[4]

In Italy Prince Philip had unlimited access to funds, as was evident by Posse's letter of June 28, 1941, when he increased the special account at the German embassy by the amount of 13,200,000 lire for the prince to acquire works of art in Italy. Therefore Philip could outbid Göring's agent Hofer and this was evident in the case of the celebrated Memling *Portrait of a Man*, owned by Prince Corsini of Florence. Göring's agent, Walter Andreas Hofer, bid high for the picture but was waved off by Prince Philip of Hessen, who acquired it for Linz at a price stated to have been between five and six million lire. Hans Posse once traveled with the prince and found at that time a Titian, which he purchased for a very large price. Later he told his wife, "If Haberstock knew this he would explode."[5]

Towards the end of 1942 Field Marshal Erwin Rommel flew from North Africa to

the Führer's headquarters to report on the threatening situation there and plead for permission to withdraw his forces. Rommel knew that due to the Allied air superiority and lack of supplies his forces would be driven into the sea. Göring assured Rommel this would not happen and said he would personally take care of all the commander's needs. They would discuss his needs on Göring's personal train as he took Rommel to southern Italy, where he could disembark for North Africa.

Göring further told Rommel to bring his wife on the trip and she could keep Emmy company for their short holiday. During the trip, Mrs. Rommel was appalled by Göring's behavior and Emmy's devotion to him. She thought of him as a great fat imposter and was disgusted with his ostentation—his emerald clip, watch case dotted with precious stones, and his enormous diamond ring. "You will be interested in this," he told her proudly, "it is one of the most valuable stones in the world." Then Göring went off on a search around Rome for paintings and when he came back, he described how he had beaten down a dealer who had tried to sell him a painting. He never mentioned supplies or aircraft protection to the field marshal and Rommel knew he faced certain defeat when he got back to Africa.[6]

After the Allies invaded Italy and Mussolini was arrested by the Italians, the Gestapo arrested Prince Philip von Hessen's noble wife. The prince made no effort to save her and she died later in a brothel within the Buchenwald concentration camp. Then, in 1943, Hitler called for von Hessen to visit him at his headquarters. They spent late hours discussing the war, and their friendship seemed as close as ever. The Führer had been consistently charming. Then on September 8, 1943, without warning the prince was sent to the Flossenburg concentration camp and remained there for the duration of the war.[7]

The Göring collection gained a great many valuable additions from Italy. Purchasing was done entirely by his agents and sometimes by the Reichsmarschall. During their absence, details were taken care of by General Ritter von Pohl, who was in charge of the Luftwaffe headquarters in Rome, and by Colonel von Veltheim, Luftwaffe attaché to the German embassy. Transportation was done by Göring's special train and objects were stored in the German embassy in Rome awaiting the train's arrival. The correspondence concerning the purchases also went through the embassy.

Hofer as always was Göring's principal agent and in the beginning did not have any contacts in Italy. Angerer, who had worked the art market in Italy for many years, introduced Hofer to many of the dealers. However, his most important intermediary was his former employer Gottlieb F. Reber, a German collector and dealer who resided in Switzerland. During one of his trips to Switzerland, Reber suggested that if Göring would make it possible for him to go to Italy, he would be very useful in introducing Hofer to his contacts there and help with buying opportunities as they appeared on the market. Hofer obtained introductory papers for Reber, who established himself in Italy as an unofficial representative of Göring's art interest. Reber's most important contacts were the introduction of Hofer to Bonacossi Contini and Count Paplo Labia. Hofer established a personal relationship with the two men and met a large number of dealers independent of Reber.

About six months later, Reber's papers were taken back by Hofer after reports reached Göring that Reber was taking advantage of his position in Italy. This happened at the

time when the Italian government was concerned about the number of works of art being purchased by the Germans. Reber remained in Italy and still collected a 10 percent commission of items purchased for Göring. In 1944 Reber was deprived of his German citizenship because he had been a Freemason; at that same time, the Gestapo investigated his activities in Italy. Hofer attempted to help Reber by confirming that he had been officially an agent for the Reichsmarschall. He wrote the Gestapo in Berlin: "Dr. Reber behaved correctly throughout in his handling of materials; and I have never been informed he has behaved incorrectly in any other business."[8] Later the Swiss refused him a reentry visa and he remained in Italy.

Just as Angerer had been active in Italy before the war and had his own contacts among dealers and collectors, so Reber did a considerable business in the purchase of modern textiles, which he bought for himself to be used in the manufacture of air-raid blackout material.[9]

13

Art Dealers in Italy

S.E. Brassini, His Excellency Armando, 487 Via Flaminia, Rome. Reber arranged for Hofer to purchase from S.E. Brassini about 1,600,000 lire worth of vases, statues and columns. Brassini was a member of the Italian Academy and a prominent architect. His office was full of ambitious projects for public monuments, among them a plan for a new Berlin stadium. He was not necessarily a dealer, and he only dealt with Hofer. The objects purchased were used by Göring for decorations in Carinhall, particularly for the exhibitions of sculpture. They included the following marbles: Imperial Roman Sarcophagus, Torso of a Boy, Four Female Portrait Heads, Eight Large Columns and more, valued at 1,500,000 lire. Later, all of this was left behind when Göring fled Carinhall in front of the advancing Soviet army.

Contini-Bonacossi, Count Alessandre, Villa Vittoria, Florence. The count was a senator and formerly had been one of Mussolini's chief advisors on financial matters. He was made a count by Mussolini in exchange for giving his then large collection of art to the state, though he retained a usufruct of the collection for life. Contini was very wealthy and owned, among other properties, a mineral water factory and a great many vineyards and farms. Whenever he sold an object, he maintained that it was because he needed to acquire more land. During the war he was the biggest figure in the art market and a man to whom all small dealers brought their wares first.

Contini worked exclusively with Göring and it was quite certain that he sold to no other German buyers. Göring enjoyed Contini's company and went to visit him as often as possible. Reber stated that Göring was fanatically interested in art and that when in Florence he would spend hours with the painter Contini to the despair of Luftwaffe units and officers who were waiting to honor him. Göring had to beg Contini to sell and then argued at length over the price, a process he enjoyed because he always had the illusion that he was getting the price down. In Contini's dealings with Göring, Hofer had worked out a method by which he always offered a given percentage below what was asked and eventually came to an agreement halfway between the price and what Contini wanted. Göring wanted to buy everything possible and Hofer had some serious arguments with Contini because the count did not want to part with certain of his paintings. Contini

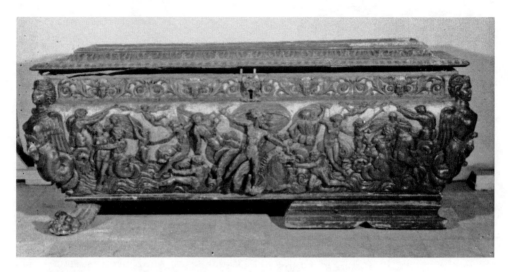

Italian 16th century, *Birth of Venus*, Contini Gallery, purchased by Hofer in 1943.

told Reber that Göring had said one day, "Contini, it's too bad you are not a Paris Jew, and I would just take them all away from you."[1]

The most important deal Reber arranged was when Hofer bought approximately 20,000,000 lire worth of paintings from Count Contini's dealings. Reber's role in this purchase was to obtain the consent of Contini, who in turn insisted on waiting for approval from the Italian government. Reber then evaluated and judged the originality of the paintings for Hofer, who paid the cash and arranged the details. Reber received 5 percent of the total amount for handling the deal. He noticed that Contini charged Hofer very high prices; he had also noticed that, generally speaking, all Italians were anxious to sell art objects to Göring, probably because he paid such high prices.[2] It was from Contini that Göring purchased antique furniture for the first time. Previously all his furniture came from the stock of Einsatzstab Rosenberg. However, in Italy he acquired antique furniture in large quantities. Two of the more valuable paintings Göring chose were Giovannia Bellini, *Male Saint, Female Saint*, in 1942, for 4 million lire, and, a year later, Masolino, *Madonna and Child*, for 2 million lire. Reber also handled business details for Hofer and on one occasion he received a telephone call from the Florence Luftwaffe headquarters to appear and collect 2,000,000 lire for payment to Contini.[3]

The following were purchased from Contini:

Veronese, Paolo	*Venus and Mars* (164 × 237)
Italian, 16th c.	*Birth of Venus*
School of Ferrara	*Birth of Christ* (180 × 189)
Moretto	*Nativity* (138 × 180)
Italian, 16th c.	*Chest Front Fight of Tritone*
Carriara	*Portrait of a Lady* (77 × 53)
Piemont, 15th c.	*St. Barbara, St. Catherine and Females*
Piemont, 15th c.	*St. Bernardino, John the Baptist* (67 × 124)
Piombo d. Sebastiano	*A Knight* (97 × 108)

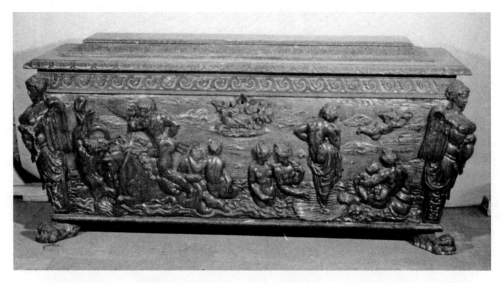

Italian 16th century, *Fight of Tritons*, Contini Gallery, purchased by Hofer in 1943.

School of Titian	*Lying Female Nude* (82 × 150)
Botticelli (?)	*Self Portrait (?)* (59 × 44)
	Portrait of a Lady (70 × 88)
Bacciacca	*Portrait of a Lady* (70 × 88)
Ferrrari	*Triptych: Adoration of the Magi* (43.5 × 28.5)
Carpaccio	*Portrait of a Standing Young Man* (185 × 86)
Carpaccio	*Allegorical Woman with Book, Dog* (186 × 87)
Robbia Pella	*Bust of Holy Virgin with Child* (× 88)
Italy, 1420	*Three Relief Two Heads Putti* (28 × 44 × 28)

Bellini, Commendatore Luigi, 3 Lungarne Sederini, Florence. Hofer introduced Reber to Joseph Angerer for the purchase of furniture in the latter part of 1941, and Reber arranged for Angerer to purchase about 4,000,000 lire worth of Bellini's furniture of the 15th and 16th centuries, and also a few unimportant Bellini paintings.[4] Hofer described Bellini as a strange character with many talents. He was a musician, a painter and a sculptor, and Göring enjoyed visiting his shop whenever possible. Bellini was something of a cynic and frequently joked about his gullible American clients to whom he sold many fakes before the war and whose return he awaited with impatience. Hofer said it was through Bellini that he acquired his taste for furniture and sculpture.[5]

Göring's special train left Italy with the following purchases from Belli:

Toscana 1300	*St. Bishop* (× 156)
School of Fontainebleau	*Flora* (110 × 180)
Toscana	*St. Virgin* (× 142)
Italian 16/18th c.	Green Silk Velvet (58 × 120)
Italian 16/18th c.	74 large Textiles and Tapestries
16/17th c.	Armchair

Left: Toscana, *Saint Virgin*, Bellini Gallery. *Right:* Italian 16th–18th century, green silk, velvet, Bellini Gallery.

Italian 16th c.	Picture of Half Nude (53 × 71)
Fiorentini	*Madonna with Child and St. John*
Della Robbia	*Holy Franciscus* (× 77)
North Italy 1550	*Mary of Annunciation* (× 120)
Toscanna	*Angel with Candlestick* (× 48)

Grassi, Giulo and Luigi, 1066 Via Cavour, Florence. The Grassi brothers were an old established Florentine firm with an excellent reputation. Both spoke fluent English and Hofer believed that they had contacts with England during the war. They worked with Hofer and Angerer, who had known the brothers for many years. Angerer lived in a house of a close friend of the brothers, Mrs. Rosamond Mullmann. Her husband was a client of Angerer, from whom Angerer bought blankets and rugs. Mullmann asked his wife to rent to Angerer, whom she had never seen, one of her two houses in Florence. In September 1941 the wife, Anneliese Angerer, and her two children moved in.

Toscana, *Angel of Annunciation*, Ventura Gallery, exchanged for an Impressionist painting from Einsatzstab Rosenberg in 1942.

Josef Angerer boasted to Mrs. Mullmann that he was buying many things for Göring, but he was mostly interested in tapestries. He bragged a great deal about the works of art he managed to sneak out of Italy without paying export charges. Mrs. Mullmann found him an extremely unpleasant, blustering German. She visited the German consul in order to have the Angerer family evicted. She was informed that Angerer could have her thrown into a concentration camp, as she was an American citizen, and she had to tolerate the situation. He was gone most of the time but finally the family moved out in June 1943. During the following year he telephoned Mrs. Mullmann several times but she had gone into hiding. According to her servants he appeared in June 1944 dressed in German camouflage fatigues looking for Mrs. Mullmann. She had long since departed.[6]

Ventura, Commendatore Eugenio, 8 via Pescia, Florence. According to Hofer, Ventura was an old man of sixty and he had the best art objects after Contini. Göring visited him on more than one occasion and made an important exchange with him involving a painting from Einsatzstab Rosenberg.

Göring visited Ventura's gallery on December 8, 1942, and selected 17 art objects; he took eight of these valuable items with him to Berlin, including Paolo Venezianno's *Madonna with Child*. Hofer then wrote Ventura saying he had been informed of the Reichsmarschall's choice and that he intended to exchange these items for some French 19th century paintings. In late January, Ventura traveled to Berlin and viewed the French paintings, and details of the exchange were discussed. Hofer then prepared a list of the nine paintings with the prices. Ventura requested photographs of the paintings to take back to Florence. Ventura was interested in a large Cézanne, *Douler*, from the Kann collection, and a Picasso. Arrangements were made for final settlement on the next trip. The nine paintings had been confiscated by Einsatzstab Rosenberg; the prices assigned by the Foreign Currency Control were 37,750 reichsmarks each. Hofer's total value for the paintings in negotiating with Ventura was 540,000 reichsmarks. Ventura stated that Hofer's

established prices were very high. Hofer responded that the Reichsmarschall would find Ventura's objection unfriendly. In other words, the art had little value when confiscated from the French, but when Göring wanted the paintings for his own purpose, they were multiplied by 14 or more.

A month later, Hofer received a phone call from Florence requesting that he bring the French paintings on his next trip. The deal for the exchange had been accepted. On March 8, 1942, Hofer was in Florence and retrieved the paintings from the German embassy and handed them over to Ventura. The paintings were presented with a letter that they were pictures for restoration by Ventura's wife. This was done so Ventura could avoid paying import tax on the paintings. The paintings had been confiscated from the Kann, Rosenberg, Weinberger and Lindenbaum collections.

The following were purchases from Ventura:

Della Robbia	*Relief of an Angel* (102 × 61)
Toscana	*Angel of Annunciation* (× 150)
Fueehechio, Italian, 15 c.	*Before a Tournament* (45 × 84)
Master of Rimini	*Altar Piece* (39 × 47)
Master of Santa Orpe	*Madonna with Child* (58 × 36)
School of Guido Reni	*Mythological Scene with Man and Girl*

In the museum of the Palazzo Commune of Vipiteno in the Bolzano Province just south of the Brenner Pass, there were four highly prized panels by Hans Multscher, the Master of Sterzing Altarpiece. They were considered the most important pieces of art in this heavily German South Tyrolese area, which, then known as Sterzing, became part of Italy after World War I. Represented on their fronts

Master of Sterzing, *Nativity of Christ and Annunciation to Shepherds* (left) and *Flagellation of Christ* (opposite right). These Master of Sterzing paintings were presented to Hermann Göring for his 50th birthday on January 12, 1943, from Mussolini.

and backs were four scenes from the "Life of the Virgin": *Annunciation, Nativity, Adoration of the Magi,* and *Death of the Virgin,* and the "Passion": *Agony in the Garden, Flagellation, Christ Derided, Christ Bearing the Cross.* In 1458 artist Hans Multscher of Ulm was called to Sterzing and began his work with his pupils. These panels, painted between 1456 and 1458, had formerly been doors on the main altar of the parish church and were located in the various ecclesiastical buildings of Vipiteno.

Göring first spoke to Hofer about this altarpiece in early 1941 when he showed him a book containing reproductions of the sculptor Hans Multscher, who shared a workshop or worked in the immediate circle of the master of Sterzing Altarpiece. He then instructed Hofer to travel to Vipiteno, Italy, and report on the altarpiece. Hofer carried out the orders and brought back a detailed account of the objects, their state of preservation and their locations in the various ecclesiastical buildings in Vipiteno. He further included information regarding the conditions under which they could be purchased. This information was given to Göring's personal staff on June 6, 1941.[7]

Göring said he intended to propose an exchange with Mussolini for some well-known Italian works of art located in Germany. After several months, Göring told Hofer that the matter had been settled and that he would receive the altarpiece as a present from Mussolini. Göring had told Dino Alfrieri, the Italian ambassador to Germany, that

he would like to have the Sterzing Altarpiece in his private collection and that he "would not be able to sleep at night" until he got possession of it. Alfrieri then proposed to Mussolini that the pictures be given to Göring as a birthday present.

Even if the people of Vipiteno had been willing to part with their cherished pictures, the current law of Italy would not have permitted the gift, and there is no evidence that special legislation was enacted. The Fascist ministry informed the Commune of Vipiteno that Mussolini had decided to make the Sterzing Altarpiece

a gift to Göring and directed the commune to furnish details at once on the condition and value of the paintings, as the ministry would have to approve the transfer and export. After prolonged telephone conversations with the Fascist ministry, during which the commune appears to have raised every conceivable objection, they were authoritatively telegraphed on January 7, 1941, by the Fascist minister that a special diplomatic courier would arrive the next day to get the paintings. On January 8, 1941, the leader of the commune released the paintings to a courier who gave him a receipt and sent them off that evening as baggage on the fast train to Berlin.

Two days later, on January 10, 1941, the Fascist ministry decided to purchase from

the commune the painting that had already been sent to Berlin and also two wooden paintings, by an unknown German of the 15th century, depicting *The Visitation* and *Flight into Egypt*, which were the property of the local civic hospital. The value of the paintings was fixed at 9,000,0000 lire ($400,000), to be paid to the Commune of Vipiteno by the Fascist ministry.[8]

On his next birthday, January 12, 1941, these paintings were presented to Göring by the Italian ambassador in Berlin. Göring expressed a desire to gather all the scattered parts of this great German masterpiece and reconstruct it in Carinhall.[9] In its 500 year life, the work of Hans Multscher at Vipiteno had suffered many trials. The original altar was taken apart and scattered, the paintings were sent to the mayor's office, and the saints on the side were in the church at Spital, Austria. The shrine with the Madonna remained in the

Master of Sterzing, *Visitation,* taken from the Saint Margaret Church, Sterzing, Italy, and sent to Germany in 1941 as a gift to Hermann Göring.

Priest Church, while parts of the Pieta were in the Castle Museum at Ambras, and some figures of angels were in the National Museum in Munich. Thus, with the Sterzing Altarpiece, one of the most significant works of the late Gothic period had now passed into German possession.[10]

The property of the Naples Museum, consisting of 187 cases of sculpture and objets d'art was moved to the Monte Cassino Abbey on September 9 and 10 in 1943. During the battle for the abbey the Hermann Göring Division moved the treasures the following month to their rear headquarters at the Villa Colle-Ferreto, near Spoleto. Efforts were made by the German Army Group to have these valuables taken to the Vatican, but resistance by the Hermann Göring Division hindered these efforts. Finally, through the efforts of the pope, Italian fine art officials and the German art officials in Italy, the first shipment arrived in Rome on December 8, 1943, and was handed over to Vatican authorities along with the Monte Casino Library.[11] A few days later the second shipment arrived, bringing the number of cases to 172, fifteen short of the total number. The Germans explained that two trucks had not yet arrived because machine gun fire en route was bad. The Italian guards waited for the trucks, but they never arrived. After inspection, it was noted that the better paintings were missing. The Hermann Göring Division had taken the

Master of Sterzing, *Flight to Egypt*, oil on wood, taken from Saint Margaret Church and sent to Germany in 1941 as a gift to Göring.

15 cases north to their chief with the intention of presenting them to him for his birthday.

On July 4, 1944, Dr. Langsdorff, director of German art for Italy, ordered the art collection from the Palazzo Pitti and Uffizi galleries in Florence sent north of the Apennines to Marano sul Panaro near Bologna. The German division that removed them was told to offer the collection to the cardinal-archbishop of Bologna for safekeeping. Suspecting a trick, he refused to accept the collection and after much bickering it was sent towards the Brenner Pass and stored in two unused jails at Campo Tures. During this time, Langsdorff acquired several valuable paintings, *Adam* and *Eve* by Cranach being one of the more notable. Between the middle of June and September 1944, Langsdorff succeeded in transporting to Campo Tures the contents of five depositories of Italian state-owned art consisting of 532 pictures and 153 cases of sculpture. The private collections were also shipped, but in Italy the Germans did not attempt to seize Jewish collections.

After the collapse of Mussolini and during the retreat from Italy the Germans did a great deal of plundering, under the guise of aiding their ally to carry her art treasures to safety. The systematic burning of Italian libraries and the looting of villas and palaces occurred when discipline was lax and feelings ran high against Germany's former ally. During the shipment of these valuables the Italian Fascist government clamored for the return of the art to Italian control. The Italian ambassador in Berlin protested to Joachim von Ribbentrop, who promised to speak to the Führer. But it was to no avail. The Germans intended to keep what valuables they had obtained. These objets d'art were destined for Alt Aussee, but because of a lack of fuel only a few of the most valuable items left the rocky, northern Italian outpost of Campo Tures.

14

The Art Market in Switzerland

Switzerland was the only neutral country that made important contributions to the Göring Collection. The normal Swiss market had never been interesting to Göring because it offered mostly Impressionist works and modern art. However, during the war, there appeared suddenly a large number of paintings of the German school and it was in Switzerland that Göring purchased his best Cranach works. There were few, if any, collectors of early German art in Switzerland, and the appearance of these paintings probably meant that Germans who heard the Reichsmarschall was buying in Switzerland sent their paintings there to be sold. The Swiss import taxes for works of art were almost nonexistent and the prospect of payment in Swiss francs, one of the most stable currencies, made this a most attractive proposition. Many German accounts then concealed in secret Swiss banks were probably initiated in this manner. There is abundant evidence leading to this conclusion.

Switzerland had been attractive to German dealers before 1939 and many of them traveled there during the war. Many resided there, as some were Jewish, and others were there for business purposes only, such as Hans Adolf Wendland. The most important Swiss dealer was Theodor Fischer and he had always been in close contact with German dealers. In 1938, it was he who had auctioned the "degenerate art" in Lucerne that had been expelled from Germany by the Nazi government. Acting on a decree from Hitler and under advisement from Josef Goebbels, German museums disposed of modern art, including such works as van Gogh. The paintings were selected by art committees and dispensed from Germany. The museums were reimbursed in reichsmarks for the confiscated paintings by German government.[1] British pound notes were the prerequisite currency for purchasing the "degenerate" art from Fischer. The sale of these Expressionist and Impressionist paintings netted the German government 30,000 pounds in cash, which was transferred to an account of the Reichsbank in London.[2]

French Impressionist paintings, chosen by Wendland during one of his visits to Berlin, were transmitted to Switzerland through the German diplomatic pouch in order to avoid delay and complications. Wendland admitted offhandedly that the suggestion for this procedure may well have been his. The pictures went with the Foreign Office

courier to the German legation at Berne. There they were turned over by Riekmann, chief of the Courier Bureau, to Hofer, who had come into Switzerland at the same time. Hofer then accompanied them to Lucerne and there gave them to Wendland.

Three French Impressionist paintings were also included, as well as two or possibly three pictures bought by the Swiss arms manufacturer Buehrle from Dequoy in Paris. These were a David, *Self Portrait*, a Renoir, and possibly an alleged Titian, which Buehrle stated that he intended to donate to a Swiss museum. Wendland claimed to be unable to remember the method by which Buehrle's pictures were transmitted so conveniently from Paris, but it is possible that Wendland had begged this favor for his good friend and powerful protector. It is also possible that the favor was a gesture on Göring's behalf toward one who had made substantial deliveries of arms to Germany and who may also, as Hofer stated, have had an agreement with Göring regarding the supply of Swiss francs.

When the Impressionist pictures arrived in Lucerne late in 1941, Wendland noted that four of the finest pictures he had chosen were missing. These Wendland named as a Van Gogh—*Man with a Pipe*—a Jan Steen, and possibly a Van Gogh landscape and a Cézanne portrait. Hofer explained their absence with the cock-and-bull story that they were hanging in Göring's bedroom because Göring's nephew, a lieutenant, had grown too fond of them to bear to part with them. In 1943 Wendland accompanied Buehrle and a Zürich lawyer to a bank vault in Zürich for the purpose of viewing some paintings which, according to the lawyer who was the custodian of the key to the vault, were being offered for sale by a Dutch firm. The paintings were recognized by Wendland as the four missing paintings which were supposed to be adorning Göring's bedroom, and he advised Buehrle against buying them. The lawyer was undoubtedly Dr. Wiederkehr and the pictures were probably the following: Van Gogh, *Landscape*, sold to Buehrle; Jan Steen, *Marriage of Cana*; Cézanne, *Portrait*, held by Dr. Wiederkehr for Alois Miedl; and Van Gogh, *Self Portrait with Bandaged Ear*.

Göring himself never went to Switzerland. Hofer and Angerer were the only two agents active there and, of the two, Hofer was the more significant as he had lived there and was closely associated with the two most important figures, Fischer and Wendland. It was rumored Hofer was selling art there and was involved in espionage. True or false, the Swiss authorities took notice and, in May 1944, refused his entry visa to their country.[3]

15

Art Dealers in Switzerland

Fischer, Theodor, 17 Haldenstrasse, Lucerne. It was in 1920 that Wendland had met, in Berlin, Theodor Fischer of Lucerne. Fischer was an important established dealer, and the business arrangements between Wendland and Fischer became of primary importance in the career of Wendland. Fischer, through his large gallery and auction house in Lucerne, became the most important outlet for the works of art ferreted out by Wendland.

Fischer was both the most important of the Swiss dealers and the only one who did business on an international scale. All other small-business dealers depended on him in some way or other. Prior to and at the beginning of the war, Fischer had traveled to Berlin more than once and met with his chief associate, Wendland. But after hostilities, Fischer never went to Berlin, grumbling, according to Wendland, that "he was not going to run the risk of getting a bomb on his head just to see some pictures,"[1] but Wendland went there and made the choice of pictures. He was outstanding among the Swiss dealers for the large number of Einsatzstab Rosenberg confiscated paintings he acquired. Hofer reported that any of the German art objects which were presented by middlemen were located in Swiss banks "full of pictures."[2]

Göring was all set to purchase seven

Hans Grun, *Portrait of Knight of Malta*, Fischer Gallery, today in the Bavarian Museum, Munich, Bayerische Staatsgemäldsammlugen.

117

Cranach, *Madonna with Child*, originally from the Fischer Gallery, oil on wood, dated 1518 with Cranach's sign of the flying snake. A christening gift to Edda Göring from the Wallraf-Richartz Museum, the painting was presented by the mayor of Cologne, Konrad Adenauer, who became the first postwar chancellor of Germany. Today this Cranach resides in the Wallraf-Richartz Museum.

paintings from Fischer. Originally Göring had agreed to pay Fischer with Swiss francs, but due to a lack of Swiss francs he was unable to complete the transaction. During a visit to Berlin by Fischer, the ideas of an exchange of art was proposed to Fischer and he accepted. Fischer selected from a 54-page Einsatzstab Rosenberg appraisal list 25 paintings that he would take in exchange for the seven paintings. Wendland was presented as Fischer's advisor. Fischer would give Göring five by Cranach, one by Frankfurt Master, a triptych and a South German School (ca. 1500) *Statue of Female Saint Holding a Ring*. Fischer would receive six by Cottet, five by Degas, two by van Gogh, three by Sisley, a Renoir and eight better-noted paintings. The paintings Fischer selected had come from the Levi-Benzion, Kann and Lindenbaum collections, all taken from the Jeu de Paume.

These paintings were stored in Neuschwanstein Castle in Bavaria. They were sorted out by members of Einsatzstab Rosenberg, packed into two cases and signed out by Miss Margret Boesken and sent to Berlin accompanied by a Sergeant Jankel. Miss Limberger signed for the paintings on July 12,

Jacopo de Barbari, *Portrait of Man with a Flower*, Fischer Gallery, dated 1502. This work was purchased by Hofer before the beginning of the war and today is in the Bavarian Museum.

1941. The export permit from Germany and transportation from Berlin to Lucerne was arranged by Fischer. Göring's personal staff supplied Fischer with an official statement that the exchange was being conducted on Göring's behalf. The export permit was obtained and the paintings arrived on October 22, 1941. This concluded the first exchange.

The next exchange began in January 1942. Göring presented Fischer with a Coret, a Monet and a Sisley, all confiscated from the Rosenberg Collection in Bordeaux on September 14, 1941, in exchange for three tapestries (Brussels ca. 1530)—*Scenes from the Life of Scipic*—with a value of 100,000 Swiss francs. Wendland, on Fischer's behalf, chose the paintings from the Rosenberg Collection during one of his trips to Berlin. Fischer did not need an export permit for these paintings as they were taken to Switzerland by a German diplomatic courier.

On the next trade, working through Fischer, Wendland exchanged a Rembrandt, *Portrait of an Old Man with a Beard*—which according to Wendland he discovered in Marseilles, where it was offered to him by a French Jew who required payment in U.S. dollars—and two Flemish tapestries by Lucas van Leyden, *Skating Scene* and *The Fish Market*. In 1808 these tapestries were given by Napoleon to the Princess de Franceville. Wendland originally wanted 120,000 Swiss francs for the tapestries; however he finally

agreed to include the Rembrandt for 400,000 Swiss francs, to be paid half in cash and half in French 19th century paintings.[3]

Wendland consistently claimed that there was no formal relationship between Fischer and himself and that the percentage of participation in the art which they held jointly varied. Wendland states that he has no financial interest in the Fischer firm, and although he constantly refers to their joint dealings in terms of "we did this" or "our pictures," etc., it is very likely that their business relationship was an informal one. Theodor Fischer did not incorporate his business until January 1, 1945, and up to that time he is thought by the Swiss to have held all assets in his firm.

Wendland pointed out on several occasions that, because of his position as a German citizen resident in Switzerland, he was forbid-

Master of the Female Half, *Portrait of a Young Woman with Goblet*, Fischer Gallery. The Master of the Female Half was a painter or a studio artist from Antwerp, Holland, specializing in the paintings of young upper-class ladies.

den to sell on the Swiss market and that it was for this reason that he sold through Fischer. He has, however, admitted selling some art in Switzerland, and explains this by saying that he sold only enough to cover his actual living expenses in Switzerland — an arrangement which he feels was legal under the Swiss laws.

Whatever the actual arrangements may have been, it seems apparent that Fischer remained the businessman and Wendland, the stronger personality of the two, the salesman, gambler, connoisseur, agent and motivating factor in their joint dealings. Certainly all evidence indicates that it was Wendland who chose, and persuaded Fischer to accept, the looted art which came to Gallery Fischer during the war through exchanges with the Germans.

Following are some of these Swiss transactions:

Master of Sterzing	*St. George* (79 × 39)
Rubens	*Diana before the Hunt* (58.5 × 100)
Cranach	*Crucifixion of Christ* (35 × 54)
Master of Frankfurt	*Wing Altar* (60.5 × 39)
Cranach	*Paradise, Adam and Eve with Animals*
Cranach	*Repose on Flight to Egypt* (88 × 58)
Grien	*Portrait of Knight of Malta* (43 × 58)
Cranach	*St. Mary and Child St. John in Landscape*
Barbiari	*Portrait of Man with Flower* (35 × 24)
Poelenburgh	*Roman Ruins with Four Bathing Women*
Cranach	*Portrait of Melanchton* (19 × 13.5)
Cranach	*St. Anne and Child* (32.5 × 25)
15th c.	*Arm Chair*
South Germany, 1700	*Holy Virgin* (× 105)
Bavaria, about 1520	*St. Sebastian* (× 93)
Cranach	*Portrait of a Man* (53 × 45)
Cranach	*Madonna with Child* (56 × 38.5)
Schonganer, 1460	*Crucifixion of Christ* (52 × 35)
Cranach	*Portrait of a Gentleman*
Master of Female Half Figure	*Portrait of Young Woman with Pocal* (45 × 32)
Montagna	*Madonna and Child* (56 × 43)
Cranach	*Portrait of Christiane V. Eulenar* (63 × 44)
David German Isenbrand	*Madonna with Six Saints* (61 × 60.5)
South German	*St. Virgin* (× 102)

Giese Gallery, 9 Talstrasse, Zürich. Giese was a German resident for many years who worked with Hofer. Before and during the first years of the war he made a habit of going to Germany for six to eight weeks per year. He was involved in an espionage trial and finally expelled from Switzerland in 1944. He sold Göring the following:

South Germany 1480	*Whitsuntide*
Cranach	*Portrait of Frederic the Wise*
Cranach	*Friedrich der Weise*

Schmidlin, Maria, 7 Bahnhofstrasse, Zürich. Schmidlin's husband owned a large frame-making firm which did art dealing as a sideline. She was a German from Stuttgart and conducted the art transactions. Hofer denied purchasing any art from Mrs. Schmiblin but admitted that he visited her when he was in Switzerland. Records prove that he had in fact purchased a Cranach in 1940 and another in 1942 from Mrs. Schmidlin. She also sold a painting by Leibl to Joachim von Ribbentrop and Hofer delivered it to him at the Foreign Ministry in Berlin.

It was obvious that Hofer wanted to distance himself from Mrs. Schmidlin, as she was tried for espionage by the Swiss in connection with the activities of a German dealer, F.C. Valentine, also of Stuttgart, who asked her to provide him with copies of documents having to do with her husband's work. She and her husband were both interrogated and

may have been involved in some secret transmissions. She was acquitted, reportedly because she had not complied with the request, but she was kept under observation because she had not reported Valentine. She had previously introduced Hofer to Valentine and in a letter dated February 22, 1943, Valentine asked Hofer to give him the details of the case he had learned about through Miss Roeder, the daughter of Mrs. Schmidlin. Hofer, who was most careful, answered that he would not discuss such matters in a letter but offered to tell Valentine the story when he next came to Berlin. It was possible that Hofer acted as a messenger between Mrs. Schmidlin and Valentine and this may have had something to do with the Swiss refusal to issue him a visa in 1944.[4]

The following were purchased from Schmidtlin:

Lucas Cranach, ***Christ with Samaritan Woman at Well***, Schmidtlin Gallery, purchased on October 29, 1940, by Paul Koerner as a gift for the Reichsmarschall. Koerner was a senior administrator in the Hermann Göring Works.

Wertinger	*Portrait of a Man* (55 × 47)
Teniers, David	*Landscape with Figures* (33 × 44)
Cranach	*Christ with Samaritan Woman at Well*

Schulthess, Margrit, 36 Aeschenverstadt, Basel. Margrit Schulthess worked with Hofer and was a former friend of Reber. She was left with many debts to pay after her father's death. Reber owed her money and they were involved in a quarrel connected with a lawsuit over a painting by Gruenwald which Reber had tried to sell to Fritz Thyssen. She was associated with the German dealer F.C. Valentine. On March 30, 1943, she sent a painting

by Bernhard Strigel, *The Marriage of a Virgin*, to von Hummel, Martin Bormann's secretary in Munich.[5]

Paintings which were sold by Wendland to Hofer in Paris occasionally came to Göring bearing receipts purportedly from Mrs. Margrit Schulthess. In this manner, Hofer was able to obtain Swiss francs from Göring in payment for bills which he had settled in French francs. Wendland admitted to having given Hofer false receipts in order to enable him to obtain Swiss francs, but he denies ever having cognizance of the use of Mrs. Schulthess' name in this connection.[6]

The Schulthess transaction included the following:

Vermeyer	*Holy Family in Landscape*
School of Weyden	*Madonna with Child* (44.5 × 26)
Cranach School	*Lucretia* (62 × 41)

Master of the Female Half, *Lucretia*, Schulthess Gallery.

16

Göring's War Wealth

As the war continued, so did Göring's wealth. Works of art confiscated by Einsatzstab Rosenberg formed an important part of the Göring Collection. It was fairly estimated that they constituted nearly 50 percent of the total, as Einsatzstab Rosenberg alone supplied in the neighborhood of 700 objects. Göring had considered confiscated property as a source of his collection from the very outset. More than once a private collection was frozen by the Foreign Currency Control until it was proven the owner was not a Jew. During the time these assets were frozen, Hofer would stand by, hoping that the outcome of the investigation would make it possible for him to step in and choose items from the collection for the Reichsmarschall.

Göring's attitude towards these confiscations was characteristic. On the surface, he disparaged crude, undisguised looting; but he wanted the works of art and he took them. He always managed to find a way of giving at least the appearance of honesty, by a token payment or a promise of one to the confiscating party. Although he and his agents never had an official connection with the German confiscation organizations, they nevertheless used them to the fullest extent possible.

Incidentally, purchases and gifts were the most important aspect of Göring's collection and the gifts were given according to an unusual system. He preferred works of art to any other kind of present, but he wished to avoid receiving anything which did not fit into the overall scheme of his collection. So he worked out the following method: when he visited art dealers he would pick items for immediate delivery and select other objects of art that were put on "layaway" with the knowledge of Hofer. Later, when prominent friends wished to give Göring a gift, they consulted Hofer, who would put them in touch with the art dealer. Hofer would then suggest the work of art Göring had already chosen. That way Göring was happy with his own selections and his friends came off looking good.

The use of the exchange of art was a method of acquisition that was the most significant aspect of the formation of Göring's collection. The Reichsmarschall of the Greater German Reich considered property confiscated by his government for ideological reasons to be his own, to dispose of commercially as he saw fit. He also was not above resorting

to any trick, however low, to get what he wanted. The origin of the idea points to Hofer and Wendland as the men chiefly responsible. The primary reason for an exchange was the lack of foreign currency, which made it necessary for Göring to find something he could use instead of money. The paintings Göring used in exchanges cost him nothing in the first place and were a new way of buying cheaply.

His art collection was to be housed in a museum to be built at Carinhall. In describing the collection, Göring stated, "You have to differentiate between two entirely different sets of objects. First of all there were these objects which I had acquired from my own means, and which were my personal property, and which I intended for this gallery. Then there were those art objects that were acquired from the art budget, and I informed the Minister that the whole collection was supposed to be handed over to the people."[1] Göring's plans were to turn over the gallery in the beginning of the year 1953. This late date was to avoid a conflict with the grand establishment of the Führer Linz Museum, the art Hohe Schule that Rosenberg was going to build at Chiemsee, the expansion of the Kaiser Frederick Museum in Berlin, and the art museum to be erected in Koenigsberg, Prussia, containing mostly Polish art treasures.[2]

Each January 12, Göring had a large birthday party at Carinhall. It was not unusual for him to receive several rooms full of paintings. On his 51st birthday, he received from Hitler a most expensive gift — two German state insignia with 36 diamonds. And then he received a memorial case for the Grand Cross that was made of brown leather with small diamonds.

To Göring's enormous annoyance, he was compelled to refuse the greatest birthday gift ever offered to him, the art treasures from Monte Cassino. As the Allies continued their advance up the Italian boot, the Naples Museum art was removed by the Hermann Göring Division from the monastery and 15 cases were taken to Reinickendorf, the headquarters of the Hermann Göring Division. The remainder were sent to Rome and presented to the pope. It was the intent of the officers to present this collection to Göring as a surprise on his birthday. With that in mind, the collection was sent to Carinhall and Hofer set to work preparing it for Göring's 50th birthday on January 12, 1944.

However, Miss Limberger heard about this and immediately told Göring, who called in Hofer and told him that under no circumstances would he allow such a thing to be presented to him on his birthday. He gave instructions that they be set aside as a temporary exhibit in Carinhall. A few months later the paintings were moved to an antiaircraft shelter at Krufürst. The sculpture and other objects of art remained in Carinhall. About a year later Göring suddenly ordered Hofer to send all the artwork from Monte Cassino to the Reich chancellery, where they were turned over to Bormann to be included with the Führer Collection. All of the objects from Monte Cassino were turned over to Einsatzstab Rosenberg and then sent to the Steinberg Salt Mine at Alt Aussee, arriving there on March 25, 1945.[3]

Two of Göring's most carefully negotiated acquisitions were obtained from the Louvre in March 1944. These sumptuous works were the wooden statue of *St. Mary Magadalena* by Gregor Erhart and an altarpiece by the Masters of the Holy Kinship, an artist of the Cologne School of the 15th century. The center panel was the *Presentation of Christ in the Temple*, the right panel the *Adoration of the Magi* and the left panel *Christ Appearing*

to Mary. Göring, after much maneuvering, obtained these two works of art in exchange for two sculptures and three paintings from his collection. These exchanges were of doubtful origin.

In acquiring his vast collection of art, Göring traded, bargained, swindled or pawned and as a last resort used cash. Despite all sorts of legalistic shenanigans it was generally the pressure of Göring's name and position that finally closed the deal. There is little doubt about the claim Göring made that he possessed the most valuable art collection in the world. His pieces were estimated to be valued at more than $200,000,000 at that time.

The use of different currencies was the most important aspect of Göring's purchasing power. He took advantage of every loophole afforded by the German law as it extended over conquered Europe. These loopholes were his chief means of camouflaging the overwhelming majority of his transactions, which were made possible only by the war and never could have been carried out under normal conditions. To present a facade of legality in acquiring his art, Geisla Limberger, a chain-smoking, heavy-drinking librarian, kept detailed records of the collection. She photographed, catalogued and documented each piece.

Göring liked to refer to himself as the "renaissance type" and he consciously played this role. The business of collecting art dominated every phase of his life and he intended the collection to be a monument to his name. In 1939 it numbered about 200 objects. By the end of World War II, he had acquired 1,375 paintings, 250 sculptures, 108 tapestries, 200 pieces of period furniture, 60 Persian and French rugs, 75 stained glass windows and 175 other objects of art.

The most striking fact about Göring's collection is the extraordinary amount of time he spent in looking for works of art, even in the most crucial years of the war. He made trips, displacing his entire military staff and special trains, solely for the purpose of visiting a dealer. No matter the circumstance, he always found time to stop to consider the purchase of something new. Toward the end of the war, when prices soared to astronomical heights, he formulated a plan by which to control the market. He always expressed his astonishment at the variation in value of different paintings. In short, he was a passionate collector, and all who knew him concurred that he was.

In the general lurid picture of Europe during the last days of World War II — with its wrecked cities, uprooted farmlands, demolished transportation facilities and public utilities, with its starvation, disease, ashes, rubble and death — Göring continued to wine and dine at Carinhall. In scenes of Roman luxury, he feasted, hunted and entertained while dressed like an Oriental rajah or in a light blue uniform with a jeweled baton of pure gold. The house contained a domed library with a 26-foot-long desk of mahogany with bronze inlaid swastikas. The library also contained a pornographic table supported by four large replicated penises, each inserted through a pair of female breasts. On the lawns of Carinhall were carved French cupids, Greek satyrs, busts of Roman matrons, alabaster vases, Renaissance sundials and tons of weathered antiques and classical garden trimmings. His birthday party in 1945, held in this opulent setting, was considered most inappropriate with its hundreds of pictures, guarded at all times by Göring's paratroopers.

The history of the Göring Collection is a perfect reflection of the character of its creator and the political regime for which he stood. Due to the blatancy of the gifts the

Reichsmarschall received during this critical time of the war, Otto Ohlendorf, head of the Central Security Office, investigated the affair and submitted a report to Himmler. To Ohlendorf's complete surprise, he was instructed to destroy the report and all documents relating to the investigation — a surprise because Ohlendorf knew that Himmler absolutely loathed Göring.

Much to Göring's dismay, Himmler had a special section of trained security policemen assigned to protect him. They never wore uniforms and were always present everywhere with Göring and his wife. Their duties were to protect Göring and at the same time watch him and report his actions to Himmler. During the last years of the war they were generally referred to as his "keepers" rather than as his protectors. This may have been a classic example of the fox guarding the henhouse, as Himmler had established the Ahnenerbe, an organization that may well have surpassed Göring in the scope of looting.

It is possible that some of Göring's collection was removed to Spain by Alois Miedl. In February 1944, Alois Miedl, a native of Germany and naturalized Dutchman, asked Göring for permission to move his family to Spain. Göring arranged for Miedl's wife to obtain an exit visa from Holland to Spain. The required permission from customs was waived and Miedl's household went to Spain — along with many paintings from the Goudstikker Collection. A few months later, Miedl went through Switzerland to Spain. Otto Ohlendorf stated this was done in order for Miedl to establish a nest egg of currency for Göring. Ohlendorf added that "the fact is no one dared to investigate Miedl because everyone knew that he was a good friend of Göring's and therefore under his protection."[4]

Indeed, Miedl had received special privileges due to his relations with Göring. Miedl, formerly of Munich, had established his residence in Amsterdam in 1933 and engaged himself there in various businesses. He became the owner of a bank and managed several firms. From about 1938 he became engaged in the art trade by buying paintings in Germany and selling them in Holland. This relation to the Dutch art trade is how he established himself with the Goudstikker agency. Later on, after his acquisition of the Goudstikker Collection, he established a large loan through the Shantung Handels, from the Landsvolkbank in Berlin. The loan was guaranteed by Miedl and his Goudstikker agency by pledging as security paintings and carpets. On July 1, 1944, the loan was due and the amount in arrears was 1,776,753.65 reichsmarks. Therefore the paintings were sold at public auction in Germany and the proceeds were made as payment to the bank. The most valuable painting, Rembrandt's *Young Man With a Sword*, was sold and then delivered to Georg Spitz, who usually "fronted" for Heinrich Hoffmann.[5]

Miedl's activities in the art field had come to the Allies' attention when confidential reports surfaced that he had reached Spain with a number of paintings and was seeking safe haven for the paintings and his family. A number of his paintings were presumably smuggled into Spain, while others entered through the firm Baquera, Kusche y Martin and were stored in the free port of Bilbao. The Spanish government granted permission to have the paintings examined by Dutch officials and members of the United States embassy. This led to the positive identification of the paintings as being Dutch in origin, with 13 bearing the Goudstikker label. The paintings were frozen by order of the Spanish government. It is almost impossible to track Miedl and his activities after he reached Spain. Again he had embedded himself with some powerful protectors.

17

The Flight from Berlin

The Allies made their summary move against Fortress Europe in Normandy: the D-Day attack of June 6, 1944. Five months later three million Allied troops were in France preparing to smash the West Wall, or "Siegfried Line," and crash through Germany, but Germany made a massive counterattack in the Ardennes. This counterattack, the Battle of the Bulge, would be Germany's final blitzkrieg. After one month of bitter fighting, the German Ardennes offensive failed and the U.S. Army penetrated the West Wall into Germany. In March 1945, the U.S. Army crossed the Rhine River for the first time and dashed across Germany into the Eastern state of Thuringia.

In late January, with the Allies advancing from the west and Soviet forces closing in from the east, Göring decided to move his collection away from Berlin to the south of Germany. He had his train Sonderzug sent from Forst Zinna near Jüterbog north about 25 miles to Berlin. Attached to the train were six normal freight cars and three autopackers, freight cars for the transport of motor vehicles, and two French freight cars. The train continued on to Carinhall and here Göring himself went through Carinhall with Hofer and pointed out what he wanted to send immediately and what should wait for later transportation. It was Göring's intentions to leave behind all the objects he had obtained from Einsatzstab Rosenberg. Hofer insisted these items be removed and the Reichsmarschall consented to his request. Five of the normal freight cars were packed with treasures from the Kurfuerst bunker near Potsdam and Carinhall. The autopackers contained antique furniture, several large paintings, gramophone records and the libraries of Göring and Hofer. The two French freight cars were loaded with food. The dining car was loaded with the personal belongings of Generaloberest Loerzer and Göring's sister, Olga Rigele.[1]

On February 17, 1945, Hofer had the selected objects packed. They were trucked to the local train station, placed aboard Göring's special train Sonderzug, and sent to Neuhaus for storage in Veldenstein Castle. The air raid shelter being built for this collection had not been completed at Obersalzberg and this is what necessitated the shipment to the castle. As a result, only the smaller objets d'art could be shipped because of the small rooms in the castle. Hofer and Heinrich Gerch traveled with the train, and upon arriving at Neuhaus station they had the objects unloaded onto trucks and stored in the castle

according to special instruction sent down by Göring and carried out under the supervision of the architect Hetzeldt.[2]

When Christa Gormanns arrived that spring, Veldenstein Castle was stuffed with art objects. They were crammed into empty rooms, some in the tower and the rest in other parts of the castle. Neither Gormanns nor Göring was in Veldenstein when the art arrived or left. Mr. Hofer was in complete charge of packing and moving Göring's vast works of art.[3]

In March some items were removed from the Kurfuerst shelter, loaded onto the special train Vorzug, and transported to Carinhall. Here other valuables selected by Göring were packed with Hofer's help and sent to Veldenstein Castle. In early April the third shipment containing everything that was left in the air raid shelter and most of what remained in Carinhall had been loaded onto one of Göring's special trains about 10 miles north of Carinhall at Vogelsang. At the last minute an order was received that the train remain there until further notice. Hofer was instructed to travel to Veldenstein. On approximately April 5, Fritz Goernnert appeared in Veldenstein with orders from Göring that all objects were to be packed and loaded onto special train Sonderzug, there to await an imminent move. Some tapestries, sculpture and paintings that had been in Veldenstein Castle were left there with Georg Schrembs. After a week of waiting the train was sent to Piding, 15 miles west of Salzburg. Here it made contact with the Verzug from Vogelsang. On April 16, 1945, the two trains containing the valuables arrived in Berchtesgaden.[4]

In Carinhall there remained a few exceptional paintings, some of the heavier sculpture, such as the Greek *Venus* presented to Göring by Italian field marshall Balbo, and some decorative garden pieces. There also remained sets of chairs and sofas which stood in the music room and main hall that had been seized by Einsatzstab Rosenberg. A series of nine Brussels tapestries representing hunting scenes, after designs by Rubens, that had been lent to Göring by the Vienna Art History Museum remained in the Kurfuerst shelter. As Hofer later stated, they were left "for further safekeeping."[5] *The Bagatelle Ceiling* and furniture were never removed from the Ringenwalde home. Everything stored in the model farm at Collin was also left behind. All of this art was overrun by Soviet forces.

When the trains arrived in Berchtesgaden they were parked in the station tunnel. Hofer was in charge of the trains and lived in one of the cars. Thus, on April 12, all trains were together in Berchtesgaden. Goernnert was responsible for unloading the trains and placing all the valuables into a secure area. He began by finding secure places to store his own valuables, which amounted to about 50 cases. Thus two weeks were lost in moving Goernnert's valuables. Göring's art treasures remained in the trains, which were pulled into the tunnel whenever the air raid sirens sounded. One or two days later one of the trains, with eight baggage cars, was sent to the village of Unterstein.

Göring left Berlin on the night of April 20 and arrived at his villa in Obersalzberg the following evening. Upon arriving, he told his wife that his secretary, Miss Limberger, had mishandled the private property they owned and that almost everything they had which was meant for their child, Edda, was lost.[6] Göring made the same statement to Miss Gormanns: "That good old Limberger through her neglect and disorder has caused me to lose my private fortune."[7] It appears that Limberger had allowed some life insurance policies that favored his wife and daughter to lapse. As a result of this and other mistakes,

Limberger was *persona non grata* and had left Carinhall for the house of a friend, Dr. Huber, in Mattsee, near Salzburg, Austria. At this time Göring gave Christa Gormanns the painting *Christ and the Sinner* by Vermeer; he made the remark that from the sale of that painting her family might be able to live one day.[8]

During the night of April 22, 1945, General Koller followed Göring to Berchtesgaden by airplane and reported to him that Hitler had decided to stay and die in Berlin. Thereupon Göring sent a telegram to Hitler informing him that, in view of Hitler's former appointment of Göring as his successor, he would assume full control of the German Reich unless he received orders to the contrary by 10:00 that night. He was encouraged in his actions by a remark Hitler is supposed to have made on being told that it was high time to start negotiations with the Allies. "I can never do that," Hitler allegedly said. "Göring can do much better."[9]

The clearly obedient telegram that Göring wrote was too long in its original form; according to orders, in this deteriorated situation, all radiograms had to be as short as possible. The shortened form was read in Berlin as an ultimatum. It was sent at 3:00 P.M. Seven hours later Göring was put under house arrest by SS troops. This was not a simple task, as Göring's permanent guard numbered about 1,000 men. In the early evening, a great number of SS troops arrived. Göring's guards on post were under the impression that the troops were merely reinforcements. Once the entire zone around Göring's home was surrounded, his staff was placed under custody. All telephone communications were immediately broken, and Göring's home and air raid shelter were searched and cash and weapons were taken.[10] The following people in his entourage were also detained:

Emmy Göring and their seven-year-old daughter, Edda

Miss Elsa Sonnemann, Emmy's 57-year-old sister

Mrs. Ellen Kiurina and her 3-year-old child. Kiurina was the 26-year-old niece of Emmy Göring and an actress by profession. She lived in Berlin with the Görings from 1937 to 1939 while attending stage school. From 1939 to 1941 she acted under the stage name of Ellen Segall. She became very ill after the birth of her son and because of that illness and the insecure conditions in Germany she had been saying in the Göring household since 1943. Her husband, Hubert, was in the army, but he stayed in Berlin because his services were claimed by the theater. He left Berlin before Soviet forces arrived and went to the Isle of Sylt, presumably to surrender to British forces.[11]

Reichsleiter Philip Bouhler and his wife. Bouhler was born in Munich on September 2, 1899, and was severely wounded in World War I. He had held a number of positions with various German publishing industries. In 1939 he was responsible both for the killing of disabled children within the scope of the so-called child euthanasia and for the killing of inmates of institutions pursuant to the "euthanasia" decree. Bouhler was also involved in the extermination of Jews in Poland. He committed suicide in May 1945 after being arrested by soldiers of the American army. His wife committed suicide by jumping out of a window at Fischhorn Castle in the early part of June 1945.

Colonel Bernd von Brauchitsch, son of Field Marshall Walther von Brauchitsch

Lieutenant Colonel Werner Teske, adjutant to Göring for five years
Major Muelle
Lieutenant Colonel Klass
One Luftwaffe soldier at the switchboard
Robert Kropp, Göring's valet
Lisakofsky, the cook, and his wife and two children
General Houseman Zyschky, his wife, and two children
Karl Eichmann, a servant
Irena Schultz, Emmy Göring's secretary
Cilly Wachowiak, a maid who had worked for the Göring family since 1930.
Mrs. Paula Hueber, Hermann Göring's sister, and Roswitha, her 14-year-old
 daughter
Miss Martha Mader, Edda's teacher since July 15, 1943, when she replaced Edda's
 nurse. Mader was highly educated linguist, pretty and blond.
Miss Elsa Altmann, Mrs. Göring's personal maid ("I am a personal maid, taking care
 of Frau Göring. I bath her, dress her, take care of her washing and her room and
 dress her hair."[12])
Miss Christa Gormanns

Simultaneously, General Erwin Schulz, commander of Security Police for the Salzburg District, was notified that, under orders of the Führer, Göring was to be arrested and any attempt at flight was to be prevented. Schultz immediately ordered the three airfields in the area guarded and any attempted flight was to be prevented. All roads leading from Obersalzberg were to be blocked and all communications by telephone were to be cut. Since the particular circumstances were unknown to General Schulz, he traveled to Obersalzberg, arriving in the early morning hours of the next day. Schulz was told by the chief of staff of the SS that everything was quiet and the whole incident, in his opinion, was the result of a misunderstanding. Schultz felt his mission was completed and he removed the restrictions on the airfield and arrived back in Salzburg at 5:00 in the morning.[13]

A telegram signed by Hitler then arrived, giving Göring two choices: to be executed for treason or to resign all his offices under the pretense of a heart attack. The radiogram began: "Your treachery in the darkest hour of the Fatherland can be avenged only by death."[14] The death penalty would also be applied to his wife and child.[15] According to Göring's interpretation, this referred only to the office he was holding at the time and did not include his appointment as Hitler's successor. A second telegram arrived signed by the Führer — which Göring said was a fake since it was sent after Hitler's death by Martin Bormann, the secretary of the Nazi Party — sentencing him and his family to death.[16]

In a later, secretly taped conversation between the Reichsmarschall and Hans Heinrich, Göring told Heinrich, "I have always known that, in the event of something happening to the Führer, my life would be in the greatest danger in the following 48 hours. After that time I would have performed the swearing in, and it would have been a legal fact. At any rate, I would have carried out two personal actions immediately: the arrest of Bormann and the firing of Ribbentrop. They were thorns in my side."[17]

Christa Gormanns was arrested along with Göring and confined to her room for the first two hours. Then she was allowed to take food from the kitchen and carry it to Göring's room, but she was warned not to speak to him or anyone else. That same night the SS made a search of the villa and took away a trunk containing Göring's personal documents, 150,000 reichsmarks and other items. They left Mrs. Göring's case containing her personal jewelry.[18]

Kurt Hegeler, Emmy Göring's chauffer for ten years, had made a good impression on her and she considered him a good and honest person. He did not have much to do because of the gasoline shortage and he helped out wherever needed. On April 21, when Göring and his staff were arrested, Hegeler, the lowly chauffer, was permitted to go in and out freely. On the night of April 23 he asked Frau Göring if there was anything he could do, such as telephone a Luftwaffe regiment of general officers that could help, as he pointed out their fate was now unfortunately in the hands of Martin Bormann. She responded that the whole thing was probably a mistake that would be cleared up in the morning. Hegeler then turned about abruptly and left. Going downstairs, he met Frau Göring's personal maid, Else Altmann, and asked her for Frau Göring's jewels on the pretense of taking them to a safe place. Altmann responded that she could not give him the jewels without permission. He then left and later drove off in a large American-made Chrysler.

Meanwhile, General Erwin Schulz had received orders from Berlin that everyone arrested at Obersalzberg were to be taken to the provincial court prison in Salzburg. He considered this impractical and later a radiogram arrived advising him to hold Göring and his staff in Göring's castle at Mauterndorf. Schulz recommended releasing the guards, employees and children. While Schulz was awaiting a decision from Ernst Kaltenbrunner regarding the release, on April 25, 1945, at nine in the morning, hundreds of British Lancaster bombers made an air attack on Obersalzberg and everything was completely destroyed in fifteen minutes. During the bombing, Göring's entourage went through the cellar, where the jewelry was kept in a small closet, to an air raid shelter below the cellar. After the raid, the Reichsmarschall asked his wife where her jewelry was and she stated that it was upstairs in the cellar closet. She then asked SS sergeant Helmut Meyers, one of the bodyguards, to go upstairs and get the jewelry. Meyer then went upstairs and brought the satchel containing the jewelry down to Emmy Göring.

As the more than 50 homes at Obersalzberg had been mostly destroyed by the devastating air attack, the group left Göring's small bunker and went to the large air raid shelter built by Göring's next door neighbor, Martin Bormann. Mrs. Göring stated, "The next three days were spent in the air raid shelter with the satchel constantly next to me, or between me and my husband. From there we left for Mauterndorf, where [about three days later] a friend of mine asked me for a pen and this caused me to open my satchel. To make it short, I found the rubies missing. When I looked carefully through the satchel, I found about one-half of my jewelry missing."[19] (At this place in the record of the interrogation is typed: "NOTE: if Hegeler did take the jewels, the place where he probably would have taken them is at the Jewelry Shop in Paris owned by the father of a girlfriend of his.")

Indeed, on the night of April 27, as the Allied forces were closing in on Berchtesgaden,

SS troops set fire to the partially damaged building in Obersalzberg as Göring's entourage was split with the arrested guards, and some of Göring's staff left on trucks, under the guard of a large group of SS troops, for Salzburg. Here they were allowed living quarters in the Glasenbach Army Barracks.[20]

Göring, his immediate staff and Bouhler left Obersalzburg under SS guard and traveled 50 miles south to Castle Mauterndorf. This castle had been left to Göring or his daughter by Mrs. Lilly Epenstein. In spite of the continuing war the castle had been extensively refurbished by Göring. Here they remained under close guard by the SS until May 5, when news came from General Keller that he had obtained a release from the new chief of the Luftwaffe, General Ritter von Greim. There were still difficulties, as the SS did not report to the Luftwaffe and had no orders to that effect, but the treatment of the prisoners was immediately better. Göring had been cut off from all news and immediately tried to obtain information regarding the current situation of the German military.

Goernnert, along with Göring, had been arrested by the SS. On April 30 Goernnert was released and returned to Berchtesgaden with orders to unload the train and place the objects into the large unfinished air raid shelter situated along the road from Berchtesgaden and Koenigsee. The important paintings were taken out first and packed into new cases. Then they were removed from the cases after it was discovered that the shelter was too small to hold the entire collection. Goernnert had orders from Göring that all

Nicolas Laucret, *Picnic Partly*, Rothschild Collection. When Allied troops advanced into Berchtesgaden they sprayed Göring's stationary train with .50-caliber machine gun bullets. This is one of several paintings damaged by the bullets. The hole is by the dog on the left.

material from Einsatzstab Rosenberg was to be left on the train if any questions of priority arose.[21]

When nothing more would fit into the bunker, Goernnert decided to store some of the small paintings and very large rolled paintings on the premises of one of the local Nazi officials, Johann Winkler, who owned a large grocery store. The art objects of lesser value which were left over were loaded back into the baggage cars and moved to the village of Unterstein. The cars containing furniture, Göring's library and his personal records (Stabamt) were left in the tunnel.

During this time, Gerch had come from Mauterndorf with a message from Göring requesting 15 to 20 tapestries, which Gerch took back with him. In addition to the tapestries Göring had with him the Rothschild Memling, *Madonna with Child*; the Renders Memling, *Madonna with Child*; the Roger van der Weyden, *Madonna with Child*; the Vermeer/van Meegeren *Christ and the Woman Taken in Adultery*; and his personal jewelry. Emmy Göring had some jewelry and four small Memling angels from the Goudstikker Collection.

Immediately after the Allied bombing of Obersalzberg, civilians started looting everywhere, and when the Allies took over the looting continued for several more days. On May 4, 1945, as United States troops captured Berchtesgaden, Oberkommissaer Boos described the looting of one of Göring's trains just before the arrival of the Americans: "Innumerable persons [German civilians] moving ant like from all directions towards Unterstein station. The whole population seemed to be on their legs fighting to get into the cars, carrying heavy loads, cutting up big carpets, beating and scratching each other in their greed to conquer a part of Göring's heritage."[22] Boos, at first rather reluctant to interfere, fired a shot into the air and as a result most of the looters disappeared. About 4:30 the troops arrived and disarmed Boos and ordered him to collect the objects lying around near the train and in the neighborhood of the station.

Mrs. Joseph Pfnür, in whose house was found a rug from the train, offered a creditable-sounding alibi. She was prevented from looting, she said, because of the death of her mother. While her mother lay in state in the living room, her daughter was desperately trying to find an undertaker. The day the Allied soldiers raided the home, her mother's body smelt so bad the soldiers left the house in a hurry.

About May 15, the two-story, cement and steel reinforced bunker containing most of Göring's art collection was discovered by members of the 2nd Platoon, Company A, of the 1269th Combat Engineers, which had been assigned to the army intelligence unit known as T Force. The location had been revealed by the interrogation of a prisoner of war who had helped build the bunker. They then carefully dug through a freshly poured cement wall and there was the treasure. This unit of 40 men, under the supervision of Captain Harry Anderson, immediately began moving the art from the dripping bunker. They carried the works of art in a hodge-podge manner up a trail in the forest and loaded them onto uncovered army trucks. The heavy sculpture was loaded into a wheelbarrow, with a blanket for padding, and transferred to the trucks. The objects were stored in a requisitioned dry, fireproof hotel at Unterstein that had been used as a rest center for the Luftwaffe.

During the three days it took to empty the bunker, Layton F. Jones removed a sil-

ver-bound copy of *Mein Kampf* and sold it to a private collector.[23] Göring's Carinhall guestbook, bound in solid silver, was taken and presented to General Maxwell Taylor, who donated the volume to the West Point Military Academy in 1948. Sergeant Robert Thibodaux removed the baton presented to Göring by Italian field marshall Balbo. Thibodaux also walked off with Göring's wedding sword, today valued at more than 500 thousand dollars. Both items are today in private collections. But the person who collected the best was the commander of the 2nd Platoon, Lieutenant Warren Eckberg, who took a large diamond-encrusted solid gold medallion hanging from a gold chain and one of Göring's diamond-studded batons given to him by the Führer.[24]

Hofer appeared and offered his assistance to Captain Anderson, who was already moving art objects from the air raid shelter to Unterstein. Two or three days later he and Anderson went to the Berchtesgaden station and found that the baggage cars in the tunnel had been plundered and wrecked by the local population and soldiers. A similar fate had overtaken the baggage cars parked in Unterstein. Army trucks were backed up to the baggage cars and the art, handled with vigor, was loaded by members of the 101st and stored in the Unterstein hotel. When they visited Göring's house in Obersalzberg, they found it too had been plundered.

James J. Rorimer arrived and, following up on the remarks of a trainman, found the paintings that Goernnert had taken to the residence of Johann Winkler, the owner of a grocery store. The art objects were stored in a large garage next door. He discovered a bundle

A binder of documents taken from the Göring train at Berchtesgaden by U.S. Military Intelligence. The cover reads: Military Personal Documents of the Reichsmarschall of the Greater Germany Reich—since 1905—arranged by special school administrator Gritzbach.

of tapestries and about 100 of Göring's best paintings. Rorimer was reluctant to move these pieces in an open army truck. But considering the conditions, the two-and-a-half army trucks were used. Rorimer tried to impress upon the Airborne troops the nature and importance of their cargo without much success, as the paintings were unloaded mishmash and stored against Rembrandts and Rubenses.[25] Anderson ordered Hofer to begin an inventory of the collection indicating the source and value of each object. This was a large job as the collection filled 40 rooms in the hotel. Hofer's wife, a restorer, was instructed to begin the work of first aid to the objects which had been damaged by the dampness in the bunker.[26]

A few days later, U.S. Army intelligence removed many documents from the train that included a large Russian loose-leaf atlas, a secret photograph album of the German 5th Luftwaffe during it operations in Norway, two large Russian atlases, an autographed pamphlet by Sven Tunberg, a catalogue of old paintings in connection with Göring's art treasures, and four folders of names and addresses concerning SS leaders. Overall, 11,000 books were removed from the train. Thousands of these maps, books and photo albums are today in the Library of Congress. Göring's World War I records and many of the letters from Göring's first wife, Carin, were removed and are today archived in the U.S. Army Military History Institute, Carlisle, Pennsylvania. While searching through the Göring train, intelligence officer George Allen reported, he "found enough drugs in the bedroom of his [Göring's] train to kill about 30 men."[27]

In a clearing on the left side of the road was a low rambling structure of whitewashed stucco in the familiar farmhouse style, and it was here Göring's art collection was stored — a hotel at Unterstein that had been a rest and recreation center for the German Air Force. The center section, three stories high, had a gabled roof with wide overhanging eaves. On either side were long wings two stories high. Inside was the Göring Art Collection. The 101st Airborne Division had placed on display the world's most valuable private art collection — Göring's collections of Rubenses, Rembrandts, van Dycks, Valázquezes, Bouchers, and, incredibly, 52 Lucas Cranachs.

18

Göring's Capture

On the evening of May 7, 1945, the German First Army and the U.S. Seventh Army had negotiated a cease-fire and both units agreed to stop troop movements as well as to cease shooting at each other. During this time, Göring sent a note to Seventh Army headquarters in Kitzbühel, informing them that he would meet the Americans at Fischhorn Castle at Zell am See, at which time he wished to surrender. On May 8, 1945, the day of the surrender of Germany, General Robert L. Stack, assistant division commander of the U.S. 36th Infantry Division, traveled to the castle. At the time of their arrival the castle was occupied by armed troops of the Waffen SS Florian Geyer Division. This castle had been headquarters for the high command of that division throughout the war. Stack was informed that Göring was being held up due to German roadblocks and snow on the roads.

At that point Stack, his aide, Lieutenant Bond, and a German major drove away in a jeep and a staff car in the general direction toward Göring. They were no more than 30 miles from Mauterndorf Castle when they found the Reichsmarschall and his household stopped on a country road. Stack told him that he had received his letter and that he would accept his surrender immediately. Stack further told Göring he would take him to Fischhorn Castle at Zell am See that night and that then Göring would be sent to Seventh Army headquarters either that night or the next day.

It was about 8:30 P.M. as the entourage headed back towards Fischhorn Castle, arriving around midnight. Stack made the decision to spend the night at the castle.[1] He immediately notified the 36th Division commander, General John E. Dahlquist, that he had arrested Göring. The following morning Stack had the SS troops disarmed and at about 10:00 A.M. left in his staff car, followed by Göring, on the trip to command headquarters located in the Grand Hotel at Kitzbühel

There the Reichsmarschall was loaded into a small two-seater liaison and flown to Augsburg, Germany, the U.S. Seventh Army headquarters and interrogation center. Göring was taken to the office of General Arthur White, the chief of staff. (The Seventh Army commander, General Alexander M. Patch, was at the command post of XV Corps, so Göring had to be brought to the second in command.) As Göring entered, White motioned

him towards a chair. Göring sat down in the small straight-back chair, hardly designed for a man of his girth. He appeared very ill at ease and was sweating profusely.

General White asked Göring about his family and assured him that no harm would befall them and that they would be kept under American guard. Göring replied with a bow and a thank you. White then told Göring that he would be quartered in the vicinity according to whatever means was available to an army in the field. The general then rose and nodded to indicate that the interview was over. Göring rose, clicked his heels, raised his baton in a salute, and did not wait long for a return salute that never came.

As Göring left, White told Colonel William W. Quinn that Göring's baton was the badge of office of a field marshal, just as a sword or saber is the badge of an officer of lesser grade. Quinn was instructed to take the $30,000 baton from Göring, and when General Patch returned the baton was presented to him as a token of surrender of the man who had identified himself as Hitler's successor.[2] Also taken from Göring was his Smith & Wesson police revolver with holster and a unique bronze and leather hunting dagger that he was wearing.

(Patch returned to the U.S. in June 1945 and presented the baton to President Harry Truman, who kept it on his desk for a while and then returned it to General Patch. The 56-year-old Patch was then assigned as commanding general of the Fourth Army, Fort Sam Houston, Texas, until his untimely death from pneumonia on November 21, 1945. On March 23, 1946, Göring's baton, pistol and dagger were turned over to West Point, where they remain today.)

Robert Kropp, Göring's personal valet since 1933, had traveled by car and arrived on May 9 at 10:00 P.M. at Seventh Army headquarters. He was immediately allowed to assume his duties for Göring. On May 15, Major Paul Kubala telephoned Colonel Quinn and informed him that the Reichsmarschall had stated that he had a very famous painting and that if he were allowed to collect some clothes he would turn the paintings over to the military authorities. Kubala asked if he could send one of his men to collect the painting. Quinn instructed Kubala to type a note addressed to Mrs. Göring for the Reichsmarschall's signature instructing her to turn over to the officer the painting, as well as shirts, underwear and other clothing.

Göring then told his valet, Kropp, to accompany the officer to Fischhorn Castle at Zell am See, where Emmy Göring was still staying, and to bring him a uniform to wear to a conference that he thought was scheduled with Eisenhower. Göring requested his best uniform — the Bismarck Rock, a uniform of the Old Prussian Political Party. He also requested that Kropp bring back a small painting that he had promised to Major Kubala.[3]

After graduating from the Washington University School of Law, George P. Mueller entered the U.S. Army. During the combat stage of the war Captain Mueller had been assigned to the 12th Armored Division to interrogate prisoners of war, as he spoke fluent German learned from his parents, who had emigrated from Germany. In late May he was transferred to the Seventh Army Interrogation Center. His first assignment was to take Robert Kropp to Fischhorn Castle. They arrived there and found it was being guarded by an American soldier of the 506th Parachute Infantry Regiment. Mueller explained his mission and the guard allowed him and Kropp to enter the castle gate. This was in com-

plete violation of all military protocol, as Captain Mueller should have reported to the unit commander and received an appropriate pass to travel in the area of the 101st Airborne.

Nevertheless they were in the castle. As it was around noon, Mueller told Kropp to get something to eat, take care of the clothing and picture and be ready to leave in a couple of hours. Kropp then went to get the painting. He requested that Else Altmann, Mrs. Göring's maid, bring him the small painting. The maid left and returned, and then she handed the painting over to Kropp. Meanwhile, Mueller had sat down to have lunch with a number of German Luftwaffe generals and colonels who were on Göring's staff. The main topic of conversation was what was going to happen to them; after all, it had only been a week since the end of the war. After lunch Mueller and Kropp packed up the jeep for the return to Augsburg.

Mueller saw Göring's wife and little girl at this time but had no reason to talk to them. On the trip back, an American second lieutenant tried to relieve Kropp of his wristwatch. The lieutenant had a collection of watches he had stolen from civilians passing through his checkpoint. Mueller outranked the lieutenant and used some appropriate army language in "dressing him down." On the return, just as well as on the trip out, they encountered a number of bridges that had been blown up during the German retreat, requiring the jeep to make several retreats.[4]

Upon returning to Augsburg, Mueller delivered to Major Kubala the valet Kropp, the Bismarck Rock uniform, other clothing, a photograph of Emmy and Edda Göring in a silver frame, the small wood *Madonna with Child* wrapped in a towel, and, unbelievably, an accordion. Mueller then went to dinner knowing he had accomplished his first assignment efficiently and without a hitch. It was at this point he learned that the painting was Memling's *Madonna* and that Göring had looted it in France.[5] He also found out that Major Kubala, his immediate commanding officer, wanted to present the painting to General Alexander Patch so that he could return it to the French government. This knowledge of the painting made absolutely no impression on the young captain.

Several days later, Mueller participated, along with ten other officers, in an interrogation of Göring during which he told them about his art treasures that had been hidden by his staff in a bunker near Berchtesgaden. The following day he was ordered to go to Berchtesgaden and report to the headquarters of the 101st Airborne and tell them what they had learned from Göring regarding his art collection. Mueller was somewhat disappointed when the 101st informed him that they had already found the art treasure in the bunker. Then he mentioned to the headquarters staff in passing that he had been down in that area the previous week and picked up the Memling painting from Fischhorn Castle. With that, the officers leaped to their feet and in a rather unfriendly way said, "So you're the one who got it!"

The day after Mueller had picked up the painting, Captains Anderson and James J. Rorimer had arrived at the castle for the express purpose of picking up the painting. They were told that an unknown American captain who had not left his name and who had not cleared his mission with headquarters had picked up the painting and left for parts unknown. The 101st Airborne officers were quite indignant and told Mueller they would write to his headquarters through channels and register an official complaint regarding

his actions.[6] It only took a few days for Mueller to form the opinion that Major Kubala was a somewhat unsavory character, a "promoter with a heavy German accent. He kept a fierce German police dog at his quarters that was intimidating to anyone who came near. It became so vicious that Kubala eventually shot the dog."

Some proof of his opinion was in Mueller's next assignment, a trip to a small Bavarian town and home of the young attractive wife of Wilhelm Ohnesorge, the postmaster general. During his capture Ohnesorge had in his possession two jewel-encrusted, gold and platinum cigarette cases. Kubala had to have these cigarette cases. He promised Ohnesorge that if he would willingly give him the cigarette cases he would arrange for him to spend the following weekend with his attractive wife in privacy at the interrogation center. Ohnesorge happily jumped at the chance of being with his wife for a private weekend. As the weekend approached, and with the cigarette cases in his possession, Kubala was in a tight situation.

He approached Ohnesorge and said his request for the visit of his wife was turned down by higher authority, but he could arrange for her to receive a letter hand delivered. Mueller left Augsburg with the handwritten letter from Ohnesorge and traveled to the Bavarian village looking for Mrs. Ohnesorge. She was living in a villa with her small son and Ohnesorge's chauffer. Mueller could not help but notice the son looked exactly like the chauffer.

Ohnesorge's complaint to army officials regarding the ruse in obtaining his valuable cigarette cases and other charges regarding having sex with female prisoners caught up with Kubala. A court-martial offense was charged against Kubala. Mueller's departure from Germany was delayed for several weeks because he had to give a deposition regarding the Ohnesorge affair. Kubala plea bargained for a lesser charge and accepted punishment under the 104th Article of War.[7] This meant he would receive company punishment, a slap on the wrist, rather than a trial by court-martial.

During this activity at the interrogation center, Major John Jack H. Smith, assistant chief of staff, G-5, 101st Airborne Division, informed Monuments, Fine Art, and Archival (MFA&A) officer James J. Rorimer that a valuable painting had been removed from Fischhorn Castle. Rorimer promised Smith that he would look into the matter and try to locate the painting. Rorimer called Kubala and asked about the painting. With his well-known temper flaring, Kubala responded that Rorimer should call Quinn and he would tell Rorimer the facts of life.

Kubala, recognizing the value of the painting, on May 15, 1945, wrote: "We, the undersigned, certify that we have received from Reichsmarschall Hermann Göring one XV century painting, called *The Madonna of Memling*, supposedly belonging to the Rothschild Collection, Signed P. Kubala and Albert Zoller Captain Liaison Officer (French)."[8]

Later, he took the painting to Colonel Quinn and the two of them took the painting over to General Patch's office. Patch was not in, so Quinn dismissed Kubala and left the valuable painting on the general's desk wrapped in a piece of paper. Quinn then called the army photography officer to come over and photograph the painting. Realizing the painting should not be left unattended on the general's desk, Quinn returned and took the painting. During this time, several people, including Rorimer, had gathered around and had been admiring it. Rorimer cautioned Quinn to advise the photographer to handle

it with utmost care. At that time Quinn decided not to have the painting photographed. It was then locked in a safe by Kubala. A week later the painting was given by Colonel William Quinn to James Rorimer. On May 19, Rorimer traveled to the Berchtesgaden headquarters of the 101st Airborne and gave the painting to Major Smith and Captain Harry Anderson, who gave Rorimer a receipt. All involved with the painting agreed that it was 10 × 16 to 12 × 18 inches in width and length.

On May 21, Whit Monday (the date supplied by Calvin Hathaway),[9] Captain Harry Anderson and Thomas C. Howe, an MFA&A officer, went to Fischhorn Castle and presented papers to Emmy Göring identifying themselves as Fine Art officers. The MFA&A officers took Emmy's seven nest eggs — (1 through 4) four small *Angel Musicians* paintings by Hans Memling, (5) Vermeer/van Meegeren, *Christ with the Woman Taken in Adultery,* (6) Roger van der Weyden, *Madonna with Child,* and (7) Renders' Memling, *Madonna with Child.*[10]

Göring had taken the Renders painting from Carinhall in a red velvet-lined box that served as its frame and had given it to Emmy Göring, who had placed the painting with her personal belongings. She had taken it to Mauterndorf Castle, where Göring removed it from the velvet-lined box. Emmy then took the "unframed" painting, along with eight other paintings, with her to Fischhorn Castle. Mrs. Göring denied any knowledge of the Vermeer/van Meegeren. But finally Christa Gormanns brought the painting from its hiding place wrapped around a stovepipe. She said, "Guard this carefully, it is of great value." Mrs. Göring wept bitterly as the paintings were removed. Captain Anderson made out a receipt for the paintings and, according to a Memorandum of Conversation, Captain Anderson did not list the paintings by artist "because he didn't know one painter from the other."[11] Emmy Göring later gave the receipt to her lawyer, Dr. Sthamer.[12] Anderson did not return with Emmy Göring's personal jewelry and the 20 expensive tapestries that had been taken from the train by Heinrich Gerch.

While guarded at Unterstein by the 101st Airborne, two of the four Memling *Angel Musicians* paintings — *Angel with a Viola* and *Angel with Psalter* — from the Goudstikker Collection, and two small landscapes — *Winter Landscape and Summer Dunes* — by Jan van Goyen were stolen. On July 3 another small portrait, *Melanchton,* by Cranach from the Philip Collection, was also stolen.[13] Also missing in the process was the Memling, *Madonna and Child,* from the Renders Collection.

On May 20, Göring was transferred from the luxury of Seventh Army headquarters to the Grand Hotel in Mandorf-les-Bans, Luxembourg. Although the hotel had "Grand" in its name, Göring's small unlit room on the fourth floor was Spartan in nature. On August 12, he was sent to Nuremberg to a solitary cell in a detention block, his final destination. When Göring arrived at Nuremberg Prison he brought with him 16 matched, monogrammed suitcases, a red hatbox and his valet, Robert Kropp. His Pour le Mérite and 40 more medals and valuables items were removed from Göring's luggage and locked in the Gun Room. See Appendix A for list of these items. Regarding Göring's valuables the commander of Nuremberg Prison, Colonel Burton C. Andrus, wrote the following:

> I wanted to make absolutely sure that none of Göring's huge collection of jeweled insignia would remain to be glorified by an imitator. I had every piece of jeweled encrusted decoration torn apart. The precious metals were melted and the stones put together. They were

Memling, *Angel with a Lute* and *Angel with a Harp*. The paintings were recovered and restored to Goudstikker's heirs. *Angel with a Psalter* and *Angel with a Viola* (opposite page) are still missing. These four Memling angel musicians, altarpieces, were considered by Göring to be among his most valued objects. Originally there were two angel pictures painted on both sides. Göring split these, which resulted in four paintings. The four were recovered by U.S. troops, but the opposite two were stolen and remain missing.

handed over unrecognizable as far as origin was concerned to the new German economy. The rest of the inventory of valuables was given to his widow.[14]

Meanwhile, Mrs. Göring was staying at Fischhorn Castle in the same luxurious style that she had lived in prior to the end of the war. When they arrived at Fischhorn Castle, Frau Göring had 12 to 15 thousand reichsmarks and Christa Gormanns has about 60 to 64 thousand reichsmarks. This money was given to Christa by Heinrich Gerch before he

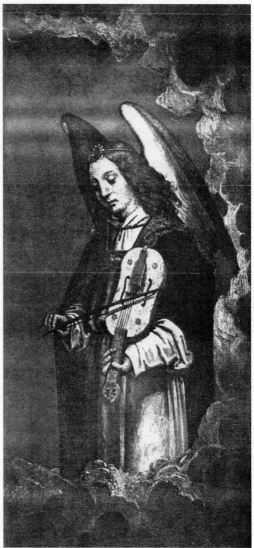

went to the POW camp.[15] Gerch had taken over the responsibility of paying Göring's bills from the now disgraced Limberger. It was also rumored that he left Berchtesgaden for Mauterndorf and there committed suicide. Meanwhile, at the Fischhorn, Captain Hornet (the name is not certain) told Mrs. Göring that she would have to surrender her personal jewelry to the American army. She had the impression that the captain was under the influence of alcohol and she appealed his decision to Colonel Robert F. Sink. The next day Captain Hornet came by and inspected their luggage, looked at the jewels and told them they could take the jewels when they left.[16]

Emmy Göring remained at the Fischhorn until June 11, 1945, at which time she left for her large estate, Veldenstein Castle. She lived luxuriously in this spacious and exquisitely furnished castle that rivaled the most opulent Hollywood setting. The picture of a

renowned courtesan and wife of the Reichsmarschall living in ease amidst all the servants and attendants who waited upon her did not, from a psychological viewpoint, lift the morale of the American troops, many of whom were living in tents. Furthermore, it gave the local population the impression she was a royal subject of the American army.[17] Thus an investigation of her preferential treatment began in September 1945, initiated after Cicely Easley wrote President Harry Truman a letter regarding Emmy Göring being chauffeured about in a Mercedes.

During this time, on September 15, Mrs. Göring was visited by U.S. Treasury agent Emanuel E. "Duke" Minskoff. He asked her many personal questions as to her past and present friends. Frau Göring was most candid with her answers, describing her days as an actress and her marriage to Göring. When asked about Goernnert, she responded that he was a very able man who came from a simple family; but she recently had heard that he was hoarding food, rations, watches, and chocolates. When Minskoff questioned Emmy Göring about Kurt Hegeler, she told him about missing jewels and stated that Hegeler denied stealing the jewels and now wanted to meet with her and rectify himself.

Telling about the jewels was a mistake, for at that point Minskoff asked about the remaining jewels and proceeded to take four different lots of jewels from the surprised Frau Göring. He took one lot consisting of 97 valuable pieces. The more expensive items, described respectively as inventory numbers 15 and 37, follow:

> Flexible platinum bracelet made up of five motifs, each having in its center an emerald surrounded by diamonds, the body of the bracelet covered with round diamonds and baguette diamonds.
>
> Platinum tiara adorned with laurel leaves strewn with diamonds and eight emerald cabochons. Platinum setting decorated with baguette diamonds.[18]

The second lot was described as jewels of Frau Emmy Göring and consisted of 49 items. The third lot was 14 pieces of jewelry belonging to Edda Göring. Two of the pieces were described as "one bracelet with lucky charms" and the other "one bracelet with diamonds." The fourth lot was 24 pieces that belonged to the Reichsmarschall himself. Minskoff simply gathered up the valuables, put them in a sack, and gave Frau Göring a receipt. He took the sack to Nuremberg and gave them to Eldon J. Cassidy.

As a result of the preferential treatment investigation, on October 15 Emmy Göring, her sister, Elsa Sonnemann, Ellen Kiurina and Christa Gormanns were all ordered to pack a small bag. They were arrested and imprisoned in the Straubing jail. Edda and baby Hans Kiurina were put in an orphanage. After seven weeks the children were moved into the small jail with their mothers. They remained there until February 28, 1946. After leaving the jail they lived in a small cottage without water or electricity in the woods near Veldenstein.[19] Emmy Göring died a natural death in Munich in 1973.

During an interrogation during this time, Hermann Göring told his American interrogator, Herbert Steward Leonard, that "every item has been taken from me including the smallest items which my little daughter received as baptismal presents. Everything has been taken from me except a hat, a dress, a blouse, two shirts, and one pair of shoes. Everything has been confiscated from my wife. I merely wish to state this because it is being denied here [by the Allied powers]."[20]

On October 7, 1945, Eldon J. Cassidy arrived at the Foreign Exchange Depository

with a sack of Göring's jewels that he wished to deposit. Colonel William Brey, chief of the Foreign Exchange Depository, was skeptical of the deposit and refused to accept the bag. Four days later, Cassidy convinced Brey to accept the bag of jewels. The jewels were checked against an inventory list and then sealed in a bag with Mr. Cassidy's signature on the seal. Brey observed that the jewels appeared to be personal jewelry of Emmy Göring and Edda, her seven-year-old daughter, as a gold bracelet forming a medallion contained a picture the child. The bag did indeed contain 14 items from the child and 24 pieces of the Reichsmarschall's collection. It was placed in the Foreign Exchange Depository as Shipment Number 70.

Brey insisted on a written statement regarding the jewels, which Cassidy promised to send, but he reneged, as the statement was never received. Further investigation by Colonel Brey revealed that Mr. E.E. Minskoff, accompanied by an interpreter and reporter, sometime during the period between September 14, and October 6, 1945, was at Veldenstein Castle for the purpose of interrogating Frau Emmy Göring. During the interrogation Minskoff demanded, and obtained possession of, her jewels and gave her a receipt. She then gave the receipt to her lawyer, Friedrich Strobel, in Nuremberg. See Appendix B for a list of the jewels.

Colonel Brey and the officials at the Foreign Exchange Depository were at a loss as to the disposition of the bag of valuables. In December 1945, they considered releasing the jewelry to the Intergovernmental Committee on Refugees as looted property. An undated letter from G.H. Garde depicts the disposition of jewels: "Certain property alleged owned by Emmy, Edda and Hermann Göring is now deposited in the Foreign Exchange Depository. Since the Military Government no longer has any reason to retain this property, it has been decided to release it to the Amtsgericht-Hinterlegungstelle [District Court Depository] for disposition pursuant to applicable German Law ... arrange to accept this property and take possession thereof on 6 July 1948."[21] Thus the bag of jewels was transferred to the Federal Republic of Germany.

19

The U.S. Acquires the Hermann Göring Art Collection

When the war ended, Austria was a gigantic depot of art treasures which the Nazis had looted from all over Europe. One of the most difficult jobs of the Reparations and Restitution Division of the United States in Austria was finding these priceless treasures and restoring them to their pre–Nazi owners. The large art lodes of the salt mines were uncovered almost as soon as General George S. Patton's Third Army invaded Austria, but dozens of smaller depots in castles scattered throughout the German and U.S. Zone were found only after diligent searches by American restitution experts.

The largest art repository was located in the salt mine at Alt Aussee. This mine contained the greatest deposit of Nazi loot uncovered in Europe. Here was found the larger part of the collection intended for the Linz Museum, a museum designed and administered by Adolf Hitler. The art for this museum had been seized from all of Nazi-occupied Europe. This was accomplished under the supervision of Dr. Hans Posse, a former professor of fine arts at Dresden University and director of the Führer Linz Museum. Alt Aussee contained 7,000 paintings and drawings and approximately 3,000 boxes of art objects.

The air in the salt mine was dry and remained at a constant temperature, so the environment was not harmful for the stored valuables. Records kept by the Germans for two years at Alt Aussee verified that the mine was a more ideal storage place for the art than most art museums. After this manner of storage had proven most advantageous and safe, Adolf Hitler ordered that his own collections, from Neuschwanstein Castle and Kremsmünster Monastery, be moved to the Alt Aussee salt mine.

On May 8, 1945, the American Army arrived at the Alt Aussee salt mine and the records of the contents of the mine were turned over to the American military. Four days later Captain Posey arrived there and took over the entire administration of the mine and sole responsibility for the safety of the art objects. Entrance to the mine was gained through the so-called Steinberg Haus, which housed a heavy iron double door to protect the entrance to the main shaft. Before one entered the mine, carbide lamps were issued

at Steinberg Haus. After traveling through the main shaft for one-half mile, one reached the first chamber, and again entrance to the chamber was blocked by two large doors. Each chamber was locked in this manner and had electric lights and was well equipped with wooden floors and wooden racks on which the art objects were stored.

Five MFA&A officers — Lieutenants Thomas Howe, Lamont Moore, George Stout, Steve Kovalyak and Frederick Shrady — were assigned to the salt mine operation in Alt Aussee. Their assignment was to remove the works of art that were not of Austrian origin. Howe and Moore were to work underground with Karl Sieber and select from the many storage racks the most valuable items for shipment to Munich. The Alt Aussee mine was entered by a horizontal tunnel, not an elevator shaft as in the other mine repositories. The mine consisted of seven large caverns, each of which had a series of vast vaulted chambers. The chambers were the result of over 1000 years of activity in mining salt. These chambers were all electrically illuminated and the Alt Aussee valuables could be reached by a small 18-inch track using small flatcars attached to a train powered by a gasoline engine. The train went through a narrow tunnel cut through solid rock. The tunnel was connected to the seven large mine chambers and each main chamber had two U.S. soldiers on duty as guards in this cold dismal place.

Moore and Howe selected hundreds of paintings and sent them up by the train. The first items selected were the Ghent Altarpiece, Michelangelo's *Madonna and Child* from Bruges, Vermeer's *The Artist in His Studio* and art objects taken from Monte Cassino in Italy by the Hermann Göring Division. The statue and Vermeer had survived the journey without any harm, but the Ghent Altarpiece had some minor damage. The ninth panel, *St. John*, had been split lengthwise during the move. Weakened due to worm activity, the panel had been repaired by Karl Sieber. Most fortunately, the crew found in a crate in Alt Aussee a card catalogue of objects seized by the Einsatzstab Rosenberg for the Linz Museum. This was a duplicate of the destroyed card catalogue at Dresden and would prove most valuable in the identification of the origins of the art removed from Alt Aussee.

Up on the surface, the art objects were packed, crated, sorted according to size and sent to the Munich Collection Point under the guard of two half-tracks from the 11th Armored Division. From June 6 until July 20, 1945, the workers emptied chambers two, four and seven, which contained ninety truckloads of these sensational finds, and transported them to the repositories of the U.S. Art Collection Center in Munich. The U.S. Army had established several of these large art depositories in Germany during the closing days of the war. In order to avoid a duplication of effort, General Clark had made the decision to transfer the art at Alt Aussee and other locations in Austria to the Munich Collection Point.

To provide a means to collect and process objects of art, the United States established three main collection points in the U.S. Zone of Germany. The Wiesbaden Collection Point held mostly German artworks, primarily from former state museums, plus a certain amount of loot taken from German Nazis. The Wiesbaden Collection Point contained about 700,000 objects. The Offenbach Archival Depot was for archival material, books, and precious scrolls and contained primarily collections looted from Jews. The Munich Collection Point specialized in art objects seized from museums and art seized from

individuals and would eventually contain over one million objects. These collection points contained approximately one-fifth of the artwork of the world.

The transfer of valuable property to these collection points began immediately after the war. On June 4, 1945, two naval officers, Lieutenant Craig Smyth and Lieutenant J. Hamilton Coulter, arrived in Munich to establish the Munich Collection Point. Their staff consisted of six officers, 180 enlisted men for security, and several noted civilian historians and curators of art. Twin buildings, a large complex formerly used as the headquarters for the Nazi Party, were selected as being suitable for the depository.

Joining the staff of Smyth and Coulter was Lieutenant Thomas Howe; all three were in the U.S. Navy. These officers had been key men in prominent American art galleries. Howe had been director of the California Palace of the Legion of Honor, one of San Francisco's two municipal museums of fine art, and Smyth had been on the staff of the National Art Gallery in Washington. On May 11, 1945, Smyth and Howe had flown from Washington to Europe for their present assignments. They — like quite a few other Americans in the mid–'40s — had been trained for the eventual occupation of Germany.

On July 21, 1945, the day following the termination of operations at Alt Aussee, the MFA&A team of Thomas Howe, Lamont Moore, and Kovalyak arrived at Unterstein, a small village in the immediate area of Berchtesgaden, and contacted Captain Harry Anderson. Captain Anderson conducted a tour of the 40 rooms. Four rooms and a wide corridor on the ground floor were jammed with sculpture. Three rooms were crammed with barrels, boxes and trunks full of porcelain. A small chapel in the hotel was overflowing with Italian Renaissance furniture. The condition of the art objects was excellent except that many items from Göring's collection contained scratches and some bullet holes. Göring's collection of artwork, the crème de la crème, consisted of approximately 1,000 paintings, 80 pieces of sculpture and 60 tapestries.[1]

The men then sat down and discussed moving the objects with Captain Anderson and tech 4 Richard S. Peck, a college art teacher, before the war, who had inventoried the complete collection. It was Peck's suggestion that the art be packed up and shipped one room at a time; but Howe explained that the paintings had to be shipped according to size for more efficient storage in the trucks. Later that afternoon Howe and Moore surveyed the rooms again and looked at the back of the paintings. They noticed several paintings that had belonged to Katz and a portrait of *Titus* that had been in the van Pannwitz Collection, which Göring had obtained in Holland, and the Rembrandt *Portrait of an Old Man with a Beard*, which Wendland had discovered in Marseilles. In the second room they visited, in one corner stood the full length portrait of the *Duke of Richmond* by Van Dyke. In another room there were 70 cases containing 11,000 books and pamphlets. Two rooms, numbered five and eight, were referred to as the gold rooms and were padlocked, as they contained many small silver and golden items, including several ceremonial swords that had been presented to Göring.

Next on their tour was an unframed canvas standing on a washbasin by a window. It was Göring's most treasured possession, Vermeer's painting *Christ and the Woman Taken in Adultery*. The two men looked at the painting and were puzzled as to who had painted it. They consulted the inventory and discovered it was the Vermeer. They questioned the artist again. A month later it was proven by Dutch authorities that *Christ and the Woman*

Taken in Adultery and other paintings in the same style were fakes, painted by Hans van Meegeren, who signed a full confession after his arrest by Dutch authorities. Prior to his arrest, there existed 42 Vermeers in the whole world; after his arrest there remained only 35 verifiable Vermeers. (Today only two Vermeers are in private hands; the Queen of England owns one and Las Vegas mogul Steve Wynn owns the other. Another was stolen in 1990 from the Isabella Stewart Gardner Museum in Boston.)

In five years Meegeren had created seven Vermeer masterpieces. The Dutch art gallery of D.G. Hoogendijk acquired five of the fake Vermeer paintings; the Vermeer/Meegeren *The Supper at Emmaus* was the finest painting ever attributed to Vermeer. In creating the "Vermeer" acquired by Göring, Meegeren had become a bit lazy and careless, but art experts, including Hoogendijk, agreed that the same painter had created both masterpieces. They were correct. Unfortunately, both were by the counterfeiter Meegeren. For the seven fake paintings Meegeren had collected $3,024,000 from the most prestigious art museums and collectors in the world.

The following day the team of Thomas Howe, Lamont Moore, and Kovalyak had their first four trucks loaded for the 90-mile trip to Munich, which was autobahn all the way. They also packed two swords, one with a beautiful etched blade of Toledo steel presented to Göring by the Spanish air force, the other a gift from Mussolini. There was also a gold baton with precious stones, a present from the Luftwaffe. One of the last objects packed was the *Belle Allemande*, the work of art that had been owned by the Louvre. Howe and Moore admired the statue of the beautiful nude German and fancied that Göring detected a resemblance between the statue and his wife, Emmy.[2]

The Göring Collection was turned over to the Monuments, Fine Arts and Archives officer Thomas C. Howe. On August 4, 1945, after 13 days, it had been moved in 31 truckloads from the three-story rest center at Unterstein to the Munich Collection Point. It is interesting to note that the inventory contained art and books marked for Hitler's museum as well as 61 paintings and two boxes of paintings not from Göring's collection.[3]

Howe was ready for a new assignment and thought he was finished with Berchtesgaden when he received a phone call from Major Lincoln T. Miller requesting his help that afternoon in reference to the arrests of Josef Angerer and Fritz Goernnert on July 29, 1945. A bombed-out Berliner, Mr. Hettwer, living in Berchtesgaden, on the previous night had informed Captain Nathan R. Preston, 220th Counter Intelligence Corps Detachment, that a group of dangerous Nazis still existed in Berchtesgaden. Hettwer produced a shotgun and a .38 caliber American Colt revolver that he had removed from the house of Johann Winkler, where the guns had been hidden by Dr. Goernnert and Josef Angerer. Angerer, like most Nazi bigwigs, had purchased a home in Berchtesgaden. In February 1945, Goernnert's home in Berlin had been destroyed by Allied air attacks and since that time he had shared Angerer's home.

Hettwer further stated that both men had also unloaded 50 crates of items from Göring's trains; the items had been taken to Angerer's home by trucks and horse-pulled carts. The following morning, a Sunday, Captain Nathan R. Preston and three agents of CIC Detachment went to Angerer's home and with weapons drawn ordered the occupants to come out with their hands above their heads. Angerer and Goernnert were searched and immediately removed to a local jail. As they were taken away, their wives were ordered

to remain in the kitchen while the CIC agents made a thorough inspection of the house. The agents began in the attic, where they found a few crates of art. Then they pried up the floorboards and found other valuable art objects. During the three hours that Mrs. Angerer and Mrs. Goernnert were confined to the kitchen, the agents removed a quarter-ton truckload of a large quantity of clothes, food of Dutch origin, liquor, jewelry, cameras, radios, field glasses, cigarette cases engraved with Hermann Göring's name, 180 Wehrmacht wristwatches, a suitcase of cigars with some inscribed "Especially made for Reichsmarschall Hermann Göring," a valuable stamp collection, and a film showing the most prominent Nazi leaders' and Göring's travels in his special train.[4]

Realizing the project was more than their detachment could handle, Preston then called Major Miller, Intelligence Unit (G-2) of the 44th AAA (Antiaircraft Artillery) Brigade, and advised him of the loot in Angerer's home. In their conversation, they decided to place the home under military guard pending the arrival of art experts. The two women were given 30 minutes to pack their necessary clothing and then ordered to leave. During that time, Major Miller arrived and the house was locked and guards of the 44th AAA Brigade were posted around the house.

The following morning, Major Lincoln T. Miller, Lieutenant George A. Warren and Sergeant Keith R. Grimm, all of the 44th AAA Brigade, removed 2,761.00 reichsmarks, a coin collection, a large bag of silk stockings, some small paintings, a small statue and two radios. Miller then placed a phone call to Lieutenant Thomas Carr Howe and told him he would pick him up after lunch. The two drove from Munich to Berchtesgaden and entered Angerer's home. Howe looked around for about 20 minutes and noticed the second floor contained a large collection of church vestments, tapestries, Oriental rugs, and rare textiles, individually tagged and the tags written in French. Howe told Miller he would take the items to the Munich Collection Point, where they would be held until ownership had been determined. Grasping the scope of the job, Howe stated he would return the following morning.[5]

Lieutenants Thomas Carr Howe, Lamont Moore and Steve Kovalyak drove a large command car to Angerer's residence and removed 11 large tapestries, 20 rugs, 213 fabrics and draperies, 81 mounted textiles, 1 painting by Dirk Bouts, 8 portfolios of drawings (uncounted), goblets and crated boxes of art objects labeled "Reichsmarschall Hermann Göring." The car was crammed as they drove back to Munich. A day later Howe received another call from Miller to come at once as they had dug a four-foot-deep hole in Angerer's backyard and uncovered more art. Upon his arrival, Howe saw four bundles of faded newspapers on the edge of the excavation. The first bundle contained a wood statue of *Madonna and Child* about 18 inches high. The next two bundles contained another *Madonna and Child* and *St. Barbara*. The fourth package contained an ivory figure of *Madonna and Child*. It was a fine piece of French sculpture of the 14th century. Howe wrapped the statues in fresh paper for the return trip.

Five days after his arrest on August 4, 1945, Angerer and his wife and Goernnert and his wife were allowed to return to their home. Upon entering they saw that the house was in terrible shape. Contents of dresser drawers were strewn all over the floor, furniture was turned over, feathers were torn from a feather bed and scattered all over. The house had been thoroughly searched. And then, a fact-is-stranger-than-fiction happening occurred.

Northern France, 1530, *Story of St. Etiene,* with detail close up. It is described as wool and silk, Stephanus Legende 1550, 229 × 198 cm. This tapestry was taken from Angerer's resident by Thomas Carr Howe to the Munich Collection Point in August 1945. It was reclaimed by Josef Angerer on May 14, 1948.

Captain Harry A. Palmer, of the U.S. War Crimes Investigation Team, filed a four-page report with attached exhibits regarding the robbery "of the house occupied by Doctor and Mrs. Fritz Goernnert and by a Mr. and Mrs. Joseph Angerer." Palmer writes: "It is in my opinion that this matter should be fully investigated by the Inspector General's Department to determine whether disciplinary action should be taken."[6] Palmer's job was to investigate the war crimes of Nazi Germany, not U.S. military misdeeds. Furthermore, he did not report the alleged crime to local military authorities, but took it to the top by

filing his report with the U.S. Third Army's Office of the Inspector General. This incident triggered an extensive investigation of the search and seizure of items from Angerer's home.

This investigation resulted in several character witnesses giving testimony. Katharina Winkler, wife of the grocer Johann, made the following deposition:

> I met Goernnert in 1940 in the Berchtesgaden railroad station through the station master. Through Goernnert my son was transferred to the Luftwaffe and he became the Antiaircraft gunner on the defense train which always accompanied the Göring special train. When my son was killed in Italy, Goernnert had the body brought up to Berchtesgaden where my son was buried, and for that reason I was very grateful to Goernnert.

Katharina's daughter, Anna testified:

> I have known Goernnert one year before my brother was killed in Reggio, Italy on December 3, 1942, and since we met we became good friends. We often made parties in the mountains and I was always under the impression that he was a clever and intelligent man who worked himself up from great poverty. I was often in his office and he told me frequently that he had great influence on the Reichsmarschall Hermann Göring who in turn influenced Hitler. About six days ago Mrs. Ebner, the wife of the shoemaker, told me about a conversation she had with Mrs. Goernnert who urged her to free her husband, by contacting Captain Palmer through her brother who worked in the office of the War Crimes Investigation Commission. I remember that Mr. Goernnert once told me that he had made a very good impression on Captain Palmer who thought highly of him.[7]

Story of Alexander, Battle between Horsemen and Macedonians. The tapestry taken by Howe was identified as belonging to Fritz Goernnert. It was never claimed by him and was turned over to the German authorities in 1949.

Apparently Captain Palmer did think highly of the 38-year-old Goernnert, for Palmer went with members of the 220 CIC when they traveled to Angerer's residence and interrogated and arrested Goernnert as being a member of the SS with the rank of Oberführer, major general.

Colonel C.B. Spicer's investigation concluded on September 1, 1945. He determined that the food taken from Angerer's home was given to DPs (displaced people) and the German military watches were distributed to U.S. soldiers. The colonel was unsure of the MFA&A activity of Howe and made the following recommendations:

(1) That no action be taken against Captain Preston.
(2) That the commanding general of the 44th AAA Brigade be directed to reprimand Major Lincoln T. Miller for the insufficient manner in which he conducted the search and the removal of articles.
(3) That a recommendation be made to have Lt. Thomas C. Howe Jr. and Lt. Lamont Moore indicate on a claims list the articles removed from the house by them, for the benefit of any subsequent claims officer.

At the Munich Collection Point it was determined that most of the items removed by Howe and Moore were taken from France by Einsatzstab Rosenberg, and those items were subsequently returned to France. Many tapestries had been removed from Italy, and they were turned over to German representatives in 1949. Some items were claimed by Angerer and returned to him from the Munich Collection Point in early 1948. While at the Collection Point, Angerer told Herbert Stuart Leonard, the chief of Restitution Branch, that during the war five extremely valuable Gothic goblins were purchased by Göring. These most prized items of his tapestry collection were purchased with gold by the Reichsbank through Spain from the California Hearst collection.[8] This came as a surprise to Leonard. No items were ever claimed or returned to Goernnert. Also, Captain Harry A. Palmer's role in this situation is puzzling.

20

The Missing Paintings

As noted previously, while under guard by the 101st Airborne Division at Unterstein the following valuable paintings disappeared:

Memling's *Angel with a Viola* and *Angel with Psalter* (a psalter was a biblical stringed musical instrument)
small landscapes by Jan van Goyen
small portrait, *Melanchton,* by Cranach from the Phillips Collection
Memling's *Madonna and Child,* from the Renders Collection.[1]

In regard to the Memling "Angel Musicians" paintings from the Goudstikker Collection, Andreas Hofer, curator for Göring, states that "two Angel Musicians by Hans Memling from the Goudstikker Collection, shown on the attached color reproduction [these paintings have been previously shown in this book], were formerly in the temporary storage at Unterstein. These paintings have not been seen by any representative of this Headquarters."[2]

It was also reported that the people living in Schloss Hubertus (the hotel where the 101st warehoused the Göring Art Collection) at Unterstein were present when the Göring Collection was gathered in their building. They allegedly observed that the two missing "Angels" by Memling were discovered in the luggage of one of the American guards during an inspection in June 1945. The inspection was made by Captain Walker, 101st Airborne Division. Some informants stated that a supply sergeant known by the name of "Kid" took as a souvenir one small painting of the Göring Collection representing crucifixions by an old master (panel 50 by 20 cm); also, other guards had allegedly collected souvenirs, mostly paintings.[3]

Regarding the missing small portrait, *Melanchton,* by Cranach from the Philip Collection, Edward S. Peck Jr., Tech/4, 101st Airborne Division and assistant to Captain Anderson, states that *Melanchton* by Lucas Cranach, (portrait on an oak panel, 15 × 18.5 centimeters (6 × 7 inches), green-blue background, with no landscape or curtain) was lost from the collection on July 3. In 1941 Göring had finagled this small portrait from the giant Dutch electronic firm of Phillips. Extensive searching during the moving of the Goering Collection failed to locate this painting.[4]

Paul Helberg had returned from Germany and entered Brooklyn College as a student on the GI Bill, which was a congressional act that provided college education for returning World War II veterans. Helberg became friends with student advisor Peter Blos, a German psychoanalyst with a degree in education and a PhD in biology who was born February 2, 1904, in Karlsruhe, Germany. During their friendship at Brooklyn College, Helberg informed Blos that he had a Lucas Cranach painting in his possession. In the conversation, Helberg lied to Blos by saying he took the painting from the Führerhaus, or Nazi head-quarters building, in Munich. Blos contacted the Metropolitan Museum and informed them that Helberg was willing to surrender the picture to the proper authorities, provided the painting was not returned to Germany but was displayed in an America museum. Blos further stated that Helberg would surrender the painting in good faith. Blos wrote: "I would appreciate it if you could advise me how to proceed in this matter because the student has entrusted me with this confidence and I promised to obtain for him author-itative advice."[5] The U.S. Army was indifferent to Blos and Helberg's lackadaisical inten-tions and shortly thereafter the painting was seized by U.S. Customs. Helberg had stolen the Cranach painting from the Göring Collection. The painting was returned to Germany in 1949.

Regarding the missing Renders Collection Memling *Madonna and Child*, Captain Mueller had been told the painting (enthroned with angel on the right, wood 22 × 13.5. or 8.5 × 5.5 inches) was from France. Kubala had signed that the painting was from the Rothschild Collection.[6] Frau Göring confirms that she gave the picture of the Madonna to Kropp, which he took to her husband in Augsburg. She could, however, not identify this picture from the photograph of the Renders Madonna. She remembered that the picture given to Kropp was oval-shaped in its upper part. This would refer only to the Rothschild Collection Memling, which was received by the Munich Collection Point from Berchtesgaden.[7] An army investigator wrote that due to the small size of the picture, 6 × 10 inches, there is the possibility that it is still kept with the G-5, Seventh Army records.[8]

In November 1946, the MFA&A section in Munich began the search for Emmy Göring's missing jewels. They interrogated Göring's former chauffeur, Kurt Hegeler, who was now working as a waiter at a teahouse called Kelstein, in Berchtesgaden. Hegeler told MFA&A investigator Edgar Breitenbach that Frau Göring's jewelry was kept in a safe while she was at Obersalzberg and when she wanted a piece of jewelry she would give the key to her personal SS bodyguard, Karl Zimmer, and he would retrieve the selected jewels. Hegeler further stated that Zimmer had disappeared on April 19, 1945, and no one had heard anything of him since. After Zimmer's disappearance his position was taken over by SS member Helmuth Meier. Hegeler also told Breitenbach that Emmy Göring had given him an earring, which was taken away from him by an American soldier. During a later interrogation of Emmy Göring by Breitenbach, he was completely taken by surprise when she informed him that the remainder of her jewels had been taken by U.S. Treasury agents.

A year after Emmy Göring's jewels had been stolen at Obersalzberg they were still missing and, interestingly enough, Hegeler was working for the U.S. Military government as a live-in guard at Hitler's Kelstein Teahouse at Berchtesgaden.[9] If Hegeler had stolen

the jewels, he presumably would not have been working as a guard. These 10 pound of jewels, worth a half million dollars back then, were never recovered.

During this time of turmoil the two German state insignia with 36 diamonds and a memorial case for the Grand Cross with small diamonds that Göring had received from Hitler on his 50th birthday disappeared. Regarding this theft Göring told the America investigator the following:

> GÖRING: I also know who took them out, but I do not want to reveal his name. How he managed to do this is something I shall find out later on.
> INTERROGATOR: Was it taken by a German?
> GÖRING: Yes, but I do not want to blame them altogether. The reason was most likely to safeguard the stones for the Reichsmarschall, but whether they did save them for me or for themselves is another question.[10]

An Allied military tribunal convicted Hermann Göring of war crimes and sentenced him to death by hanging. He avowed this was a dishonorable death for a military officer and insisted on being executed by a firing squad. Denied this request, on October 15, 1946, Hermann Göring cheated the hangman by crushing a capsule of cyanine between his teeth. He died immediately. Apparently he never discovered who had taken the diamond-studded German state insignia, as this valuable object has never surfaced.

On June 18, 1945, Mr. Renders filed a request with Supreme Headquarters Allied Forces Europe for the return of his art collection, which had been confiscated by Hermann Göring. The response to his request follows:

> He was advised also to address himself to the Ministry. The Renders case provides an interesting situation: he claims he was forced, and produced documentary evidence to show that he was, to sell under threat to Göring; the feeling among the Belgium officials is that his sale was voluntary. If it were a volunteer sale, it would seem that Göring was a legitimate owner, since no one disputes Renders' prior ownership; if these paintings were Göring's property they would seem to become United States Government property by virtue of seizure, in which case it would appear that only the magnanimity of the United States could insure their return to Belgium.[11]

Then the Belgium government submitted a claim for the Renders Collection, which included the Memling painting *Madonna and Child*. On August 4, 1947, Herbert Steward Leonard wrote the Restitution Branch in Germany, saying that Major Paul Kubala was the last known person in possession of the missing painting and suggesting that Kubala be questioned as to the location of this very important work of art. Based on information in his letter, Headquarters, European Command, contacted the commanding general, Army Air Force, and asked for an investigation of Major Kubala, who had transferred from the army to the Army Air Force. Based on information from Leonard and pressure from the Belgium embassy in Washington, the Criminal Investigation Division (CID) from the Pentagon in Washington, D.C., became deeply involved in the case. Renders had attached a color photo of the missing painting with his original request and a copy of this was furnished to the CID.

As it happened, at that time Kubala was transferring from Germany to the United States. The Criminal Investigation Division began their investigation of him and discovered that his household goods from Germany were in the process of being shipped to the

United States. The CID agents contacted the U.S. port authorities and asked them to hold the 16 boxes of household goods so they could be searched without the knowledge of Major Kubala. When the boxes arrived in October 1947, a customs inspector and three CID agents broke the steel bands surrounding the containers and searched them. A detailed search revealed silverware, clothing, and personal effects, mostly those of a woman. The baggage was then repacked and resealed. The painting was not found.[12]

On November 17, 1947, Kubala was interrogated and informed Lieutenant Colonel William A. Stephens, a CID agent, that he could not discuss his assignments due to his role as an intelligence agent for Strategic Services, formerly the Office of Strategic Services, or OSS. When asked about these assignments Kubala responded: "Sir, I don't know whether I am really free to tell you. I was an agent — top security man, and I don't know whether I am allowed to divulge this information or not." Stephens asked Kubala about the missing Memling *Madonna with Child*. Kubala said that Göring had brought the painting to Seventh Army headquarters and that it was turned over to an MFA&A expert in the presence of Colonel William Quinn. Kubala further stated that he had a receipt in his personal papers.

Kubala then left the room and returned with a number of folders. After about 15 minutes he was unable to locate the missing handwritten receipt and told Stephens that he would look further in his personal possessions for it. Kubala was asked a few more questions and suggested that Colonel William Quinn be interrogated. At the end of the session Stephens told Kubala not to discuss the investigation with anyone. A week later Kubala was again interrogated and shown a picture of the missing painting. He responded: "That is not the painting. The painting was a Madonna standing in a long robe. There was no angel and this one holds a child."[13]

A week later some of the suspicion was taken off of Kubala by the aforementioned Colonel William Quinn, who was serving in the Pentagon. Quinn was questioned by CID agents and claimed that Kubala was not responsible for the disappearance of *Madonna with Child*. Quinn further identified the MFA&A expert who had taken the Memling painting from the office, in May 1945, as 40-year-old Lieutenant James J. Rorimer. Quinn iterated that valuables worth millions had been taken from high-ranking Nazi officers but that the Memling was the only painting confiscated by Seventh Army headquarters.

The investigation now centered on Rorimer, who had moved on to become curator of the Cloisters, Metropolitan Museum, in New York City. (He was later elected director of the Metropolitan Museum of Art.) On January 25, 1948, Rorimer gave agents of the 10th CID, New York, a five-page written statement. It stated that on May 17, 1945, he had taken the painting from Colonel Quinn and on May 19 traveled to Berchtesgaden and turned over the painting in question to Major John "Jack" H. Smith of the 101st Airborne Division. Rorimer then received a receipt from Captain Harry Anderson for the delivery of Memling's *Madonna with Child*. Further, Rorimer produced a photograph showing both Smith and Anderson holding the painting in the sunlight to admire its details.

Then James Rorimer, curator of the Department of Medieval Art of the Metropolitan Museum of Art, dropped a bombshell! He told the CID investigator that the photograph the investigator had showed to him was not the painting they were discussing. The

painting taken by Göring's valet, Kropp, and transported to the Seventh Army Interrogation Center was the Rothschild Collection Memling, *Madonna and Child*; the Rothschild inventory number 86 was on the back of the painting.[14] This agreed with Kubala's previous interrogation. This statement absolved Kubala and Quinn of any guilt in stealing the missing painting since Rorimer, Quinn and Kubala were all telling the same story. Now the CID agents were confused as to what was missing, so they continued the investigation.

The CID agents then went looking for John "Jack" H. Smith. They started in Detroit, where he had been employed by the *Detroit Times* prior to his entering military service in 1942. After his service stint, in June 1947, Smith returned to the *Detroit Times* for a couple of months and then went to Washington, D.C., and took a job with *International News Photos*. There he was interviewed by the CID Military District of Washington. Following this session, on March 5, 1948, chief warrant officer Jason Benjamin wrote the following: "An Interview with John Jack H. Smith revealed that, some times during May 1945, he received from Colonel William Quinn a painting to be photographed. Smith described the painting to the best of his knowledge as being approximately ten by sixteen inches. After photographing the painting he returned it to Colonel Quinn. Smith added that the negative of the painting photo was sent to the Army Signal Corps Library in Washington."

A search of all photographs taken by the Seventh Army failed to reveal any trace of the photograph of the painting. Smith's statement completely contradicted the statements given by Kubala, Quinn, and Rorimer. Both Smith and Harry Anderson by now were civilians and not under the jurisdiction of the American military. Therefore, the investigation disclosed that Rorimer had in fact received the Rothschild painting from Colonel Quinn and delivered it to Major Smith and Captain Anderson. It further rightfully concluded that there were many confusing factors surrounding the actual identity of the missing painting. What the CID investigator did not know was that the Memling, *Madonna with Child* (47.8 × 26.3), belonging to Edouard de Rothschild and from the Göring Collection, had been restituted to France from the Munich Collection Point on 20 September 1945.[15] Therefore, everyone involved in the painting taken to the Seventh Army Interrogation Center was absolved of any crime involving the Rothschild painting, as that painting was indeed handled in an honest manner by Major Smith and Captain Anderson.

There is one more confusing factor about the Rothschild inventory 86 painting. The Rothschild family's art collection did not include one painting by Memling that was taken by Göring. The October 20, 1942, "Liste der für die Sammlung des Reichsmarschall Hermann Göring abgegenbens Kunstgegenstände" does not contain a Memling. Page 3 of that list contains inventory number R86 with this description: "Bouts, Dirk, *Maria mit Kind* [Madonna with Child], Umkreis des, Holz 48 × 27 or 20 × 10 inches."[16] When the painting is returned the description is this: "Memling: *Madonna with Child*, 47.8 × 26.3 belonging to Edouard de Rothschild and out of the Göring Collection from the Munich Collection Point on September 20, 1945." The size is the same as the German inventory rounded to the centimeter. Who changed the name of the artist from Dirk Bouts to Hans Memling? Was it a mistake on the 1942 German inventory, a mistake on the 1945

Göring train inventory or fraud on Göring's part? In several interviews, Hofer gave conflicting stories regarding these two paintings. Was he intentionally muddying the situation?

For historical accuracy in this matter, the conscientious investigator Nicholas J. Abysalh wrote the following:

> On January 26, 1948, the undersigned contacted Mr. Rorimer again after he communicated with this office relative to further information he had gathered pertaining to the missing painting. He stated to the undersigned that he had contacted a former OSS agent, Theodore Rousseau Jr. and Mr. Rousseau had produced a compilation of a Consolidated Interrogation Report, date September 15, 1945, containing information of the Reichsmarschall Göring Art Collection. For clarifications in the subsequent details, it is to be noted that included in the Göring Art Collection were two paintings by Memling of the Madonna and Child, which were procured by Göring from the Rothschild and Renders Art Collections. These paintings known as the Rothschild and Renders Memling will forthwith be referred as such.
>
> A section of the aforementioned report contains information about the activities and statements of a Mr. Hofer, identified by Mr. Rorimer as Göring's Art Representative and Agent. Mr. Hofer stated in the report that sometime after May 11, 1945, Captain Anderson of the 101st Airborne Division, went to Mauterndorf [Fischhorn Castle], identified by Mr. Rorimer as Mrs. Göring's home and recovered the Rothschild Memling, in addition to others and that the Renders Memling and some jewelry were missing. Mr. Rorimer pointed out to the undersigned that an error was made in the last paragraph of the OSS Report concerning the acquisition of the painting by Captain Anderson, as related by Mr. Hofer. Mr. Rorimer said the painting recorded in the report as missing, should have been recorded in the report as the Rothschild Memling, and the one recorded as being recovered by Captain Anderson should have been recorded as the Renders Memling. The one painting was recorded in the OSS report as missing, because it had already been taken by Göring's Valet and a representative from Seventh Army Interrogation Center, and turned over to Major Kubala, who delivered it to Colonel Quinn who later turned it over to Mr. Rorimer as recorded in paragraph 2 of the undersigned's report. It was therefore established that the missing painting is the Renders Memling which was erroneously reported in the OSS report as the Rothschild Memling.
>
> It has also been established, according to Mr. Rorimer's statement and his photograph of Major Smith, Captain Anderson and the Rothschild Memling, that Major Smith and Captain Anderson are the last known persons to have the Rothschild Memling in their possession and also according to Mr. Hofer's statement in the OSS report, Captain Anderson is the last known person to have the Renders Memling in his possession.[17]

The question is why Captain Harry Anderson was never questioned in this matter. He had taken from Mrs. Göring, and signed for, three of the now missing paintings, the two Memling Angels from the Goudstikker Collection and the Renders Memling. When the results of this investigation were sent to the CID office in the European Command, the originator of the investigation, Herbert S. Leonard, had major time-consuming problems on his mind concerning art taken from Italy, as well as the status of art removed from Austria. He no longer had the time to devote to only one valuable painting. Therefore, on March 24, 1948, this case was closed. Memling's small, 7 by 10 inch, *Madonna with Child* was never recovered despite the need to question Smith and Anderson further. In response to a Belgian claim from the Renders Collection in Bruges, the case was briefly reactivated in 1954 by Ardelia R. Hall of the Department of State. A couple of letters were written but no action was taken, nor was new evidence uncovered.

 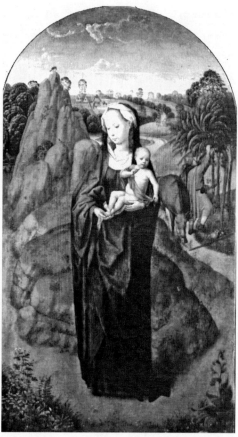

Above, left: Memling, *Madonna with Child with an Angel,* Renders Collection. This picture belonged at one time to Leopold Philippe d'Arenberg. The wealthy duke was born in Brussels and served with the Austrian army. He passed this painting on to his librarian, who gave it to his daughter prior to the acquisition by Renders. This Memling was stolen while under protective custody of the U.S. Army. The U.S. Criminal Intelligence Division investigated the theft, but they were tracking the Rothschild Memling in error. After an extended investigation they realized their mistake. Their belated note (top of page 161) is attached to the actual missing Memling. *Above, right:* Memling, *Madonna with Child in Rocky Landscape,* Rothschild Collection. This is the one the U.S. Army was mistakenly searching for.

A June 19, 1952, letter written from Seventh Army headquarters in Stuttgart, Germany, suggested the following G-5 staff be questioned regarding the missing Renders painting:

 Colonel Harvey S. Gerry
 Major Robert H. Bennett
 Captain William L. Batt Jr.
 Master Sergeant Harold W Eells
 Tech/4 Joseph P. Patti
 Corporal John P. Mortimer
 Private George Gross

Private Armedor B. L'Heureux
Private Phillip Martin

This chapter ends as it began, for after years of intensive investigation and research the six paintings never surfaced and remain missing to this day:

Memling's *Angel with a Viola* and *Angel with Psalter*
small landscapes by Jan van Goyen
small portrait, *Melanchton,* by Cranach from the Phillips Collection
Memling, *Madonna and Child,* from the Renders Collection

The Renders Collection Memling *Madonna and Child* was alleged to have surfaced in 1976. See this author's correspondence regarding the matter in Appendix D.

21

Munich Collection Point

The Hermann Göring Art Collection had arrived at the Munich Central Collecting Point, which specialized largely in materials subject to restitution, although in addition it contained the cultural objects of the Bavarian state museums. The Munich Collection Point was more than a warehouse. It was the administration headquarters and technical operating center for all monument and fine art activities under the supervision of two

The Nazi Headquarters building in Munich, renamed Gallery I and used to store looted art.

Hitler's office in the Nazi Headquarters building. Munich was the home of the Nazi Party; Berlin was its business address.

naval officers, Lieutenant Craig Hugh Smyth and Lieutenant Hamilton Coulter. The collection point was housed in two identical, large, three-story buildings that served as the former Nazi headquarters and Nazi administrative buildings. Munich was the home of the Nazi Party and Berlin was its business address.

The collection point employed a large staff of 220 German civilians, of which about 30 were carefully selected German art scholars who helped with classifications, maintained statistical files and operated an art reference library. These activities were performed under the supervision of Dr. Erika Hanfstaengl, whose father had been the former director of the Berlin National Museum. Working for Miss Hanfstaengl was Dr. Karl Mueller, former curator of the Bavarian National Museum, and several more prominent former curators with doctoral degrees. There were also well-equipped photo studios and laboratories, repair and crating shops, supply rooms and a transportation pool. As each item of the Göring Collection had left the truck, this staff checked the item against a list of the truck's contents and accompanied the art to the arrival room, where it received a catalogue card marked with the same number that was attached to the item when it arrived. The card was then filled out by one of the curator staff with a brief description of the art item and its condition. The art item was then sent to the storage room, where the room number was then entered onto the card. A staff of expert packers and carpenters assisted the curators.[1]

A liaison officer and art expert from each Allied nation was provided with an office

and separate storage room. Starting with an extensive collection of German art books, Lieutenant Smyth organized an art reference library. To this was added reference material uncovered in outlying repositories, and also a large amount of captured purchasing records and files of identified code markings which had been used by Einsatzstab Rosenberg.

Ten art officers representing eleven liberated European countries brought photographs and other identification to the collection point. These documents would be used to identify an object originating from their country. The work was greatly facilitated because many of the records of shipments from occupied countries were not destroyed and still accompanied the works of art. The recovered records, while not complete in every case, were carefully arranged and indexed. By cross-referencing bills of lading to the numbers on the backs of the pictures, it was a fairly simple matter to assign a particular item to the country of origin. If the German records were incomplete, then the documents assembled by the art officers were examined for further identification.

As items were tentatively identified they were placed in separate national rooms for examination and for the presentation of further proof by the art officers. When agreements were reached, the items were moved to the representatives' own storage rooms. The individual art officer then made arrangements with a transportation company for shipment from the collection point by train or truck. The responsibility of the United States authorities ceased with the loading of the valuables.

The acquiring country signed a receipt for the valuables. This receipt made it the

Photograph session for van Dyck, *Family Portrait*, from the Katz Gallery. The vast majority of the photographs in this book were made in this photography studio.

The C-47 pilot, Lieutenant Craig Smyth and Colonel Alphonse Vorenkamp of the Royal Netherlands Forces manage the first token shipment to the Rijksmuseum, Holland. The shipment consisted of 26 of the most valuable items belonging to the Dutch and was sent in October 1945.

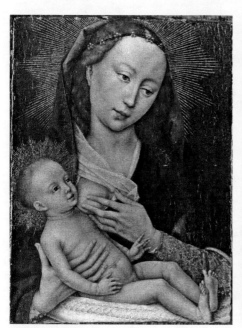

Above, left: This oil on wood, Roger van der Weyden, *Madonna with Child,* from the Renders Collection, was the first painting returned to Brussels. It may have been purchased from the Chicago Museum in the 1920s by Renders. It is today in the Musée Royaux des Beaux-Arts, Belgium. *Right:* Rubens, *Helene Fourment,* Koenig Collection. This painting from the Göring Collection was one of the first to be returned to Holland. The 53-year-old Rubens married the 16-year-old Helen Fourment and painted many portraits of his young wife. In 2003 the Dutch government ruled against the Koenig family for claims for the return of this painting and others taken during World War II.

John Nicholas Brown, U.S. honorary colonel and advisor on cultural affairs (second from left), and other distinguished guests at the Munich Collection Point examine part of the Göring Collection. The silver-framed photograph on the right is of Göring's wife and small daughter.

responsibility of the acquiring country to return the valuables to its own citizens. Problems of individual ownership were left to the governments concerned, leaving the Unites States free from any liability.[2]

Routine restitution of the art objects from the collection points began when large shipments were returned to France, Belgium, and the Netherlands. Included in the shipments were many of the paintings from the Hermann Göring Collection. The Göring Collection, taken from Berchtesgaden and housed at the Munich Collection Point, consisted of 982 paintings, 219 sculptures, and 1,950 gold, silver, and glass objets d'art (details in appendices C, D, and E).

Trainloads of objects were returned to France. The statue Göring had acquired of Mary Magdalene, known as *La Belle Allemande*, by Gregor Erhart, and the painting *The Presentation of Christ in the Temple* by the Master of the Holy Family, both obtained from the Louvre, were part of a shipment of 21 freight cars of objects. In total, 394 paintings were returned to France from the Herman Göring Collection. Of the many paintings returned to France, 2,143 were simply kept by the French government.[3]

Thirty-eight paintings were returned to Belgium along with four Renders paintings that were in Göring's collection. The Belgium government ruled against Renders' request

for the return of his paintings. They simply kept the paintings and displayed them in their national gallery.

Allied forces had confiscated 3,500 artworks in Germany which were returned to the Dutch government. Of these, 365 were paintings acquired by Göring. Allied forces recovered the art treasures in Germany and transferred them to the Dutch government with the intention that they be returned to their rightful owners. But, instead of returning the artworks from the Goudstikker Collection to Goudstikker's wife, who sought their recovery in 1946, the works were retained by the Dutch state as part of the national collection. This included from the Hermann Göring collection 143 paintings from Goudstikker along with 80 more paintings from Hoogendijk, Paech, Katz, and others. Renaissance and baroque jewels from the Mannheimer Collection and many paintings by Dutch 17th century artists were returned. But not everything that was designated "stolen art" and returned to Holland had really been stolen in Holland. Many of the artworks had been traded regularly by private art dealers, both Jewish and non–Jewish.

The Dutch benefited from the confusion generated by World War II in order to stock up on the nation's cultural assets. According to the London Declaration of 1943, the governments of the liberated nations were obliged to return artworks to their former owners. But by Dutch law, the crime of collaboration had been committed not just by the buyers but by the sellers too — and the sellers were mostly Jewish. In fact, only 12 percent of the artworks the Dutch government received from Germany was returned to their former owners or their inheritors. The rest passed to the foundation Nederlands Kunstbezit (Netherlands National Collection).

The Hague declared most of the returned paintings enemy property, along with the remains of the Goudstikker Collection, originally 1,113 paintings, and seized the paintings. A number of paintings thought to be of inferior value were simply sold off, including some 50 works from the Goudstikker Collection. They include a van Dyck that now hangs in the lobby of Dr. Oetker Ltd's headquarters in Bielefeld, Germany, and a self-portrait by Baroque painter Cornelis Bega, currently in the possession of Hamburg's Kunsthalle Museum in Cologne.[4]

Many items were returned to Austria, but the situation was a bit different with Austria and Italy, as they were basically Axis countries allied with Germany during World War II. A great many items, including 8 from the Göring Collection, were returned along with the Jan Vermeer painting *The Artist in His Studio*, which had been purchased from the Czernin brothers of Vienna. The brothers suggested that the painting was a forced sale and asked for its return. The Vermeer was returned to the Austrian government in 1945 by U.S. Forces. Austrian courts ruled against a forced sale and the painting is today on display in the Austrian National Gallery in Vienna.

Three large chests and 41 crates of books from the Göring Collection were sent to the Offenbach Collection Center, which distributed books. Ninety-two photo albums were sent to Washington, D.C. The bulk of albums and books may well have ended up at the Library of Congress, where a large number of these items can been viewed today.

By the end of 1947, the bulk of the items in the Munich Collection Point had been returned to the country of origin. The original teams of Monument Fine Art and Archival officers had long since left Germany. The situation had changed and the disposition of

the returned artwork to our Allies had left the restitution team in Munich with a bit of resentment. Although the bulk of the art had been returned, there still remained among others, 565 art objects from the Göring Collection alone that were destined to remain in Germany.

The Munich Collection Point was now directed by Herbert Stuart Leonard. Most of the remaining inventory in the center was from Austria and Italy. Some national treasures had been returned to Austria and the obvious Italian items, such as the looted objets d'art from Monte Cassino, had been returned. The panels of the Sterzing Altarpiece had been restored to Italy, as an exceptional return. The remaining valuables in the Göring Collection were Italian or declared unidentifiable as to origin. The rules had not changed: the valuables were to be returned to the country of origin. General Lucius Clay, deputy military governor of Germany, insisted upon this policy and set a deadline of December 31, 1948, for all items to be returned. Leonard became a self-appointed ambassador for Germany and insisted he represent their side. His attitude on this endeavor is most evident in his July 26, 1948, letter to Calvin Hathaway:

> Another and more serious problem has come up and about that I feel most concerned. It is, apparently, the policy of the Departments of Army and or State to return to Italy those things wrongfully acquired. Thus the purchases made by Phillip, Prince of Hesse, for Hitler, the Göring purchases, etc., made while they were still allies will be returned. Of the legal basis for this I can not speak. It would seem that the illegal acts, insofar as they were committed, were acts of the proper Italian authorities. The Italians claim that an export license was requested for, say, the Memling "Portrait of a Man" from the Carsini Collection and that the request was refused by the ordinary channels but that was overruled by higher authorities, specifically Mussolini. And so the thing was bought and paid for and removed. Now it is to be returned…. And if those things which Hitler and Göring gave Mussolini and Ciano were to be returned, that might make a difference. Unfortunately I neither know nor can find out just what things Hitler and Göring removed from the museums for presents.[5]

U.S. Monuments officer Evelyn Tucker, serving as a civilian with U.S. Forces Austria, unfortunately took the same position as Leonard for that country. She insisted all unidentified artwork taken from the Alt Aussee salt mine be returned, as Austria was the country of origin. By the largest stretch of imagination the Inter-Allied London Declaration regarding country of origin could not apply to American soldiers legally bringing art objects from Austria to Germany.

On September 20, 1948, Miss Tucker met with Leonard to discuss the return of the remaining Austrian objects from Munich to U.S. Forces Austria. He told her that he had sent a letter to Berlin and if it was not accepted he would resign. Tucker had no way of knowing the letter was a protest regarding the return of the Italian art. She assumed it had to do with her and the removal of art to Austria. To his statement that he would resign, she said, "Stewart, you know very well that you would not do any such thing." He replied, "I certainly shall and what is more I will retire to Northern Italy and blast my head off." In this tone they spent three days discussing the return of art. During this time Leonard indeed resigned. Miss Tucker never knew why Leonard quit and thought it had to do with her actions. In a letter to Hathaway, Richard Howard summed it up best:

Some few objects which it was decided with the full concurrence and knowledge of General Clay personally and Ambassador Murphy were not returned because in my opinion, H. Stuart Leonard and the German curators involved, deliberately, "failed to find them."

Anyone who implies that there was any lack of validation, concurrence, agreement or legality within the military Government with the sole exception of Leonard who in the process violated security measures and disobeyed the direct order of the Military Government, is imbued with the same Germanophile prejudice which permitted Leonard to go off his rocker. This last is certainly true and is the most charitable explanation of his activity. The man was a nervous wreck—unstable from the beginning, unwilling to discuss anything reasonable and unable to stay sober during that period. Why anyone would think this collection of objects of art belonged to anyone other than Italy is something neither I nor General Clay could understand, except of course, for the plain selfishness of [Dr. Erika] Hanfstaengel and the rest of the Germans.[6]

After Leonard's departure Stephen Munsing was appointed director of the Munich Collection Center. He quickly shipped out 18 works of art on November 16, 1948, to the Italian government under orders from the military governor, Lucius Clay. It was, however, a departure from the usual restitution of looted or stolen cultural property and was called an exceptional return. One of these items was from the Hermann Göring Collection, Bacciacca, *Portrait of a Lady*, purchased from the art dealer Contini.

Munsing then met with the indefatigable Evelyn Tucker, who was still pressing her case involving the return of art to Austria. Munsing told her that the return of the Italian art had been a rotten business and he was going to make sure that the matter with Austria was handled in accordance with international law. Therefore he had turned the decision over to the U.S. Army Legal Division and the matter would indeed be handled in accordance with international law. Tucker responded that she did not know the details of the Italian transaction but it must have been quite serious for Leonard to resign. Munsing said, "Yes, that was a bad business." Tucker replied that she considered Leonard to be a friend. Munsing looked at her pointedly and said, "He was my best friend." He further said, "Oh no, Eve, I am not nervous or excitable and nobody is going to bother me. I have not the slightest intention of resigning and anybody who bothers me will simply be eliminated."[7] What was the state of mind of Munsing during these trying days? For, unfortunately, on Munsing's watch, 166 objects were shrewdly stolen, including four paintings from the Hermann Göring Collection.

In December 1948, Ante Topic Mimara turned up, claiming to be the Yugoslav government's representative in charge of restitution. Mimara presented a list of 166 objets d'art that he claimed had been looted from Yugoslavia by the Nazis. Mimara had been able to compile the lists because he had helping him a young German art historian, Dr. Wiltrud Mersmann, who worked as a junior curator at the Central Collecting Point. Munsing must have known the art was taken from the Göring and Hitler collections. The inventory numbers and storage location of the art was evidence that the art had not originated in Yugoslavia. Did Munsing release this art as an act of defiance to insure that it would not be returned through Evelyn Tucker to Austria? Did he have any monetary motivation?

Whatever the answer, on June 2, 1949, the bulk of the requested art, which had arrived at the Collection Point from the Hitler Collection at Alt Aussee, was loaded onto

trucks and disappeared. The receipt granting the art to Yugoslavia was signed by Stephen Munsing. Meanwhile, the French government had filed claims for 54 additional pieces of art, which were fully documented and were on the list that had left for Yugoslavia. It did not take long for collection point staff to figure out what had happened but by then Mimara, too, had vanished.[8]

Four of these paintings—*View of Tivoli, Portrait of a Girl, Madonna and Child, and Madonna and Child with Angels*—filched by Mimara had been in the Hermann Göring Art Collection. Mimara had previously used *View of Tivoli*, attributed to Hubert Robert, and *Portrait of a Girl*, attributed to Albert Cuyp, from the collection of Baron Maurice de Rothschild as exchange for other objets d'art. The two paintings had arrived in the Munich Collection Center as a result of these past transactions. The two Italian paintings were acquired by Göring from dealers in Florence. A *Madonna and Child* by Veneziano was obtained from art dealer Eugenio Ventura. This trade was done through an exchange of paintings. The paintings given to Ventura were from the Kann, Rosenberg, Weinberger, and Lindenbaum collections looted in Paris.[9] The second painting, *Madonna and Child with Angels*, attributed to the School of Ferrara, was purchased from the dealer Bellini. Both of the Italian acquisitions were taken to the Munich Collection Center after being recovered by American troops in Berchtesgaden.

Tracked to Tangier by the U.S. Department of State, on March 24, 1956, in an interview Mimara stated that all the objects he took in 1949 had signed receipts, were loaded onto trucks and were escorted by U.S. military police to the Yugoslav border and turned over to Yugoslavian authorities. Topic further lied by saying that Dr. Veljko Petrovic, director, showed him the objects on display in June or July 1946 at the Academy of Belgrade. He saw that the valuable tapestries and textiles had been cut in sizes to fit the floor of the offices of the museum. He returned to Belgrade in 1950 and had no idea as to where the objects were now located.[10]

A March 10, 1954, unsigned letter, "Restitution in Error to Yugoslavia," to Mr. Crutcher has this to say: "It would be impossible to expect a satisfactory answer from Yugoslavia without providing photographs, a full description, and justification of the request…. However the Yugoslav claims are not in the Munich Collection Point files. We cannot find any trace of this folder of the original claim."[11] The 166 objects stolen by Mimara have never been recovered.

Regardless of Mimara's con man abilities, in 1963 Thomas Hoving, curator of the Metropolitan Museum's Cloisters (and later director of the Metropolitan), purchased the most marvelous and enigmatic work of art ever created—*Bury St. Edmunds*, an ivory cross, from Mimara for $600,000. Mimara refused to give Hoving or the museum any details about the provenance of the piece, which had been missing for eight centuries, saying only that it had been purchased from an Eastern European monastery. James Rorimer, director of the Metropolitan, called the cross one of the most important acquisitions the museum had ever made. Mimara used the proceeds to purchase Schloss Neuhaus, the castle near Salzburg where his widow, Dr. Wiltrud Mersmann Mimara, now lives. The junior curator and former employee from the Munich Collection Point had done quite well for herself.[12] Artwork stolen by Ante Topic Mimara is shown on page 171.

Early 18th century, *Venus and Putti*. Mrs. Hofer restored this painting in May 1940, after it was purchased from Helene Tepelmann at an estate sale in Cologne, Germany.

On December 8, 1948, the *New York Herald Tribune* reported on the artwork that had been released from the Munich Collection Point by Stephen Munsing. The paper stated the following:

> The Italian museum officials jubilantly displayed several million dollars worth of art objects which have been returned from the American Zone in Germany.
>
> The artworks were restored to Italy on the ground that they were exported during or before the war in violation of a 36-year-old Italian law forbidding the exportation of art antiques. The works were purchased by or for the German government, but Italians have not been required to refund the money paid for the objects.
>
> The objects were restored to Italy after a three year argument. The Germans con-

Titian, *Portrait of Princess Christina of Sweden*, the Contini Gallery, purchased by Göring in 1942.

tended that they were purchased and exported with the consent of Benito Mussolini but the Italians argued successfully with American military officials that the Fascist dictator had no right to approve exportation.

Opinions among Americans in Germany were divided, but American Military Governor General Lucius D. Clay always supported Italy's view according to Rodolfo Siviero, the Italian who handled the negotiations.

Mr. Siviero told a delighted audience that he overcame demands for repayment by insisting that Germany first restore the dozens of other Italian art objects which were still missing. Mr. Siviero said that Italy has good hopes of getting back another fifty pieces of art but that many others were lost during the war with Germany.[13]

Siviero had been the cultural expert for the Italian government at the Munich Collection Point for several years and his comments in the paper were greatly distorted.

Highly offended, the officials of the American embassy in Rome undertook to determine the facts in connection with the matter. The information received from the field representatives in Munich established that Mr. Siviero, "cultural expert for the Italian Government, who has been located in Munich for an extended period of time, appears to figure in an important capacity in a virulent press campaign in Italy. We no longer consider Mr. Siviero as an accredited restitution representative in as much as there are two cultural restitution men presently attached to the Italian Consulate who are capable of handling cultural restitution matters."[14] Furthermore, he had been declared persona non grata by the high command of Germany when he was serving as the Italian representative in the American Zone of Germany.[15]

After much debate, the Italian consul general in Frankfurt informed American au-

Heinrich Knirr, *Adolf Hitler*. Knirr recreated this portrait in 1935 from a Heinrich Hoffmann photograph. Hitler was most pleased with Knirr's work but actually sat for only one portrait that was painted by Knirr. This was a 1937 birthday gift to Göring from the Führer.

CHommel 41

Conrad Hommel, *Head of Hitler.* Hommel adjusted his style for the Nazi era. He was the favorite artist of the party and painted many portraits of its leaders. His portraits of Hitler were Nazi inspirations and were most popular as propaganda postcards.

thorities that the Italian government had relieved Mr. Siviero from further duty in connection with the activity in Munich because it was found that he could not successfully deal with Americans and because he had entered into press polemics which had proved embarrassing to the Italian government.[16] Siviero was relieved of his position, but still the Italian government intended to pursue its claims for the return of the majority of works acquired by Hitler and Göring. These claims had previously been deferred by the military government on the grounds that the works of art claimed were not adequately identified.

Italy and Germany were active allies during World War II and the art was purchased from a then legally constituted Italian government. The objects were purchased on a free market without any duress and were sent to Germany after valid export licenses had been issued and high export taxes paid. When the art objects arrived in Italy they were not returned to former ownership and were claimed by the Italian state under a special decree. The Italian government, in special Law 77 of January 14, 1950, "asserted a right of possession to all works of art which were transferred from Italy to the German State, to political figures of the Nazi regime, to German subjects and whose return to Italian Governments had obtained through Allied Military Government in Germany."[17] War Trophies sent to the U.S. Army Center of Military History are pictured on page 174.

On May 26, 1952, an agreement was worked out between the Allies and Germany to terminate the occupation status and West Germany gained complete sovereignty. Thousands of non-restitution works of art housed in the Munich Collection Point and Wiesbaden Collection Point were turned over to the New Federal Republic of Germany, including the bulk of art objects acquired from art dealers in Italy.

The chief disagreement between the new German custodians concerned not the bulk of the art collection but the remainder of Hermann Göring's collection, which "was the main bone of contention."[18] The State of Bavaria took the point of view that major parts of the collection were either privately owned or purchased by Nazi Party funds and should be turned over to Bavaria. The German Federal Republic was adamant that the bulk of Göring's collection had been purchased by Reich funds and belonged to the Federal Republic. It appears from what documentation exists that the collection did not go to Bavaria.

The collections of several high Nazi officials were turned over to the Federal Republic of Germany. The valuables those officials acquired in Germany were described as follows:

Swords and cane presented to Göring and sent to Washington on June 29, 1950, as military trophies. From left: sword, metal, silver handle slightly damaged; sword, modern steel; sword, modern, iron chased, handle gilt; sword, modern, iron, handle gilt, a gift from Mussolini; walking stick, shaped like an ax, iron, bronze.

Hermann Göring	approximately 450 paintings
Hans Frank	four or five paintings
Julius Streicher	a group of paintings by himself
Arthur Seyss-Inquart	a small number of art objects
Martin Bormann	three or four art objects
Rudolf Hess	eight items
Walter Funk	a few items
Joachim von Ribbentrop	a few items from his collection
Alfred Rosenberg	a few items
Albert Speer	two tons of archival material
Robert Ley	a few items
Baldur von Schirach	a library of several hundred volumes
Adolf Hitler	Approximately 2,500 objects of art belonging to the Linz Museum Collection. Separately were 50 to 75 personal items that belonged to Hitler.[19]

Under denazification laws, the intent was for these items to be used for the support and relief of politically persecuted individuals who had suffered under the Nazi regime. This noble intent was never carried out, either by the Allies or, later, by the Federal Republic of Germany.

Several inquiries from Swiss art dealers were made of the Munich Collection Point and the Federal Republic of Germany. These were from dealers who had traveled to Munich to acquire part of Göring's estimated $200 million in art. These dealers were obviously under the impression that certain Göring art objects would be released and available for purchase.

The United States did not protest the sale of the acquired Göring loot, but issued a strong protest against returning any items to Göring's wife, Emmy. In a letter, S. Lane Faison wrote: "Whether or not the German courts release such works to Frau Göring, the American authorities would, I believe, never agree to return them to her. To make it all the easier to refuse, I am writing you of the American attitude in advance."

Emmy Göring had visited the Munich Collection Point during Faison's appointment and inquired about her husband's art collection. Faison stated that she should have any personal items such as a portrait of herself or objects of little or no value, but any works of art given by Göring to his wife or daughter during the war should not be given to Mrs. Göring. The German courts had convicted Emmy Göring of being a Nazi and she was barred from working. Deprived of any way to make a living, she spent her last years with her daughter in a tiny apartment in Munich. The art below was turned over to the German government by the U.S. government.

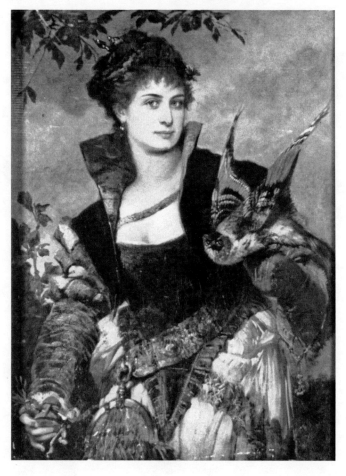

Hans Makart, *The Beautiful Falconer.* **This was a gift from Adolf Hitler to Göring on Göring's 45th birthday in 1938.**

Wilhelm Peterson, *Northern Expedition*, purchased by Göring from the artist before the war.

Bruno Liljefors, *Wild Geese in Winter*, given to Göring as a gift by Robert Ley, who cheated the Nuremberg gallows by hanging himself in his jail cell.

German, 17th or 18th century, *Castle Kitchen,* acquired from Halm Auction in Frankfurt, 1939.

Hugo Kaufmann, *Scene of Fighting Peasants in Inn,* signed and dated 1893, identifying marks, Kunsthandlg. H.O. Mietke, Vienna. It was sold to Göring prior to the war.

Master of the Female Half, *Neptune Embracing Nymphet*, "borrowed" from the Kaiser Friedrich Museum, Berlin, in 1939 just before the war.

Anthony van Dyck, *Andromeda with Persous on Pegasus*, a
gift to Göring from the city of Berlin.

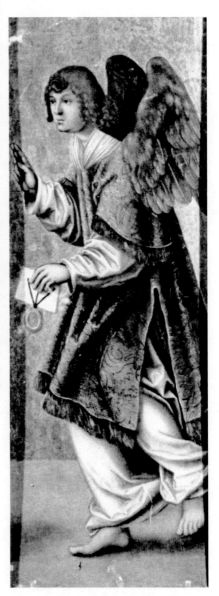

Cranach, *Angel of Annunciation*,
dated 1534, a 1935 wedding gift
to Göring from the Reich Credit
Union.

Conclusion

Göring liked to refer to himself as the Renaissance type and it is evident that he played this role. The business of collecting came in every phase of his activity and he intended that his collection be a monument to his name. As an outgrowth of the Nazi regime the collection grew simultaneously with the expansion of German power. In 1939 it numbered 200 objects. When its growth was cut short by defeat the total had reached over 2,000 and included every variety of work of art. Fortunately, the major part of the collection was recovered by U.S. forces. Some objects were damaged, particularly sculpture that suffered through the many moves, and a few items were stolen.

In amassing his hoard, Göring showed that any means of satisfying his omnivorous appetite was acceptable, provided that some appearance of legality was maintained. He refused to have anything to do with undisguised looting, but he was always ready to support another organization in it and act as the receiver of the looted goods. Although Einsatzstab Rosenberg has become notorious as the most prominent German looting organization, evidence proves the man who inspired its depredations and profited from them was Göring. When the Foreign Currency Control stepped out of its normal role to become responsible for the initial confiscation of the Rothschild collections, it was by order of the Reichsmarschall.

In the open market Göring never failed to take every advantage he could derive from his position as second in command of the Greater German Reich. He always wanted to bring down the price and it was not easy for a citizen of an occupied country to stand up against him. Just as the occupied countries were beaten down, so were Germany's allies and neutral countries deceived when they did business with Göring.

The study of the formation of his collection dispels any illusions that Göring was one of the "better" Nazis. In his pursuit of art, he may have shown himself as a different type of man, but in fact he was cruel, grasping, deceitful and hypocritical, well suited to take his place with Hitler, Himmler, Goebbels and the rest.

But in his collection of art his greed and fraud was apparently addictive, for the governments of Austria, Belgium, France, Holland, and Italy introduced the same arrangements as the Nazis. They simply adapted laws that enabled them to keep the art that was

181

returned to their countries by the victorious Allies. Then, after 50 years, the art treasures looted by the Nazis from Jewish homes resurfaced as the result of political change. Suddenly missing art became an ethical concern, and embarrassed governments, museums, and auction houses promised to make amends. They did not want to be viewed as benefiting from the Holocaust. It is true that just after World War II thousands of works of art were returned to the rightful owners, but since only a small part of this art has been returned, there has been a most expensive cost to owners.

In 1995, after a series of international conferences in which this author participated had exposed many inequities, the French museums and other countries began to study the provenances regarding the acquisition of art during World War II. In 1999, the Austrian government reversed its policies and returned 200 items to the Rothschild family of Vienna. The Dutch government established a committee that examined the Goudstikker Collection and, in February 2006, part of the collection was returned to Goudstikker heir Marei von Saher. The legal expenses to von Saher for the return of the Goudstikker objects were $10.4 million. Many claimants cannot afford the research and legal fees necessary. The burden should not be on the claimant to prove ownership but on the European governments to provide provenance of the items in question. What is apparent is that most of the artwork taken by Göring and his henchmen will never be returned. If anything, this book confirms that greed is indeed addictive.

Perhaps Kajetan Muehlmann summarized it best with this postwar statement: "But the Third Reich had to lose the war because this was based on robbery and a system of injustice and violence, which can only be broken from the outside. Every individual has now to pay personally for the mortgage which the German people have accepted."[1]

Appendix A

Items Taken from Hermann Göring at Nuremberg

1. One medal, Pour le Mérite
2. One Iron Cross, 1st Class, 1914
3. One Gross Kreuz
4. One gold Luftwaffe badge
5. One gold Luftwaffe badge with diamonds
6. One platinum Iron Cross
7. One diamond A/C brooch
8. One gold stickpin with swastika of diamond chips
9. One personal silver seal
10. One watch fob, platinum, onyx stones, diamonds inlaid as an A/C insignia
11. One gold cigarette case, inlaid with amethyst and monogrammed by Prince Paul of Yugoslavia
12. One fountain pen inscribed "Hermann Göring"
13. One desk watch
14. One travel clock by Movado
15. One large personal toilet case
16. One emerald ring
17. One silver pill box
18. One gold and velvet cigar case
19. One square watch by Cartier, set with diamonds
20. One gold chain, gold pencil and cutter
21. Three keys
22. One diamond ring
23. One ruby ring
24. Four semiprecious buttons

25. One small eagle with diamond clip
26. Four cuff links with semiprecious stones
27. One gold pin in the shape of an evergreen twig
28. One pearl stickpin
29. One small watch set with artificial diamonds
30. One gold cigarette lighter
31. One wristwatch
32. Two old Norse collar buckles
33. One brass compass
34. One silver cigar cutter
35. One brooch
36. One silver watch
37. One set of lapis lazuli cuff buttons
38. One heart-shaped silver box
39. One gilded pencil
40. One large Swiss wristwatch
41. 81,268 reichsmarks

Appendix B

EMMY, EDDA, AND HERMANN GÖRING'S JEWELRY

Jewelry of Emmy Göring

A braided bracelet, serpent shape, in gold

A bracelet made of 10 cameos, gold setting

A bracelet with 5 green stones in the center, gold setting

A bracelet of leaf-like design, having a row of blue stones at the center between two rows of false stones — silver setting

A bracelet decorated with 5 oval amethysts — gold setting

A bracelet made up of seven motifs, decorated with a ruby, sapphires, diamonds and pearls, gold setting

A rigid bracelet, decorated with 9 cultured pearls on a leaf-like silver motif — silver setting

A rigid bracelet forming a medallion (picture of a baby) decorated with oak leaves, gold setting

A rigid bracelet having in its center an aquamarine surrounded by rose diamonds, on a gold setting, 2 motifs, each decorated with three cultured pearls

A flexible bracelet decorated with 8 diamonds of unusual color, and 7 pendants each decorated with a ruby, the whole set in platinum

A bracelet made up of 10 oval-shaped diamonds, and 9 fine pearls, platinum setting

A flexible bracelet having in its center a motif composed of 3 cabochon sapphires between 4 little bars decorated with diamonds, 2 little bars of diamonds on the platinum setting

Flexible bracelet formed of 8 motifs, each one having in its center a blue stone, paved (strewn) with diamonds, platinum setting

Flexible bracelet having at its center a motif of an emerald surrounded by diamonds; on the setting 2 motifs, each formed of 3 circles covered with diamonds, platinum setting

Flexible platinum bracelet made up of 5 motifs, each having in its center an emerald, surrounded by diamonds, the body of the bracelet covered with round diamonds and baguette diamonds

Flexible bracelet made up of 5 motifs in knot form; strewn with round and baguette diamonds between each of these motifs a round diamond, platinum setting

Flexible bracelet made up of 3 round motifs, each having in the center a diamond between two lines of baguette diamonds. Between each of these motifs 10 round diamonds, between two half circles strewn with diamonds, platinum setting

Flexible bracelet made up of 5 ruby motifs surrounded by diamonds — the body strewn with round and baguette diamonds, platinum setting (rubies placed against a grindstone, in a very bad condition)

Stream of diamonds (necklace) in platinum formed of 85 bezels, each decorated with a diamond; this stream of diamonds can be transformed into two bracelets

Small bracelet of diamonds made up of 6 motifs, each decorated with a baguette diamond, the body of the bracelet strewn with diamonds, platinum setting

Gold bracelet watch, the watch being between 21 ball-shaped motifs, each decorated by a diamond (made by Cartier)

Platinum bracelet watch decorated with diamonds, letters H.G.

A commander's decoration — platinum and gold — decorated with rose diamonds and brilliants, the center enamel

Ornament made of 3 clips in the form of palms, decorated with round and baguette diamonds, platinum setting, spatula in white gold

A brooch in flower form having at its center an imperfect pearl, the base strewn with diamonds, platinum setting

Platinum clip decorated with an emerald of cabochon form, with round and baguette diamonds, platinum setting (the duplicate clip is missing)

Clip forming a flowered brooch decorated with cabochon rubies, emerald and sapphire — the base of the brooch decorated with round and baguette diamonds, setting gold and platinum

Brooch of octagonal shape having in its center an emerald surrounded by baguette diamonds, platinum setting

Little platinum clip decorated with round and baguette diamonds. Spatula in silver

Two gold-colored brooches in knot shape decorated in the center with a cornelian, on the body of the brooch motifs decorated with diamonds

Platinum brooch of interlaced design, having in its center a Japanese pearl

Little brooch made up of 4 motifs having in the center an imperfect pearl, surrounded by diamonds, platinum setting

Gold-plated silver clip having in its center an amethyst between 4 pearls

Metal clip decorated with garnets

Small silver barrette decorated with 8 amethysts

Little brooch having in its center a sapphire between two pear-shaped motifs decorated with diamonds, platinum setting

Platinum tiara adorned with laurel leaves strewn with diamonds, and 8 emerald cabochons. Platinum setting decorated with baguette diamonds

Tiara having at its center a round sapphire between 2 pearls and 3 diamonds; on the base motifs of foliage decorated with brilliants and some rose diamonds, platinum setting

Silver tiara decorated with 7 Japanese pearls

An impressive pair of pendant earrings formed of a square emerald surrounded by diamonds, held up by 2 small chains also decorated with diamonds

Gold ring which opens up, having two bezels, each adorned with a colored stone, the base of the stone decorated with 2 enamel figurines

Ring adorned in the center with a cornelian stone surrounded by a motif decorated with brilliants and rose diamonds, setting platinum and gold

Ring with amethyst between 2 motifs decorated with diamonds, platinum setting

Ring with amethyst between 2 small bars of diamonds, gold setting

Modern rose-gold ring decorated with square rubies and rectangular sapphires

Emerald ring, setting diamonds, between 2 motifs of diamonds on the platinum mounting

Ring of 3 cabochon rubies, the bezel of each of these stones strewn with diamonds (1 diamond missing) platinum mounting

Small ring, decorated with 2 pearls, between 2 motifs strewn with diamonds, platinum mounting

Important ring, decorated with a green stone platinum and gold mounting (Werkanserbe-Handwerk)

A tie pin decorated with a cabochon emerald between two lines of baguette diamonds, setting diamonds, mounting platinum

A tie pin decorated with a cabochon sapphire between two lines of square diamonds between diamonds, platinum mounting

A necklace in platinum, decorated with some rose diamonds, sustaining a motif in foliage style, in the center of which is a blue stone, platinum mounting

Ring in oval form in gold, decorated in the center with the head of a deer with antlers (Deutsche Jagd-Museum), on the body of the ring 3 oak leaves with 3 acorns

Very important ring in oval form, decorated in its center with an intaglio representing the head of a deer with antlers, on the body of the ring 2 soaring eagles, mounting gold, silver and platinum

Gold ring in very bad condition, representing two animals, sustaining an intaglio in a gold oval

Emerald ring between 6 baguette diamonds, in a platinum mounting

Siamese ruby ring, setting round and baguette diamonds, platinum mounting

Small gold ring, decorated with a scarab

Pommel of a scepter decorated with a cabochon emerald, the mounting platinum and silver, decorated with diamonds and 5 small cabochon emeralds

A pendant, in the form of a coat of arms, decorated with a crown above which is an Iron Cross, in the center 3 principal diamonds, the body strewn with diamonds and rose diamonds, a callipered sapphire motif, platinum mounting

Small necklace in white gold, sustaining a small pendant decorated with 6 cultured pearls and rose diamonds, white gold mounting

Gold necklace, sustaining a pendant decorated in its center with a moonstone surrounded by 7 imperfect pearls and 8 red stones (1 pearl missing)

Necklace in small pearls sustaining a pendant in agate decorated in its center with a sapphire and 6 rose diamonds, the motif connecting the pearls decorated with diamonds and rose diamonds

Gold-trinket, in ball form decorated with rose diamonds, pearls and half-pearls

Gold (intertwined) necklace, sustaining a cross decorated with 6 amethysts, gold mounting

Collar formed of ball-shaped emeralds between cultured pearls, platinum clasp decorated with 3 diamonds, sustaining an emerald cross, mounted in white gold

Bracelet formed of 3 rows of emerald balls

Comb in blond shell, in its own case, decorated with a cabochon emerald motif surrounded by 7 diamonds

Watch fob, in blue material, decorated with a cabochon emerald motif surrounded by 7 diamonds

Watch fob, in violet material, decorated with a large amethyst surrounded by diamonds, a barrette decorated with 2 square diamonds and little diamonds, platinum mounting

Watch fob, in green material, encrusted with oak leaves and acorns, sustaining a motif in heavy gold, decorated with 3 cabochon emeralds, representing a bison

Ornament comprising 2 brooches of oval form and a loop, all in gold decorated with cabochon emeralds, small diamonds and imperfect pearls

1 pair of cuff buttons, decorated with cabochon emeralds, gold mounting

1 pair of cuff buttons, decorated with cabochon rubies and diamonds, gold mounting

1 pair of cuff buttons, in gold with coat of arms

Old brooch in gold, head of a man

1 brooch in gold, wild boar and 2 dogs

1 tie pin, cultured pearl, gold mounting

1 tie pin, star sapphire, gold mounting

1 hair pin, motif rubies heart form, gold mounting

1 tie pin, head of a deer, in gold

1 small necklace, in silver

1 evening bag, in silver, having on its cover a flower motif, decorated with cabochon rubies and diamonds

1 chain in gilded silver

1 small chain in platinum

1 trinket in gilded silver

1 jewel box in silver-plated gold, the cover decorated in the center with a large oval topaz

1 cigarette box in gold, the design in ray form, the clasp decorated with a diamond

1 cigarette box in gold, re-covered in lapis lazuli, forming a match box with an inflammable cord, blue, some calibered sapphires (Cartier)

1 sack in gold, the clasp decorated with 2 cabochon sapphires

1 lot of 4 diamonds, weight about 2.35 carats

1 lot of 4 diamonds, weight about 1.50 carats

1 lot of 9 diamonds, weight about 0.83 carats

1 lot of 28 diamonds, weight about 0.82 carats

1 diamond baguette cut, weight about 0.17 carats

1 lot of small calibered emeralds, weight about 0.32 carats

1 tall champagne cup in gold, the design of sirens, grapes, and coat of arms, decorated with diamonds, emeralds, rubies and pearls, weight of cup about 470 grams

Jewelry of Edda Göring

One bracelet with lucky charms

One bracelet set with diamonds

One bracelet set with fancy stones

One bracelet set with cameos

One pendant with moonstones, and chain

One pearl pendant with chain

One antique pearl pendant

One gold handbag

One gold wristwatch and band set with diamonds

One comb set with stones

One green necklace with bracelet to match

One ring set with ruby

One ring set with emerald

One ring set with Egyptian beetle

Jewelry and Valuables of Hermann Göring

One ring set with a green stone

One tie clip with emerald

One tie clip with sapphire

One hunter's ring with bluish-green stone

One antique gold ring

One gold hunter's ring

Four gold cuff links

One pair of ruby cuff links

One pair of emerald cuff links

One opal pin

One pearl pin

One gold hunter's pin

One watch fob ribbon with 2 aquamarines

One gold hunter's pin

One gold round brooch

Handle of a hunting knife set with one large and 5 smaller emeralds

One belt buckle with pearl and 8 sapphires

Two matching pins with emeralds

One lapis lazuli cigarette case

One gold cigarette case with diamond

One decoration set with diamonds

One long gold chain

Fancy unset chips

One watch fob ribbon with three emeralds and one diamond

Appendix C

PAINTINGS AND SCULPTURES, BY ARTIST

6510	12me Siecle Forgery	Heads of Two Kings	Bacri Society	France
6026	15th c.	Armchair	Fischer, Swiss	Germany
5264	15th c.	Chest	San Girgo, Italy	Germany
6097	15th c.	Figure of a Knight with Loin (× 77)	Rothschild	France
6497	15th c.	St. Bishop (× 95)		Germany
6367	15th c.	St. Gregors Mass (50 × 32)		France
5662	16/17th c.	Armchair	Bellini, Italy	Germany
7036	16/17th c.	Maria with Child (× 25.4)		Germany
5709	16th c.	Drinking and Singing Party (198.5 × 118)		Germany
5117	16th c.	St. George Relief		Germany
5117	16th c.	St. Martin		Germany
5737	17th c.	Angel of Annunciation		Germany
7034	17th c.	Three Graces in Landscape (42 × 28)	Germany	
5570	18/19th c.	Sleeping Venus (75 × 65)		Germany
5948	18th c.	Castle Glienecke (20 × 30)	Germany	
5597	18th c. After Wouwerman	River Landscape Bathing People (50.5 × 65)		Holland
5120	18th c. Lancret ?	Portrait of a Painter (94 × 73)	Wildenstein	France
6496	193?	Bust of Marianne Hoppe (× 66)		Germany
5194	5194–5231	41 Crates of Books		Offenbach
5441	c. 1500	Casula with St. George and St. Martin	Mauterndorf Castle	Austria

6714	Adam, Franz	Before the Ride		Germany
5365	Aertz, Pieter	Drinking Couple	Goudstikker 1688	Holland
6360	Albani	Venus and Amor (42 × 40)	Germany	
5691	Alpinian Country	Holy Virgin Sitting with Child (× 122)		Germany
6099	Alsace c. 1490	The Adoration of the Child (83 × 75)	Ofenheim	Holland
6100	Alsace c. 1490	The Circumcision of Christ (80 × 74.5)	Ofenheim	Holland
5171	Alsloot, van	Forest Landscape with Rider (113 × 146)	Muehlmann	Holland
7143	Alt, Rudolf	Forum Near in Rome (51 × 66)	Gruess, Julia	Austria
6158	Alt, Rudolf	Pantheon in Rome (44.5 × 59.5)		Germany
5495	Alt, Rudolf	Street Scene Porta Capuana (67 × 49)		Germany
5498	Alt, Rudolf	Wien Hausergruppe (49.5 × 76)		Germany
5982	Angelico after Fra	Angel	Looted from CCP	Germany
5250	Anghiari Master	Triumph of Aemilius Paulus	Goudstikker 2331	Holland
5108	Antonis Mor	Portrait of a Huntsman (130 × 100)	Unknown	France
5111	Antwerp 16th c.	Triptych: Wings Adoration of the Magi (111 × 89)	D' Atri	Germany
6066	Archaic Style	Head of Woman (× 37)		Germany
5624	Austria 1520	St. Knight (× 127)		Germany
5618	Austria 1520	St. George (× 108)		Germany
5616	Austria 1520 Forgery	St. George (× 103)		Germany
5615	Austria c. 1520	Saint Knight (× 120)		Germany
5092	Austria c. 1520	Saint Knight, Wood	Jagenan Collection	Austria
6112	Austria c. 1520	St. Knight (× 175)		Germany
5632	Austrian 1520	St. Barbara (× 147)		Germany
5743	Austrian 15th c.	S. Florian (42 × 56)		Germany
7381	Averkamp	Winter River Scene	Koenigs	Holland
5288	Baalen, v. Hendrik	Diana with her Women after Hunt (53 × 75.5)	Hoogendijk	Holland
6061	Baccatagliata Putti	Door Handle with Nude Woman (40 × 25)	Unknown	France
5853	Bacciacca	Portrait of a Lady (70 × 88)	Contini, Italy	Germany
6356	Backhuysen	Marine (36 × 36.5)	Paech	Holland
5610	Balten, Pieter	Popular Fete (115 × 69.5)	Denijs	Holland

5654	Bamberger	Mountain Landscape with Lake (81 × 126)	Eva Braun	Germany
5921	Barbiari	Portrait of Man with Flower (35 × 24)	Fischer, Swiss	Germany
5519	Bartolo di Maestro, Fredi	Archangel Michael (115 × 30)	Unknown	France
5520	Bartolo di Maestro, Fredi	St. Francis (115 × 30)	Unknown	France
5314	Basaiti, Marco	Madonna with Child	Goudstikker	Holland
5673	Bavaria 1490	St. George (× 125)		Germany
6057	Bavaria 1520	St. Urusula on Boat (× 62)		Germany
5637	Bavaria 1520	Woman with St. John Under Cross (× 130)		Germany
6090	Bavaria c. 1520	St. Sebastian (× 93)	Fischer, Swiss	Germany
5149	Beaubrun, Charles	Mad, de Mantespan as Diana (183 × 100)	Schmit, Jean	France
5530	Beauvais 18th c.	Shepard Scene with Girl at a Well (53 × 150)	Dreyfuss Gal.	France
6771	Belleganbe	Christ Led to Golgatha (174 × 129)	Perdoux	France
5345	Bellevois, Jacob	Sea Battle (77.5 × 118)	Hoogendijk	Holland
5411	Bellevois, Jacob	Seestueck (75 × 103)	Göring	Germany
5872	Bellini	Madonna and Child (48.5 × 42)	Goudstikker	Holland
5302	Benson	Madonna	Goudstikker 1487	Holland
5534	Bereskine	Female Nude Lying (75 × 64)		Germany
5788	Bereskine	Nude Woman Bathing (45 × 37)		Germany
5432	Bereskine	Portrait of Carin Göring	Göring Collection	Germany
5785	Bereskine	Portrait of Carin Göring	Göring Collection	Germany
5387	Bereskine	Three Women Under Trees (102 × 113.5)		Germany
5547	Bereskine	Two Women on Oranges (75 × 60)		Germany
5533	Bereskine	Young Woman with Chain of Pearls		Germany
5544	Bereskine	Young Woman with Mirror		Germany
5832	Berghem	Italian Harbor (67 × 88)	Wassermann	France
5241	Beukelaer	Sellers of Vegetables and Fruit (142 × 227)	Veken	Belgium
5172	Beukelaer	The Easter Lamb (98 × 105)	de Boer	Holland
5886	Beyeren	Marine	Goudstikker 5970	Holland

5162	Beyeren, von	Girl with Basket of Fruit (107.5 ×)		Germany
5190	Beyeren, von	Still Life with Fruit (99 × 122)	Katz	Holland
7171	Bicci	Angel Delivering a Man	Goudstikker 2668	Holland
7170	Bicci	Angel with Two Riders	Goudstikker 2669	Holland
6177	Bles de met, Henri	Landscape	Goudstikker 2655	Holland
6430	Bles de met, Henri	Lot with Daughters (27 × 40)	de Boer	Holland
5795	Bles de met, Henri	The Way to Golgotha (40 × 100)	Seligmann	France
7164	Bles de met, Henri	Two Sailing Boats (31.5 × 68)		Germany
5498	Boecklin	Landscape in the Pontin (27 × 22)		Germany
5931	Bohemian Master	The Virgin with Child (44 × 34)	Gelder van	Belgium
5233	Bol, Ferdinand	Alexander and Roxane (179 × 219)	Hoogendijk	Holland
5575	Bol, Ferdinand	Portrait of a Boy with Cap (81 × 60)		Germany
5191	Bol, Ferdinand	Pyrrus (118 × 96.5)	Wolf, Marcel	Holland
5491	Bol, Ferdinand	Self Portrait with Wife	Goudstikker	Holland
5318	Bol, Ferdinand	Vertumnus and Pomona	Goudstikker 2456	Holland
6822	Booser	Landscape (30.5 × 52)		Germany
5775	Botticelli (?)	Self Portrait (?) (59 × 44)	Contini, Italy	Germany
5801	Botticelli School	Maria with Child (87 × 58)		France
7150	Boucher Workshop	Woman with Two Children (62 × 44)	Rothschild	France
5363	Boucher, Francois	Allegory Music or Poetry (96.7 × 130)	Wildenstein	France
5138	Boucher, Francois	Allegory of the Air (2.75 × 2.09)	Rothschild	France
5138	Boucher, Francois	Allegory of the Earth (280 × 200)	Rothschild, A	France
5138	Boucher, Francois	Allegory of the Fire (270 × 200)	Rothschild	France
5138	Boucher, Francois	Allegory of the Water (270 × 210)	Rothschild	France
5137	Boucher, Francois	Amore	Wildenstein	France
6746	Boucher, Francois	Couple of Lovers (94 × 75)	Lacarde	France
6751	Boucher, Francois	Couple of Lovers (94 × 75)	Lacarde	France
5821	Boucher, Francois	Entrance to Parc	Goudstikker 1668	Holland

6738	Boucher, Francois	Landscape (56 × 46)	Jacobsen	France
5726	Boucher, Francois	Lying Female Nude (42.5 × 27.5)	Stern, Caroline	France
5133	Boucher, Francois	Mythological Female Figure (137 × 192)	Goudstikker 2183	Holland
5937	Boucher, Francois	Venus (30 × 25)	Wildenstein	France
5938	Boucher, Francois	Venus (30 × 25)	Wildenstein	France
5266	Boucher, Francois	Venus and Amor (280 × 85)	Rothschild	France
5335	Boucher, Francois	Venus and Amor (86 × 145)	Rothschild	France
5336	Boucher, Francois	Venus Chastising Amor (86 × 145)	Rothschild	France
5265	Boucher, Francois	Venus Crowned by Amorets (280 × 85)	Rothschild	France
6710	Boucher, Francois	Venus with Rose (34 × 42.9)	Rothschild	France
6710	Boucher, Francois	Venus with Two Pigeons (34 × 42.9)	Rothschild	France
7144	Boucher, Francois	Woman Reading (60 × 49)	Wildenstein	France
7145	Boucher Workshop	Woman with Water Jug (62 × 44)	Rothschild	France
7169	Boudin	Harbour (35 × 59)	Stall	France
6180	Boudin	Sailing Vessel (24.5 × 35.5)	Levy, Benzion	France
5913	Boudin	Strand at Tronville (14 × 27)	Lindenbaum	France
5914	Boudin	Sur La Jettee (18 × 27)	Levy, Benzion	France
6734	Bouts	Birth of Christ (37 × 30)	Kleinberger	France
7042	Bouts	St. Joseph Stirring (16.5 × 23.5)		Germany
6142	Brekelenkamp	Interior (47 × 66)	Andriesse	France
5727	Brekelenkamp	Interior Two Figures (42.5 × 53)	de Boer	Holland
5303	Bronzino	Portrait of a Lady	Goudstikker 2776	Holland
7382	Brosamer	Portrait of a Young Man	Unknown	France
5917	Brouwer	Drinking Peasants (33 × 42.5)	Katz	Holland
6130	Brouwer	Landscape with Cottage (34 × 25)	Dick	Holland
6117	Brouwer	Peasant Fair (47 × 64)	Dick	Holland
5360	Brueghel & Balen	Diana with Companions in Woods (174 × 188)	Unknown	France
6012	Brueghel, d.j. Pieter	April Landscape (21.5 × 30)	Goudstikker	Holland
6005	Brueghel, d.j. Pieter	August Landscape (21.5 × 30)	Goudstikker	Holland
6769	Brueghel, d.j. Pieter	Autum Boochas, Many Girls (58 × 85)	Schleissheim	Germany

6007	Brueghel, d.j. Pieter	December Landscape (22.5 × 30)	Goudstikker	Holland
5367	Brueghel, d.j. Pieter	Diana and Callisto (102 × 135)	Private Collection	France
6008	Brueghel, d.j. Pieter	February Landscape (22.5 × 30)	Goudstikker	Holland
6002	Brueghel, d.j. Pieter	January Winter Skating People (22.5 × 30)	Goudstikker	Holland
6003	Brueghel, d.j. Pieter	July Landscape (21.5 × 30)	Goudstikker	Holland
6010	Brueghel, d.j. Pieter	June Landscape (21.5 × 30)	Goudstikker	Holland
5447	Brueghel, d.j. Pieter	Kermis (126 × 80)	Berlin Museum	Germany
5725	Brueghel, d.j. Pieter	Landscape with Windmills and People (53 × 38)	Unknown	France
6004	Brueghel, d.j. Pieter	March Landscape (22.5 × 30)	Goudstikker	Holland
6013	Brueghel, d.j. Pieter	May Landscape (22.5 × 30)	Goudstikker	Holland
6006	Brueghel, d.j. Pieter	November Landscape (22.5 × 30)	Goudstikker	Holland
6011	Brueghel, d.j. Pieter	October Landscape (21.5 × 30)	Goudstikker	Holland
6009	Brueghel, d.j. Pieter	September Landscape (21.5 × 30)	Goudstikker	Holland
6770	Brueghel, d.j. Pieter	Spring with Flowers and Fruits (59 × 86)	Schleissheim	Germany
5645	Brueghel, d.j. Pieter	Summer (91 × 56)	de Boer	Holland
6761	Brueghel, d.j. Pieter	Summer Landscape Ceres with Girls (58 × 87)	Schleissheim	Germany
5972	Brueghel, d.j. Pieter	The Village Street (26 × 38)	Wassermann	France
6762	Brueghel, d.j. Pieter	Winter Society Eating (59 × 86)	Schleissheim	Germany
5802	Brueghel, Jan	Riverview	Goudstikker	Holland
5351	Brueghel near of Pieter	Crucifixion of Christ (118 × 161)	Paech	Holland
5350	Brueghel the Younger	Flemish Wahe (111 × 162.5)	Veken	Belgium
5327	Brueghel the Younger	The Dutch Proverbs (125 × 171)	Simon Levy	France
5047	Bruggen, Van Caspar	Tapestry, Wool and Silk	Rothschild	France
5479	Brussels c. 1510	Triumph of Cupid	Unknown	Belgium
6015	Bruyn	Portrait of a Lady	Goudstikker 2619	Holland
7125	Bruyn	Portrait of Gentleman Standing (135 × 64)		Germany
7124	Bruyn	Portrait of Lady Standing (135 × 64)		Germany
7183	Bruyn	St. Barbara (24 × 46)	Goudstikker	Holland
7189	Bruyn	St. Bartholomeus (24 × 45)	Goudstikker	Holland
5749	Bruyn	Portrait of a Man	Goudstikker	Holland

5751	Bruyn	Portrait of Lady Skull on Back	Veluwe Hooge	Holland
5981	Bruyn (?)	Portrait of a Man (28.5 × 22)	Goudstikker 2539	Holland
5498	Buerkel	Sheep Shearing (64 × 45)	Germany	
5307	Buonconsiglio	The Circumcision	Goudstikker 1375	Holland
6056	Burgund	St. George with Dragon in Hand (× 104)	Galadakis	France
6076	Burgundy	Madonna with Child (× 100)	Delaunay	Holland
6741	Burgundy	Portrait of a Young Man	Koenigs	Holland
6508	Burgundy	St. Genivene (× 96)	Schmit, Jean	France
6520	Burgundy 14th c.	Madonna with Child (× 82)	Unknown	France
6842	Cairati	Potter's Ware (46 × 70)		Germany
5381	Calcar, v., Toos	Portrait of Man with Astrol Watch (110 × 93)	Lopko	Germany
5487	Canaletto	View of Piazetta Venice	Bottenwieser	France
5281	Cantena	Portrait of a Man (66 × 44)	Rochlitz	France
5166	Capelle, van de	Marine Landscape (105 × 77)	Hoogendijk	Holland
5354	Circle of Caravaggio	Lying Venua and Faun (128 × 178)	Unknown	Germany
6830	Carolsfelf	Landscape with Crusaders (49 × 66)		Germany
6379	Carpaccio	Allegorical Woman with Book, Dog (186 × 87)	Contini, Italy	Germany
6376	Carpaccio	Portrait of a Standing Young Man (185 × 86)	Contini, Italy	Germany
6518	Carpeaux 1873	Les Trois Graces (× 75)	Weill, David	France
6518	Carpeaux 1873	Three Graces	Weill, David	France
5545	Carriara	Portrait of a Lady (77 × 53)	Contini, Italy	Germany
6783	Cassel	Landscape with Flight from Egypt (72 × 92)	Paech	Holland
6782	Cassel (?)	Landscape with Flight from Egypt (72 × 92)		Germany
5052	Causasia, Karabach	Carpet Runner, Black	Goudstikker T.117	Holland
6747	Chardin	Petite Fille au Volant (65.5 × 82)	Rothschild	France
7392	Chardin	Still Life (41 × 31.5)	Wildenstein	France
7393	Chardin	Still Life (41 × 32)	Wildenstein	France
6866	Charlemont	Still Life Fruits (60 × 76.5)	Germany	
5233	Ciacomo, Pelma	The Judgment of Paris (160 × 258)	Leyandeck	Germany
5992	Circle of Rogier	Madonna with Child (33 × 24)	Paech	Germany
5855	Cleef	Portrait of a Man	Goudstikker 5714	Holland
7119	Cleve	Half Figure Nude Woman (96 × 72)		Germany

5837	Cleve, van	Adoration of the Magi	Goudstikker 2724	Holland
5714	Cleve, van	Holy Family (52.5 × 60)	Wildenstein	France
5846	Cleve, van	Portrait of a Man (66 × 83)	Wolf, Marcel	Holland
5740	Clouet	Portrait of a Lady (40 × 32)	Unknown	France
5882	Clove	Leda (84 × 68)	Unknown	France
5942	Cock de Wellensz	St. Anthony (31 × 35.5)	Goudstikker 1717	Holland
7185	Cock van Aelst, Pieter	Adam and Eve (48.5 × 38)	Katz	Holland
7388	Cock van Aelst, Pieter	The Young Christ in Temple (38 × 30.5)	Goudstikker	Holland
6186	Cock van Aelst, Pieter	Triptych: Madonna with Child and Saints (43 × 30)	Unknown	France
5315	Cock, Aelst van, Pieter	Alter with Adoration and Presentation	Goudstikker 5163	Holland
6763	Codde	Portrait of a Boy (54 × 41)		Germany
6092	Cologne 15th c.	St. Agnes (× 95)	Brosseron	France
5283	Conti, dei Bernardino	Man's Portrait Half Length	Goudstikker 2133	Holland
6502	Copy of Giovanni Bologna	Kneeling Nude Girl with Veil (× 25)	Rothschild	France
6110	Corot	Early Spring Landscape (46 × 56)	Rosenberg	France
6362	Corot	River with Boat (24 × 35)	Aschberger	France
6112	Corot	Small Harbor (46 × 56)	Rosenberg	France
5133	Cossa, Franc	Angel of Annunciation (203 × 119)	Koenigs	Holland
5253	Cossa, Franc	Scene in Troja	Goudstikker 1904	Holland
7181	Costa	Madonna with Child	Goudstikker 2132	Holland
5294	Coster, Vallayer	Still Life	Goudstikker 1338	Holland
6172	Cotter, de Coolin	Dolorous Maria (54 × 35)	Dequoy	France
6125	Courbet	Female Nude Before Open Sea (46 × 55)	Rosenberg	France
5836	Courbet	Landscape (60 × 74)	Rosenberg	France
5770	Courbet	Snow landscape with Cottages and Two Men (50 × 60)	Rothschild	France
5389	Cousin, Jean	The Rape of the Sabines (190 × 115)		Germany
5364	Coypel	Armida Rinaldo (102 × 129)	Unknown	France
5258	Cranach	Adam	Goudstikker	Holland
5718	Cranach	Adam and Eve (73 × 61.5)		Germany
5550	Cranach	Angel of Annunciation (69 × 26.5)		Germany
5659	Cranach	Christ and the Children (71 × 121)		Germany

5924	Cranach	Christ with Samariter Woman at Well (53.5 × 37.5)	Schmidtlin, Swiss	Germany
5756	Cranach	Crucifixion of Christ (35 × 54)	Fischer, Swiss	Germany
5833	Cranach	Eva Half Length (88 × 68)	Roy, Le	Belgium
5260	Cranach	Eve (70 × 188)	Goudstikker	Holland
7133	Cranach	Frederic Weise	Giese, Swiss	Germany
6147	Cranach	Joachim II as a Knight (58.5 × 40)	Berlin Museum (?)	France
6363	Cranach	Lucretia (41 × 27.5)	Germany	
5827	Cranach	Lucretia (73 × 52.5)	Paech	Germany
6124	Cranach	Madonna and Child with Grapes (61 .5 × 42)	Tietje	Holland
5742	Cranach	Madonna and Child with St. John (64.5 × 41)	Pannwitz, v	Holland
6166	Cranach	Madonna with Child (56 × 38.5)	Fischer, Swiss	Germany
5807	Cranach	Paradise Adam and Eve with Animals (86 × 57)	Fischer, Swiss	Germany
6781	Cranach	Paulus (114 × 54)	Unknown	France
6780	Cranach	Petrus (114 × 54)	Unknown	France
5282	Cranach	Portrait of a Lady (65 × 49)	Germany	
7139	Cranach	Portrait of a Man (42 × 61)	Lippmann	Holland
6137	Cranach	Portrait of a Man (53 × 45)	Fischer, Swiss	Germany
5739	Cranach	Portrait of a Saxian man (42 × 38)		Germany
5923	Cranach	Portrait of Frederic Sage at Saxony (52 × 35)	Wildenstein	France
5868	Cranach	Portrait of Frederic the Wise (77 × 52.5)	Giese, Swiss	Germany
5955	Cranach	Portrait of Martin Luther (15 × 19)	Philips	Holland
5953	Cranach	Portrait of Melanchton (19 × 13.5)	Fischer, Swiss	Germany
5922	Cranach	Portrait of Priest (51 × 36)	Unknown	France
5870	Cranach	Portrait of Saxon Princess (87.5 × 69)	Reber, Swiss	Germany
6178	Cranach	Portrait of Sibylle Duchess of Cleve	Goudstikker 3075	Holland
6165	Cranach	Printz Moritz of Sachsen (57 × 38)	Grossherz Hesse	Wiesbaden
5723	Cranach	Pyramus and Thispe (58.5 × 39)		Germany
5867	Cranach	Repose on Flight to Egypt (88 × 58)	Fischer, Swiss	Germany

5980	Cranach	St. Anne and Child (32.5 × 25)	Fischer, Swiss	Germany
6764	Cranach	St. Magdalena (72 × 56.5)		Germany
5877	Cranach	St. Mary and Child St. John in Landscape (66 × 46)	Fischer, Swiss	Germany
5546	Cranach	The Judgment of Paris (66 × 58)	Hirsch, Robert	Wiesbaden
5261	Cranach	Venus	Proehl	Holland
5316	Cranach	Venus and Amor	Goudstikker 2071	Holland
5259	Cranach	Venus and Amor	Museum Hooge	Holland
7384	Cranach	Lucretia		Germany
6745	Cranach	Portrait of Christiane V. Eulenar (63 × 44)	Fischer, Swiss	Germany
6743	Cranach	Portrait of Gentleman with Taison (37 × 24)	Unknown	France
6329	Cranach	Portrait of a Gentleman	Fischer, Swiss	Germany
5643	Cranach	Six Nude Couples in Paradise (105 × 74)		Germany
7147	Called Cranach	Portrait of a Lady (67 × 54)	Boitel	France
6381	Cranach Copy	Venus and Amor (178 × 83)	Germany	
7390	Cranach School	Allegory of Virtue (20.5 × 32)	Rothschild	France
5602	Cranach School	Altarpiece, Crucifixion of Christ (67 × 43)		Germany
5861	Cranach School	Hercules and Omphale (72 × 53)		Germany
6364	Cranach School	Lucretia (26 × 39)		Germany
6337	Cranach School	Lucretia (62 × 41)	Schultheiss Swiss	Germany
6372	Cranach School	St. Catharine and St. Margaret (75 × 222)		Germany
7178	Credi	Madonna with Child (63 × 46)	Laudry	France
6758	Cross, van, Jan Anton	View of Town with Many Churches (70 × 194)		Germany
5328	Cross, van der, Anthonie	View of Haarlem (134 × 161)	Goudstikker	Holland
5528	Cussone Painter	Assault of Carthage (40 × 130)	Toulino	France
5406	Cuyp	Cock on a Basket with Hens (104 × 80)	Unknown	France
5313	Cuyp	Fisher in Moonlight	Goudstikker 2272	Holland
5352	Cuyp	Horsemen in Landscape with Castle (123 × 170)	Rothschild	France
6164	Cuyp	Landscape with Ruins	Goudstikker 1535	Holland
5790	Cuyp	Portrait of a Gentleman (74 × 60)		Germany

5297	Cuyp	Portrait of a Girl	Goudstikker 5831	Holland
5809	Cuyp	Portrait of a Man and His Wife (80.5 × 64.5)	Andriesse	Belgium
6115	Cuyp	Sailing Vessels	Goudstikker 2420	Holland
5289	Cuyp	Young Boy with Hawk (79 × 106)	Katz	Holland
5153	d'Artois, Jaques	Landscape (131 × 219)	Muehlmann	Holland
6768	David German Isenbrand	Madonna with Six Saints (61 × 60.5)	Fischer, Swiss	Germany
5106	de Croy	Garden Party (90 × 118)	Wildenstein Gallery	France
6830	Defregger	Das Letze Aufgebot (57.5 × 42.7)		Germany
5630	Defregger	Talking Old Peasant with Wife (76 × 110)		Germany
5745	Diaz	Female Nude (34 × 42)		Germany
5883	Diest van	Marine (58 × 80)	Delaunay	Holland
7107	Diez	Landscape with Rainbow (20 × 40)		Germany
5498	Diller 1938	View of Linz (47 × 40)		Germany
5684	Donau School	Adoration of the Magi (145.5 × 75)		Germany
5683	Donau School	Visitation of St. Mary and St. Ann (145.5 × 75)		Germany
7116	Donau School	Portrait of a Man (48 × 35.5)	Tietje	Holland
7140	Donau School	Portrait of a Woman (48 × 35.5)	Tietje	Holland
5711	Doomer	Mountain Valley with Donkey Driver (26 × 30)	de Boer	Holland
6846	Dopfe (?)	Landscape (38 × 53)		Germany
5752	Dou	Woman and Child in a Window (38.1 × 53.4)	Rothschild	France
5702	Drathmann	Winter Landscape with Bears		Germany
5165	Droochsloot	Village Street	Hoogendijk	Holland
7148	School of Duccio	Madonna with Child (23 × 10)	Unknown	France
5722	Durer	Three Female Saints (41 × 30)	Tuffier, Mme.	France
5951	Durer Reproduction	Cavaliers on Horses		Germany
7049	Dutch 1526	Madonna with Child (24.5 × 17.5)		Germany
6509	Dutch 15th c.	Caritas (× 73)	Unknown	France
5633	Dutch 15th c.	Madonna (× 116)	Geladakis	France
5628	Dutch 15th c.	St. John (× 122)	Geladakis	France
5565	Dutch 16th c.	Birth of Christ (49 × 100)	Germany	

5189	Dutch 16th c.	Triptych (× 120)	Katz	Holland
5110	Dutch 16th c.	Triptych: Adoration of the Magi (118 × 83)	Voltarie Gal.	France
5429	Dutch 17th c.	Ceres and Pomona (80 × 84)	Lange	Germany
7134	Dutch 17th c.	Dutch Market (65 × 84.5)	Rothschild	France
5496	Dutch 17th c.	Marine (70 × 40)		Germany
5159	Dutch 17th c.	Peasants, Mostly Women (74 × 98)		Germany
5843	Dutch 17th c.	Seascape (72 × 94)		Germany
6103	Dutch 17th c.	Still Life Lobster and Fruit (137 × 79)		Germany
5584	Dutch c. 1480	Madonna with St. Ursula and Katharina (105 × 56)	Rothschild	France
7157	Dutch c. 1500	Magdalena (?)		Germany
5416	Dutch c. 1590	Eva (97.5 × 76.5)		Germany
6375	Dutch end 15th c.	Passion of Christ Holy Communion (96 × 185)		Germany
6374	Dutch Follow t Mostaer	Gentlemen from Liere (95.5 × 183)	Paech	Holland
5536	Dutch Marbuse (?)	Eve (127 × 43)		Germany
5358	Van Dyck	Duke of Richmond (206 × 125)	Katz	Holland
5177	Van Dyck	Family Portrait	Katz	Holland
7118	Van Dyck	King Charles of England	Goudstikker 2152	Holland
5298	Van Dyck	Portrait of a Lady (85 × 112)	Goudstikker	Holland
5233	Van Dyck	Portrait of a Lady Marquise Dorra (240 × 168)	Rothschild	France
5280	Van Dyck	Portrait of Adrian Moena	Goudstikker 1539	Holland
5357	Van Dyck	Portrait of Duchess of Hamilton (213.5 × 127)	Katz	Holland
5485	Van Dyck	Portrait of Lady (109 × 145)	Hoogendijk	Holland
5320	Van Dyck	Portrait of Lord Stanley	Goudstikker 1979	Holland
5489	Van Dyck	Andromeda with Persous on Pegasus		Germany
6825	EVD (?), Modern	Head of Christ (33 × 27.5)	Germany	
7149	Eckhout	Lady with Candle (66 × 51)	Halim, Brey	France
7135	Eckhout	Christ and the Adulteress	Muehlamnn	Holland
6867	Eibl	Still Life (42.5 × 70.5)	Germany	
6358	Elisheimer	Biblical Scene	Goudstikker 0177	Holland
5419	End of 18th c.	Child Riding on a Leopard	Looted from CCP	Germany
5854	Engelbrecht, Cornelius	Legend of St. George and St. Magdalena (49.5 × 71)		Germany
5932	Engelbrechtsen	Adoration	Goudstikker 1191	Holland
5956	Engelbrechtsen	Christ with Crown of Thorns	Goudstikker 1275	Holland

7391	Engelbrechtsen	St. Adrianus (31 × 22.5)	Seligmann	France
5465	England c. 1580	Embroidery Decoration Fight with Two Knights	Unknown	France
6314	English	Annunciation of St. Mary (29 × 43)	Unknown	France
6314	English	Burying Scene (25.5 × 25.5)	Germany	
5834	English 16th c.	Portrait of a Lady in Red (88 × 73)		Germany
6334	English 18th c.	Girl's Head (35.5 × 43)	Unknown	France
6324	English c. 1530	Portrait of a Man	Tietje	Holland
6327	English c. 1530	Portrait of a Lady	Tietje	Holland
5378	English c. 1400	Torture of Bishop (28 × 42)		Germany
6666	Erhardt, Greger	Belle Allemande	Louvre	France
7162	Faluca	Holy Family (48 × 32)	Unknown	France
6836	Fedeler	Landscape (70 × 100)		Germany
6772	Femish 1480	Golgotha (130 × 200)	Seligmann	France
5919	Fendi	Girl at Spinning Wheel (26.5 × 21)		Germany
5105	Ferrara or Florence 15th c.	Cassone: Scene of a Young Gentleman (180 × 51)	Unknown	France
6161	Ferrari	Triptych: Adoration of the Magi (43.5 × 28.5)	Contini, Italy	Germany
5755	Feselen	Judith and Helefernes in a War (61.5 × 39.5)		Germany
5692	Feselen, Melchior	Large Scenery with Soldiers, Judith (105 × 160)		Germany
5493	Feuerbach	Petrarca and Laura in Garden (78 × 61)		Germany
5929	Feuerbach	Roman Girl	Goudstikker 2229	Holland
6340	Fiorentini	Madonna with Child and St. John (42 × 59)	Bellini, Italy	Germany
5334	Fiorentino, Francesco	Madonna Enthroned with Saints Angele (169 × 180)	Gelder, van	Belgium
5362	Fiorentino, Rosso	Madonna with Child, St. Joseph and Angel (192 × 98)	Unknown	France
6160	Flanders c. 1650	Lucretia Bust (× 32)	Unknown	France
6095	Flemish	Part of a Crucifixion (123 × 76)	Raton	France
5361	Flemish 1500	Three Wings of Altar Madonna with Child (118 × 181)	d'Atry	France
5251	Flemish 1560/70	Praying St. Elizabeth from a Visitation (176 × 50)		Germany
5252	Flemish 1560/70	Standing St. Mary with Landscape (176 × 50)		Germany
5978	Flemish 15th c.	Madonna and Child (43 × 32)	Wassermann	France

5173	Flemish 1600	Caritas with Five Children (112 × 81)	de Boer	Holland
5181	Flemish 16th c.	Christ Bearing Cross (95 × 129)	Unknown	Belgium
5118	Flemish 16th c.	Procession of Horsemen		Germany
5828	Flemish 16th c.	Susanna and the Elders (67 × 51)	Paech	Holland
5497	Flemish 17th c.	Landscape with Figures (87.5 × 45.5)		Germany
5349	Flemish 17th c. Proven (?)	Orpheus in Forest (154 × 172)	Berlin Museum	Germany
6380	Flemish c. 1510	Two Bishops (213 × 68)	Goudstikker 2902	Holland
5109	Flemish Master 1520	Adoration of the Magi (90 × 68)	Charpentier Gallery	France
5128	Flemish Master 1520	Circumcision of Christ (91.5 × 30)	Charpentier Gallery	France
5129	Flemish Master 1520	Nativity of Christ (91.5 × 30)	Charpentier Gallery	France
5291	Flemish School	Portrait of Catherine Tudor of Brends (97 × 68)	Hoogendijk	Holland
5359	Flemish School 1600	Landscape with Attack Robbers	Hoogendijk	Holland
6223	Flemish/French 17th c.	Charitas (× 54.8)		Germany
6105	Flinck	Portrait of a Young Man (46.5 × 54.5)	Hoogendijk	Holland
5440	Flinck Govert	Little Boy as Amor (90 × 123)	Germany	
5958	Flink	Sleeping Amor	Goudstikker 1924	Holland
6365	Florence 15th c.	Crucifixion with Figures (34 × 20)	Unknown	France
5555	Florentine 14th c.	Two Male Saints (96 × 52.5)	Reiffers, Luxembourg	Belgium
5582	Florentine 14th c.	Two Male Saints (96 × 53)	Reiffers, Luxembourg	Belgium
5418	Floris, Franz	Allegory of Justice and Peace (77 × 108)		Germany
5167	Fontainebleau	Venus with Mirror (80 × 106)	Germany	
6102	Forgery	Angel (× 84)	Stora	France
6070	Forgery	Knight (× 40)	Germany	
6075	Forgery	St. George (× 91)	Germany	
5456	Forgery	St. George on Horseback (× 101)	Bornheim	Germany
5158	Forgery Italian 14th c.	Holy Virgin with Angels (× 31)		Germany
6788	Fragonard	Girl with Sculpture of a Chinese (75.6 × 89.7)	Rothschild	France
5831	Fragonard	Les Marionettes (68 × 89)	Wildenstein	France
6113	Fragonard	Head of Old Man	Goudstikker 1278	Holland

5453	Fragonard	Girl with Flower Basket (30 × 100)	Unknown	France
5812	Fragonard	Girl with Lute (40 × 60)	Rothschild	France
6149	Fragonard (?)	Women Washing Laundry at Well (47 × 62)	Unknown	France
6369	Fragonard	Adoration of the Kings (37 × 46)	Unknown	France
5450	Fragonard School, Boucher	Two Children with Cat (72 × 90)	Halphen, F.	France
6044	France 1350	Holy Virgin with Child (× 65)		Germany
6046	France 1350	Holy Virgin with Child (× 68)		Germany
6534	France 1350, Pretend	Holy Virgin with Child (× 72.5)		Germany
6050	France 1370	Holy Virgin with Child (× 77)		Germany
5605	France 1390	Statue of Holy Virgin with Child (× 107)		Germany
5606	France 1450	Holy Virgin with Child (× 127)		Germany
6049	France 1480	Holy Virgin with Child (× 83)		Germany
6047	France 1500	Saint (× 67)		France
7048	France 19th c.	Portrait of a Boy (46 × 36.5)		Germany
6513	France c. 1330	Four Apostles Architecture Fragments (81 × 52.5)	Unknown	France
6528	France c. 1460	Holy Virgin with Book (× 72)	Unknown	France
6525	France c. 1700	Kneeling Goddess with Faun (53.5 × 65 × 90)	Unknown	France
5589	France or Holland 1489	Two Saints with Family of Founder (× 65)		Germany
5277	Copy after Francia	Madonna and Child with Saint	Goudstikker 2303	Holland
6063	Francinia 1600	Adam and Eve (32 × 38.5)		Wiesbaden
6094	Francionia c. 1520	Holy Kindred Relief (85 × 120)		Germany
6155	Francks	Horsemen in Armor on Wood Path (60 × 45)	Unknown	France
5523	Franco Flemish 1515	Pieta with Saints	Unknown	France
5641	Franconia 1490	Holy Virgin with Child (× 136)	Germany	
5668	Franconia 1500	Holy Virgin with Child (× 150)	Germany	
5629	Franconia 1510	Holy Virgin with Child (× 108)	Germany	
6087	Franconia c. 1490	Angel Formerly St. Michael		Germany
6045	French 1300	Female Saint (× 65)	Brime	France

5656	French 13th c.	Madonna with Child (× 98)	Stora	France
6794	French 14th c.	Madonna	Leonardi	France
6796	French 14th c.	Part of Madonna	Leonardi	France
6495	French 14th c.	Sitting Madonna with Child (× 91)	Geladakis	France
6134	French 15th c.	St. John on Patmos (41 × 33)		Germany
5603	French 15th c.	Madonna with Child (× 118)		Germany
5734	French 15th c.	Sepulchration of Christ (52 × 71)		Germany
6811	French 15th c.	St. Martin		Germany
6062	French 15th c.	St. Barbara with Book (× 102)	Geladakis	France
6314	French 15th c.	St. Michael (× 91)	Rothschild	France
5556	French 15th c.	St. Jaques (80 × 40)	Unknown	France
5271	French 15th c. Forgery	St. Martin with Begger (× 75)	Leonardi	France
6506	French 15th c. Forgery	St. Michael (× 140)	Geladakis	France
5786	French 16th c	Venus in Room with Magi (49.5 × 64.5)	Unknown	France
6515	French 16th c.	Angel (× 110)	Leonardi	France
6756	French 16th c.	Diana and Akthon (76 × 93)	Germany	
6179	French 16th c.	Portrait of a Boy (32 × 22)	Unknown	France
6173	French 16th c.	Portrait of a Man (49 × 38)	Rothschild	France
5669	French 16th c. Forgery	Architect (× 113)	Leonardi	France
5634	French 16th c. Forgery	St. George (× 118)	Geladakis	France
5147	French c. 1750	Shepard Scene (152 × 182)	Wildenstein	France
5148	French 1755	Shepardess at Fountain (152 × 182)	Wildenstein	France
5707	French 17th c.	The Death of (?) (169.5 × 121.5)		Germany
5747	French 17th c.	Venus, Amor and Other Gods (34 × 43.5)	Mailand Italy	Germany
5433	French 18/19th c.	Female Nude Lying (75 × 64)		Germany
7115	French 18th c.	Gallant Party (41 × 50)	Unknown	France
6151	French 18th c.	Portrait of Lady (55 × 46)	Unknown	France
5377	French 18th c.	The Family Concert (135 × 148)	Unknown	France
6084	French 18th c.	Venus on Base (× 75)		Germany
6812	French c. 1460	Bust of Holy Virgin with Book (× 45)		France
6154	French c. 1580	Portrait of Lady (57 × 38.5)	Brosseron	France
5871	French c. 1600	Portrait of a Lady (60 × 49)	Kann	France

5405	French c. 1600	The Temptation (73 × 98)	Schmit, Jean	France
5116	French Austrian 18th c.	Portrait of a Child (130 × 103)	Unknown	France
5099	French Dutch 16th c.	Historic Scene Before a Town (99 × 153)	Muehlmann	Germany
5874	French Netherlands 16th c.	Portrait of Lady with Book (59 × 73)	Unknown	France
7385	French or English	Vertumnus and Pomona (42 × 30)	Wildenstein	France
6855	Frey	Nymphs (60.5 × 84.5)		Germany
7064	Frueauf	History of the Four Crowns (52.5 × 106.5)	Goudstikker 5710	Holland
5518	Fueehechio, Italian 15th c.	Before a Tournament (45 × 84)	Ventura, Italy	Germany
7110	Futterer	Portrait of a Man (125 × 82.5)		Germany
5175	Fyt, J	Still Life with Dead Sheep	Hoogendijk	Holland
6318	Gaertner	Portrait of a Lady	Goudstikker 2679	Holland
5760	Gaertner	Portrait of a Man 1527	Goudstikker	Holland
6722	Garbo, Raffaelino	Madonna with Child (60 × 60)	Unknown	France
6784	Garbo, Raffaelino	Maria with Child and Angel (77 × 163)		Germany
6542	Garbo, Raffaelino	St. John and St. Justus (64 × 155)		Germany
6789	Garbo, Raffaelino	St. John and St. Justus (64 × 155)		Germany
6185	Gassel	Landscape with Hunters	Goudstikker 1412	Holland
7167	Gassel	Landscape with Village (79 × 33)	Unknown	France
5577	Copy of Gebauer	Portrait of Frederic the Great (78 × 52)	Berlin Museum	Germany
6314	Genua 16th c.	One Round Plate	Rothschild	France
6522	German 1500	The Last Supper (110 × 110)	Delaunay	Holland
5655	German 1510	Disciple (× 104)	Germany	
5959	German 1555	Adam and Eve (16 × 8)	Wendland, Swiss	Germany
5657	German 15th c.	Female Saint (× 100)	Marchand	France
5690	German 15th c.	Flight to Egypt (158 × 104.5)	Sterzing	Italy
5604	German 15th c.	Madonna (× 110)	Geladakis	France
5792	German 15th c.	St. Mauritius	Goudstikker 2648	Holland
5689	German 15th c.	Visitation (158 × 104.5)	Sterzing	Italy
6016	German 1630	Angel with Candlestick (× 30.5)		Germany
6017	German 1630	Angel with Candlestick (× 30.5)		Germany
6720	German 1650	Two Angel Heads (× 50)	Delaunay	Holland
5688	German 16th c.	Awaking of Lazarus (161 × 106)		Germany

6435	German 16th c.	Godfather with Angels (57.5 × 27.5)		Germany
5527	German 16th c.	Nude Girl (124 × 38)		Germany
5521	German 16th c.	Nude Standing Girl (124 × 38)		Germany
5796	German 16th c.	Portrait of a Lady (50 × 81.5)	Rothschild	France
5916	German 16th c.	Portrait of Maximilian (45.5 × 37)	Seligmann	France
6385	German 16th c.	Scene in Temple (264 × 107)		Germany
5444	German 17/18th c.	Castle Kitchen		Germany
5445	German 17/18th c.	Domestic Festival		Germany
5446	German 17/18th c.	Hall in Castle		Germany
5452	German 17/18th c.	Washing and Ironing Room		Germany
6223	German 17th c.	Saint Family (13.7 × 13.2)		Germany
7047	German 18th c.	Female Portrait (64 × 80)		Germany
7109	German 18th c.	Frederic the Great War Scene (143 × 104)		Germany
6103	German 18th c.	Portrait of a Bavarian General (143 × 112)		Germany
5329	German 18th c.	Portrait of a Princess (148 × 110)		Germany
6295	German 18th c.	Weeping Madonna (× 33.3)		Germany
5857	German 19th c.	Frederic the Great (58 × 75)		Germany
5498	German 19th c.	Portrait of a Lady on Red Ground (69 × 56)		Germany
5384	German 1450–1490	Adoration of the Kings (159 × 114)		Germany
5386	German 1450–1490	St. Magdalena and St. Elizabeth (158 × 113)		Germany
5388	German 1450–1490	St. Margaratha and St. Dorothea (159 × 114)		Germany
6081	German c. 1425	Pieta	Hoogendijk	Holland
5869	German c. 1480	Madonna and Child with Angels (80 × 56)		Germany
5561	German c. 1480	St. George (82 × 40)		Germany
6387	German c. 1496	Triptych: The Adoration of the Magi (149 × 135 × 35)	Lagrand	Belgium
5257	German c. 1500	St. Agnes (144 × 54)		Germany
5119	German c. 1500	St. John in the Desert and St. Mary	Germany	
6086	German c. 1510	Apostle (× 102)		Germany
6089	German c. 1520	Group of Joachin and Anne (× 84)	Meller	France
6088	German c. 1526	Group of Visitation (× 86)	Meller	France
6072	German c. 1700	Two Puttos (86 × 30)		Germany
6371	German c. 1800	Portrait of Queen Louise of Prussia (30 × 28)		Germany
5758	German c. 1929	Portrait of Carin Göring (64.5 × 54)	Göring Col.	Germany
5498	German Achenbach	Southern Landscape (49 × 62)		Germany
5591	German c. 1500	Saint Virgin with Child (× 53)		Germany

6069	German late 14th c.	St. Virgin with Child (× 78)		Germany
6295	German late 15th c.	Flying Angel (× 31)		Germany
5852	German Modern	Female Nude Lying and Reading (90 × 70)		Germany
6314	German Modern	Girl with Dish (15.7 × 68.5)		Germany
6828	German Modern	Horse (63 × 51)		Germany
6389	German Modern	Nymphs and Satyr		Germany
6841	German Modern	Sea Beach (72 × 87)		Germany
6626	German 1260	Holy Virgin (36 × 20 × 114)		Germany
6527	German 1520	Console with a Man (42 × 44 × 55)		Germany
6082	Germany c. 1490	Part of Crucifixion (73 × 134)		Germany
6091	Germany c. 1500	St. Catherine (× 93)	Brosseron	France
5286	Giordano	Diana and Actaeon (103 × 122)	Unknown	France
7180	Giovanni	Madonna with Child (66.5 × 54)	Gelder, van	Belgium
5101	Giovanni di Paolo	Madonna with Angels (144.5 × 59.5)	Reiffers	Belgium
5102	Giovanni di Paolo	Two Saints: Pieter and Marguarit (146 × 43.5)	Reiffers	Belgium
5100	Giovanni di Paolo	Two Saints: St. Paul and Nicolas (142 × 44)	Reiffers	Belgium
5789	Göring Carin	Still Life with Flowers (56.5 × 40.5)	Göring Collection	Germany
7168	van Gogh	Flower Piece (32 × 67)	Wolf, Marcel	Holland
7174	van Gogh	Sunflowers (30.5 × 60.5)	Rosenberg	France
5805	van Gogh	The Bridge (60 × 64)	Rothschild	France
5353	Goltius	Jupiter and Antiope (128 × 175)	Hoogendijk	Holland
5898	Goltius	Mars and Venus (43.5 × 74)		Germany
5729	Gossaert	Madonna with Child (54 × 39)	Unknown	France
6168	Gossaert (?)	Madonna with Child (53 × 40.5)	Wassermann	France
5699	Goth 1933	Mrs. Carin Göring	Göring Collection	Germany
7061	Gothic	Saint × 85	Lacarde	France
6036	Gothic Style	Chair	Pannwitz, v	Holland
5885	Goyen, van	Carriages before Peasants Inn (60.5 × 84.5)	Andriesse	Belgium
6323	Goyen, van	Castle on River	Goudstikker 2947	Holland
6107	Goyen, van	Cottage Near River (57.5 × 46)	de Boer	Holland
6169	Goyen, van	Cottages (36 × 51)	Strauss Emil	France
5939	Goyen, van	Figure Before a House (38 × 49)	Wassermann	France
5993	Goyen, van	Lake de Kaag	Goudstikker 2367	Holland
5798	Goyen, van	Landscape	Goudstikker 5862	Holland

6428	Goyen, van	Landscape (35 × 31)	Holland	
6146	Goyen, van	Landscape (45 × 63)	Katz	Germany
5586	Goyen, van	Landscape and River Boats (60 × 105)	Wassermann	France
5884	Goyen, van	Landscape with Monastery (89 × 58)	Katz	Holland
6141	Goyen, van	Landscape with Two Cars (41 × 58)	Katz	Holland
6114	Goyen, van	Marine	Goudstikker 5969	Holland
6749	Goyen, van	Portrait of Isabella of Bourbon (82 × 66.5)	Rothschild	France
5797	Goyen, van	River Landscape Near Ehenen (49 × 73)	Unknown	France
5936	Goyen, van	River with Two Boats (31 × 51)	Unknown	Holland
5587	Goyen, van	Riverscape near Dordrecht	Goudstikker 2638	Holland
6665	Goyen, van	Riverscape with Village	Goudstikker 2745	Holland
7172	Goyen, van	Seascape	Goudstikker 1986	Holland
6351	Goyen, van	Skating near Dordrecht (43 × 67.6)	Katz	Holland
7122	Goyen, van	View of Antwerp (120 × 75)	Goudstikker	Holland
5581	Goyen, van	View of Nymwegen	Katz	Holland
5864	Goyen, van	View of Nymwegen (91 × 47)	de Boer	Holland
5894	Goyen, van	View of Rhenen	Goudstikker 5822	Holland
6347	Goyen, van	Winter Riverscape	Goudstikker 5153	Holland
5263	Gozzoli Workshop	Tournament (43 × 155)	Unknown	France
6295	Greek 3rd c.	Female Head (× 25)	Germany	
6499	Greek 3rd c.	Female Head (× 25.6)	Germany	
6434	Greuze	Head of Young Girl (40 × 32)	Kraemer Carl	France
5875	Grien	Portrait of Knight of Malta (43 × 58)	Fischer, Swiss	Germany
6373	Grien	Venus and Amor	Veluwe, Hooge	Holland
6338	Grien	Venus and Mirror (24 × 46)	Germany	
6713	Grimmer	Landscape with Castle (37.5 × 72)	Paech	Holland
6728	Grimmer	Winter Landscape (22.5 × 35)	Tietje	Holland
5642	Grimmer, Abel	Winter Landscape (75 × 110.5)	Delaunay	Holland
6854	Groeber	Portrait of a Woman (57 × 36)	Germany	
5552	Grueneberg, Arthur	Mrs. Emmy Göring	Göring Collection	Germany
5596	Grueneberg, Arthur	Mrs. Emmy Göring (56 × 43)	Göring Collection	Germany
5554	Grueneberg, Arthur	Mrs. Emmy Göring with Edda	Göring Collection	Germany
5601	Grueneberg, Arthur	Portfolio with Drawings	Germany	
5553	Grueneberg, Arthur	Seven Red Chalk Drawings	Göring Collection	Germany
6869	Gruetzner	Monk (17 × 12)	Germany	

5494	Gruetzner 1903	Conversation with the Praelate (75 × 97)		Germany
5430	Haarlem, Cornelius	Adam and Eve	Germany	
5284	Haarlem, Cornelius	Portrait of Nude Woman (70.5 × 60)	Reiffers Luxem	Belgium
5568	Haarlem, van Jan Vermeer	Landscape	Goudstikker 5843	Holland
7105	Hademann	Winter landscape with Figures (27 × 20.5)		Germany
6815	Halberg-Krauss	Landscape (23.5 × 29)		Germany
6737	Hall	Portrait of Carin Göring (54.5 × 46)	Göring Collection	Germany
5844	Hals, Frans	Portrait of a Man (68 × 84)	Katz	Holland
5719	Hals, Frans	Portrait of Wilhelm Warmondt	Goudstikker	Holland
7152	Harlem	Fruit Crop		Germany
6863	Hartmann	Repose at an Inn (94 × 64)		Germany
6120	Hayn	Two Girls with Flowers		Germany
5340	Heck, van der	Landscape with St. John Preaching (98 × 145)	Unknown	France
5847	Heda	Still Life (68 × 79)	Unknown	France
6103	Heem, de	Still Life Lobster and Fruit (100 × 150)		Germany
5486	Heem, de	Still Life 1644	Goudstikker 1137	Holland
5818	Heil, van	A Town at the Port (50.5 × 83)	Paech	Holland
6795	Hellenistic	Pallas Athene (× 143)		Germany
5410	Hetzelt, Architel	Planene Karinhall	Göring	Germany
5873	Heyden	Castle Myenrode	Goudstikker 2872	Holland
6845	Hiasl	Steam Boat Station in Chemise (60.5 × 50)		Germany
5635	Hildesheim Low Saxon	Holy Virgin with Child (× 150)	Paech	Germany
5385	Hilz, Sepp	Blind Man (120 × 100)		Germany
5697	Hischmanny 1941	Portrait of Emmy Göring (111 × 80)	Göring Collection	Germany
5599	Hobbema	Landscape		Germany
5701	Hobbema Copy	Landscape with Water Mill (88 × 105)		Germany
6730	Holbein	Portrait of a Man (24 × 32.8)	Rothschild	France
6723	Holbein	Portrait of a Man (54 × 41)	Rothschild	France
5893	Holstein	Bathing Women and Men (57 × 82)	Unknown	France
5443	Hommel, C.	Head of Hitler (47 × 57)	Military Nazi	Wiesbaden
6767	Hooch	Small Party Drinking Wine (60 × 68.5)	Rothschild	France

6766	Hooch	The Little Garden (59.2 × 62.2)	Rothschild	France
5308	Hoogh, Pieter de	Couple on Horseback Landscape	Goudstikker 1693	Holland
5848	Hoppner	Portrait of a Young Girl (60 × 49)	Lyndhurst Collection	Belgium
5396	Hubert, Robert	Bridge in Italy (285 × 135)	Rothschild	France
5137	Hubert, Robert	House Near a Lake	Wildenstein	France
5394	Hubert, Robert	Italian Landscape in Mountains (285 × 135)	Rothschild	France
5395	Hubert, Robert	Italian Ruins (285 × 135)	Rothschild	France
5133	Hubert, Robert	La Caravane (256 × 172)	Wildenstein	France
5397	Hubert, Robert	Landscape with Figures at River (68 × 97)	Unknown	France
5137	Hubert, Robert	Landscape with Washing Women (240 × 192)	Wildenstein	France
6325	Hubert, Robert	Landscape with Waterfall (48 × 37)	Wildenstein	France
5242	Hubert, Robert	Le Château Fort (256 × 172)	Wildenstein	France
6776	Hubert, Robert	Ruin of a Round Roman Temple (160 × 105)	Wildenstein	France
7156	Hubert, Robert	Theater Scene (36 × 43)	Wildenstein	France
6321	Hubert, Robert	Theater Scene (36 × 43)	Wildenstein	France
5399	Hubert, Robert	Water Plays (285 × 135)	Rothschild	France
5881	Hubert, Robert	Women Washing Laundry Before Ruins (81.5 × 64)	Unknown	France
5851	Huchtenberg	Hattue in the Woods (77 × 68)		Germany
5126	Huet	Figures in a Park (72 × 90)	Wildenstein	France
6786	Hurbert, Robert	Roman Ruins with Card-Playing Soldiers (162 × 105)	Wildenstein	France
5647	Huysum, van	Still Life with Flowers Drawings		Germany
5598	Huysum, van	Still Life With Flowers PRINTS (53 × 39)		Germany
6162	Hylst	River Landscape (33.5 × 52)	Paech	Holland
7128	Isenbrandt	Madonna with Child (82 × 62)	Germany	
5794	Italian	Madonna with Child (60 × 34)	Unknown	France
5249	Italian	Part of a Cassone of a Saint's Life (58 × 170)	Rothschild	France
5566	Italian 14th c.	Madonna and Child (95 × 50)	Unknown	France
6421	Italian 15th C	Cassone with Coat of Arms	Rothschild	France
6423	Italian 15th c.	Cassone with Centaur (41 × 45)	Rothschild	France
6660	Italian 15th c.	Cassone with Resting Nude Woman (57 × 188)	Unknown	France
6661	Italian 15th c.	Cassone with Resting Nude Woman (57 × 188)	Unknown	France
6422	Italian 15th c.	Cassone with Two Nude Figures (41 × 46)	Rothschild	France

6342	Italian 15th c.	Girl with Musical Instrument (131 × 75)		Germany
6424	Italian 15th c.	Sidepart of Cassone (41 × 46)	Rothschild	France
5256	Italian 15th c.	St. George (138 × 56)	Unknown	France
5661	Italian 16/18th c.	74 Textiles	Bellini, Italy	Germany
5661	Italian 16/18th c.	Green Silk Velvet (58 × 120)	Bellini, Italy	Germany
5269	Italian 16th c.	Birth of Venus	Contini, Italy	Germany
5499	Italian 16th c.	Chest Front Fight of Tritone	Contini, Italy	Germany
6659	Italian 16th c.	Christ in the Tomb (48 × 222)		Germany
5783	Italian 16th c.	Picture of Half Nude (53 × 71)	Bellini, Italy	Germany
6368	Italian c. 18th c.	Head of a Young Girl (33 × 30)		Germany
6517	Italy 13th c.	Fragment Rose of a Window (39 × 46.5)		Germany
5193	Italy 1400	Maria with Child		Germany
6521	Italy 1420	Three Relief Two Heads Putti (28 × 44 × 28)	Contini, Italy	Germany
6744	Italy 14th c.	Madonna Crucifixion (95 × 51)		Germany
6048	Italy 1550	Female Bust (× 50)		Germany
5130	Italy 15th c.	Tilt from a Cassone (41 × 156)	Unknown	France
5963	Italy 16th c.	German Emperor (19 × 23)	Unknown	France
6215	Italy 16th c.	The Holy Virgin (× 139)		Germany
6156	Italy 16th c. School	Girls Portrait (38.5 × 58)	Rothschild	France
6223	Italy 17th c.	Rape of Women (× 61)		Wiesbaden
5455	Italy c. 1300	Statue of Female Saint (× 69.2)	Altonnian	Germany
7037	Italy c. 1700	David and Goliath		Germany
6499	Italy Modern	Head of Medusa (× 32)		Germany
5850	Janssens	Portrait of a Lady (78 × 66)	Unknown	France
5179	Janssens, Abraham	Allegory of Vanity (117.5 × 92.5)	Muehlmann	Holland
5650	Janssens, Abraham	Diana with Maids (94 × 123)		Germany
5434	Janssens, Abraham	Lascivia Allegorical Figures (107 × 97)	Muehlmann	Belgium
7166	Jonking	River Landscape (32 × 53)	Lindenbaum	France
5878	Jordaens School	Three Nude Women Sleep Watched by Man (45 × 53)	Unknown	France
5808	Jordans	Nymphs and Satyrs	Goudstikker 2892	Holland
5424	Kampff, Arthur	Chorall v. Leuthen		Germany
7127	Kappenberg	Adoration of the King (78 × 96)		Germany
5469	Karel v, Mamdern	Story of Alexander	Italy	Germany
5612	Kaufmann, Hugo	Scene of Fighting Peasants in Inn (94 × 130)		Germany
5498	Kaulbach	The Source (55 × 45)		Germany
5823	Keij	Portrait of a Gentleman in Black (70 × 54)	Unknown	France

5977	Kessel	Winter Landscape	Goudstikker 1475	Holland
5804	Keyser, de	Portrait of a Man	Steiner Max	Holland
5820	Keyser, de	Portrait of Constantine Huygens (78 × 55)	Stern, Caroline	France
5733	Keyser, de	Portrait of P. Post (54 × 72)	May, R.	Holland
5435	Keyser, de	Rider on White Horse	Goudstikker 5607	Holland
6864	Kirchback	Landscape with two Knights (55.5 × 85.5)		Germany
6824	Kirstein 19th c.	Winter landscape (42 × 52)		Germany
5748	Klerk, de	Venus and Young Knight (34 × 43)		Germany
5571	Copy of Klincker	Portrait of Napoleon (73 × 59)		Germany
5169	Klumbach	The Birth of Maria (1.10 × 98)	Pannwitz, v.	Holland
5648	Knirr, Heinrich	Adolf Hitler (100 × 72)	Military Nazi	Wiesbaden
5490	Koninck	Landscape	Goudstikker 0617	Holland
5999	Koninck	Portrait of a Girl (41.5 × 34.5)	Goudstikker 2240	Holland
5830	Koninck	Portrait of a Man (68 × 95)	Unknown	France
5715	Koninck	View of Hague (71 × 61)	Delaunay	Holland
6354	Kulenbach	Holy Family	Goudstikker 2137	Holland
6353	Kulenbach	Holy Family	Goudstikker 2138	Holland
5136	Lairesse	Apollo and Phaidon (430 × 300)	Goudstikker	Holland
5136	Lairesse	Downfall of Phaidon (420 × 273)	Goudstikker	Holland
5136	Lairesse	Zeus Enthroned with Figures (434 × 294)	Goudstikker	Holland
6426	Lancrert	Shepherd Couple in Garden (41 × 55)	Rothschild	France
5115	Lancret	Picnic Party (12.3 × 91)	Rothschild E	France
5824	Lancret School	Couple of Pilgrims (55 × 71)	Wildenstein	France
7111	Lang	Spanish Woman (58 × 71)	Germany	
5287	Largilliere	Portrait of a Gentleman (78.5 × 62)	Goudstikker	Holland
5050	Late 16th c.	Schachspiel, Amber, with Ivory	Unknown	France
5113	Late 18th c.	Portrait of a Woman	Rothschild	Unknown
6058	Late 19th c.	Horseman in Weapons on Base (× 50)		Germany
5799	Lautrec	Woman Reading (51 × 72)	Rosenberg	France
6830	Leidentz	Richard Wagner (46 × 51)		Germany
5346	Lemoyne	Bathing Women (161 × 119)	Dequoy	France
7108	Lemoyne	Girl with Old Man at Fountain (100 × 143)	Brosseron	France
5144	Lemoyne	Venus and Adonis (157 × 195)	Wildenstein	France
5145	Lemoyne	Venus and Adonis (157 × 195)	Wildenstein	France
5514	Lenbach	Bismark with Black Hat		Germany

5611	Lenbach	Bismark with Black Hat		Germany
6103	Lenbach	Portrait of Bismark (122 × 87.5)	Germany	
5849	Lenbach	Portrait of Bismark (75 × 67)		Germany
5451	Lenbach	Portrait of Bismark (98 × 126)		Germany
5498	Lenbach	Sketch of Red-Haired Girl (60 × 47)		Germany
5621	Lendenstreich	Virgin with Child (× 122)	Duprez	Belgium
5412	Leopold, Robert	Ruin of Temple with Arch (67 × 96.5)	Wildenstein	France
6826	Leupold	Landscape (28 × 42.5)		Germany
6837	Leurs	Sheep and Shepherd (66 × 82)		Germany
6126	Leyden	Couple (28 × 32)	Unknown	France
6355	Leyden Copy	Several Groups in Landscape (28.5 × 39.3)	Rothschild	France
6183	Leyster	Boy Playing Guitar (34.5 × 23.5)	Loebl	France
5498	Lier, Adolf	Landscape with Sheep (50 × 68)		Germany
5810	Liljefers	Flying Bird (50 × 68)		Germany
5687	Liljefore, Bruno	Winter Landscape with Partridges (100 × 160)		Germany
5580	Liljefors	Winter Landscape Hare Springing Away (× 100)		Germany
5421	Liljefors, Brund 1924	Elk Hunter (100 × 69)		Germany
5420	Liljefors, Brund 1924	Wild Geese in Winter (100 × 70)	Germany	
5132	Limoges	Portrait of Lady Medici (70 × 55)	Rothschild	France
6726	Limoges	Triptych	Seligmann	France
6718	Lippi	Holy Family	Goudstikker 2604	Holland
6752	Lisse, van, Dirk	Bathsheba and Her Servant (44.5 × 35)		Germany
5946	Lisse, van, Dirk	Nude	Goudstikker 1432	Holland
5918	Lisse, van, Dirk	Six Bathing Women (29 × 23)		Germany
5137	List	Two Hunters with Dead Hares (150 × 250)	St. Peters Abby	Austria
6729	Lochner (?)	Nativity of Christ Rev Crucifixion (36 × 23)		Germany
6830	Loewith	Seven Clergy in Library (45.5 × 67)		Germany
6719	Loo, van	Lady with a Flute (80 × 82)		Germany
5137	Loo, van	Bathing Girls	Wildenstein	France
5233	Loo, van	Diana and Amor (164 × 157)		Germany
5174	Loo, van	Diana and Callysto (120 × 85.5)	Hoogendijk	Holland
5572	Lorenzetti	St. Magdalena	Goudstikker 2599	Holland
5304	Lorrain, Claude	Jupiter and Europa	Goudstikker 2563	Holland
5660	Low Rhine 1470	Holy Virgin with Child (× 86)		Germany
5178	Lower Rhine after 1480	Assembly of Apostles and Saints (120 × 82)	Seligmann	France

5127	Lower Rhine after 1480	Life of St. Ursula (62 × 82)	Rothschild 250	France
6068	Lower Rhine Forgery	Holy Virgin with Four Angels (64 × 64)		Germany
5551	LueBeck (?)	A Priest Preaching (125 × 68)	Seligmann	France
6793	Luttichuys	Portrait of Ester de Bary	Goudstikker 0928	Holland
6755	Maes	Still Life with Cauliflower	Goudstikker 2030	Holland
5114	Maes	The Happy Child (81.3 × 111)	Rothschild, E.	France
6818	Mahr	Two — Ulrich v Hutten Head		Germany
7188	Mainardi	Madonna with Child St. John as Child (77 × 41)		France
5243	Makart, Hans	Bachantic Scene (2.80 × 1.95)	Haberstock	Germany
5694	Makart, Hans	Naked Boy Carrying a Vase with Roses (164 × 96)	De Heuvel	Belgium
5704	Makart, Hans	Couple of Lovers (98 × 137)	Unknown	France
6419	Makart, Hans	Dancing of Children (46 × 28)		Germany
7175	Makart, Hans	Diana and Maid (48 × 24)		Germany
5338	Makart, Hans	Mythological Scene of a Battle (140 × 96)		Germany
5337	Makart, Hans	Mythological Scene (95 × 146)	Unknown	France
6827	Makart, Hans	Portrait of a Woman (37 × 31)		Germany
6135	Makart, Hans	Portrait of Lady (50.5 × 39.5)		Germany
5686	Makart, Hans	Siesta at the Court of Medici	Hitler	Germany
5436	Makart, Hans	The Beautiful Falconer	From Hitler	Germany
5998	Mallet	The Auction of the Bride (25 × 33)	Reinach	France
5901	Manessische Workshop	(Seven) Hartmann von Aue (27 × 25)		Germany
5910	Manner of Master	Saint Crowned with Cross (44 × 26)	Goudstikker	Holland
5909	Manner of Master	St. Oswald (44 × 26)	Goudstikker	Holland
5133	Manner of Pater	Noble Society in a Park (176 × 306)	Unknown	France
6861	Maris	Water Kant (183 × 140)		Germany
6343	Marmion	Madonna and Child (43.5 × 30.5)		Wiesbaden
5952	Martin Copy	Portrait of Maria Roehl 1852 (34 × 43)		Germany
5721	Massys	Madonna with Child on Lap (47.5 × 34)	Renders	Belgium
5414	Master, H.B.	Samson and Delilah (70 × 53)	Unknown	France
5736	Master, H.R.	Portrait of Mayor of Ingolstadt		Germany
5773	Master, L.P. 1530	Portrait of Man in Landscape (56 × 46)		Germany

6157	Master of Alkmaar	Madonna St. Ann with Large Group (61 × 47)	Gelder, van	Holland
5558	Master of Alkmaar	Rejection of St. Joachim's Sacrifices (71 × 24.5)	Tietje	Holland
5557	Master of Alkmaar	St. Joachim and St. Anna Golden Gate (71 × 24.5)	Tietje	Holland
6184	Master of Baroncelli	The Annunciation (40 × 50)	Renders	Belgium
5325	Master of Bruesseber	Josef and Potiphar (158 × 158)	Bornheim	Germany
5780	Master of Burgundy 1480	St. George and the Dragon (69 × 74)	Schmit, Jean	France
6319	Master of Cologne	The Flight to Egypt (46 × 32)	Hoogendijk	Holland
6171	Master of Female Half Figure	Lucretia (35.5 × 25.5)		Germany
5754	Master of Female Half Figure	Lucretia (47.5 × 36)	Schalthess, Swiss	Germany
5738	Master of Female Half Figure	Neptune Embracing Nymphet (41 × 31)	Berlin Museum	Germany
6331	Master of Female Half Figure	Portrait of Young Woman with Pocal (45 × 32)	Fischer, Swiss	Germany
5043	Master of Female Half Figure	Venus with Amor (28 × 20)		Germany
5522	Master of Frankfurt	Angel and Black Holy Knight (116 × 26)	Seligmann	France
6785	Master of Frankfurt	St. Catherine (69 × 157)	Pannwitz, v.	Holland
6790	Master of Frankfurt	St. Barbara	Pannwitz, v.	Holland
7126	Master of Frankfurt	St. Ottilia and St. Cecilia	Goudstikker 2145	Holland
5816	Master of Frankfurt	The Adoration by the King (45 × 32)	Unknown	France
5767	Master of Frankfurt	Wing Altar (60.5 × 39)	Fischer, Swiss	Germany
6330	Master of Grootsche	Adoration of the Magi (32 × 44)		Germany
5378	Master of Holy Parentage	Madonna with Child, 3 Figures of Parentage	Loebl	France
6773	Master of Holy Parentage	Presentation at the Temple (183 × 127)	Louvre	France
5378	Master of Holy Parentage	Standing Figure Man	Loebl	France
5378	Master of Holy Parentage	Three Standing Figures of Men	Loebl	France
6332	Master of Mansi	St. Magdalena (37 × 56)	Goudstikker	Holland
5133	Master of Marienleben	Two Saints with Monks (160 × 266)	Bornheim	Germany
5321	Master of Messkirch	St. Wernherus (37 × 164)	Pannwitz v	Holland
5454	Master of Nuremberg	Madonna with 14 Altarpieces (92.5 × 114)		Germany
6384	Master of Pflock	Two Feminine St. Agnes and Ursula (221 × 76)		Germany

5746	Master of Rimini	Altarpiece (39 × 47)	Ventura Italy	Germany
5696	Master of San Mingnato	Madonna and Child (1.17 × 78)		Germany
5730	Master of San Miniato	St. Mary and Child (44 × 34)		Germany
5860	Master of Santa Orpe	Madonna with Child (58 × 36)	Ventura Italy	Germany
5720	Master of St. Gudule	The Betrothal of Mary	Tietje	Holland
5141	Master of Sterzing	Adoration of the Magi Christ with Thorns (195 × 175)	Gift, Mussolini	Italy
5142	Master of Sterzing	Annunciation St. Mary Christ at Gethsemane	Gift, Mussolini	Italy
5140	Master of Sterzing	Christ Bearing Cross Death of Mary (195 × 175)	Gift, Mussolini	Italy
6765	Master of Sterzing	Holy Woman with Gilded Background (49 × 38)	Cassiere	Germany
5139	Master of Sterzing	Nativity and Flagellation of Christ (195 × 175)	Gift, Mussolini	Italy
5559	Master of Sterzing	St. George (79 × 39)	Fischer, Swiss	Germany
5681	Master of the Altar	Mass of Gregory (83 × 166)	de Boer	Holland
5400	Master of the Forties	Portrait of a Man	Chesnier, Mme.	France
6361	Master von Delft	Christ Carrying Cross (35 × 25)	Trotti, Conte	France
7163	Master Wilhelm	Christ de Pitie Virgin and St. Catherine (48 × 29)	Renders	Belgium
6821	Max, Gabriel	Woman Behind Looking Glass (58 × 42)		Germany
5793	Melesskircher	Daniel in the Lion's Den (45 × 76)		Germany
5753	Melskirchner 1480	Scene from a Legend of Saints (76 × 43)		Germany
5526	Melzi, Franzesco	The Priestess, Romulus, Remus (66 × 147)	Cassierer	Holland
6732	Follower of Memling	Madonna with Child (47 × 26.3)	Rothschild R 86	France
5985	Memling Copy	Angel with Guitar (23 × 10.5)	Goudstikker 2447	Holland
5984	Memling Copy	Angel with Harp (23 × 10.5)	Goudstikker 2446	Holland
6711	Memling, Hans	Angel from Annunciation (83 × 26.5)	Renders	Belgium
6712	Memling, Hans	Virgin from Annunciation (83 × 26.5)	Renders	Belgium
6020	Menzel 1851	Frederic the Great		Germany
5292	Metsu	The Tease (141 × 110)	Wolf, Theodor	Holland
6754	Metsu	The Visitor (47.5 × 64)	Rothschild	France
5693	Meytens, Daniel	Venus and Amor (110 × 163)		Germany

5427	Mielich, Hans	Portrait of a Gentleman (75 × 68)		Germany
5428	Mielich, Hans	Portrait of a Lady	Bornheim	Germany
5163	Miereveld, van	Female Portrait (90 × 112)	Hoogendijk	Holland
5098	Miereveld, van	Portrait of a Lady (126 × 93)	Unknown	France
5716	Miereveld, van	Portrait of a Lady (69 × 52)	Unknown	France
5164	Miereveld, van	Portrait of a Man (1.12 × 90)	Paech	Holland
5839	Miereveld, van	Portrait of Marten Harpertsz	Goudstikker 5247	Holland
6792	Miereveld, van	Portrait of Miss Teding van Berkhout (57 × 68)	Katz	Holland
5996	Mieris	Danae with Old Woman (31 × 39)		Germany
5957	Mieris	Sleeping Woman (28.5 × 23)	Schmit, Jean	France
7192	Mieris	The Poultry Purchase (34 × 28)	Stern, Caroline	France
5151	Mignard	Portrait of Mad. V Maintenon	Unknown	France
7039	Mignon	Still Life with Flowers (36.5 × 28)		Germany
5990	Millais	Knight Fettered to Tree (28 × 20)		Germany
7184	Mirou	River Landscape (29 × 46)	Delaunay	Holland
5791	Mirou	Landscape with Village and Cattle (35 × 56)	de Boer	Holland
5950	Modern	Coat of Arms		Germany
6715	Modern	Landscape with People and Houses (79 × 59)		Germany
6314	Modern	Sitting Lion (16.8 × 8.7)		Germany
5548	Modern	Still Life with Roses (54 × 69)		Germany
6175	Modern Copy	Praying Madonna (35 × 26.5)		Germany
6148	Molenaer	River with Castle (48 × 63)	Unknown	France
5407	Molenear, Jan	A Peasant Scene (80 × 99)	Goudstikker	Holland
6317	Molijn	Landscape	Goudstikker 5650	Holland
5865	Molijn	Landscape	Goudstikker 2015	Holland
5889	Momper	Mountain Landscape (59 × 94)	Unknown	France
5866	Momper	Procession in a Grotto (62 × 92)	de Boer	Holland
5401	Momper de Frans	Village Landscape with Figures (62.5 × 100)	Paech	Holland
5573	Monaco, Lorenzo	Madonna with Child	Hoogendijk	Holland
5800	Monet, Claude	River Landscape with Bridge (71 × 53)	Flavian	France
6336	Montagna	Madonna and Child (56 × 43)	Fischer, Swiss	Germany
5762	Antonis Moor School	Portrait of a Man (50 × 39)	Dequoy	France
5777	Mor	Portrait of Young Lady (78 × 58)	ten Horn	Holland
5182	Morcelae	Portrait of Young Lady (93 × 119)	Douwes	Holland
5184	Morcelse	Portrait of a Woman (92 × 80)	Paech	Holland

6748	Moreelse	Female Dressed up as Juno (87 × 73)	Heulens	Belgium
5301	Moreelse	Portrait of a Lady 1625	Goudstikker 2445	Holland
5576	Moreelse	Portrait of a Shepherdess (76 × 63.5)		Germany
5299	Moreelse	Portrait of Philips Ram 1625	Goudstikker 2444	Holland
5332	Moretto	Nativity (138 × 180)	Contini, Italy	Germany
5311	Mostaert	Conquest of America by Spanish	Goudstikker 0490	Holland
6663	Moucheron	Landscape with Bathing Figures (85 × 212)		
5326	Multscher, Hans	The Journey of Three Kings (142.5 × 165)		Germany
7131	Mythens	Family Portrait	Goudstikker 0512	Holland
5380	Nattier	Diana with Dog (197 × 132)	Kraemer	France
5095	Nattier	Portrait of a Gentleman (150 × 115)	Unknown	France
5564	Nattier	Portrait of a Lady (65 × 54)	Beraudiare	France
5374	Nattier	Portrait of Henriette de Bourbon 1759 (101 × 123)	Beaudiere	France
5425	Nattier	Portrait of Lady (81 × 65)	Kraemer	France
5096	Nattier	Portrait of Mme. Joffrin (147 ×113)	Wildenstein	France
5370	Nattier	Portrait of Young Diana (91 × 135)	Rothschild	France
5170	Neck, van, Jan	Lying Venus with Amor (82.5 × 145)	Unknown	France
6333	Neer	Daylight Landscape (42.7 × 28.5)	Hoogendijk	Holland
6119	Neer	Riverside in Moonlight	Goudstikker 2654	Holland
5732	Neer, van	Winter Riverscape	Goudstikker	Holland
5300	Neer, van, der Aert	Winter Landscape Skating (81 × 122.5)	Wolf, Marcel	Holland
5107	Neroccio, du, Landi	Aubetung der Kinder (95 × 51)	Laudry	France
6731	Netherlands 16th c.	Portrait of Magdalene (26.5 × 40.1)	Rothschild	France
7177	Netherlands 16th c.	St. Lucas with Virgin with Child (28 × 18.5)	Unknown	France
7176	Netherlands 16th c.	St. Magdalena (48 × 65)	Seligmann	France
5636	Netherlands 1460	Mary of Annunciation (× 121)	Weinmann	Wiesbaden
6074	Netherlands 1460	St. Virgin with Book (× 97)	Germany	
6507	Netherlands 1560	Death and Coronation of St. Mary (72 × 88)	Unknown	France
5813	Neufchatel	Portrait of lady (49 × 59)	Goudstikker 2239	Holland
6122	Nolpe	Landscape	Goudstikker 5825	Holland
6843	Noolk	Orpheus		Germany
5845	Noort	Mythological Scene (65 × 79)	de Boer	Holland
6328	North German Master	Portrait of a Man	Koenigs	Holland

6067	North Germany	Feet Washing, Christ by Magdalena (× 70)		Germany
6052	North Germany	Head of Beam (× 50)		Germany
6053	North Germany	Head of Halo (× 46)		Germany
6051	North Germany	Head of King (× 41)		Germany
6054	North Germany	Head with Beam (× 53)		Germany
6055	North Germany	Head with Beam (× 53)		Germany
6098	North Germany 1657	Lion with Coat of Socle (× 55)		Germany
6526	North Italy 1550	Mary of Annunciation (× 120)	Bellini, Italy	Germany
5290	North Swabian c. 1480	Nativity		Germany
7123	North Swabian c. 1480	Nativity of Christ (108.5 × 67)		Germany
5426	Northcote	Portrait of Lavinia Countess Spencer (80 × 65)	Lyndhurst Collection	Belgium
6320	Oosten	Landscape with 3 Peasant Cars (31 × 43)	Paech	Holland
5246	Oostsanen	Altar Wing (40 × 150)	Goudstikker	Holland
5245	Oostsanen	Altar Wing with Bishop (40 × 150)	Goudstikker	Holland
5247	Oostsanen	Altar Wing with Christ at Gethsemane (40 × 150)	Goudstikker	Holland
5248	Oostsanen	Altar Wing with St. Catherine (40 × 150)	Goudstikker	Holland
5717	Oostsanen	St. Mary with Child and Angels (57 × 66)	Hoogendijk	Holland
5759	Oostsanen, van	Seller of Spectacles	Goudstikker	Holland
6341	Oostsanen, van	Story of Jacob and Esau	Goudstikker 2502	Holland
5343	Oostsanen, van	The Last Supper	Goudstikker 1503	Holland
5973	Orley School	Portrait of a young Woman (30 × 20)	Loebl	France
5735	Orley, van	Triptych Center Crucifixion and 14 scenes (68.5 × 43)	Katz	Holland
5897	Orley, van, Copy	Madonna with Child (75 × 50)	Unknown	France
5161	Orley, van	Scene from Life St. Quentin	Seyffers Col.	Belgium
6357	Ostade	House and Hay Carriage (37 × 33.5)	de Boer	Holland
7114	Ostade	Landscape	Goudstikker 1512	Holland
6182	Ostade v, Adrian	Blind Man with Dog (26 × 19)	Leegenhock	France
5994	Ostade v, Isaak	Interior of a Barn	Goudstikker 2497	Holland
5317	Ostade v, Isaak	Interior of a Farm House	Goudstikker 2189	Holland
6111	Ostade v, Isaak	Interior of Stable (39 × 57)	Goudstikker	Holland
5971	Ostade v, Isaak	Interior with Loom	Goudstikker 1927	Holland
5920	Ostade v, Isaak	Man Reading a Paper (29 × 22.5)	Lagrand	Belgium

5408	Ostade v, Isaak	Peasants (82.5 × 94.5)	Rothschild	France
5417	Ostade v, Isaak	Peasants at Inn (89 × 80)	Rothschild	France
5891	Ostade v, Isaak	Peasants Gathering Peat	Goudstikker 2644	Holland
6116	Ostade v, Isaak	Peasants Slaughtering a Pig (65 × 48)	Hoogendijk	Holland
6139	Ostade v, Isaak	Stable Interior	Goudstikker 5713	Holland
5945	Ostade v, Isaak	The Forge (33 × 28)	Goudstikker 2095	Holland
5342	Ostade v, Isaak	Winter	Goudstikker 2566	Holland
7186	Pacchiarotti	Virgin with Child St. Gerome and Monk	Goudstikker 2541	Holland
6378	Pacher, Friedrich	Holy Bishop (223 × 77)	Goudstikker	Holland
6377	Pacher, Friedrich	St. Barbara (223 × 77)	Goudstikker	Holland
5267	Pacher, Friedrich	St. Andrews (223 × 79)	Goudstikker	Holland
5268	Pacher, Friedrich	St. Florian (223 × 77)	Goudstikker	Holland
5815	Pacher, Michael	St. Barbara (48 × 48)	Neumann, Chas.	Austria
5640	Pacher, Michael	St. Michael (× 140)	Gozzeti	Germany
5578	Padovanino	Allegorical Female Half Nude (70 × 99)	Bossi, Italy	Germany
7120	Padovanono	Venus Sleep, Two Women in Background (94 × 135)		Germany
7158	Padua	Madonna and Child (47 × 28)	Unknown	France
6132	Pagani	View of Port with People (35 × 29)		Germany
5187	Pannini	Girls and Warrior Under Ruins (97 × 73)	Muehlmann	France
5186	Pannini	Landscape Persons Under Ruins (72 × 96)	Muehlmann	France
5439	Pannini	Roman Ruins (94 × 114)	Bornheim	Germany
5890	Paolo	Madonna and Child		Germany
6664	Paolo, Kallo	Cassone: Triumphal Procession (39 × 172)	Rothschild	France
6152	Pater	Gallant Scene at Fountain (41 × 61)	Stern, Caroline	France
5961	Pater	Le Concert la Comedie (35 × 28.5)	Rothschild	France
5940	Pater	Rural Scene (15.5 × 22.2)	Stern, Caroline	France
5991	Pater	Rural Scene (33 × 43)	Lindenbaum	France
7387	Pater	Fete Champetre (31.7 × 23.2)	Rothschild	France
7386	Pater	Scene Galante (31.6 × 23.1)	Rothschild	France
6725	Patinier	Sodom and Gomorrha	Koenigs	Holland
5543	Pauser, Sergius 1940	Portrait of Child Edda Göring (64.5 × 52)	Göring Collection	Germany
5393	Pausinger 1899	Stags in the Forest (149 × 265)		Germany
5155	Peiner 1937	Landscape Venus with Girl (175 × 152)		Germany
5437	Peiner, Werner	African Landscape		Germany
5771	Perroneau	Portrait of a Lady (66 × 54)	Wildenstein	France

5050	Persia	Sword and Sheath, Steel, Crystal, Gold, Rubies	Rothschild	France
5600	Peseline	The Expulsion from Paradise (96 × 47)	Koenigs	Holland
6229	Pesne (near)	Portrait of Officer Frederic the Great (37 × 30.5)		Germany
5154	Petersen 1937	Norman Boat in Stormy Sea (217 × 120)	Herbst Gekauft	Germany
5392	Petersen 1937	Northern Expedition (200 × 200)		Germany
5438	Petersen 1937	Young Knight		Germany
6830	Peterson 1928	Hindenburg (54 × 45.5)		Germany
6683	Petiti	Cows in a Forest		Germany
5695	Piamingo	Allegories of Venice (148 × 83)		Germany
5188	Pickenoy	Portrait of a Lady (89 × 123)	Katz	Holland
5964	Picture of a Calendar	Seven Prints		Germany
5613	Piemont 15th c.	St. Barbara, St. Catherine and Females (67 × 124)	Contini, Italy	Germany
5614	Piemont 15th c.	St. Bernardino, John the Baptist (67 × 124)	Contini, Italy	Germany
6326	Piertro	Madonna with Child (63 × 46.5)	Germany	
7394	Pietro	Madonna with Child (35.5 × 26.5)	Unknown	France
6957	Pietro	Madonna, Child and Saints (36.5 × 52)		Germany
5652	Piombo d., Sebastiano	A Knight (97 × 108)	Contini, Italy	Germany
5322	Pisano	Angel of an Annunciation (× 160)	Goudstikker	Holland
5325	Pisano	Maria of Annunciation (× 16c)	Goudstikker	Holland
7159	Piza	Coronation of St. Mary (83 × 44)	Unknown	France
5529	Pleydenworff	A Saint (120 × 48)	Unknown	France
6346	Poelenburgh	Diana Bathing	Goudstikker 5915	Holland
6420	Poelenburgh	Landscape with Nude Woman and Amor (31 × 26.5)		Germany
6128	Poelenburgh	Landscape with Six Bathing Girls (25 × 32.5)		Germany
6344	Poelenburgh	Nymphs and Satyr	Goudstikker 5876	Holland
5941	Poelenburgh	Roman Ruins with Four Bathing Women (22.5 × 30.5)	Fischer, Swiss	Germany
6000	Poelenburgh	Roman Ruins with Peasants (16 × 20)	Ward	France
6370	Poelenburgh	Sleeping and Bathing Woman (23.5 × 31.5)		Germany
5535	Pollack, Jan	St. Martin (125 × 54)	de Boer	Holland
5296	Pontormo	Portrait of a Cardinal	Goudstikker 2645	Holland
6840	Poschinger	Landscape (60 × 109)	Germany	

6170	Pourbus	Portrait of a Lady (46 × 40)	Unknown	France
5285	Poussin	Venus and Aeneas	Goudstikker 2516	Holland
5840	Predis, de	Portrait of a Man (30 × 42)	Unknown	France
6844	Preetorius	Girl Head (38 × 25)	Germany	
7065	Preller	Wood Landscape (110 × 140)	Germany	
6494	Pretended forgery	Angel with Candelabrum (Rt March 5, 1954)	Rothschild	France
5811	Primaticcio	Diana from Poitiers (48.5 × 37)	Goudstikker 2489	Holland
5933	Primaticcio	Two Studies of Hands (15 × 25)	Reinach	France
5516	Provoost, Jan	Female Saint with Book and Palm (75 × 24)	de Boer	Holland
5517	Provoost, Jan	St. Catherine (24 × 75)	de Boer	Holland
7165	Provoost, Jan	St. Dominic	Goudstikker 2683	Holland
7161	Provoost, Jan	St. John the Baptist	Goudstikker 2682	Holland
6432	Prudhon	Bathing Nymph (40 × 31)	Unknown	France
5431	Raffaels, Einfluss	Madonna with Child Joseph and Petrus (104 × 104)	Unknown	France
6868	Raupp	Bathing Girl (23.5 × 19.5)		Germany
5763	Rembrandt	Portrait of a Man with Beard (59 × 72)	Pannwitz, v	Holland
5934	Rembrandt	Portrait of Boy with Red Cap (44 × 33)	Rothschild	France
7146	Rembrandt	Portrait of His Sister Elizabeth Ryn (53 × 69)	Katz	Holland
6739	Rembrandt	Portrait of Lisbeth wan Rijn (57 × 41)	Goudstikker	Holland
5779	Rembrandt	Portrait of Old Man (77 × 64)	Wendland Marseil	France
7151	Rembrandt	Portrait of Saskia (48 × 66)	Katz	Holland
5595	Reni Guido	Half Figure of an Angel (49 × 64)	Germany	
7193	Renior	Portrait of Mm. Grimpel (35 × 44)	Rosenberg	France
7190	Renior	Portrait of Mm. Grimpel (41 × 32)	Rosenberg	France
7191	Renior	Portrait of Woman (35 × 27)	Stern, Caroline	France
5233	Reubens School	Venus and Adonis (203 × 240)	Schmit, Jean	France
5382	Reymerswaele v	Two Men Counting Money (119 × 97)		Germany
6927	Reynolds	Portrait of a Lady (75.5 × 63.5)	Rothschild	France
5378	Rhenish 15th c.	St. John (× 63)	Negbaur	Germany
6085	Rhenish Franconia 1520	St. Bishop (× 108)		Germany
6760	Rhineland c. 1727	Portrait of a Bishop (53 ×36)	Unknown	France
5390	Ricci, Sebastiano	Adam and Eve (183 × 180)	Morandotti, Italy	Germany
5391	Ricci, Sebastiano	Zeus and Venus (168 × 210)	Morandotti, Italy	Germany
5330	Rickelt, Karl	Portrait of Hitler (148 × 113)	Military Nazi	Wiesbaden
6187	Ridinger, Joh El.	Twenty-Two Drawings (20 × 25)		Germany

6784	Riedinger	Many Stags in a Park (90 × 115)		Germany
5097	Rigaud	Portrait of a Nobleman (142 × 106)	Wildenstein	France
6294	Rimini	Crucifix	Goudstikker 2212	Holland
6519	Della Robbia	Bust of a Man in a Fruitwreath (× 70)	Mannheimer	Holland
6514	Della Robbia	Bust of Holy Virgin with Child (× 88)	Contini, Italy	Germany
6511	Della Robbia	Holy Franciscus (× 77)	Bellini, Italy	Germany
6505	Della Robbia	Holy Virgin with Goblet (× 194)		Germany
6512	Della Robbia	Relief of an Angel (102 × 61)	Ventini, Italy	Germany
6523	Della Robbia	Tonde Man in a Fruit Wreath (× 79)	Mannheimer	Holland
5055	Roemisch Sculpture	Bocher aus Bosco Reale, Silver	Unknown	France
6127	Roesstraten	Vase in Niche (38.5 × 27.5)	Military Nazi	Wiesbaden
6516	Roman	Kneeling Venus (× 75)		Germany
6101	Roman	Lion Foot, Part of Architecture (× 82)		Germany
6059	Roman 5th c.	Head of Dionysos (× 35)		Germany
6797	Roman after Greek Original	Torso of Young Man (× 70)	Rothschild	France
7179	Romano	Madonna with Child Two Saints	Goudstikker 2694	Holland
6144	Romano	Madonna with Child	Goudstikker 2160	Holland
5700	Roth, Toni	Still Life with Flowers (116 × 92)		Germany
5442	Roth, Toni	Still Life with Flowers (127.5 × 78)		Germany
6335	Rottenhammer	Festival Meal of Gods (43 × 63)		France
5569	Rottenhammer (?)	Diana with Attendance Bathing Landscape (55 × 75)	Giorgio, Italy	Germany
5244	Rottenhammer, Attributed to	Landscape with Venus, Flora, Baccus (184 × 222)	Heulens	Belgium
5731	Rotti, Pacchi	Madonna and Child (59.5 × 45.5)	Goudstikker	Holland
6104	Rubens	Achilles and Daughter of Lycomedes	Koenigs	Holland
7182	Rubens	Burning Town	Goudstikker 2253	Holland
5997	Rubens	Callisto	Koenigs	Holland
5585	Rubens	Diana before Hunt (58.5 × 100)	Fischer, Swiss	Germany
6322	Rubens	Diana Hunting	Koenigs	France
5757	Rubens	Head of a Moorish King	Gelder, van	Belgium
6350	Rubens	Landscape	Goudstikker 2676	Holland
7130	Rubens	Landscape	Koenigs	Holland
6427	Rubens	Landscape in a Storm	Koenigs	Holland
5233	Rubens	Maria with Child (260 × 210)	Keppel	New York
5724	Rubens	Meleager and Atalanta (57.5 × 75.5)	Rothschild	France
5180	Rubens	Portrait Antonio Archbishop Treste (108 × 121)	Dreyfuss Gal.	Germany

7158	Rubens	Two Roman Soldiers	Koenigs	Holland
5278	Rubens	Female Head (× 52)	Hoogendijk	Holland
5542	Rubens	Helene Fourment	Koenigs	Holland
6742	Rubens	Meleager and Atalanta (56.5 × 45)		Germany
5176	Rubens	Crucifixion	Koenigs	Holland
6775	Rubens Workshop	Diana at Bath	Koenigs	Holland
6830	Rubens Copy	Satyres, Women and Children (51.5 × 40.3)		Germany
6736	School of Rubens	Madonna with St. and Children (38.5 × 52)	Wassermann	France
5803	School of Rubens	The Bath of Dianna	Koenigs	Holland
5133	Rubens Workshop	Diana (216 × 180)	Rothschild	France
5772	Rubens Workshop	Susanne Fourment (52 × 58)	Wendland	France
5895	Ruysdael, v	Boats on a River (58 × 82)	Goudstikker	Holland
5769	Ruysdael, v	Cows at a River (47 × 61)	Muir	France
5324	Ruysdael, v	Ferry Boat	Goudstikker 2635	Holland
5863	Ruysdael, v	Ferry Boat with Cattle on the River Vecht	Goudstikker 2772	Holland
5975	Ruysdael, v	Fortified Town on River	Goudstikker 2590	Holland
6163	Ruysdael, v	Landscape	Goudstikker 5869	Holland
6348	Ruysdael, v	Landscape	Goudstikker 5870	Holland
5609	Ruysdael, v	Landscape (69 × 107)	Wildenstein	France
5372	Ruysdael, v	Landscape (85 × 115.5)	Paech	Holland
5879	Ruysdael, v	Landscape in the Morning	Goudstikker 2440	Holland
6118	Ruysdael, v	Landscape Village and Two Riders (39.5 × 56)	Goudstikker 1565	Holland
5309	Ruysdael, v	Landscape with a Tower (103 × 139)	Goudstikker 1644	Holland
5409	Ruysdael, v	Landscape with Carriage Before Inn (65 × 95)	Rothschild	France
5806	Ruysdael, v	Landscape with Castle	Goudstikker 0481	Holland
5819	Ruysdael, v	Landscape with Cottages (58 × 70)	Stern, Caroline	France
6121	Ruysdael, v	Landscape with Horseman (39 × 46)	Bachstitz	Holland
7138	Ruysdael, v	Landscape with River (62.5 × 74)	Goudstikker 2569	Holland
5305	Ruysdael, v	Large Landscape	Goudstikker 5240	Holland
5825	Ruysdael, v	River Landscape (49 × 78)	Unknown	France
5415	Ruysdael, v	River Landscape with Boats	Goudstikker 2771	Holland
6138	Ruysdael, v	River Near Rhenen (42.5 × 52)	Hoogendijk	Holland
5899	Ruysdael, v	River with Cow	Goudstikker 5738	Holland
5339	Ruysdael, v	The Ferry Boat (100 × 145)	Andriesse	Belgium
5856	Ruysdael, v	Town Near Sea (64 × 76.5)	Goudstikker 5974	Holland
6167	Salzburg 1460	Holy Virgin with Child (× 135)		Germany
6064	Salzburg 1520	Group of Sepulcher of Lord (67 × 58.5)		Germany

6859	Samberger	Head of a Man Drawing (14.5 × 10)		Germany
6813	Samberger	Head of Man (37 × 32)		Germany
6835	Samberger	Portrait of a Man (90 × 71)		Germany
5306	Sarto, Andrea del	Madonna and St. John (94 × 130)		Germany
6425	Sassetta	Madonna and Child (50 × 37)	Rochlitz	France
5776	Sassoferato	Holy Family	Goudstikker	Holland
7173	Savery	Landscape with Hunter (49 × 31)	de Boer	Holland
6131	Savery	Mountain Landscape	Koenigs	Holland
5888	Savery	Mountain Landscape (50 × 92)	Unknown	France
6431	Savery	Paradise with Animals (31 × 41)		Germany
6779	Savery	Paradise with Noah's Ark (83 × 137)	Rochlitz	France
5930	Schall	The Broken Fan (43 × 35)	Lindenbaum	France
5703	Schenck, Petrus	Map of Balkan Countries (Print) (100 × 120)		Germany
5537	Scheuffelin	Christ and His Followers (50 × 155)	Dreyfuss Gallery	Germany
5275	Schiavoue	Stoning	Goudstikker 1948	Holland
6816	Schlieben	Head of a Girl (28.5 × 24.5)	Looted from CCP	Germany
6865	Schmutzler	Portrait of a Woman (78 × 65)		Germany
6174	Schonganer 1460	Crucifixion of Christ (52 × 35)	Fischer, Swiss	Germany
7389	Schonganer 1460	Death of Mary (38 × 45.5)	Rothschild	France
5183	School of Leonardo	Leda with Four Children (× 105)	Bornheim	Germany
6721	School of Avignon	Hunting Boy (57 × 57)	Unknown	France
5574	School of Baldung Grien	To an Eremit Is shown a Nude Woman (63 × 50)		Germany
5644	School of Bodensee	Interior Madonna Reading (88.5 × 51)		Germany
5347	School of Bologna 1550	Mother of Romulus and Remus (120 × 163)	Unknown	France
6716	School of Botticelli	Virgin, Child, St. John	U.S. Forces Aust.	Austria
5653	School of Boucher	Leda (120 × 107)	Seligmann	France
5935	School of Boucher	Woman with Children (44 × 35)	Unknown	France
5112	School of Cleve	Nativity (88 × 87)	Unknown	France
5782	School of Drouet	Lady Sitting at a Table (65 × 55)	Unknown	France
5331	School of Ferrara	Birth of Christ (180 × 189)	Contini, Italy	Germany
5841	School of Fontaine-bleau	Diana (47 × 25)	Unknown	France
5344	School of Fontaine-bleau	Flora (110 × 180)	Bellini, Italy	Germany
5366	School of Fontaine-bleau	Mythical Scene (96.5 × 133)	Unknown	France
6060	School of Fontaine-bleau	Portrait Bust of Lady (× 46)	Padou	France
5829	School of Fontaine-bleau	Singing Women (53 × 68)	Unknown	France

5373	School of Fontaine-bleau	The Three Graces (142 × 102)	Unknown	France
5368	School of Fontaine-bleau	Venus (133 × 104)	Unknown	France
5369	School of Fontaine-bleau	Venus and Adonis (132 × 107.5)	Rochlitz	France
5341	School of Fontaine-bleau	Venus Reposing (101 × 158)	Rochlitz	France
5774	School of Fontaine-bleau	Venus with Two Putti (33 × 35)	Schmit, Jean	France
5706	School of Gaddi	St. John and Baptist and St. (95 × 70)	Unknown	France
5272	School of Guggen-bichler	Nun (× 172)		Germany
5927	School of Guido Reni	Mythological Scene Man and Girl (22.5 × 22.5)	Ventura, Italy	Germany
5658	School of Lein-berger	St. Ann with Virgin and Child (× 125)		Germany
5928	School of Netscher	Lady Playing a Guitar with Cavalier (48 × 39)	Unknown	France
6077	School of Pacher	St. Angel of Baptism of Christ (× 90)		Germany
5607	School of Rotten-hammer	Diana and Callisto (56.5 × 94)	Heulens	Belgium
5233	School of Rubens	Henry IV Makes Peace (2.30 × 2.73)	Gutbier	Germany
5293	School of Rubens	Large Picture of Woman	Goudstikker 5674	Holland
5728	School of Martin Simode	Angel (47 × 36)	Unknown	France
5682	School of Titian (Licino?)	Lying Female Nude (82 × 150)	Contini, Italy	Germany
5356	School of Veronese	Male Portrait	Hoogendijk	Holland
5781	School of Watteau	Comedians (58 × 71)	Halphen F	France
5960	School of Watteau	Garden Party	Unknown	France
6014	School of Weyden	Madonna with Child (44.5 × 26)	Schultheiss Swiss	Germany
5348	School of Weyden	Madonna with Child, Joseph Angels (158 × 100.5)	Gelder van	Belgium
5383	School of Wohl-gemut	Nativity of Christ (160 × 114)		Germany
5375	School of Paolo Veronese	Portrait of a Lady (118 × 94)	Unknown	France
6829	Schrader-Velgen	Child in Garden (70.5 × 59)		Germany
6019	Schreoder	Lust Garden in Berlin Drawing		Germany
5562	Schuechlin c. 1480	Adoration, other side Annunciation (118 × 76)	Unknown	France
5423	Schuster-Woldan 1937	Carin Göring	Göring Col.	Germany
5422	Schuster-Woldan 1937	Emmy Göring	Göring Col.	Germany

5104	Schwabish School 15th c.	The Adoration of the King (150 × 75.5)	Hoogendijk	Holland
6830	Schwind	Two Eremits (61 × 46)		Germany
5524	Scorel, van	Founder with Her Patron (88 × 23)	Katz	Holland
5525	Scorel, van	Founder with His Patron (88 × 23)	Katz	Holland
5160	Scorel, van	Mary and Child St. Ann (89 × 58)	Katz	Holland
6774	Scorel, van	St. Magdalena as Penitent (107 × 133)		Germany
6735	Scorell, van	Portrait of a Young Man (47 × 34)	Rothschild	France
5262	Sebastian, Vrancx (?)	Village Landscape Many People (75 × 187)	de Boer	Holland
5567	Seeschwaben 15th c.	Birth of St. Mary		Germany
5549	Seeschwaben 15th c.	Presentation of Christ in the Temple		Germany
5766	Seisenegger	Portrait of a Lady (70.5 × 52)		Germany
5085	Seventy-four	92 Göring Photo Albums Sept 2, 1946		Washington, D.C.
7160	Siena	Virgin and Child with Angels (71 × 30)		Germany
6382	Silesia, Franconia	Altar Wing with Six Apostles (115 × 228)		Germany
6383	Silesia, Franconia	Altar Wing with Six Apostles (115 × 228)		Germany
6386	Silesia, Franconia	Relief Coronation of Holy Virgin (127 × 228)		Germany
5125	Simon, Vouet	Portrait of the Duchesses Longeville (127 × 86)	Bernard, Mme.	France
6123	Sisley	Village Street in Winter (45 × 54)	Rosenberg	France
6727	South German	Altarpiece (19 × 37.1)		Germany
7060	South German	St. Anne with Christ (× 79)		Germany
6799	South German	St. Virgin (× 102)	Fischer, Swiss	Germany
6096	South German 1480	St. Florian (× 77.5)	Staal	Holland
5676	South German 1490	St. Martin on Horseback (× 108)		Germany
5622	South German 1491	St. Knight (× 115)		Germany
6071	South German 1520	St Prince (× 44)		Germany
5103	South German 15th c.	Captivity of Christ (161 × 74)	Muehlmann	Germany
5255	South German 16th c.	Monk with a Lily (129 × 46)	Unknown	France
5156	South German c. 1720	Flying Angel (× 110)		Germany

5157	South German c. 1720	Flying Angel (× 115)		Germany
5983	South German 17th c.	Head of Old Man (7.5 × 5)		Germany
5588	South German c. 1520	Maria with Child and 2 Angels		Germany
5712	South German Master	Portrait of a Man	Koenigs	Holland
5639	South Germany	Holy Prince (Sebastian?) (× 150)		Germany
5617	South Germany	St. Knight (× 102)		Germany
5583	South Germany 1480	Whitsuntide	Giese Swiss	Germany
5627	South Germany 1490	Angel of Annunciation (× 120)		Germany
6080	South Germany 1700	Holy Virgin (× 105)	Fischer, Swiss	Germany
6078	South Germany 1700	Ornament with Leaves and Head of Youth (× 124)		Germany
5590	South Tyrol 1490	Kneeling Angel (× 62)		Germany
6079	South Tyrol 1490	Kneeling Angel (× 62)		Germany
6073	Spain 1250	Holy Virgin with Child (× 98)		Germany
6504	Spain 14th c. Forgery	Adoration of the King (30 × 12 × 74)		Germany
5498	Spitzweg	Monk on Rocky Seashore		Germany
6366	Spranger	Baccanal (40 × 29)		Germany
5787	Spranger Copy	Venus and Mercury (37 × 48)		Germany
6848	Stademann	Landscape (42 × 65)		Germany
6852	Stademann	Landscape in Winter (42 × 67)		Germany
7113	Stahl	Ploughers (80 × 124)		Germany
6860	Stahl	Landscape (13.5 × 19)		Germany
6853	Stahl-Erding	Grey Horse in Stable (52 × 40)		Germany
6106	Steen	Landscape with Peasant Family (53 × 45)	de Boer	Holland
6750	Steen	Samson and Delilah (67.5 × 82)	Bachstitz	Holland
6181	Steen	Village Landscape Dancing Dog (39.5 × 47.5)	Paech	Holland
5355	Steen, Jan	Iphigenie	Goudstikker 1972	Holland
6108	Stimmer	Portrait of a Man (42 × 67)	Tietje	Holland
6524	Stoss, Veit	Two Young Knights (165 × 85)	Gelder van	Belgium
5402	Strozzi	Portrait of a Man	Goudstikker 0052	Holland
6043	Style of Lorraine	Holy Virgin with Child (× 72)		Germany
6065	Suabia 1520	St. Catherine of Siena (× 50)		Germany
5093	Suebia c. 1480	Annunciation	Akademie, Vienna	Austria
5094	Suebia c. 1480	Nativity of Christ	Akademie, Vienna	Austria
6800	Swaben 1530	Bust of Angel (× 34)		Germany
5623	Swabia 1500	Angel Annunciation (× 117)		Germany
5619	Swabia 1510/20	St. George (× 110)		Germany
5620	Swabia 1510/20	St. Knight (× 112)		Germany
6093	Swabia c. 1520	Adoration of Holy Three Kings (73 × 127)		Germany

5592	Swabia c. 1490	Saint Virgin (× 58)		Germany
5665	Swiss c. 1500 Forgery	Female Saint (× 91)	Leonardi	France
5626	Syrlin the Young	Holy Virgin with Child (× 124)		Germany
5674	Syrlin the Young	St. Knight (× 102)		Germany
5625	Syrlin the Young	St. Magdalena (× 122)		Germany
6839	Szankonski (?)	Nude Girl on Bed (80 × 100)		Germany
6153	Szankonski, Boleslaw	Edda Göring	Göring Collection	Germany
6352	Teniers	Interior with Soldiers	Goudstikker 5777	Holland
6145	Teniers	Mountain Landscape	Goudstikker 5004	Holland
6176	Teniers	The Visit in Night	Goudstikker 2423	Holland
5862	Teniers, David	Country Love	Goudstikker 1587	Holland
5887	Teniers, David	Landscape with 2 Monks (83 × 53)	Unknown	France
5911	Teniers, David	Landscape with Figures (33 × 44)	Schmidtlin, Swiss	Germany
5822	Teniers, David	Smoking Men before an Inn	Goudstikker 2087	Holland
5192	Teniers, David	The Game Kitchen (90 × 133)	Delaunay	Holland
6140	Teniers, F.	Happy Party Before Inn (58 × 40)	Unknown	France
6753	Terborch	Lady Washing Her Hands (40.5 × 48.5)	Rothschild	France
6109	Terborch	Portrait of a Gentleman (65 × 48)	Mannheimer	Holland
7187	Terborch	Portrait of Prinz Cosimo III	Goudstikker 1946	Holland
5713	Teunissen	Portrait of a Man (39.5 × 44.5)	Hoogendijk	Holland
6850	Th. Herbst, Nachl	Landscape (34.5 × 52)		Germany
5539	Thoma, Hans	Girl with Amor Riding on a Delphine (46 × 56)		Germany
5146	Thulden, von	Portrait of Bart. Avianus	Bornheim	Germany
6150	Tiepolo	Alexander and Campaspe at Apelles (54 × 43) Unknown		France
6759	Tiepolo	Scene out of History of Venice (71 × 107)	Rothschild	France
7106	Tiesenhausen	Mole in Surf (19.5 × 40)		Germany
5233	Tintoretto	Danae (153 × 163)	Merandotte	Germany
5279	Tintoretto	Holy Family	Goudstikker 2492	Holland
5310	Tintoretto	Portrait of Sculptor Strada (103 × 1280)	Wolf, Marcel	Holland
5698	Tintoretto	St. Catherine of Siena (115 × 145)	Bank, v, Embden	Holland
5233	Tintoretto School	Annunciation (171 × 276)	Wolf, Theodor	Germany
7137	Titian Copy	The Bath of Diana (68 × 57)	Koenigs	Holland
5892	Titian	Portrait of a Man (88 × 73)	Unknown	France
5379	Toscana	Angel of Annunciation (× 150)	Ventura, Italy	Germany
5638	Toscana	St. Virgin (× 142)	Bellini, Italy	Germany
5273	Toscana 1300	St. Bishop (× 156)	Bellini, Italy	Germany
6630	Toscana 1480	Angel with Candlestick (× 86)		Germany
5254	Toscana-Umbrian	St. Virgin of Annunciation (× 178)		Germany

7196	Toscanna	Angel with Candlestick (× 48)	Bellini, Italy	Germany
5538	Tour de la, George	The Smoker (76 × 63)	Carre, Louis	France
5371	Troy de, Francois	Portrait of Mme. Titon de Coigny (140 × 105)	Loebl	France
6083	Tyrol about 1490	St. Knight (× 105)		Germany
5515	Tyrolese School 15th c.	St. George (34 × 73)		Germany
5741	Uden	Landscape	Goudstikker	Holland
5926	Umbrian School	St. Sebastian	Hoogendijk	Holland
6787	Upper Germany	St. Mary from Annunciation (150 × 67)		Germany
5708	Upper Italy	Adoration of the Kings (108 × 155)		Germany
5671	Upper Rhine	St. Agnes (× 83)		Germany
5705	Urlaub, George	Man at his Desk with Servant (197 × 126)		Germany
5896	Valckenborgh, L	House and Bridge at Small River (54.5 × 83)	Lagrand	Belgium
5152	Valkenbrough	The Constantine Battle (135 × 267)	Rochlitz	France
5413	Vecchi	Allegory Statue of a Woman Vanity (78 × 94)		Germany
5646	Vegt, Max	Frederic the Great (62 × 52.5)		Germany
6757	Velazquez	Portrait of Infant Margaret Therese (100 × 70)	Rothschild	France
5817	Velde, van	Garden Party (50 × 84)	Wetzlar	Holland
6143	Velde, van	Sailing Vessels	Goudstikker 2018	Holland
6359	Velde, van	Seascape	Hoogendijk	Holland
5750	Venedig, Barbieri	Female Half Nude		Germany
5150	Venetian	Sleeping Venus (128 × 181)	Unknown	France
5912	Venetian 16th c.	Portrait of Lady (41 × 28.5)	Giorgio, Italy	Germany
7129	Veneziano	Madonna with Child	Goudstikker 2542	Holland
5962	Venusti	The Holy Family (23.3 × 16.5)	Wildenstein	France
5295	Vermeer Fake	Christ and the Adulteress		Holland
7142	Vermeer	Holy Family (55 × 63)	Cassiere	Holland
5880	Vermeer	Holy Family in Landscape (61 × 78)	Schultheiss Swiss	Germany
6345	Vermeyer	Portrait of a Man (34 × 46)	Katz	Holland
5826	Vernet	Rocky Beach with Bathing Women (52 × 74)	Mandl, Victor	France
6724	Veronese	Head of a Negro	Goudstikker 2840	Holland
5233	Veronese, Paolo	Venus and Mars (164 × 237)	Contini, Italy	Germany
5319	Verspronck	Portrait of a Girl	Goudstikker 2097	Holland
5761	Vinkebooms	Sow Chase (49.5 × 69)	Delaunay	Holland
6349	Vlieger	The Docks (43 × 67)	Goudstikker 2119	Holland
6857	Vollbehr	Landscape (27.5 × 35.5)		Germany
6862	Voltz	Cowherd in a Village (39 × 92)		Germany

7063	Voort	Portrait of a Man	Goudstikker 2196	Holland
7112	Voort	Portrait of Justina Kies van Wissen	Goudstikker 1567	Holland
7121	Voort	Portrait of Kies van Wissen	Goudstikker 1566	Holland
5312	Voort, v d	Portrait of a Lady	Goudstikker 2197	Holland
6103	Waldmueller	Bathing Woman (138 × 97)	Landau, Pollander	Austria
6429	Wattean	La Polonaise (36.5 × 28.5)	Lazienski Castle	Poland
5976	Watteau	Family in a Garden (40 × 32)	Rothschild	France
5513	Watteau de Lille	Carnival Scene (89 × 108)	Wildenstein	France
6817	Weber	Landscape, drawing (40 × 53)		Germany
5333	Weenix Jan	Still Life with Game (150 × 162)	Unknown	France
6838	Wenk	Breakers (81 × 65.5)		Germany
5744	Werff	The Art Pupils (48 × 34.5)		Germany
6159	Werff	Venus (54 × 41.5)	Mandl, Victor	France
5925	Werms	Crucifixion of Christ (33 × 24)		Germany
6830	Werner	Lover of Fine Art (39 × 30.5)		Germany
5563	Werner von, Anton	Field Marshal Moltke (66 × 50)		Germany
5814	Wertinger	Portrait of a Man (55 × 47)	Schmidtlin, Swiss	Germany
6733	Weyden	Madonna with Child (39 × 29)	Renders	Belgium
5233	Wildens, Jan	Diana in Solo Chase (140 × 218)	Hoogendijk	Holland
6778	Willaerts	Harbor Scene	Hoogendijk	Holland
5185	Willaerts, Adam	In a Harbor	Douwes	Holland
6856	Willroider 1910	Landscape (29.5 × 22.5)		Germany
6847	Wilm	Landscape (27 × 45)		Germany
5049	Wilm, Berlin	Shape of a Book, Silver	Military Nazi	Wiesbaden
6858	Wopfner	Four Landscapes (17 × 9)		Germany
5403	Workshop of Titian	Lavinia Lady's Portrait Before Rainbow (95 × 80)	Rochlitz	France
5124	Wouverman	Horseman at an Inn (98 × 114)	Rothschild R 13	France
7136	Wouverman	Landscape with Bridge	Goudstikker 1102	Holland
5842	Wouverman	Officer on Horseback	Hoogendijk	Holland
5838	Wouverman	Stable Scene (36.9 × 48.7)	Rothschild	France
6433	Wouverman	The Riding School (52 × 44)	Rothschild	France
5995	Wouverman	White Horse	Goudstikker 1990	Holland
5979	Wouverman	Winter Landscape	Goudstikker B024	Holland
5954	Wytewael	Judgment of Paris (21.5 × 28)	Heulens	Belgium
5764	Zick, Januarius	Fisher and Girl and 3 Other Figures (62 × 55)		Germany
6103	Ziegler	Female Nude (145 × 85)		Germany
5608	Ziegler	Joachim and Ann under Golden Gate (90 × 67)	Rochlitz	France
6103	Zuegel	Grazing Sheep (127 × 65)		Germany
6823	Zuegel	Peasant and Two Oxen (36 × 24)		Germany

Appendix D

Books, Photographs, Dishes, Silver, etc.

5087	2 Chests of Books		Offenbach
5055	Ashtray, Silver	Military Nazi	Wiesbaden
5046	Box for Cakes, Glass & Silver	Military Nazi	Wiesbaden
5055	Box for Smoking Utensils, Silver	Unknown	France
5050	Box with Documents, Silver and Copper	Military Nazi	Wiesbaden
5058	Box with Documents, Silver and Copper BG20/27	Military Nazi	Wiesbaden
5058	Can with Cover BG 20/22	Military Nazi	Wiesbaden
5049	Candlestick, Silver	Military Nazi	Wiesbaden
5049	Candlestick, Silver	Military Nazi	Wiesbaden
5049	Candlestick, Silver	Military Nazi	Wiesbaden
5049	Candlestick, Silver	Military Nazi	Wiesbaden
5049	Candlestick, Silver	Military Nazi	Wiesbaden
5049	Candlestick, Silver	Military Nazi	Wiesbaden
5049	Candlestick, Silver	Military Nazi	Wiesbaden
5049	Candlestick, Silver	Military Nazi	Wiesbaden
5050	Candlestick, Silver	Military Nazi	Wiesbaden
5050	Candlestick, Silver	Military Nazi	Wiesbaden
5089	Candlestick, Silver	Military Nazi	Wiesbaden
5089	Candlestick, Silver	Military Nazi	Wiesbaden
5089	Candlestick, Silver	Military Nazi	Wiesbaden
6018	Carin Göring Portrait		Washington, D.C.
5055	Chest of Books		Offenbach
5043	Crate Containing Glass, Cups, Dishes		France
5045	Crate of Glasses, 24 Water, 30 Wine, etc.	Unknown	France
5053	Crate of Porcelain		France
5054	Crate Porcelain, 23 Fruit Dishes, Plates Knives, etc.		France
5039	Cup and Saucer, Silver	Rothschild	France

5055	Cup, Silver		Unknown
5046	Drinking Cup, Silver	Gutmann, Eugen	Holland
5987	Emmy Göring with Frame		Washington, D.C.
5989	Emmy Göring with Frame		Washington, D.C.
5058	Photo Emmy & Child, Gold BG50	Göring	Germany
5050	Frame with photo of Göring	Göring Etzelwang	Germany
5050	Frame, Silver,		Unknown
5050	Frame, Silver,		Unknown
5050	Frame, Silver,		Unknown
5050	Frame, Silver, Photo of Göring	Military Nazi	Wiesbaden
5055	Goblet, Silver	Military Nazi	Wiesbaden
5055	Goblet, Silver	Military Nazi	Wiesbaden
5058	Göring's Daughter, Tin,	Göring, Etzelwang	Germany
5949	Göring's Mother with Glass & Frame		Washington, D.C.
5986	Karin Göring		Washington, D.C.
6830	Landscape	Looted from CCP	Germany
5050	Leucher, Silver	Military Nazi	Wiesbaden
6531	One Sword, Iron Chased Handle	Military Nazi	Wiesbaden
6532	One Sword, Iron Handle	Military Nazi	Wiesbaden
6530	One Sword, Silver Handle	Military Nazi	Wiesbaden
6533	One Sword, Steel	Military Nazi	Wiesbaden
6740	Parade Sword of Göring	Military Nazi	Wiesbaden
5947	Photo Edda Göring		Washington, D.C.
6001	Photo Emmy and Edda		Washington, D.C.
5055	Photo of Göring in Wood Frame	Göring, Etzelwang	Germany
5055	Photo of Hitler in Wood Frame 27	Military Nazi	Wiesbaden
5050	Photo of Mrs. Göring, Leather, Glass	Göring, Etzelwang	Germany
5974	Photo Two Women		Washington, D.C.
5058	Picture of Göring Family BG 20/26	Göring, Etzelwang	Germany
5058	Plaquette BG 20/55	Military Nazi	Wiesbaden
5089	Plate, Mother of Pearls	Rothschild	France
5089	Plate, Silver BG 51/19	Military Nazi	Wiesbaden
5049	Plate, Silver & Amber	Military Nazi	Wiesbaden
5048	Porcelain, 10 Plates, etc. With Göring's Coat of Arms		France
5778	Portrait of a Lady (70 × 88)	Contini, Italy	Germany
5944	Portrait of a Woman Drawing		Washington, D.C.
5988	Portrait of a Man		Washington, D.C.
5090	Set of Porcelain	Göring	Germany
5058	Small Box, Silver & Stones	Military Nazi	Wiesbaden
5089	Small Case for Jewels, Marble & Glass	Military Nazi	Wiesbaden
5055	Small Cup, Silver	Military Nazi	Wiesbaden
5089	Vase BG 51/2	Military Nazi	Wiesbaden
6529	Walking Stick in Shape of Ax	Military Nazi	Wiesbaden

Appendix E

Objets d'Art

Description of Pieces	Dimensions (cm)
4 Gold-washed Female figures; Table Ornament, green stones in bases	60
1 Gold-washed ornament with 4 smaller female figures with green stones	40
1 Gold-washed standing maiden holding tray	68
1 Gold candelabra woman's head with tiara containing amethysts, topaz, etc.	43
1 Candelabra of silver & gold (parts missing)	60
1 Japanese Vase-Silver (?)	35
1 Floor lamp, gold-washed	200
1 Gold box with ivory cover (Nazi eagle on top of box)	9 × 23 × 17
1 Sword, Spanish, Toledo blade, presented to Göring by Spanish air force	116
1 Sword, gold handle, presented to Göring by Mussolini	85
1 Gold-handled ceremonial cane	90
1 Gold-handled sword (Mycenean design)	
1 Gold box, green stone panels, design set with pearls	27 × 15 × 12
1 Green stone case, glass cover — portrait	15 × 16 × 10
1 Leda-Marble medallion in wood-gilded frame	16 × 12
1 Chain with bird	
1 Pewter plate (Swedish) with decorative lion in center	27
1 Brass, highly decorated wall plate	56
1 Silver salver with Bacchic figures (repoussé)	65 × 76
Brass Plate — Scenes with Neptune	63
Pewter plate initialed: "L.S.H." Dated 1741	46
1 Silver stein, with relief decoration	20, 22
1 Silver stein, coat of arms on lid, gold-washed inside	18, 14
2 Gold Cups (1596 German or Dutch)(Coins in the bases of the cups)	28
1 Bronze Cup showing sacrifice of bull	10, 12

235

Description of Pieces	Dimensions (cm)
1 Table Ornament, marble base: Nymph on the back of Triton	40
1 Chalice (17th c. [?], Dutch or German)	40
1 Clock, French, gold-washed, lion-drawn chariot with Ceres & other figures	70 × 25 × 58
1 Jewel box — gold with lapis — figure on top	24
1 Baton with mother of pearl	79
1 St. George — gilded silver (?) with jeweled belt & shield (German)	
1 Silver bowl & lid (circular), heavily engraved Eastern technique	20
1 Pitcher, brass-Triton handle (Medusa head below lip), (Sticker: R. Museo Nazionale, Bibliotica, Florence)	38
1 Pair of candelabra — gold-washed (3 putti and 3 griffins)	30
1 Gold box (glass panels with ancient gold disks & plaques)	27 × 13 × 15
1 Pitcher — gold plated brass with mother of pearl (handle missing)	24
1 Crozier — brass & enamel with stones inset (12th c.?) (Coronation of Mary within the Crook)	34
Bottom Piece: Same material & type of ornament	12
1 Silver-handled sword	97
("Wirberg" on blade of Sword)	101
1 Chalice — brass — elaborate design (German) (3 scenes — lid with Roman soldier on top)	68
1 Relinquary with limoges — enameled scenes on doors (gilded brass figures of Madonna & Angels inside) French 14th Century	23 × 20
1 Relinquary box — brass, gilt & enamel (earlier)	20 × 21
1 Bronze bathing figure (French)	25
1 Bronze lion on marble base (Lombard, Italian)	19
1 Stein — gold-washed (German)(Meleager scene)	40
1 Bronze cup — Early Medieval (Byz.?) (3 gold plaques with griffin & birds, Silver border — stone inlay)	8.5 × 1?
1 Brass breast piece — Silver filigree & stones	27
1 Pitcher, brass — very elaborate, Satyr bandle, Many medallions around bowl-winged grotesque under lip	38
1 Bowl — blackened silver exterior, gold-washed interior, deer in repoussé inside	16, 6
1 Bell (?), thin copper with traces of silver inside and gold wash on outside	15.5
1 Bowl, glass, wine-colored, with many figures of women (19th century Turkish [?])	13, 6
1 Chalice, brass, (over gold wash) (Handle from lid missing)	36
1 Silver fruit bowl, oval, with handles	23, 34 × 60
1 Gold globe of the Zodiac (Venetian-17th century [?])	28
4 Brass wall candelabra, 3 branched, gold-washed (one branch broken)	55
1 Jewel box with gold, lapis, enamel etc. (of possible Cellini excellence in craftsmanship)	36 × 36 × 52
1 Writing box, black lacquer with inlay of shell, silver & gold (French)	9 × 27 × 20
2 Boxes, black lacquer with gilded brass inlay (leg missing from one)(French)	24 × 32 × 11
1 Jewel box (same material as box above)(French)	12 × 15 × 20

Description of Pieces	Dimensions (cm)
1 Jewel box, black lacquer with lapis panel inlays	15 × 39 × 27
1 Door knocker, modern, lion head	24
1 Door knocker, bronze, old	
1 Backgammon board, lacquer with lapis (fragmentary)	33 × 36
1 Framed autographed letter signed by Napoleon	
1 Manuscript signed by Goethe	
Crucifix, brass	
1 Clock in gilded crown	
1 Clock with painting on face	
2 Gold-washed lamps, two nymphs on each	95
1 Silver lamp	108
4 Lampshades	
1 Large pottery lamp base	60
10 Silver frames	
2 Green tooled leather frames (photos of the Göring wives)	
1 Brass box	43 × 6 × 35
1 Rectangular brass tray	16 × 70
2 Silver dishes (Circular)	19 × 19 × 9
1 Silver dish (Oval)	28 × 22 × 11
Glass ashtray	
3 Clear glass vases	
1 Vase with red band (perhaps Bohemian)	
Brandy snifter	
2 Table candelabra of china (in box)	
4 Glasses, gold rimmed	
1 Glass wine pitcher with pewter top	
1 Christmas candelabra (table), wrought iron	40 × 74
1 Wrought iron wall clock	30
23 Colored engravings in frames	33 × 42
2 Pewter candlesticks (Swedish)	40
1 Pewter candlestick (Swedish)	10
1 Pewter candlestick (Swedish)	15
2 Old brass candlesticks	35
5 Table lamps	
4 Wall fixtures (bronze with animal motif)	
1 Ceiling fixture (bronze with animal motif)	
1 Large plain chest containing brocades, velvets and silks	
1 Crate packed with fine porcelain (flower pattern)	
2 Boxes Personal effects (Not Göring's)	
5 Boxes with table candelabra of china	
2 Boxes of china table service: (a) Göring china service (white with red figures and family crest) (b) Crate of Sevres China	

26 Oriental rugs of various dimensions
1 Rug, rolled, large (length 710 cm)
Books from Göring's library
Books from Hitler's library
2 Boxes of books from Prof. Hetzelt's library
Box No. 1 2 Rock Crystal and Gold Candelabra
Box No. 1 1 Rock Crystal Bowl (Large size)
Box No. 1 1 Large Gold Platter with Crystals
Box No. 1 1 Large Gold Platter (engraved)
Box No. 1 1 Medium size Gold Platter (Louis Funk)
Box No. 1 1 Medium size Gold Platter (Butler)
Box No. 1 1 Medium size Gold Platter (Plain)
Box No. 1 1 Silver Platter with engraved Gold Center
Box No. 1 1 Gold Vase (engraved)
Box No. 1 1 Gold Ashtray
Box No. 1 1 Gold Bowl
Box No. 1 1 Perfume Glass with Gold Cover
Box No. 1 1 Glass Vial
Box No. 1 1 Gold Bowl with handles and cover
Box No. 1 2 Statuettes
Box No. 1 1 Silver Bowl
Box No. 1 1 Small square Glass Case
Box No. 1 1 Silver Vase
Box No. 1 1 Glass Bowl
Box No. 1 3 Glass Bowls with Gold Bottom
Box No. 1 1 Glass Jug with Top (Gold-lined)
Box No. 2 1 Silver three-figured Toast Holder
Box No. 2 4 Rock Crystal Bowls (varying sizes)
Box No. 2 2 Three-Figured Gold Statuettes
Box No. 2 1 Large Gold Platter
Box No. 2 1 Box inscribed to Göring from Stockholm
Box No. 2 1 Medium Gold Cup with Cover
Box No. 2 1 Box (replica of cathedral inlaid)
Box No. 2 1 Box Silverware
Box No. 2 1 Large Gold Cup
Box No. 2 5 Rock Crystal and Gold Candelabras
Box No. 2 1 Round Gold Bowl
Box No. 2 1 Silver Platter (large)
Box No. 2 2 Silver Candleholders
Box No. 2 17 Silver Bowls
Box No. 2 1 Box with Cup and Saucer engraved to Göring
Box No. 3 1 Large Golden Plate (Golden Eagles on ends)

DESCRIPTION OF PIECES

Box No. 3 3 Large Gold Bowls
Box No. 3 1 Gold Bowl (engraved)
Box No. 3 2 Silver Platters (oblong shape)
Box No. 3 2 Large Gold Platters
Box No. 3 1 Gold Jewel Box
Box No. 3 2 Gold Clocks
Box No. 3 2 Gold Candelabra
Box No. 3 1 Rock Crystal Candelabra
Box No. 3 1 Large Silver Case (tube)
Box No. 3 1 Medium Silver Case (tube)
Box No. 3 1 Silver Coffee Container
Box No. 3 1 Silver Teakettle
Box No. 3 1 Brass Tobacco Can (Gold inside)
Box No. 3 1 Silver Mug (Corn on top)
Box No. 3 1 Silver Candleholder
Box No. 3 1 Silver Coffee Container Stand
Box No. 3 2 Medium Size Gold Platters
Box No. 3 1 Gold Plate
Box No. 3 1 Silver Plate (Gold designed center)
Box No. 3 1 Eagle's Claw (Silver covered)
Box No. 3 1 Brass Pitcher
Box No. 3 1 Ivory Horn (Cased)
Box No. 3 1 Gold Basket
Box No. 3 1 Silver Platter (large, engraved)
Box No. 3 1 Silver Platter (medium)
Box No. 3 1 Silver Bowl
Box No. 3 1 Gold Platter (small)
Box No. 3 2 Silver Cups (large)
Box No. 4 1 Gold Box (large)
Box No. 4 1 Silver Box (with Eagle & Swastika)
Box No. 4 3 Gold Wastebaskets
Box No. 4 1 Silver container (tube)
Box No. 4 1 Gold Candleholder
Box No. 4 1 Silver Vase (large)
Box No. 4 1 Gold Bowl (large)
Box No. 4 1 Silver Vase (large) inscribed to Hermann Göring Jan. 1933
Box No. 4 2 Silver Bowls (Gold inlaid)
Box No. 4 1 Silver Cup
Box No. 4 1 Silver Platter with inscription to Hermann Göring
Box No. 4 1 Silver Bowl (large)
Box No. 4 1 Silver Basket
Box No. 4 1 Silver Bowl with Silver Spoon (large)

Box No. 4	1 Glass Bowl with Silver Cover
Box No. 4	1 Silver inlaid mug
Box No. 4	1 Silver inlaid Bowl (Deer and Hunter Statuette)
Box No. 4	1 Equestrian Statuette on Marble (broken)
Box No. 4	1 Silver Vase with inlaid Eagle
Box No. 4	1 Silver Vase (Gaueffen)
Box No. 4	1 Silver Cup (large)
Box No. 4	1 Gold Vase with jewel inlaid
Box No. 5	1 Gold Bowl with Animal Standards
Box No. 5	4 Gold Bowls (large)
Box No. 5	9 Silver Candleholders
Box No. 5	1 Gold Bowl (medium)
Box No. 5	2 Silver Vases (large)
Box No. 5	1 Gold round Bowl (large)
Box No. 5	1 Silver Bowl
Box No. 5	1 Silver Container
Box No. 5	1 Box (Book shaped engraved)
Box No. 5	1 Silver Platter (large)
Box No. 5	1 Silver Platter with engraving
Box No. 5	1 Silver Candelabra
Box No. 5	2 Silver Platters
Box No. 5	1 Gold Bowl
Box No. 5	1 Round Silver Platter
Box No. 5	5 Gold Plate Rests
Box No. 6	1 Silver Box
Box No. 6	1 Brass Bucket
Box No. 6	1 Silver Bowl
Box No. 6	1 Silver Coffee Urn (Ivory Handled)
Box No. 6	1 Silver Water Pitcher
Box No. 6	1 Silver Pitcher Gold inlaid (large)
Box No. 6	3 Silver Candleholders
Box No. 6	1 Silver Portrait of Göring
Box No. 6	1 Silver Desk Set
Box No. 6	5 Candelabra (Silver)
Box No. 6	1 Silver Pot (small)
Box No. 6	1 Flat Silver Candleholder
Box No. 6	1 Silver Bowl (small)
Box No. 6	1 Silver Inkwell Container
Box No. 6	4 Silver Mugs with Eagle on top
Box No. 6	2 Silver Candleholders
Box No. 6	1 Silver Mirror
Box No. 6	4 Silver Candelabras

DESCRIPTION OF PIECES

Box No. 6	1 Silver Bowl
Box No. 6	1 Silver Container
Box No. 6	1 Silver Cup with Gold inlaid
Box No. 6	2 Silver Bowls (small)
Box No. 6	1 Silver Cup
Box No. 6	1 Silver Tea Pot
Box No. 6	1 Silver Cup (large)
Box No. 6	2 Silver Bowls
Box No. 6	1 Ink Blotter
Box No. 6	1 Silver Box
Box No. 6	2 Silver Platters (large)
Box No. 6	1 Round Silver Platter
Box No. 6	1 Silver Container (small)
Box No. 6	1 Silver Vase (small)
Box No. 6	1 Silver Atomizer
Box No. 6	3 Round Silver Platters (medium)
Box No. 7	1 Gold Desk Set
Box No. 7	1 Gold Standard for Inkwell
Box No. 7	1 Gold Ornate Box (large)
Box No. 7	1 Gold Box with 8 bands
Box No. 7	1 Gold Box with velvet lining
Box No. 7	1 Centenary Coin in Case
Box No. 7	1 Gold Knife
Box No. 7	1 Photo with decorated frame of little girl
Box No. 7	1 Silver Plate
Box No. 7	1 Silver Platter
Box No. 7	1 Silver Basket
Box No. 7	3 Ivory Containers with Gold top and bottom
Box No. 7	1 Gold Cup with leaf decoration
Box No. 7	1 Photo of Mrs. Göring and child (Gold frame)
Box No. 7	1 Ornate Gold Jewel Box (Meine Falken)
Box No. 7	1 Red Case with Coat of Arms cast
Box No. 7	4 Gold Animal Stands
Box No. 7	1 Painting with Animal figures
Box No. 7	1 Silver Vase
Box No. 7	1 Silver Cup with wolf's head
Box No. 7	1 Silver Cream Container
Box No. 7	1 Gold Ice Bucket with 3 deer heads
Box No. 7	1 Silver Pitcher
Box No. 7	1 Gold 5 Glass Holder Stand
Box No. 7	2 Silver Kettles
Box No. 7	2 Gold Cups with engraving

Box No. 7 1 Silver Gravy Bowl
Box No. 7 1 Cream Pitcher (Gold, small)
Box No. 7 2 Glass Vials
Box No. 7 1 Gold Jewel Box
Box No. 7 1 Gold Pitcher (large)
Box No. 7 1 Gold Ornate Mug
Box No. 7 1 Gold Container with Crystal
Box No. 7 1 Gold Bowl
Box No. 7 1 Gold Platter with Stand
Box No. 7 1 Silver Platter
Box No. 7 1 Gold Bowl (medium)
Box No. 7 1 Gold Bowl with orchestra players
Box No. 7 1 Gold Bowl with coin decorations
Box No. 7 1 Gold Cup (small)
Box No. 7 1 Gold Kettle with Ivory handle
Box No. 7 1 Gold Container with crystal top
Box No. 7 2 Gold Bowls with Ornate Design
Box No. 7 2 Gold Tops
Box No. 7 1 Gold Pitcher
Box No. 7 1 Photo of Göring, Wife and Child (Gold frame)
Box No. 7 1 Gold Container with Stone Base
Box No. 7 2 Gold Ornate light stands
Box No. 7 3 Gold Candlesticks with 5 musical figures
Box No. 7 1 Gold Clock
Box No. 7 1 Silver Book with Signatures of German Cabinet
Box No. 8 1 Gold Water Pitcher Ornately Designed
Box No. 8 2 Silver Kettle with Ivory Handle and Stand
Box No. 8 1 Small Silver Kettle with Ivory Handle
Box No. 8 1 Silver Kettle
Box No. 8 1 Silver Coffee Pot (large)
Box No. 8 1 Silver Water Pitcher (large)
Box No. 8 1 Portrait of Adolf Hitler
Box No. 8 1 Portrait of Hermann Göring
Box No. 8 8 Gold Forks
Box No. 8 3 Gold Knives
Box No. 8 1 Gold Butter Knife
Box No. 8 1 Silver Box with Ivory Stands
Box No. 8 1 Gold Dipper
Box No. 8 2 Silver Cups (inscribed to Edda)
Box No. 8 1 Silver Bowl (medium)
Box No. 8 1 Gold Serving Spoon
Box No. 8 1 Gold Cake Knife

DESCRIPTION OF PIECES	DIMENSIONS (CM)
Box No. 8 6 Silver Platters Ornately designed	
Box No. 8 5 Silver Butter Knives	
Box No. 8 1 Gold Horse with Marble Base	
Box No. 8 26 Silver Plates ornately designed	
Box No. 8 2 Silver Stands	
Box No. 8 2 Silver Cup Covers	
Box No. 8 1 Silver Lamp (small)	
Box No. 8 1 Silver Bowl with Ivory Handle	
Box No. 8 1 Silver Bowl	
Box No. 8 1 Silver Platter	
Box No. 8 1 Silver Plate with Coat of Arms (medium)	
Box No. 8 1 Silver Plate with Coat of Arms (small)	
Box No. 8 1 Silver Cigarette Container	
Box No. 8 1 Gold Box	
Box No. 8 1 Silver Box with velvet lining	
Box No. 8 1 Silver Box	
Box No. 8 9 Silver Forks	
Box No. 8 6 Silver Knives	
Box No. 8 2 Silver Bowls	
Box No. 8 2 Silver Cups with engraving	
Box No. 8 1 Green Velvet Box	
Box No. 8 2 Gold Containers	
Box No. 8 1 Ivory Container with Gold Top and Bottom	
Box No. 8 1 Glass Mug, ornate, of Silver	
Box No. 8 1 Silver Box with Coat of Arms	
Box No. 8 1 Silver Container	
Box No. 8 7 Silver Cups (plain)	
Box No. 8 9 Silver Cups with Coat of Arms engraved	
Box No. 8 5 Silver Cups with handles	
Box No. 8 2 Silver Cups with overlay design	
Box No. 8 1 Silver Boot Lacer	
Box No. 8 1 Silver Cup with 3 star Emblem	
Box No. 8 1 Silver Cup with Swastika	
Box No. 8 1 Silver Cup inlaid with Gold	
Box No. 8 1 Silver Cup with Wreath Design	
Box No. 8 1 Silver Cup with handle (Edda engraved)	
Box No. 8 1 Silver Bowl with Top	
Box No. 8 1 Gold Cup with leaf design	
Box No. 8 1 Large Silver Cup	
Box No. 9 Quantmeyer 4809F	370 × 387
Box No. 9 Rug	480 × 112
Box No. 9 Rug	205 × 108

Description of Pieces		Dimensions (cm) / additional information
Box No. 9	Tapestry	370 × 387
Box No. 10	Karaback	550 × 112
Box No. 10	Beschier	125 × 100
Box No. 10	Tulvis	412 × 325
Box No. 10	Rug	316 × 246
Box No. 11	Rug	647 × 309
Box No. 11	1 Large Rug	no dimensions given
Box No. 12	1 Flask	
Box No. 12	1 Pitcher with Gold Edge	
Box No. 12	29 Large Water Glasses with Gold Edges	
Box No. 12	10 Champagne Glasses with Gold Edges	
Box No. 12	8 Medium Glasses with Gold Edges	
Box No. 12	9 Dressing Dishes with Gold Edges	
Box No. 12	7 Small Wine Glasses with Gold Edges	
Box No. 13	11 Candleholders	Bthdy 50 W Coat of Arms
Box No. 13	9 Sugar Bowls	Bthdy 50 W Coat of Arms
Box No. 13	32 Salt Dishes, Tiny	Bthdy 50 W Coat of Arms
Box No. 13	21 Knife Resters	Bthdy 50 W Coat of Arms
Box No. 13	7 Cake Plates, Large	Bthdy 50 W Coat of Arms
Box No. 13	2 Flower Dishes	Bthdy 50 W Coat of Arms
Box No. 13	6 Sugar Bowl Spoons	Bthdy 50 W Coat of Arms
Box No. 13	9 Ashtrays	Bthdy 50 W Coat of Arms
Box No. 13	4 Porcelain teatrays	Bthdy 50 W Coat of Arms
Box No. 13	18 Finger Bowls	Bthdy 50 W Coat of Arms
Box No. 13	10 Small Plates	Bthdy 50 W Coat of Arms
Box No. 13	4 Large Serving Dishes	Bthdy 50 W Coat of Arms
Box No. 13	5 Casserole Bowls	Bthdy 50 W Coat of Arms
Box No. 13	2 Serving Dishes	Bthdy 50 W Coat of Arms
Box No. 13	8 Small Dishes	Bthdy 50 W Coat of Arms
Box No. 13	1 Gravy Dish	Bthdy 50 W Coat of Arms
Box No. 13	12 Saucers	Bthdy 50 W Coat of Arms
Box No. 13	1 Small Platter	Bthdy 50 W Coat of Arms
Box No. 13	1 Gravy Dish	Bthdy 50 W Coat of Arms
Box No. 13	7 Large Plates	Swastika & Crossed Batons
Box No. 13	4 Larger Plates	Swastika & Crossed Batons
Box No. 13	1 Medium Platter	Swastika & Crossed Batons
Box No. 13	30 Plates	Swastika & Crossed Batons
Box No. 13	36 Soup Plates	Swastika & Crossed Batons
Box No. 13	5 Vegetable Dishes	Swastika & Crossed Batons
Box No. 13	6 Large Flat Plates	Swastika & Crossed Batons
Box No. 13	2 Gravy Dishes	Swastika & Crossed Batons
Box No. 13	22 Medium Plates	Swastika & Crossed Batons

Description of Pieces		Additional information
Box No. 13	8 Servers Plates	
Box No. 13	7 Small Servers Dishes	
Box No. 13	1 Creamer, White Porcelain, Flower Design	
Box No. 14	61 Small Plates	
Box No. 14	4 Large Plates	
Box No. 14	64 Medium Plates	
Box No. 14	16 Saucers	
Box No. 14	4 Bowls	
Box No. 14	6 Large Platters	
Box No. 14	9 Extra Large Platters	
Box No. 14	6 Square Bowls	
Box No. 15	6 Large Plate Covers	
Box No. 15	8 Tiny Bowls	
Box No. 15	6 Oblong Containers	
Box No. 15	4 Candleholders	
Box No. 15	2 Large Soup Bowls	
Box No. 15	6 Small Bowls	
Box No. 15	5 Coffee Pitchers	
Box No. 16	5 Saucers and Plates (1 piece sets)	Engraved K.P.M.
Box No. 16	4 Large Platters	Engraved K.P.M.
Box No. 16	4 Large Round Platters	Engraved K.P.M.
Box No. 16	3 Very Large Platters	Engraved K.P.M.
Box No. 17	4 Large Bowls	Engraved K.P.M.
Box No. 17	5 Vegetable Plates	Engraved K.P.M.
Box No. 17	21 Medium Plates	Engraved K.P.M.
Box No. 17	3 Large Platters	Engraved K.P.M.
Box No. 17	2 Large Round Platters	Engraved K.P.M.
Box No. 17	9 Large Round Platters (different sizes)	Engraved K.P.M.
Box No. 17	2 Medium Round Plates	Engraved K.P.M.
Box No. 17	2 Small Plates	Engraved K.P.M.
Box No. 17	1 Saucer and Plate (1 piece)	Engraved K.P.M.
Box No. 17	1 Large Teapot	Engraved K.P.M.
Box No. 17	19 Cups	Engraved K.P.M.
Box No. 17	10 Sugar Bowls with Covers	Engraved K.P.M.
Box No. 17	3 Cream Pitchers	Engraved K.P.M.
Box No. 17	1 Large Teapot	Engraved K.P.M.
Box No. 17	3 Syrup Pitchers	Engraved K.P.M.
Box No. 17	2 Cream Pitchers (small)	Engraved K.P.M.
Box No. 17	3 Small Dressing Dishes	Engraved K.P.M.
Box No. 17	1 Small Dessert Dish	Engraved K.P.M.
Box No. 18	47 Small Saucers	Engraved K.P.M.
Box No. 18	47 Small Cups	Engraved K.P.M.

DESCRIPTION OF PIECES	ADDITIONAL INFORMATION
Box No. 18 4 Large Spoons	Engraved K.P.M.
Box No. 18 6 Ordinary Cups	Engraved K.P.M.
Box No. 18 20 Small Dressing Cups	Engraved K.P.M.
Box No. 18 10 Small Saucers	Engraved K.P.M.
Box No. 18 38 Dressing Bowls	Engraved K.P.M.
Box No. 18 1 Large Soup Bowl	Engraved K.P.M.
Box No. 18 4 Medium Bowls	Engraved K.P.M.
Box No. 18 1 Round Vegetable Bowl	Engraved K.P.M.
Box No. 18 7 Ashtrays	Engraved K.P.M.
Box No. 18 3 Round Bowls	Engraved K.P.M.
Box No. 18 1 Small Cream Pitcher	Engraved K.P.M.
Box No. 18 12 Sugar Bowls with Covers	Engraved K.P.M.
Box No. 18 3 Sugar Bowls with Handles and Covers	Engraved K.P.M.
Box No. 18 1 Pickle Dish	Engraved K.P.M.
Box No. 18 1 Sugar Bowl Top	Engraved K.P.M.
Box No. 19 36 Medium Plates	Engraved K.P.M.
Box No. 19 1 Small Plate	Engraved K.P.M.
Box No. 19 1 Large Plate	Engraved K.P.M.
Box No. 19 46 Saucers (medium)	Engraved K.P.M.
Box No. 19 5 Ashtrays	Engraved K.P.M.
Box No. 19 61 Pickle Dishes	Engraved K.P.M.
Box No. 19 26 Dressing Saucers	Engraved K.P.M.
Box No. 19 46 Small Plates	Engraved K.P.M.
Box No. 19 2 Saucers and Plate Sets	Engraved K.P.M.
Box No. 19 1 Sugar Bowl without Cover	Engraved K.P.M.
Box No. 20 1 Large Jar	
Box No. 20 12 Dressing Saucers with Flat Handle	
Box No. 20 28 Large Water Glasses	
Box No. 20 8 Large Champagne Glasses (round)	
Box No. 20 10 Medium Wine Glasses	
Box No. 20 10 Small Wine Glasses	
Box No. 20 1 Water Glass with Gold Base	
Box No. 21 92 Bordeaux Glasses, Engraved, with Gold Edges	
Box No. 22 1 Flask	
Box No. 22 1 Pitcher with Gold Edge	
Box No. 22 30 Large Water Glasses with Gold Edges	
Box No. 22 12 Small Wine Glasses with Gold Edges	
Box No. 22 13 Dressing Dishes with Gold Edges	
Box No. 22 12 Medium Glasses with Gold Edges	
Box No. 22 12 Champagne Glasses with Gold Edges	

TOTAL 1950

Appendix F

CORRESPONDENCE REGARDING THE REPORTED FINDING
OF THE MISSING RENDERS COLLECTION
MEMLING PAINTING *MADONNA AND CHILD*

Dear Elie Loos
Consul
Embassy of Belgium
3330 Garfield Street
NW Washington DC 20008

I have continued to research this valuable painting. According to original records from Vroege Nederlandse Schilderkunst, the painting was sold through Cramer in 1976 to Dr. Robert Courbier, Marselles. I wrote to Cramer, The Hague, Netherlands, and as you can see below (A), they denied this was true. And in (B) the Vroege Nederlandse Schilderkunst admitted that indeed a mistake had been made.

(A) I just saw your message with the photograph of Memling's painting "Maria with Child." I can tell you that we NEVER had this painting. Mr. Cramer had a catalogue XX 1975–1976 and there was not the painting you mentioned. I am his assistant since October 1, 1977. I got this on via my brother, who was at that time Director of the F. VAN LANSCHOT Bank in The Hague. and who was in the same Rotary-CLub as Hans Cramer. Now Mr. Cramer has retired. He is over 90 years.

I hope I could help you a little bit. With best wishes, Marie-José Berger

(B) Dear Mr Alford,

Thank you for your email. The information indeed is incorrect. According to Jean-Luc Pypaert, who published a catalogue of pastiches and heavily restored paintings by the Belgian restorer Jef Van der Veken in Autour de la Madeleine Renders ... Brussels 2008, p. 239, Cat. 139, the painting has been offered to Cramer in the Groeningemuseum in Bruges around 1976 but Cramer refused.

This publication might be interesting for you as it also contains an article by Jacques Lust on Emile Renders who sold his collection to Göring. It is however only published in French.

Best wishes, Suzanne Laemers
Conservator Vroege Nederlandse Schilderkunst/Curator of Early Netherlandish
Painting

From: Loos Elie — Belgium — Washington
Sent: Wednesday, March 23, 2011 12:19 P.M.
Subject: Madonna and Child
Dear Mr Alford,
 Please find herewith the information collected through the Museums of Bruges (curator of XVth century art, Mr Till-Holger Borchert) and through Belgian Federal Science Policy Office (Cases of Restitution, Mr Jacques Lust).
 Indeed a few of the paintings by Memling are the property of the Belgian State, all coming from the collection of the collector/merchant/writer Emile Renders from Brussels/ Bruges, who had sold (so not stolen) his collection to Herman Göring during the German occupation. In the framework of the western allied policy on restitution, the paintings belonging to the Göring collecting in Berchtesgaden were returned to Belgium. The paintings belonging to this collection, that could be recovered, are property of the Belgian State and were dispatched to several museums such as Bruges, Antwerp, Tournai. Not all of the paintings of the Renders' collection were recovered after World War II and were considered as missing. Some of the paintings appeared later on the art market. In a few cases the Belgian State sold them or distanced itself (unofficially) from the claim. The Belgian State is treating this case by case, taking into account the law and the practicability of the question of restitution.
 Among the paintings is a small devotional painting by Memling, Madonna and child in an interior — see picture enclosed — that belonged for a long time to a French private collection in Marseille. The owner died recently and as a consequence the painting ended up on the art market again. Now it seems that this painting — as so many others out of the Renders' collection — was particularly well restored by Jozef van der Veken. Van der Veken was active during the antebellum period and was considered an expert in the art of Flemish Primitive painting. He was a very talented restorer. Sometimes he restored (or corrected) so thoroughly that the works can only be considered as falsifications according to current standards. Mr Borchert made a study of this painting a few months ago in Paris. It is included in a publication by the IRPA-KIK about Emile Renders, under the leadership of Dominique Vanwijnsberghe.
 Elie Loos
 Consul
 Embassy of Belgium
 3330 Garfield Street
 NW Washington DC 20008

[This author's reply follows:]

I was most hopeful that the country of Belgium would help me with my project. After several months of patience on my part, I receive two paragraphs of worthless information. What was the conclusion of Mr. Borchert's study? Venken did not make restorations on the Memling, Madonna and Child, after it was acquired by Göring.

[On J. van der Veken, 5 rue Andre Fauchille, Brussels, this author wrote:]

He lived in Brussels and was a well known art Belgian restorer and worked many years with Renders. Hofer had great respect and admiration for his work. Hofer's wife had spent some time in his shop studying his techniques. He sold some paintings on a commission from Belgians who did not want to make direct contact with the German buyers. Payments were made direct to him in reichsmarks. In a December 18, 1942 letter, Veken informed Hofer that in 1940 he was sent by the Belgium Government to Pau, France where he was in charge of the restoration of van Eyck Ghent Altarpiece. He informed Hofer that the artwork was now in Munich, Germany and he requested Hofer's help in relocating him to Munich so he could continue his restoration of van Eyck as he further wrote; "van Eyck has remained my hobby and I go on dreaming about him."

I am most disappointed with these results of the Embassy of Belgium.

Kenneth D. Alford

Richmond VA

Chapter Notes

Preface

1. S. Lane Faison, Jr., Consolidation Interrogation Report No. 4, Linz: Hitler's Museum and Library, December 15, 1945, The National Art Gallery, Washington, D.C.

Chapter 1

Much of Chapter 1 is from an Interim Report on the Activities of Hermann Göring, Source X-2, June 12, 1945; National Archives, College Park, Md. This chapter could have been obtained from many sources; however, this public domain Interim Report from which it was edited contained sufficient historical information.

1. Leonard Mosley, *The Reich Marshal* (New York: Doubleday, 1974), pp. 11–13.
2. From Göring's official war records, U.S. Army Military History Institute, Carlisle, Pa.
3. Carin Kantzow (Göring), Letter of December 20, 1920, U.S. Army Military History Institute, Carlisle, Pa.
4. Carin Göring, Letters of November 13 and November 21, 1923, U.S. Army Military History Institute, Carlisle, Pa.
5. Carin Göring, Letters of May 25 and July 27, 1924, U.S. Army Military History Institute, Carlisle, Pa.
6. Carin Göring, Letter of October 1, 1924, U.S. Army Military History Institute, Carlisle, Pa. The underlines are in the original letters.
7. Carin Göring, Letters of January 17 and February 17, 1925, U.S. Army Military History Institute, Carlisle, Pa.
8. Mosley, *The Reich Marshal*, p. 105.
9. Mosley, *The Reich Marshal*, p. 112.
10. E.E. Minskoff, Interrogation of Emmy Sonnemann Göring, September 15, 1945.
11. Emmy Göring, *My Life with Göring* (London: David Bruce & Watson, 1972).
12. Mosley, *The Reich Marshal*, p. 161.
14. Göring, *My Life with Göring*.

Chapter 2

1. Theodore Rousseau, Consolidation Interrogation Report No. 2, The Göring Collection, September 15, 1945, The National Art Gallery, Washington, D.C., pp. 2–5.
2. Fritz Thyssen, *I Paid Hitler* (New York: Farrar & Rinehart, 1941). Thyssen and his wife were imprisoned for the remainder of the war. Göring stated he had taken the side of Thyssen and arranged for Thyssen and his wife to be committed to a sanatorium. Because of his notable service to the Nazi Party, he and his wife were given favorable treatment, survived the war, and relocated to Argentina after liberation.
3. Theodore Rousseau, Jr., Detail Interrogation Report No. 9, September 15, 1945.

Chapter 3

1. Theodore Rousseau, Detail Interrogation Report No. 9, September 15, 1945, p. 5.
2. Eldon J. Cassoday, Interrogation of Hofer, September 28, 1945.
3. Theodore Rousseau, Detail Interrogation Report No. 9, September 15, 1945.
4. Theodore Rousseau, Consolidation Interrogation Report No. 2, The Göring Collection, September 15, 1945, The National Art Gallery, Washington, D.C.
5. Theodore Rousseau, Detail Interrogation Report No. 9, September 15, 1945.
6. Herbert S. Leonard, Interrogation of Hermann Göring, August 30, 1946.
7. Theodore Rousseau, Detail Interrogation Report No. 7, September 15, 1945.
8. Eldon J. Cassoday, Interrogation of Christa Gormanns, September 16, 1945.
9. Eldon J. Cassoday, Interrogation of Christa Gormanns, September 16, 1945.
10. E.E. Minskoff, Interrogation of Emmy Sonnemann Göring, September 15, 1945.
11. Captain Jean Vlug, Kajetan Muehlmann and the Dienststelle Muehlmann, December 25, 1945.

Chapter 4

1. E.E. Minskoff, Josef Angerer, January 8, 1946.
2. Theodore Rousseau, Consolidation Interrogation Report No. 2, The Göring Collection, September 15, 1945, The National Art Gallery, Washington, D.C.
3. Theodore Rousseau, Consolidation Interrogation Report No. 2, The Göring Collection, September 15, 1945, The National Art Gallery, Washington, D.C.
4. J.S. Plaut, Detail Interrogation Report No. 6, August 15, 1945, and Theodore Rousseau, Consolidation Interrogation Report No. 2, The Göring Collection, September 15, 1945, The National Art Gallery, Washington, D.C.
5. J.S. Plaut, Detail Interrogation Report No. 6, August 15, 1945.
6. Interrogation of Mrs. Elise Posse, December 7, 1945.
7. Interrogation of Mrs. Elise Posse, December 7, 1945.
8. Interrogation of Mrs. Elise Posse, December 7, 1945.
9. These quotes are from Dr. Friedrich Wolffhardt's diary, April 24, 1943. He was Hitler's expert for the Linz Library. They quotes are from Mrs. Kormann, the wife of the son of Marianna Voss. The diary is in the National Archives.
10. S.L. Faison, Jr., Detail Interrogation Report No. 12, September 15, 1945.
11. S.L. Faison, Jr., Detail Interrogation Report No. 12, September 15, 1945, Statement of Dr. Voss, Attachment 2.
12. S.L. Faison, Jr., Detail Interrogation Report No. 12, September 15, 1945: Statement of Dr. Voss, Attachment 2.
13. Theodore Rousseau, Detail Interrogation Report No. 13, May 1, 1946.
14. S. Lane Faison, Jr., Consolidation Interrogation Report No. 4, Linz: Hitler's Museum and Library, December 15, 1945, The National Art Gallery, Washington, D.C.
15. Theodore Rousseau, Consolidation Interrogation Report No. 2, The Göring Collection, September 15, 1945, The National Art Gallery, Washington, D.C.
16. Bernard Taper, Detail Interrogation Report, September 18, 1946.
17. Bernard Taper, Detail Interrogation Report, September 18, 1946.

Chapter 5

1. S. Lane Faison, Jr., OSS Report Number 4, 1945.
2. S. Lane Faison, Jr., OSS Report Number 4, 1945.
3. S. Lane Faison, Jr., OSS Report Number 4, 1945.
4. S. Lane Faison, Jr., OSS Report Number 4, 1945 supplement page 3, Czerin-Morzin's receipt: November 20, 1940, "Ich bitte meinen aufrichigsten dank entgegennehmen zu wollen...."
5. S. Lane Faison, Jr., OSS Report Number 4, 1945.
6. Various news stories and S. Lane Faison, OSS Report Number 4, 1945.

Chapter 6

1. S. Lane Faison, Jr., OSS Report Number 4, Attachment 5, 1945.

Chapter 7

1. Robert Scholtz, Report on progress and status of Works of Einsatzstab Rosenberg, February 1941.
2. Interrogation of Hermann Göring, Special Detention Center Ashcan, July 21, 1945.
3. J.S. Plaut, Consolidation Interrogation Report No. 1, Activity of Einsatzstab Rosenberg in France, August 15,1945.
4. J.S. Plaut, Consolidation Interrogation Report No. 1, Activity of Einsatzstab Rosenberg in France, August 15, 1945.
5. Theodore Rousseau, Consolidation Interrogation Report No. 2, The Göring Collection, September 15, 1945, Attachment 1, The National Art Gallery, Washington, D.C.
6. Antony Beevor and Artemis Cooper, *Paris After the Liberation 1944–1949* (New York: Doubleday, 1994).
7. Rosenberg, To the Reichsmarschall des Grossdeutschen Reichs, June 8, 1942.
8. Theodore Rousseau, Consolidation Interrogation Report No. 2, The Göring Collection, September 15, 1945, The National Art Gallery, Washington, D.C.
9. Martin Bormann, letter to Dr. Friedrich Wolffhardt, August 21, 1941.
10. J.S. Plaut, Consolidation Interrogation Report No. 1, Activity of Einsatzstab Rosenberg in France, August 15, 1945.
11. J.S. Plaut, Consolidation Interrogation Report No. 1, Activity of Einsatzstab Rosenberg in France, August 15, 1945.
12. S. Lane Faison, Jr., OSS Report Number 4, December 15, 1945.
13. S. Lane Faison, Jr., OSS Report Number 4, Attachment 86, December 15, 1945.
14. Devisionschutzkommando, To the Military Commander in France, May 5, 1941.
15. K. Herman, To Reichsmarschall Göring, attention Miss Limberger, October 16, 1943.
16. Office of Military Government, Ralph Albrecht, July 15, 1947.

Chapter 8

1. Theodore Rousseau, Consolidation Interrogation Report No. 2, The Göring Collection, September 15, 1945, The National Art Gallery, Washington, D.C.
2. Lieutenant J.S. Plaut, OSS Report Number 1, August 15, 1945.
3. Hofer, letter to Boitel, January 21, 1944.
4. Special Report of the firm of Wildenstein & Cie, Paris art dealers. The information on which the following report is based had been obtained partly from original documents and partly by interrogations of some persons most closely concerned. The interrogations were carried out a special X art Interrogation Center in August 1945. No date report from Wiesbaden Collection Point, National Archives, Suitland, Md.
5. Special Report of the firm of Wildenstein & Cie, Paris art dealers. The information on which the following report is based had been obtained partly from original documents and partly by interrogations of some persons most closely concerned. The interrogations were carried out a special X art Interrogation Center in August 1945, No date report from Wiesbaden Collection Point, National Archives, Suitland, Md.
6. Dr. Bruno Lohse, June 15, 1943.
7. Bernard Taper, Detail Interrogation Report, September 18, 1946.
8. Theodore Rousseau, Consolidation Interrogation Report No. 2, The Göring Collection, September 15, 1945, The National Art Gallery, Washington, D.C.
9. Testimony of Hermann Göring by Colonel John H. Amen, October 7, 1945.
10. Theodore Rousseau, Consolidation Interrogation Report No. 2, The Göring Collection, September 15, 1945, The National Art Gallery, Washington, D.C.; Hofer, Letter to Bunjes, January 21, 1944.

Chapter 9

1. Theodore Rousseau, Consolidation Interrogation Report No. 2, The Göring Collection, September 15, 1945, The National Art Gallery, Washington, D.C.
2. Theodore Rousseau, Consolidation Interrogation Report No. 2, The Göring Collection, September 15, 1945, The National Art Gallery, Washington, D.C.
3. S. Lane Faison, Jr., Consolidation Interrogation Report No. 4, Linz: Hitler's Museum and Library, December 15, 1945, The National Art Gallery, Washington, D.C.
4. S. Lane Faison, Jr., Consolidation Interrogation Report No. 4, Linz: Hitler's Museum and Library, December 15, 1945, The National Art Gallery, Washington, D.C.
5. Captain Jean Vlug, Kajetan Muehlmann and the Dienststelle Muehlmann, December 25, 1945.

6. Theodore Rousseau, Consolidation Interrogation Report No. 2, The Göring Collection, September 15, 1945, The National Art Gallery, Washington, D.C.

Chapter 10

1. Theodore Rousseau, Consolidation Interrogation Report No. 2, The Göring Collection, September 15, 1945, The National Art Gallery, Washington, D.C.
2. Dr. Arthur Wiederkehr, letter to Walter Andres Hofer, September 29, 1944.
3. Captain Jean Vlug, Kajetan Mühlmann and the Dienststelle Muehlmann, December 25, 1945.
4. Captain Jean Vlug, Detail Interrogation Report No. 1, Kajetan Mühlmann and the Dienststelle Muehlmann, pp. 111–113, 120, December 25, 1945.
5. Theodore Rousseau, Consolidation Interrogation Report No. 2, The Göring Collection, September 15, 1945, The National Art Gallery, Washington, D.C.
6. Theodore Rousseau, Consolidation Interrogation Report No. 2, The Göring Collection, September 15, 1945, The National Art Gallery, Washington, D.C.
7. E.E. Minskoff, Interrogation of Walter Andreas Hofer, December 12, 1945.
8. Theodore Rousseau, Consolidation Interrogation Report No. 2, The Göring Collection, September 15, 1945, The National Art Gallery, Washington, D.C.
9. Lynn Nicholas, *The Rape of Europa* (New York: Alfred A. Knopf, 1994).
10. E.E. Minskoff, Interrogation of Walter Hofer, December 12, 1945.
11. Eldon J. Cassoday, Interrogation of Hofer, September 28, 1945. Major E.K. Waterhouse, MFA&A Canadian Army, The Goudstikker Firm, No date, estimate summer, 1945.
12. Theodore Rousseau, Consolidation Interrogation Report No. 2, page 73, The Göring Collection, September 15, 1945, The National Art Gallery, Washington, D.C.

Chapter 11

1. Theodore Rousseau, Consolidation Interrogation Report No. 2, The Göring Collection, September 15, 1945, page 93, The National Art Gallery, Washington, D.C.
2. Walter Hofer, letter to Reichsmarschall, July 14, 1943.
3. Theodore Rousseau, Consolidation Interrogation Report No. 2, The Göring Collection, September 15, 1945, The National Art Gallery, Washington, D.C.
4. Lieutenant F.S.E. Baudouin, Collection van Gelder, Brussels, August 10, 1948.
5. Ernst Buchner, "The Ghent Altarpiece," July 16, 1945.

Chapter 12

1. Theodore Rousseau, Consolidation Interrogation Report No. 2, The Göring Collection, September 15, 1945, The National Art Gallery, Washington, D.C.
2. Captain Gilbert S. Meldrum, Case No. SSN-1035-P, April 27, 1945.
3. Captain Gilbert S. Meldrum, Case No. SSN-1035-P, April 27, 1945.
4. E.E. Minskoff, Interrogation of Emmy Sonnemann Göring, September 15, 1945.
5. Interrogation of Mrs. Elise Posse, December 7, 1945.
6. Mosley, *The Reich Marshal* p. 112.
7. Major H.H. Stearns, Interrogation of Prince Philip of Hessen, July 1945.
8. Walter Hofer, letter to State Police, June 6, 1944.
9. Theodore Rousseau, Consolidation Interrogation Report No. 2, The Göring Collection, September 15, 1945, The National Art Gallery, Washington, D.C.

Chapter 13

1. Captain Gilbert S. Meldrum, Case No. SSN-1035-P, April 27, 1945.
2. Captain Gilbert S. Meldrum, Case No. SSN-1035-P, April 27, 1945.
3. Captain Gilbert S. Meldrum, Case No. SSN-1035-P, April 27, 1945.
4. Captain Gilbert S. Meldrum, Case No. SSN-1035-P, April 27, 1945.
5. Theodore Rousseau, Consolidation Interrogation Report No. 2, The Göring Collection, September 15, 1945, The National Art Gallery, Washington, D.C.
6. Lieutenant Frederick Hartt, Investigation of Josef Angerer, March 13, 1945.

7. Theodore Rousseau, Consolidation Interrogation Report No. 2, The Göring Collection, September 15, 1945, The National Art Gallery, Washington, D.C.
8. Lieutenant Colonel J.B. Ward Perkins, Pictures from Vipiteno given to Göring by Mussolini, September 18, 1945.
9. Theodore Rousseau, Consolidation Interrogation Report No. 2, The Göring Collection, September 15, 1945, The National Art Gallery, Washington, D.C.
10. Europaischer Kulturdienst, February 3, 1941.
11. Herbert Stuart Leonard, Interrogation of Hermann Göring, August 30, 1946.

Chapter 14

1. Herbert S. Leonard, Interrogation of Hermann Göring, August 30, 1946.
2. Eldon J. Cassoday, Interrogation of Karl Haberstock, September 27, 1945.
3. Theodore Rousseau, Consolidation Interrogation Report No. 2, The Göring Collection, September 15, 1945, The National Art Gallery, Washington, D.C.

Chapter 15

1. Bernard Taper, Detail Interrogation Report, September 18, 1946.
2. Theodore Rousseau, Consolidation Interrogation Report No. 2, The Göring Collection, September 15, 1945, The National Art Gallery, Washington, D.C.
3. Theodore Rousseau, Consolidation Interrogation Report No. 2, The Göring Collection, September 15, 1945, The National Art Gallery, Washington, D.C.
4. Walter Hofer, letter to Dr. F.C. Valentine, February 26, 1943.
5. Theodore Rousseau, Consolidation Interrogation Report No. 2, The Göring Collection, September 15, 1945, The National Art Gallery, Washington, D.C.
6. Bernard Taper, Detail Interrogation Report, September 18, 1946.

Chapter 16

1. Testimony of Hermann Göring by Colonel John H. Amen, October 8, 1945.
2. Testimony of Hermann Göring by Colonel John H. Amen, October 8, 1945.
3. Theodore Rousseau, Consolidation Interrogation Report No. 2, The Göring Collection, September 15, 1945, page 24, The National Art Gallery, Washington, D.C.
4. Henry Schneider, Interrogation of Otto Ohlendorf, December 14, 1945.
5. Dr. Kurt Ephardt, May 1, 1946, Declaration of Property.

Chapter 17

1. Bernard Taper and Edgar Breitenbach, The looting of the Göring Train, no date, August 1947.
2. Theodore Rousseau, Consolidation Interrogation Report No. 2, The Göring Collection, September 15, 1945, p. 24, The National Art Gallery, Washington, D.C.
3. Eldon J. Cassoday, Interrogation of Christa Gormanns, September 16, 1945.
4. Consolidation Interrogation Report No. 2, The Göring Collection, Theodore Rousseau, September 15, 1945.
5. W.A. Hofer, Tapestries from Göring Property, January 14, 1946.
6. E.E. Minskoff, Interrogation of Emmy Sonnemann Göring, September 18, 1945.
7. Eldon J. Cassoday, Interrogation of Christa Gormanns, September 16, 1945.
8. Eldon J. Cassoday, Interrogation of Christa Gormanns, September 16, 1945.
9. Eric W. Warburg, Enemy Intelligence Summaries, June ?, 1945.
10. George Allen, Hermann Göring, Guard's eye view, July 25, 1945.
11. Eldon J. Cassoday, Interrogation of Mrs. Kiurina, September 16, 1945.
12. Lieutenant Colonel L.J. Shurtleff, Interrogation, September 15, 1945.
13. Headquarters Seventh Army, Appendix Number 1, Franz Schulz, no date.
14. As remembered by General Franz Schulz, Headquarters Seventh Army, Appendix Number 1, Franz Schulz, no date.
15. Eldon J. Cassoday, Interrogation of Christa Gormanns, September 16, 1945.
16. Eric W. Warburg, Enemy Intelligence Summaries, June ?, 1945.

17. Seventh Army Interrogation Center, May 19, 1945.
18. Eldon J. Cassoday, Interrogation of Christa Gormanns, September 16, 1945.
19. E.E. Minskoff, Interrogation of Emmy Sonnemann Göring, September 18, 1945.
20. Headquarters Seventh Army, Appendix Number 1, Franz Schulz, no date.
21. Bernard Taper and Edgar Breitenbach, The looting of the Göring Train, no date, August 1947.
22. Bernard Taper and Edgar Breitenbach, The looting of the Göring Train, no date, August 1947.
23. Thomas M. Johnson, *World War II German Booty, Volume II* (Columbia, SC: Thomas M. Johnson, 1984), pp. 45–47.
24. Colonel Graham W. Lester investigation concerning removal of Göring's medallion and baton, June 16, 1947, and personal interviews with collectors by the author.
25. James J. Rorimer, *Survival* (New York: Abelard, 1950).
26. Charles L. Kuhn, Special Report, no date, May 1945.
27. George Allen, Hermann Göring, Guard's eye view, July 25, 1945.

Chapter 18

1. Eldon J. Cassoday, Interrogation of Christa Gormanns, September 16, 1945.
2. Arthur A. White, letter to Inspector General, May 21, 1947.
3. Dr. H.K. Röthel, Interrogation of Robert Kropp, March 26, 1947.
4. George P. Mueller, telephone interview, July 8, 2008, and letter to Mrs. Lynn H. Nicholas, September 19, 1994.
5. George P. Mueller, telephone interview, July 8, 2008, and letter to Mrs. Lynn H. Nicholas, September 19, 1994.
6. George P. Mueller, telephone interview, July 8, 2008, and letter to Mrs. Lynn H. Nicholas, September 19, 1994.
7. George P. Mueller, telephone interview, July 8, 2008.
8. P. Kubala, Certificate, May 15, 1945.
9. Ardelia Hall, Memorandum of Conversation, March 3, 1954.
10. Edgar Breitenbach, Memling Madonna of the Renders Collection, March 10, 1947; and Theodora Rousseau, OSS Report No. 2, The Göring Collection, p. 173.
11. Ardelia Hall, Memorandum of Conversation, March 3, 1954; Thomas Carr Howe, *Salt Mines and Castles* (New York: Bobbs-Merrill, 1946); James J. Rorimer, *Survival* (New York, Abelard Press, 1950).
12. Edgar Breitenbach, Memling Madonna of the Renders Collection, March 10, 1947.
13. Theodora Rousseau, OSS Report No. 2, The Göring Collection.
14. Colonel Burton C. Andrus, *I Was the Nuremberg Jailer* (New York: Tower, 1970).
15. E.E. Minskoff, interrogation of Emmy Sonnemann Göring, September 18, 1945.
16. Eldon J. Cassoday, Interrogation of Christa Gormanns, September 16, 1945.
17. Captain John E. Sims, Request for authority to intern Frau Emmy Göring, September 7, 1945.
18. E.N. Reinsel, Historical Background for Shipment No. 70, November 5, 1946.
19. Mosley, *The Reich Marshal*, p. 364.
20. Herbert S. Leonard, Interrogation of Hermann Göring, August 31, 1946.
21. Foreign Exchange Depository — Shipment number 70.

Chapter 19

1. Thomas Howe, Jr., *Salt Mines and Castles* (New York: Bobbs-Merrill, 1946).
2. Thomas Howe, Jr., *Salt Mines and Castles.*
3. Colonel R.W. Hartman, Herman Göring Art Collection, August 8, 1945.
4. Colonel C.B. Spicer, Sworn Statement of Nathan P. Preston, August 27, 1945.
5. Colonel C.B. Spicer, Sworn Statement of Lincoln T. Miller, August 27, 1945.
6. Captain Harry A. Palmer, Report re: Goernnert and Angerer Incident, August 16, 1945.
7. U.S. Master Sergeant Siegfried Wahrhaftig, Statements taken, no date.
8. Herbert S. Leonard, Gothic goblins belonging to Göring, May 20, 1948.

Chapter 20

1. Theodore Rousseau, OSS Report No. 2, The Göring Collection.
2. Colonel R.W. Hartman, Herman Göring Art Collection, Berchtesgaden, August 8, 1945.
3. Edgar Breitenbach, The Looting of the Göring Train, p. 12, no date, estimated 1947.

4. Colonel R.W. Hartman, Herman Göring Art Collection, Berchtesgaden, August 8, 1945.
5. Peter Blos, Letter to Mr. Huntington Carins, September 19, 1946.
6. George P Mueller, Telephone interview, July 8, 2008, and letter to Mrs. Lynn H. Nicholas, September 19, 1994.
7. Edgar Breitenbach, Memling Madonna of the Renders Collection, March 10, 1947.
8. Captain M.G. Karsher, Missing Painting of Memling, April 5, 1947.
9. Edgar Breitenbach, Interrogation of Kurt Hegeler concerning the Göring Jewels, November 11, 1946.
10. Seventh Army Interrogation Center, SAIC/X/4, May 31, 1945.
11. Colonel John H. Allen, Transmittal of Information, February 14, 1946.
12. Eugene W. Oakes, Criminal Investigation Report, November 4, 1947.
13. Major John W. Farrar, Supplementary Testimony of Major Paul Kubala, December 5, 1947.
14. James J. Rorimer, Statement, January 25, 1948.
15. Colonel John H. Allen, Economic Division, July 23, 1947.
16. Consolidation Interrogation Report No. 2, The Göring Collection, Attachment 5, Theodore Rousseau September 15, 1945.
17. Agent Nicholas J. Abysalh, Report of Investigation Missing Painting, Case No. 13-B-208, January 27, 1948.

Chapter 21

1. Monthly Report of MFA&A for period ending July 31, 1945.
2. Andrew C. Ritchie, "Return of Art Loot from and to Austria," *College Art Journal*, 1946.
3. Hector Feliciano, *The Lost Museum* (New York: Basic Books, 1997).
4. Der Spiegl — Online.
5. Herbert S. Leonard, Letter to Calvin Hathaway, July 26, 1948.
6. Richard Howard, Letter to Calvin Hathaway, August 31, 1951.
7. Evelyn Tucker, Visit to Art Collection Center Munich, December 16–18, 1948.
8. William G. Daniels, Chief, Property Division, To Department of State, June 13, 1950.
9. Theodore Rousseau, Consolidation Interrogation Report No. 2, The Göring Collection, September 15, 1945, The National Art Gallery, Washington, D.C., p. 137.
10. Holmes, Secretary of State, March 27, 1956.
11. Mr. Crutcher, unsigned letter, Restitution in Error to Yugoslavia, March 10, 1954.
12. Konstantin Akinsha, "The Master Swindler of Yugoslavia," ARTnews, September 2001.
13. *New York Herald Tribune*, December 6, 1948.
14. Phillips Hawkins, American Embassy, Rome, Telegrams nos. 19 & 20, filed July 13, 1949.
15. IES — Mr. Russell L. Riley, Mr. Rodolfo Siviero, March 30, 1953.
16. Mr. Schott, Restitution to Italy of Works of Art, November 23, 1949.
17. Exceptional Return of Cultural Objects to Italy in 1948, no date, no signature, Wiesbaden Collection Point, National Archives.
18. Edgar Breitenbach, Letter to Ardelia, March 18, 1952.
19. Airgram from the Political Adviser for Germany, Berlin, September 22, 1948, NAS.

Conclusion

1. Kai Muehlmann, Summary of Works of Art, August 5, 1945.

Bibliography

The source material used to prepare this study was largely obtained from manuscript documents, which are listed in the notes. The titles listed below were also used, largely for general background information.

Akinsha, Konstantin, and Grigorii Kozlov. *Beautiful Loot: The Soviet Plunder of Europe's Art Treasures.* New York: Random House, 1995.

Alford, Kenneth D. *Great Treasure Stories of World War II.* Mason City, Iowa: Savas, 2000.

_____. *Nazi Millionaires.* Haverty, Pennsylvania: Casemate, 2002.

_____. *The Spoils of World War II.* New York: Birch Lane Press, 1994.

Bradley, Omar N. *A Soldier's Story.* New York: Holt, 1951.

_____, and Clay Blair. *A General's Life: An Autobiography by General of the Army Omar N. Bradley.* New York: Simon & Schuster, 1983.

Butcher, Harry C. *My Three Years with Eisenhower: The Personal Diary of Captain Harry C. Butcher, USNR, Naval Aide to General Eisenhower, 1942–1945.* New York: Simon & Schuster, 1946.

D'Este, Carlo. *Patton: A Genius for War.* New York: HarperCollins, 1995.

_____. Eisenhower: *A Soldier's Life.* New York: Henry Holt, 2002.

Duberman, Martin. *The Worlds of Lincoln Kirstein.* New York: Alfred A. Knopf, 2007.

Edsel, Robert M. *Rescuing Da Vinci: Hitler and the Nazis Stole Europe's Great Art, America and Her Allies Recovered It.* Dallas: Laurel, 2006.

Eisenhower, Dwight D. *Crusade in Europe.* New York: Doubleday, 1948.

Flanner, Janet. *Men and Monuments.* New York: Harper & Brothers, 1957.

Göring, Emmy. *My Life with Göring.* London: David Bruce & Watson, 1972.

Harrison, C.A. *Cross Channel Attack.* Washington, D.C.: U.S. Government Printing Office, 1951.

Hitler, Adolf. *Mein Kampf.* Trans. Ralph Manheim. New York: Houghton Mifflin, 1943.

Holladay, Joan A. *Illuminating the Epic.* Seattle: University of Washington Press, 1996.

Howe, Thomas Carr, Jr. *Salt Mines and Castles.* New York: Bobbs-Merrill, 1946.

Konstantine, Akinsha, and Grigorii Kazlov. *Beautiful Loot.* New York: Random House, 1995.

Kurtz, Michael J. *America and the Return of Nazi Contraband: The Recovery of Europe's Cultural Treasures.* Cambridge: Cambridge University Press, 2006.

McDonald, Charles B. *The last Offensive.* Washington, D.C.: United States Army, 1984.

Mosley, Leonard. *The Reich Marshal.* New York: Doubleday, 1974.

Nazi Conspiracy and Aggression. Washington, D.C.: U.S. Government Printing Office, 1946.

Nicholas, Lynn. *The Rape of Europa.* New York: Vintage, 1995.

Nuremberg 14 November 1945–1 October 1946. Nuremberg: International Military Tribunal, 1947.

Popa, Opritsa D. *Bibliophiles and Bibliothieves.* New York: Walter de Gruyter, 2003.

Report of the American Commission for the Protection and Salvage of Artistic and Historic Monuments in War Areas. Washington, D.C.: U.S. Government Printing Office, 1946.

Rorimer, James J. *Survival: The Salvage and Protection of Art in War*. New York: Abelard Press, 1950.

Shirer, William L. *Berlin Diary: The Journal of a Foreign Correspondent: 1934–1941*. Norwalk, CT: Easton Press, 1991.

_____. *The Rise and Fall of the Third Reich: A History of Nazi Germany*. Norwalk, CT: Easton Press, 1991.

Smyth, Craig Hugh. *Repatriation of Art from the Collecting Point in Munich after World War II*. Montclair, New Jersey: Abner Schram, 1988.

Speer, Albert. *Inside the Third Reich*. New York: Macmillan, 1970.

Stanton, Shelby l. *World War II Order of Battle*. New York: Galahad Books, 1984.

Wynne, Frank. *I Was Vermeer*. New York: Bloombury, 2006.

Yeide, Nancy H. *Beyond of Avarice*. Dallas: Laurel, 2009.

Index